PICASSO'S WAR

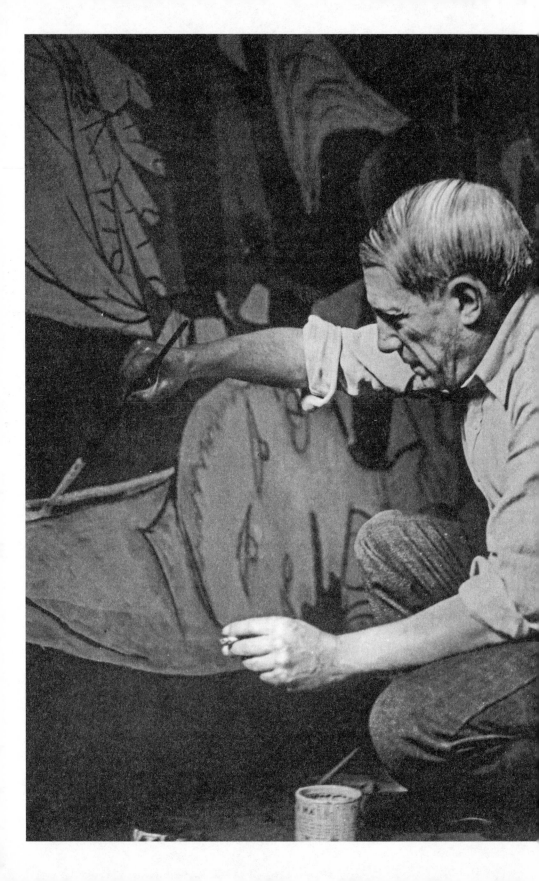

Picasso's War

—

HOW
MODERN ART
CAME TO AMERICA

—

Hugh Eakin

 CROWN
NEW YORK

FOR MY GRANDMOTHERS,
JEAN GIBSON EAKIN AND
JEANNE NEWHALL SHEPARD

Contents

PART II

Preface

I n recent years, there has been a block of Midtown Manhattan that, even in New York, stands out as a hegemonic empire of art and money. Walled in by lustrous expanses of glass and blackened steel, the Museum of Modern Art is a city-state unto itself. In a place where the only room to grow is up, it luxuriates in an ever-growing horizontal sprawl of some of the country's most coveted real estate. On its board sit more billionaires than are found in all but nine U.S. states; its paintings alone, more than two hundred thousand artworks from all over the world, are worth more than the GDP of a number of small countries.

At its pulsing center is the work of a single artist, a figure whose ghostly presence seems to course through all sixty of the museum's white-walled exhibition spaces, even in rooms filled with work created long after his death. In the museum's inner sanctum, through the luminous foyer and up the escalators, across the floating glass-walled bridge to the fifth-floor galleries where the core of the collection still holds sway, is a very large room that—even amid today's frequently shifting arrangements—continues to be defined by his art. Here, some of the greatest works of Picasso seem to become synecdoches for the museum itself. Flanking the entrance are two huge 1906 paintings that speak of a revolt about to take place. Then, on the far side of the room, dominating

an entire wall, is the jarring act, in mid-progress: a huge tableau of naked giantesses who seem to be tearing down the foundations of Western art. Surrounding them is the glorious, disturbing aftermath: In 2021, this included not only Picasso's seen-from-all-sides-at-once Catalan townscape and his defiantly unbounded bronze *Head of a Woman,* but also Louise Bourgeois's haunting painted-wood figurines from the late 1940s and the twisted, terrified bodies of Faith Ringgold's civil-rights-era masterpiece, *American People Series #20: Die*—reminding us that the revolt never quite ended.

But the vast Picasso Valhalla was not always thus. Once upon a time, the art that is now synonymous with twentieth-century American culture was ridiculed and shunned. For years, even the idea of creating such a museum, centered around this art and this artist, went nowhere. And when the museum did finally get its start, it was brought into being by little more than a society lady's whim. Occupying cramped, rented rooms, it had no endowment and hardly any budget—and not a single Picasso to its name. Once upon a time, the cultural hegemon had struggled to survive.

For nearly thirty years, the effort to bring modern art to the United States was continually impeded by war, economic crisis, and a deeply skeptical public. It was a project that might well have foundered, and almost did, but for the fanatical determination of a tiny group of people. This book tells their story.

PICASSO'S WAR

Prologue

The painting was in the corridor with its face to the wall. Measuring more than four feet high and nearly seven feet across, its huge rectangular frame beckoned, and all four guests were eager to see it. But they would have to wait. There were Bacardi cocktails to drink, followed by dinner and coffee. As they gathered in the front rooms of the cavernous ninth-floor apartment, they somehow needed to find other things to talk about. John Quinn would not be rushed in his own home. A tall, fair-complexioned man with a sharp jawline, piercing blue eyes, and a pronounced forehead in front of a balding crown, their host was an almost physical embodiment of the strength of will. Even his assertive posture appeared to be at war with his hollowed-out frame.

At last, after the coffee was served, Quinn rose from the table, stepped out to the hallway, took the painting to the drawing room, and set it up on a large easel under good lighting. Then he returned and poured each of his guests a glass of prewar champagne. It was time. Carrying their glasses, they followed him in.[1]

From the outset, the dinner had stirred up expectation. It was the early spring of 1924, and for months, the hard-charging Wall Street lawyer had not entertained. At the start of the year, he had sold off much of his incomparable collection of modernist manuscripts—including the

first drafts of nearly all of Joseph Conrad's novels and the twelve-hundred-page original text of James Joyce's *Ulysses*. And in recent weeks, Quinn had mostly suspended the vast personal correspondence he kept with artists and writers across Europe. Among his large New York circle, many had not seen him at all. Now he had abruptly summoned the four of them.

As they glanced at one another around the table, they knew they had not been chosen casually. Arthur B. Davies, painter, aesthete, and society man, was one of the city's most well-connected champions of modern art. Frederick James Gregg, mordant critic for *Vanity Fair* and the New York *Sun,* had long been one of Quinn's closest intellectual allies. Joseph Brummer, the Hungarian art dealer who had once swept floors for Matisse in Paris, was one of the very few people in the United States who knew personally many of the artists whom Quinn collected.[2] Rounding out the company was the poet Jeanne Robert Foster, a younger woman with large, inquisitive eyes, a Greek nose, and an unruly mass of reddish-blond hair. She was the literary editor of *The Transatlantic Review* and was better informed about the art and writing of twentieth-century Europe than almost anyone in Manhattan. Though she was married to another, much older man, she had for several years been Quinn's lover.

In New York at the time, only a handful of collectors were interested in living artists. Contemporary modern art was deemed to have negligible value, and many found the new colors and techniques abhorrent, or even subversive. Yet over the previous decade, Quinn had filled his eleven-room suite on Central Park West with hundreds of the most startling new artworks in existence. Hallways were cluttered with beguiling marble and polished bronze sculptures, animal and human subjects reduced to their underlying essences; bedrooms were filled with riotous canvases—not hung up, but lining the walls in thick rows, stacked under chairs, and stuffed under beds. When Quinn was in the right mood, he would bring out any number of remarkable paintings, works that challenged the imagination of his visitors: Cézannes and Van Goghs, Gauguins and Seurats, Fauvist landscapes, Futurist dancers, Vorticist women. There was an exceptional clutch of Matisses, including one that had provoked a violent backlash a few years earlier. And of course the

Picassos, several dozen of them, spanning from his early *Old Guitarist* to exquisite forays into analytical Cubism to his late Cubist masterpiece *Harlequin with Violin (Si tu veux)* and encompassing all the contrasting phases of his art.

Even by Quinn's standards, however, the painting that awaited them that night was out of the ordinary. In Paris, where it had turned up in a basement six weeks earlier, it had shocked and overwhelmed several of the leading connoisseurs of the new art; though its history remained obscure, there was talk of it going straight to the Louvre. In the United States, no one had known of its existence.

No one except Quinn. Picasso had been one of the first to see the mysterious painting, and he had immediately thought of his American friend. Two weeks later, Quinn had bought it, for a modest sum, without leaving New York, without ever seeing it. Picasso's judgment, and the fervent appeals of Quinn's other Paris friends, had been enough. They knew he had been hunting for such a singular painting for years; they felt certain this was the one. Having crossed the ocean on the S.S. *Paris* in a large crate, the very large work had been delivered to Quinn's apartment shortly before his guests arrived. Before the dinner, he had unwrapped it. But he hadn't inspected it, until now.

As they entered the room, Quinn's dinner companions were seized by the giant rectangle. Confronting them was a nocturnal encounter as alluring as it was strange: A serene, dark-complexioned woman slumbers on a barren desert ridge; as she sleeps, a huge lion approaches her and sniffs her hair, its upturned tail silhouetted against the cool night air. The two seem to be in remarkable communion, even as the beast menaces.

Overpowering in its tension and equipoise, the painting was unlike any they had seen. For sheer mastery of its human and animal forms, spareness of detail, and uncanny rhythm and balance, the giant canvas was astonishing. But it was also filled with unsettling mystery. It was hard to tell, Quinn observed, whether the lion was going to devour the woman or not. For some time, they stood looking at it. Eventually, Davies called it "wondrous." Then they raised their glasses. "To beauty," someone said.

Quinn was a man not easily pleased. He'd turned down Seurats and Van Goghs that European rivals had coveted. He had passed up countless Braques and Matisses, preferring to wait for better ones. At times, he'd rejected Picassos that the artist himself had offered him. Sometimes he'd sent paintings back that he found wanting. Up until the moment he saw it, his friends in Paris were worried about this one, too. They needn't have been. "The painting sings, every part of it, and the whole of it is perfect," he wrote the next morning.[3]

Called *The Sleeping Gypsy,* the painting was by Henri Rousseau, the French customs official and self-taught artist who had died in 1910. Though he remained little known to the general public, he was a lodestar to Picasso and other avant-garde painters, who befriended him at the end of his life. Quinn had long been fascinated by Rousseau's unworldly genius. He also knew that his paintings were widely scattered. Years earlier, he had set out to acquire a work of Rousseau's that stood out above all the others. He was convinced that such a picture existed, but none of the Rousseaus he saw measured up. Until Picasso found him the woman and the lion.

For Quinn, the painting's arrival in his apartment was the climax of a career as a cultural renegade, a life lived through the most daring art and literature of his time. Though he seldom traveled to Europe, Quinn had made friends with, and personally supported, an improbable number of the artists and writers who would go on to define modernism, picking them out, on his own judgment, because they excited him: Joseph Conrad and Henri Matisse, Ezra Pound and Pablo Picasso. He had followed them through the war, sent them letters and money, visited their studios and flats, worried about their health. Even as he struggled to keep up with his law practice, as his own health declined and he ran out of funds, he always found time for what he adamantly referred to as *living* art. The paintings and sculptures that moved him most were not just objects of uncommon beauty; they had to give off "radium," he told his friends, the energizing rays of life itself.

Nor had he been content to keep his enthusiasms private. At a time when modern art remained deeply suspect to most Americans, Quinn aggressively promoted avant-garde painting and modernist prose. He

introduced Americans to the poetry of W. B. Yeats and T. S. Eliot, to Romanian sculptor Constantin Brancusi's *Mlle Pogany* and to French artist Marcel Duchamp's *Nude Descending a Staircase*. He defended taboo-breaking novels in court and lobbied Congress to end a punitive import tax on contemporary art. The best new work, he argued, was inseparable from social progress, and introducing it to a broad public would bring American civilization to the forefront of the modern world.

Six years earlier, at the end of the war, he had embarked on an even more ambitious project: to gather together the very best works by the small group of artists who, in his estimation, were changing history. With these unheralded masterpieces, he was going to build the first great modern art collection in the United States. And he was going to transform the way Americans thought about art. With his Picassos, and now the big Rousseau painting, he seemed, at last, to be bringing that project to fruition.

As they stood admiring Quinn's greatest prize, however, Jeanne Foster knew how distant his ambition still was. Her work as a journalist and critic had given her few illusions about American culture. Modest and self-effacing despite her exceptional strength of mind, she made a striking counterpoint to Quinn's cocksure brilliance. She shared many of the lawyer's remarkable qualities, including humble origins, an elite education, and an insatiable curiosity that bridled against prevailing taste and social convention.

Were Americans ready for Quinn's Picassos and Brancusis? She doubted it. She knew many of the country's cultural institutions fiercely resisted the kind of art that Quinn supported, and few other patrons seemed ready to follow his lead. After all, only four of his close friends were present to welcome *The Sleeping Gypsy,* and they were already converted. By contrast, just a few months earlier, the socialite Louisine Havemeyer, though she was viewed as one of the city's most progressive art collectors, had taken direct aim at Quinn and his radical circle. She was tired, she'd said, of the "modern art which certain people are trying to force down the public's throat."[4]

Foster knew that many of Quinn's projects—like creating a permanent space for modern art, or getting the Metropolitan Museum of Art

to start acquiring twentieth-century paintings—had foundered. She also worried that he was running out of time. Though he was just fifty-four, Quinn was seriously ill. He had never mentioned cancer to anyone, but following a difficult operation in 1918, Foster had learned the real story. Privately, his doctors had told her that he might have another six years to live. Now his time was up. For the moment, he maintained a defiant vigor, dragging himself to his office every day and asserting his usual sharp wit whenever he could. As recently as the previous autumn, she had accompanied him on a headlong five-week trip to Paris, Venice, Florence, Siena, Rome, and Berlin. Yet he had to wear a canvas corset to support his abdomen and it took him enormous effort just to get out of bed in the morning. And while Quinn kept filling his apartment with more stupendous examples of living art, he had no direct heirs, and he had never resolved his plans for the collection after his death.[5]

The morning after the party, Quinn moved *The Sleeping Gypsy* to his own bedroom, where he set it on a table between two east-facing windows. As the sun rose higher, the light from the windows began to fill the canvas. Quinn thought it looked even better than it had during the party. Later, at his office, he dictated a letter to one of his closest friends in Paris. "I think it is not only the greatest painting Rousseau ever did . . . but one of the greatest paintings done in modern times," he wrote.[6] To those who knew Quinn only as a man of radical tastes and towering ego, these words might have simply appeared self-serving. The painting was virtually unknown, and who was to say what others might make of it, let alone its larger place in some imagined canon of the new art?

In fact, it would take years for the country to recognize how prescient Quinn had been. Though it would require the onset of another World War to decisively shift public opinion, the art he pursued would one day take its place at the very center of American culture. If it was an ending of sorts, the lonely triumph of *The Sleeping Gypsy,* in the spring of 1924, was also a beginning.

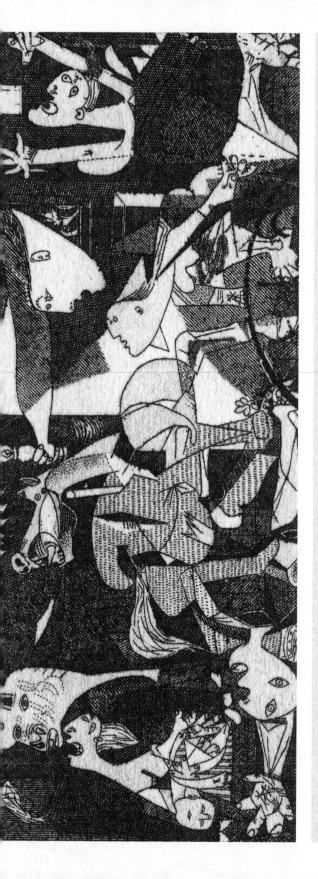

Part 1

1

NOT IN AMERICA

One afternoon shortly after his forty-first birthday, John Quinn ascended to the top of an undistinguished five-story building on Fifth Avenue. He had come to see the work of an artist who had never been shown in the United States before. As he began to move through the small, square gallery, however, he was alarmed. Crowding the bleached-burlap walls were several dozen drawings and watercolors, so many that they had been placed in vertical stacks two and three rows high. In a few, he could make out human figures, such as the austere peasant woman in profile who had greeted him at the entrance. Most of the images, though, left him queasy: heads and faces disintegrating into stacks of overlapping shapes; limbs endlessly reduced, first to primitive, carved-like forms, then to mere lines, angles, and shading. "There is something blood-curdling about some of them," he commented to one of his friends afterward. "Like some awful dream partly forgotten but haunting still."[1]

It was the spring of 1911, and Quinn was attending the first Picasso show ever held in the United States. It didn't go well. The show was at the Little Galleries of the Photo-Secession, commonly known as 291, the pioneering art space run by photographer Alfred Stieglitz. Occupying a garret that was just fifteen by fifteen feet and heated by a woodstove in a

back room, 291 had a hardy reputation for showing work that could not be found anywhere else in America, and it was less a commercial gallery than a club for Stieglitz's like-minded friends. Even among this crowd, however, the Picasso drawings had come as a shock. Critics who ventured to the show remarked on the artist's "astonishing travesties on humanity"; one charcoal sketch—*Standing Female Nude,* a twisting tower of lines and semicircles—was memorably likened to a "fire escape, and not a good fire escape at that."[2] Edward Steichen, the show's co-organizer and an avowed modernist himself, admitted that Picasso was "worse than Greek to me."[3]

Quinn had come full of expectation. As the head of a boutique downtown legal practice, the driven Irish American worked in the high-collared world of Manhattan finance. Considered one of the top legal minds on Wall Street, he served as counsel for the New York Stock Exchange and for the National Bank of Commerce, the country's second largest bank. Yet he also led a curious second life as a cultural disruptor, seeking out the most bracing new poets and artists, helping experimental writers get published, sponsoring controversial stage plays, and spending long nights arguing about the new Irish verse. "I like to be a man of my own day and time," he would tell uncomprehending friends.[4]

The previous November, he'd heard about a sensational exhibition of French modern art that was taking place at the Grafton Galleries in London. Called *Manet and the Post-Impressionists,* the show set out to introduce several generations of French artists to the British public. Though the nineteenth-century painter Édouard Manet was reasonably well known in England, the pioneering modernists who flourished after his death—Cézanne, Van Gogh, Gauguin—were not. Unprepared, many viewers found these so-called "post-Impressionists" so anarchic and unsettling that they reacted with outrage. Leading artists like John Singer Sargent ridiculed them; one supposedly progressive critic suggested they were part of a "widespread plot to destroy the whole fabric of European painting."[5] Quinn's own London friends were flummoxed. "I don't think I ever saw anything so stupid in my life," George Russell, the Irish poet and critic, wrote him.[6]

Watching from afar, Quinn was fascinated that modern paintings

could provoke such a response; he wished he could see them. Throughout the winter, he kept asking about the post-Impressionists. Pressing Russell to see the show again, he wrote, "I shall be glad if you let me know what you think of Van Gogh, of Gauguin, of Picasso, of Matisse, and of the great Cézanne."[7] Apparently their most daring follower, Picasso was the young Spaniard who had two early works in the final room in London. Here was the artist Quinn thought he needed. "Are any of Picasso's things for sale, or do you think I ought to have any of them?" he wrote one London friend. He added, "I wish the post-Impressionists were brought over here."[8]

Then the Picasso drawings had turned up at Stieglitz's gallery. But Quinn had no idea what he was in for. Until now, his exposure to new painting had mostly been limited to Irish portraits and American urban realists. Thinking himself up to date, he was attracted to the bright colors of the English painter Charles Shannon and the picturesque brushstrokes of the American landscapist Ernest Lawson. From what little he knew, he thought that Puvis de Chavannes, a late-nineteenth-century symbolist known for wispy, allegorical paintings, was the epitome of new French art. That there could be an art that shattered all rules of perspective and flouted basic precepts about beauty had not occurred to him. "I have never seen any of Picasso's work," he admitted, weeks before the 291 show opened.[9]

For the first four decades of his life, the man who would soon become the world's greatest collector of the Paris avant-garde knew astonishingly little about modern art. Not only had Quinn never encountered a Picasso, he had seen hardly any French paintings of the past half century at all. For several generations, artists in the French capital had been leading one of the greatest upheavals in Western art history. Yet Quinn hadn't absorbed the work of their nineteenth-century forerunners, the Impressionists. In his sole visit to France, a hurried, one-day Channel crossing during a hectic trip to London, all he had managed to do was spend an hour at Chartres Cathedral, which he found oppressive. Indeed, he seemed almost unaware that Paris existed.[10]

This blind spot did not come from lack of curiosity or ambition. To the contrary. At the time of the 291 show, Quinn's reputation as an art enthusiast and literary maven already extended to both sides of the Atlantic. In New York, he was admired for his legal mind, his self-possession, and his deep connections in the worlds of finance and politics; the spring of the Picasso show, the Democratic Party briefly considered tapping him to run for the U.S. Senate. In London and Dublin, where he seemed to have personal friendships with nearly all of the newest writers and poets, he was known as the improbably well-informed Yankee who had a preternatural ability to sniff out genius—and bring it to the United States.

It was Quinn who had urged the Irish poet W. B. Yeats to read Nietzsche; Quinn who served as an informal talent scout for a young New York publisher named Alfred Knopf, introducing him to a continual stream of modernist writers that would eventually include Conrad, Eliot, Joyce, and Pound, among many others. In his social circle, Quinn counted President Theodore Roosevelt and Judge Learned Hand, but also the Ashcan School painter John Sloan and the British actress Florence Farr Emery. As a young man he had stood behind Grover Cleveland at his inauguration; in London he had met a rising politician named Winston Churchill.

And then there was his energy. He routinely put in fourteen- and fifteen-hour days at his law practice, preceded by early morning horseback rides in Central Park and followed by dinners with critics, publishers, judges, and other friends several nights a week. Forswearing marriage as quaint and cumbersome, he had a continual series of women companions, who tended to find him irresistibly attractive and maddeningly elusive in equal measure. ("You brought me to life, and then . . . ? My heart is breaking," May Morris, the glamorous daughter of the late Victorian designer and artist William Morris, wrote to Quinn, around the time of the Picasso show.[11]) Nowhere was his roving spirit more in evidence than in the vast correspondence he kept with a transatlantic circle of writers, publishers, judges, politicians, and other accomplished and influential persons, among them the greater Yeats family, the novelist Joseph Conrad, the Irish playwright (and Quinn's onetime lover)

Lady Gregory, the critic George Russell, and the future Irish president Douglas Hyde. Sitting at his dining room table on Sunday afternoons, Quinn would call in as many as three secretaries, to whom he liked to dictate letters simultaneously, some of them running to fifteen or twenty pages or more. (To improve efficiency, he composed certain block paragraphs—describing a book he had read, say, or his thoughts about a particular event or international crisis—that he could drop into letters to multiple correspondents.)

Of all his exertions, perhaps most striking was his athletic reading habit, which he indulged late at night, or in train cars to and from meetings in Washington. Heine, Carlyle, Santayana, Lafcadio Hearn; French novels, German philosophy, Irish plays, Indian poetry. The *Times, The Masses, The Gaelic American, The English Review*. In an age of proliferating magazines, he read them all, and he consumed books at a rate of nearly a thousand a year, from many of which he could quote verbatim. In later years, when T. S. Eliot sent him a draft of "The Waste Land," he committed it to memory by having Jeanne Foster read it to him while he shaved. "It is amazing how seldom my mind ever gets tired," Quinn commented to one friend a few months before he saw the Picassos at 291. "My body sometimes tires."[12]

Yet there was almost nothing in Quinn's expansive orbit that connected him to the epicenter of artistic revolt in Europe. At the Metropolitan Museum, New York's only public art gallery, it was hard to find any significant French painting more recent than the late eighteenth century. The bankers and insurance magnates for whom Quinn worked had tastes that ran to the Renaissance and medieval period. And while he kept in touch with a wide network of writers and intellectuals in Britain and Ireland, they were nearly as unfamiliar with Montmartre as he was.

In many respects, it was remarkable that Quinn had gotten as far as Wall Street. Born in 1870, he grew up in an immigrant household in small-town Ohio. Both parents had escaped the potato famine in Ireland; his mother had come as an orphan of fourteen, and a few years

later married his father, who ran a bakery. Out of eight siblings, only Quinn and two sisters survived far into adulthood.[13]

But Quinn was not like other children. His youthful obsessions were Helen of Troy, whose ungodly beauty had driven men to war, and Buffalo Bill, the legendary conqueror of the West. Under the sway of his intellectually curious mother, he also began spending pocket money on novels by Thomas Hardy and other contemporary European writers, which he consumed on the living room floor—an exceedingly unusual habit for a baker's son in the nineteenth-century American hinterland. In high school, he volunteered to run an Ohio politician's campaign for Congress. He also made a large bet on the 1888 presidential election, which he lost. Already he was beginning to nourish the speculative interests in culture and politics that, along with a tendency to see the world as a series of battles to be waged and won, would define his later thrust into what he called the "modern art fight."

At the same time, his quick intelligence and extraordinary self-assurance—helped by a slender six-foot-one physique and chiseled profile—marked him as someone with places to go. Within a year of matriculating at the University of Michigan, he was recruited to come to Washington as private secretary to Charles Foster, the former Ohio governor who had just been appointed U.S. Treasury Secretary by President Benjamin Harrison. Struck by Quinn's abilities, Secretary Foster hoped his protégé would return to a political career in Ohio and marry his daughter Annie—the first in a series of attractive prospects that Quinn would turn down.

While working at the Treasury, Quinn spent nights completing a law degree at Georgetown and reading Eckermann's *Conversations with Goethe*. Moving on to Harvard Law School, he obtained a second degree, finding time along the way to study philosophy with William James and aesthetics with George Santayana. By the time he started out as a young finance attorney in New York, it was already clear that legal work would be unlikely to fully occupy his restless mind.

From the outset, it was literature and politics that excited him, and he was stifled by the conservatism he found in New York. Discovering his Irish roots, he was entranced by the literary awakening taking place

in Dublin, where a group of writers and intellectuals had set out to reinvent the Irish nation in prose, drama, language, and ideas. Traveling to Britain and Ireland in 1902, when the movement was at its height, he met W. B. Yeats and Lady Gregory, whose co-written modern stage play *Cathleen ni Houlihan,* based on the Irish rebellion against British rule of 1798, was stirring audiences to a frenzy. (Years later, after the Irish leaders of the 1916 Easter Rising had been executed by the British, Yeats in his poem "The Man and the Echo" was still recalling the reaction to *Cathleen:* "Did that play of mine send out / Certain men the English shot?") As Quinn quickly grasped, literature could change the way people think. It was a power he wanted to harness in the United States.

The following year, he brought Yeats to New York, determined to launch him in America. At the time Yeats was an obscure foreign poet who had not been published in the United States, but through an extraordinary publicity campaign and monthslong, cross-country lecture tour, Quinn managed to turn him into an improbable national celebrity. (One of Quinn's techniques was to plant stories about Yeats in local newspapers in advance of each lecture, thus guaranteeing large crowds.) In addition to setting up more than sixty lectures, including engagements at Harvard, Yale, and Carnegie Hall, Quinn arranged for Yeats to have lunch at the White House, and by the end of the tour, his works were being fought over by several of the country's leading publishers. It was a formula that Quinn would rely on frequently over the next decade, as he helped introduce a series of writers, dramatists, and politicians from Dublin and London to the United States. During a visit to Ireland in 1907, Francis Hackett, the literary editor of *The Chicago Evening Post,* was astonished by the stories he heard about the New York lawyer and his promotional talents. "I foresee a John Quinn Myth," he wrote.[14]

By the time he came face-to-face with the Picasso drawings at Stieglitz's gallery, Quinn had long since become one of the primary conduits for bringing new ideas from England and Ireland to the United States. He also was known for supporting new art in New York, including the work of The Eight, the group of artists who were striving to unshackle American painting from tired academic traditions and capture the gritty

experience of modern urban life. And yet, when it came to Picasso and the Paris avant-garde, he was no more prepared than anyone else.

Today, it is hard to grasp how perplexing it was for New Yorkers to walk into a room crammed with Picasso's Cubist figures. Conditioned by centuries of representational art, they saw his drastically simplified heads as "Alaskan totem poles"; his use of cones and cubes to capture multiple simultaneous points of view as the "emanations of a disordered mind."[15] Quinn was so baffled by the drawings that, when he described them to a friend afterward, he referred to them as "studies(?)" as if he couldn't quite conceive of them as actual works of art. And yet the lessons he drew from the experience were more complicated: Here was an artist who was doing something completely new and was willing to court disdain for it. Agreeing with the views of his British friend, Quinn wrote, "I don't suppose Picasso expects the approval of the public for a moment."[16] There was an exhilarating audacity to what the artist was up to, even if the work repelled him.

In offering a first glimpse of the new frontier of modern art, the Picasso exhibition at 291 was a coup. If its aim was to establish American interest in Cubism, however, it was a catastrophic failure. Hoping to attract adventurous collectors, Stieglitz had priced the drawings at $12 each.[17] Yet even after extending the show's run for several weeks, he had managed to sell only one of the eighty-three works in the show, the tamest of the group. Despite the low prices and his previously declared interest, Quinn declined to acquire any of them.

Saddled with a huge trove of unsold pictures, Stieglitz was desperate. Having relayed to Picasso shortly after the opening that the show was a "great success," he was in the embarrassing position of having to return nearly all of the works to Paris. In the end, he decided to purchase the magnificent *Standing Female Nude,* the "fire escape" drawing, for himself. Then he approached the Metropolitan Museum with a bold proposal: Would the museum like to acquire the entire remaining set of Picasso drawings for $2,000? In retrospect, it was an extraordinary opportunity. Here, in a single group of works, was the story of the development of Cubism between 1906 and 1911, a period during which Picasso had pushed forward one of the greatest transformations in artistic prac-

tice in five centuries. At the time, the big museum was the wealthiest art institution in the world and the price would hardly have registered. This was in the same year that Henry Clay Frick paid $475,000 for Velázquez's *Philip IV* and Peter Widener spent a half million dollars on Rembrandt's *The Mill*. The eighty-one Picasso drawings would not even have covered the dealer's commission on those sales.

But there wasn't a chance. When Stieglitz made his offer to Bryson Burroughs, the Met's curator of paintings, Burroughs could barely hide his amusement. "Such mad pictures," he told him, "would never mean anything to America."[18]

2

THE
HALF-LIFE OF
A PAINTING

During the years in which Quinn was getting his footing in New York, American society was a torrent of contradictions. Stirred by its triumph in the Spanish-American War and its growing empire, the United States could now claim world power status. And as the new ruling classes saw it, unlike the leading states of Europe, the United States was not held back by the ways of the past. With its scientific assembly lines, advanced infrastructure, and unbridled capitalism, the brash American republic could vault to the forefront of modern civilization. By 1910, American homes and businesses were connected by some five million Bell telephones; that summer, Quinn gave his friend John Sloan, the Ashcan School painter, his first automobile ride, from Coney Island to Manhattan, prompting Sloan to reflect on how the quick and apparently effortless new machines were bound to give Americans "an arrogant point of view."[1]

Yet despite the extraordinary pace of change, the American establishment was often parochial, moralizing, xenophobic, and rife with prejudice. The country's economic foundations had been built on slavery and cheap immigrant labor. Women could not vote. Factory workers had few rights. And in the Jim Crow South, a vast system of racial

terror maintained de facto subjugation over some nine million African Americans. As for culture, there was deep unease about the unconventional and the foreign. "You are wide-awake over in America, but it is in politics & practical matters," John Butler Yeats wrote to Quinn, after the lawyer's first visit to Dublin in 1902. One had to go to Ireland, he argued, to find a country that was "wide awake in ideas literature philosophy drama."[2]

Quinn would have been the first to agree. New York, for all its infatuation with global commerce, was a cauldron of ethnic rivalries and intolerance. By 1910, after a decade of record immigration, an astonishing three-quarters of the metropolitan population were foreign-born or first-generation Americans. But the influx had led to a pervasive disdain for the newcomers—Irishmen, Jews, Italians, Chinese, Slavs—and the diseases and unclean habits they were said to bring with them. The more international the city's inhabitants became, the greater the fears of its leading families that they were being overrun. (Informed by late-nineteenth-century doctrines of racial superiority, they failed to recognize that Anglo-Saxon culture itself had been imposed, with considerable violence, on the American territory over several centuries.)

At the same time, the enduring imprint of Puritan morality tended to make new literature, art, and ideas highly suspect. In New York, the U.S. postal inspector and anti-vice crusader Anthony Comstock exerted enormous power through his Society for the Suppression of Vice. Armed with Congress's broadly worded Comstock Act—which made it a criminal offense to send "every obscene, lewd, or lascivious . . . book, pamphlet, picture, paper, letter, writing, print, or other publication of an indecent character" through the mail—Comstock and his supporters censored hundreds of works of literature, from *The Canterbury Tales* and the *Arabian Nights* to modern novels by Balzac, Victor Hugo, and Oscar Wilde. They also banned suggestive images, cracked down on suffragists, and confiscated printed material referring to abortion and sex. Other American cities had similar morality squads and could be counted on to shut down any modern performance deemed too radical or risqué. Unsurprisingly, many of the targeted works came from abroad.

Quinn himself was acutely aware of the threat of censorship. A few months after he saw the Picasso show at 291, he helped arrange a U.S. tour for an Irish production of J. M. Synge's controversial 1907 drama, *The Playboy of the Western World*. Synge was a leading figure in the Irish literary awakening, and *Playboy* dealt openly with patricide and infidelity in rural Ireland. In New York, the actors were pelted with vegetables and stink bombs; in Philadelphia, the whole company was arrested for alleged immorality. In the end, Quinn managed to have the charges dismissed—"I skinned them alive," he exulted afterward—but it was only one in a series of bruising court battles in which his legal expertise would prove crucial to his activities as an avant-garde patron.[3]

The status of foreign art was particularly complex. In contrast to literature and ideas, artworks from Europe were highly coveted. "America was taking a leading place among nations," the New York society architect Stanford White asserted, "and had, therefore, the right to obtain art wherever she could."[4] J. P. Morgan was chairman of the Metropolitan Museum, and together with his wealthy friends, set out to make it a temple of art that surpassed Berlin's Nationalgalerie or London's British Museum. The Boston Museum of Fine Arts and the Art Institute of Chicago, among other municipal galleries, had similar aims. Between the 1890s and the start of World War I, more great Old Master paintings left the Continent for American shores than at any other comparable span of time in history.

For Europe's modern artists, this should have been an opportunity. While the United States was building the world's most advanced economy, France, Germany, and Russia were creating a dynamic new art. For a fraction of the cost of a single Vermeer, an American collector could buy any number of Cézannes or Van Goghs, let alone Picassos and Matisses, paintings whose dazzling experiments with form, color, and perspective, whose explosion of traditional methods and approaches, perfectly matched the forward-thrusting spirit of the age. As the recently expatriated Ezra Pound would tell Quinn, for anyone who wanted, "another Cinquecento" was there for the taking.[5] But the canvases that the new American superpower was bringing across the ocean were the masterpieces of past eras. The same men—and they were

mostly men—who were driving America's breakneck modernization had an almost pathological phobia of modern art.

Confronting this paradox, Quinn found himself increasingly disillusioned. Instead of supporting new art, the country's wealthiest collectors were seeking paintings that came with links to Queen Christina or Philip IV. In a mercantile world in which everything was judged by its economic value, they preferred to spend hundreds of thousands of dollars on a Rembrandt or Gainsborough rather than a few hundred dollars on a Cézanne. In turn, a powerful cartel of art dealers, such as the Duveens and the Knoedlers, had acquired an iron grip on the American art market and were reaping enormous profits by bidding up Old Master paintings and discouraging an interest in modern art altogether. In 1907, having returned to the United States after many years in Europe, the novelist Henry James observed that the Metropolitan Museum was in the business of buying civilization, not making it. "Creation," he wrote, "was to be off the scene altogether."[6]

By the time of the Picasso show at Stieglitz's gallery, Quinn had come to view the fashion for exorbitantly priced, and often second-rate, old Dutch and Spanish paintings as a dangerous check on the country's vitality. While he had yet to see much of the new art for himself, he sensed how hidebound American taste had become. As he complained to his friends, there was no "sport" in chasing the same painters sought by generations of earlier collectors, no sense of "discovery." Sought after for their social cachet and the air of antiquity they evoked, many of these paintings had been given so many coats of varnish by art dealers— a standard procedure used to protect underlying pigments and create a uniform glossy surface—that their backgrounds were reduced to a dark soup; Quinn likened the effect to "brown gravy." Indeed, he suspected that many of the "old" paintings on the New York market were fakes. The most damaging consequence of this booming trade, though, was its influence on America's own artists. From what he saw at the National Academy of Design, Quinn began to fear that the country was churning out painters whose only skill was making bad versions of Hals and Velázquez.[7]

Though his own taste was hardly formed, he had a growing aversion

to what he called "dead art." As with the writers who excited him most, Quinn wanted artists who could express the values and forces of his own time. "A picture is a more living thing than a book," he wrote one of his Irish friends in 1909. "It represents life or a moment of life."[8] Painting—or at least fresh, contemporary painting—could change one's sense of reality in the way that scientific advances were changing the understanding of biology or chemistry. During the first decade of the century, Marie Curie's discovery of radium had set off international interest in the luminescent substance, with its apparently miraculous potency, and for Quinn it was the mysterious, intangible force he craved in art. "I have a theory that every generation has its own art . . . painting that is alive and vital and full of radium," he told his former Harvard classmate Judge Learned Hand. "All of the radium has gone out of many old paintings."[9]

Yet Quinn was hardly more knowledgeable about modern art than his compatriots. Already, he had amassed a large number of contemporary paintings by English, Irish, and American artists, but until now he had been guided mostly by his instincts, his friendships with artists, and some vaguely formed ideas about color. Around the time of the Picasso show at 291, Durand-Ruel, a prominent French gallery with a branch in Manhattan, presented a small show of paintings by Édouard Manet, the nineteenth-century artist who had been the starting point of the controversial post-Impressionist show in London that winter. For Quinn it was a revelation. He began talking about Manet with his friends; and he tried, unsuccessfully, to persuade one of his wealthy clients to buy one of the works in the show. Eventually, he bought one himself, calling it a "foundation for a collection of modern pictures."[10] But if Manet's strong colors and bracing realism were still adventurous in New York, the painter, who died in 1883, hardly took Quinn very far into the present age. Somehow, he would have to find a way to know Paris.

3

PARIS, EAST

*I*n early July 1911, Picasso was preparing to go to Céret, in the eastern Pyrenees, to spend the summer holiday painting with Georges Braque. For several years, they had been working in an exhilarating pas de deux to transform the foundations of their art. It was a project of almost unfathomable radicalism. Spurring each other onward in the approach that would come to be known as analytical Cubism, they were not just shifting the way that paintings were made. They were stripping the physical world down to its constitutive forms and structures, and then bringing those alive on the canvas. Like Watson and Crick with their discovery of the double helix in the 1950s, Picasso and Braque were reimagining the building blocks of the animate world. They had recently taken their work into a dense, almost abstract phase—reducing their palettes to greens and grays, while creating thick compositions of crosscutting lines and planes—and their paintings were so similar that they had stopped signing them.[1]

Picasso was impatient to resume their collaboration, but he also was anxious to find out what had happened to the drawings he sent to New York. At Stieglitz's gallery, the progressive stages of his recent work had been presented to the public for the first time, and based on the gallery's early reports, he had high hopes for the result. But the show had closed

more than two months earlier, and he still had heard nothing from the gallery.

Then, on the eve of Picasso's departure, Stieglitz's associate, the Mexican illustrator Marius de Zayas, came to see him. De Zayas was a thin, courtly man with dark hair and a delicate mustache who had arrived in Paris the previous autumn. Though he had known so little about Picasso that he initially had trouble remembering his name, de Zayas had been one of the principal forces behind the New York show. He and Picasso could converse easily in their native Spanish, and soon became friends. But they hadn't seen each other for several months, and now de Zayas, embarrassed and apologetic, was bringing terrible news: Almost none of the drawings had sold. What's more, de Zayas said, he was unable to return any of the eighty-one works, because they were now with another Stieglitz associate.

Picasso erupted. "I never asked for an exhibition!" he exclaimed. It was they—Stieglitz, de Zayas, and their friends—who insisted on it. They had assured him that New York was ready, and he had given them everything they wanted. Instead, it had been a catastrophe. It proved what he'd been saying all along, that exhibitions were a waste of time. In fact, it was against his rules to exhibit, he told de Zayas, and he had done it just to please them. Then, when they failed to make any sales, they didn't tell him about it. They hadn't even bothered to give back his art.

De Zayas was shaken, but he also felt that Picasso's anger was justified. Still, he responded as diplomatically as he could. He and Stieglitz had done their best to promote the show, he said, and it had stirred up great interest, even if the drawings didn't sell; Stieglitz himself had bought one of the most important works. The failure to return the rest of the drawings, he added, was a mix-up, and Picasso would be getting them back soon. Eventually he managed to calm Picasso down, but the show left a bitter taste with the artist that would color his views of the American art world for years to come.[2]

At the time the show was proposed, Picasso had been increasingly hopeful about the United States. He had long been fascinated by American culture, having absorbed everything from Abraham Lincoln to the Katzenjammer Kids. He also shared Quinn's youthful interest in Buf-

falo Bill, whom he would eventually commemorate in a Cubist portrait. When Braque, who was strapping and tall and walked with a cowboy gait, started making airplane-like paper sculptures, Picasso decided to call him "Wilbourg," after the American aviator Wilbur Wright, who had visited Paris in 1908.[3] Besides, Picasso's first serious patrons had been Americans—the expatriate siblings Gertrude and Leo Stein—and their early support had given him a rosy sense of possibility.

In the fall of 1905, when the Steins were introduced to him by a young French writer he knew, Henri-Pierre Roché, Picasso had no regular dealer and lived on the edge of poverty. Almost immediately, however, they began buying his work and everything seemed to change. Soon, he was attending the Saturday gatherings the Steins organized in their apartment on rue de Fleurus—though Picasso often felt awkward on social occasions and didn't much like talking about art.[4] He also started a groundbreaking portrait of Gertrude Stein, a work that, uncharacteristically, took him months of sittings to complete, and that became one of his most important pre-Cubist paintings. According to the retrospective glow of Gertrude's bestselling memoir—*The Autobiography of Alice B. Toklas,* written nearly three decades later—she had, virtually single-handedly, made the artist's reputation.

But if Picasso thought the Steins might be a prelude to broader American interest in his work, he was mistaken. Contrary to subsequent legend, the Steins contributed little to the spread of modern art in the United States. Leo and Gertrude were Americans in Paris, and they were not particularly interested in their native country. Like Gertrude herself, their remarkable collection of early Picassos was firmly ensconced in the French capital, where it would remain for decades. As late as the eve of World War II, she refused to lend her paintings to shows in the United States. Moreover, the Steins' reign as Picasso's leading patrons was remarkably short-lived. One day in 1907, Leo visited Picasso's studio and decided that the artist's daring new experiments were not for him—"Godalmighty rubbish!" he called them.[5] While Gertrude remained a close friend, their buying slowed dramatically. Even Gertrude's vaunted role as a gateway to the avant-garde, and her undeniable influence on a generation of critics and writers, had only

limited effect in spurring on American collectors. It is notable that the most important Picasso collection in the United States in the first quarter of the century would be formed by a man who never met the Steins. But then again, by the time John Quinn was coming face-to-face with Picasso's drawings in the 291 exhibition, the Steins had long since been supplanted by a very young German named Daniel-Henry Kahnweiler.

In outward respects, Kahnweiler was an unlikely match for Picasso and his friends. Born into a prosperous Jewish family in Mannheim, he had no background in art and had been groomed for a career in banking; his parents had sent him to Paris to be a stockbroker, with hopes that he might marry a Rothschild. He was also shy, fastidious, and cerebral, preferring to spend evenings at home or at the symphony rather than smoking and drinking at La Closerie des Lilas or the Café du Dôme, where many of the city's artists gathered.

But Kahnweiler had a determinedly independent streak, and early on defied expectations. First, he fell in love with Lucie Godon, a Frenchwoman from a provincial background who was, on her own, raising an infant sister named Zette. There was a fight with his parents, but Kahnweiler stood firm, and he and Lucie married in 1904, when he was barely twenty years old, raising Zette as their own child. (Though it was kept secret, she was in fact Lucie's own daughter from an earlier out-of-wedlock liaison.[6]) Shortly after the wedding, Kahnweiler grew bored with the stock market and began spending long hours at the salons, the city's annual art exhibitions, which were filled with modern art. "At first I found these paintings illegible, like so many blobs of color," he said. "Only gradually did I realize that I was in the presence of a world that was new to me, new to everyone."[7]

In early 1907, with money he borrowed from a wealthy uncle, Kahnweiler decided to open an art gallery. His idea was to sell only the newest art that had not yet been embraced by the public. "It would never have occurred to me to buy Cézannes," he said.[8] It was a distinctly unpromising plan. The market for new art was generally terrible and Kahnweiler knew nothing about art dealing, having been too embarrassed to go see Ambroise Vollard, the city's leading modern dealer. Nor did he know any artists.[9] Undeterred, he rented a Polish tailor's tiny storefront on rue

Vignon, a quiet side street not far from the Church of the Madeleine, and began buying as many works as he could by the Fauvist painters André Derain and Maurice de Vlaminck, and a few others he admired. Sales were almost nonexistent, but the paintings were very cheap, and he soon began to build an inventory.

Then, a few months later, a German friend told him about a young painter who had been working for months on an exceedingly strange canvas. Early one July morning, he decided to go see it.[10] The painter lived in a ramshackle artists' building that sat atop a steep hill in Montmartre. It was bone-chilling in winter, skin-melting in summer, and had a single water source that all the tenants shared. It was generally referred to as the *bateau-lavoir* (Laundry Barge) because it looked like one of the dozens of washhouse boats that were moored in the Seine and that, until the late nineteenth century, had handled much of the city's dirty linen.

When he reached the studio, Kahnweiler knocked, and, after a pause, the door opened. Standing in front of him was a disheveled young man, short and svelte, with raven-black hair and magnificent large eyes. Picasso was in his underwear, and had clearly just gotten out of bed. Inviting the dealer in, he went to put on his pants. As Kahnweiler entered, he met a lively redheaded woman, taller than Picasso was, named Fernande Olivier, and a huge German shepherd half-breed they called Fricka. They seemed to live in remarkable squalor: Wallpaper was hanging in shreds from the unfinished walls, there was household junk scattered around, and hardly any furniture, save for a woodstove covered with tobacco ashes and a filthy, caved-in couch. The whole place smelled of dog and paint. "It was unspeakable," Kahnweiler said.[11]

But there was also a huge amount of art. There were canvases everywhere, rolled up and on stretchers, along with a number of severe-looking African figures.[12] And then, dominating the room, Kahnweiler saw the enormous painting. Ostensibly, it was a group portrait of five giant nudes. But the outrageous, shard-like bodies, limbs, and drapery, the jagged intersection of figures and background, the bright, raw skin tones and menacing gazes of the nudes themselves, affronted the senses so violently that the subject matter seemed secondary. On the painting's

right-hand side in particular, something almost demonic seemed to be taking place: The faces of the two figures were savage and masklike, and their limbs and body parts, reduced to angles and sharp-edged forms, were merging with the picture plane.

This was the work that would come to be known, euphemistically, as *Les Demoiselles d'Avignon,* the Damsels of Avignon. (Only years later would Kahnweiler understand that it depicted, as he delicately put it, "a scene of carnal pleasure"—a parade of prostitutes in a brothel.) The huge work, which Picasso had spent months and months on, had pleased no one, including the artists closest to him in spirit. Derain said that this kind of painting would lead to suicide; Braque said that looking at it was like drinking gasoline and spitting fire. In making the picture, Picasso found himself, for the first time, isolated from his own circle. "Not one of his painter friends had followed him," Kahnweiler said.[13]

Kahnweiler was repelled as much as everyone else.[14] He also thought the canvas was unfinished. Nonetheless, he sensed something important taking place, as monstrous as the work was: Picasso seemed to be making a frontal attack on painting itself. "He wants to solve all problems at once," Kahnweiler wrote.[15] He also could see that Picasso was nearly broke. On a return visit, Kahnweiler asked to see some of the other canvases that filled the studio. At first Picasso was skeptical; he'd been ruthlessly exploited by most of the small-time dealers he had worked with. (One early dealer was quite literally a horse trader; another, preying on Picasso's desperation, demanded he paint flower pictures that would be easy to sell, then walked away with extra drawings he hadn't paid for.[16]) While Kahnweiler was no different when it came to haggling over rock-bottom prices, he was deeply interested in Picasso's new work, and gradually his enthusiasm, and extensive purchases, won Picasso over.[17] Eventually he became Picasso's dealer.

Along with his advanced taste and astute negotiating tactics, Kahnweiler had a curious marketing strategy. As he did with his other artists, he asked Picasso to sign an exclusive contract and built up a huge inventory of his work. Yet he made no effort to promote it. "There was nothing—no publicity campaigns, no cocktail parties, nothing at all," Kahnweiler said.[18] He also shared Picasso's disdain for exhibitions. In all

the years that he represented Picasso before the war, Kahnweiler did not mount a single show of Picasso's paintings in Paris. The French public was easily confused by modern art, the dealer believed, and no good came of calling attention to his business. In any case, he was convinced that the greatest audience for Picasso and his fellow Cubists was abroad—and he was not thinking of Great Britain or the United States. Kahnweiler had spent time in London at the very start of his career and found it conservative and backward. "Nobody knew anything about contemporary French painting," he said.[19] By contrast, there were two countries to the east of Paris that, in his view, seemed to have extraordinary potential for modern art: Russia and his own native Germany.

When Picasso was making his first forays into Cubism, the Russian Empire had barely embarked on the Industrial Revolution. With its huge, impoverished peasantry, protectionist economy, and deeply antiquated social hierarchy, the czarist state was in many ways out of step with Western Europe and the United States. Yet in the country's major cities, a new mercantile elite had begun to amass enormous wealth; at the same time, the lively Russian tradition of intellectual debate and historical connection to French culture made the country's educated elite unusually receptive to French modernism. In turn-of-the-century Moscow, these forces helped push a new generation of merchant princes to embrace the Paris avant-garde with an intensity that was unmatched almost anywhere else in the world.

A few years after Kahnweiler opened his gallery, a small, pale man with a stutter turned up at rue Vignon wanting to see his Picassos. It was Sergei Shchukin, Moscow's leading textile baron and one of its most adventurous collectors. He had already acquired a substantial collection of Monets, Van Goghs, Gauguins, and Cézannes, and for several years he had been buying up Matisses with abandon. Now he was interested in Picasso, whose studio he had already visited. At first he had the same revulsion to the Cubist work that Quinn would experience in New York. "It felt like stuffing pieces of broken glass into my mouth," Shchukin told a Russian friend. But he was determined to understand Picasso's art, and he wanted to bring as much of it to Moscow as he could. Before long, he had become Kahnweiler's most important client,

averaging ten Picassos a year. For Kahnweiler, Shchukin opened up a crucial Paris-Moscow axis.[20]

Shchukin's purchases had a dramatic effect on Russian culture. In Moscow, he converted the baroque palace where he lived into a house-museum, which he opened to the public on Sundays; by the eve of World War I, there were so many Picassos and Matisses, including examples of their newest work, that each artist was given his own gallery. While many of these paintings were far more radical than the post-Impressionist works that had shocked Quinn's friends in London, they were soon widely embraced by the Moscow public. In the fall of 1911, Shchukin brought Matisse himself to Moscow, where he was feted all over the city as a *"grand maître."* Meanwhile, a new generation of Russian artists, from Kazimir Malevich to Vladimir Tatlin to Aleksandr Rodchenko, were inspired by the Picassos and Matisses they saw at Shchukin's to launch their own art rebellion. In the fall of 1913, when a group of eight German and Danish museum directors decided they needed to learn more about the French avant-garde, they didn't go to nearby Paris, where the works were created but rarely seen; they traveled all the way to Moscow to visit Shchukin's museum.[21]

For America's own art-obsessed elite, Shchukin's activities might have provided a model for how to bring a society to the forefront of twentieth-century culture. But as Kahnweiler quickly grasped, the nation that was most eager to follow Russia's lead was not the United States but his own rapidly modernizing country. In many ways, the German Empire was very different from its Russian counterpart. By the eve of World War I, Germany was one of the most industrialized nations in Europe. It also had numerous cities, a highly educated urban middle class, a large Jewish population, and in the sciences and other subjects, some of the most advanced universities in the world. And while the Kaiserreich did not have any avant-garde collections like Shchukin's, it boasted numerous public museums that had already embraced Van Gogh and other post-Impressionists. By 1913, having set up a flourishing trade with Moscow, Kahnweiler began to collaborate with leading German dealers to market his artists. Judging that Germans were far more ready for the new art than their French counterparts, he also supported an active program of exhibitions.

Kahnweiler's first Picasso show, which ran at the Thannhauser Gallery in Munich in 1913, proved so successful that it traveled on to Stuttgart. Soon after, he also sent a group of Picassos to Berlin, for an even more ambitious show called *Picasso and Tribal Sculpture,* which featured more than fifty paintings from Picasso's early Cubist years paired with the kinds of indigenous artifacts that seemed in part to have inspired them. During France's colonial expansion in Africa, a large quantity of artworks, ranging from Grebo masks from the Ivory Coast to Congolese wood figures, had been brought back to Paris, and exposure to them had exerted a powerful effect on Picasso, particularly during his initial development of Cubism in the years following *Les Demoiselles d'Avignon.* Today, the early-twentieth-century fascination with "primitive" ethnographic material—driven by unenlightened notions of Western cultural superiority—has rightfully come under scrutiny. But for Picasso and his fellow rebels, non-Western art was also a crucial source of innovation, giving them new tools with which to challenge the prevailing order. For the German-speaking public, the provocative show struck a chord. Versions of *Picasso and Tribal Sculpture* traveled to Dresden, Vienna, Zurich, and Basel, and many of the Picassos found eager buyers.[22]

In his international strategy, Kahnweiler developed a keen understanding of the countries where the new art seemed to have the greatest potential. Selling Cubist paintings to Russian capitalists who were more than fifteen hundred miles away, he was building some of the most extraordinary modern art collections in the world. Encouraging gallery shows all over German-speaking Central Europe, he was also creating a new audience for advanced art. So popular were the German shows that Kahnweiler began to make prints of some of his artists' work to sell to people who could not afford paintings. It made for a stark contrast with Stieglitz's experience in New York. But Kahnweiler's growing success in the east also carried risks.

In France, not everyone was pleased with the dealer's German connections. Some conservative newspapers began to spell Cubism with a German *K* and denounce it as a German plot. The insinuations seemed aimed in part at Kahnweiler himself, a German Jewish dealer who had created an apparently lucrative business marketing Picasso and his fellow Cubists abroad, at the expense of traditional French art. The ten-

sions reached a new height in the spring of 1914, when some of Kahnweiler's German partners bid up Picassos to then-record prices. In an article titled "Before the Invasion," one *Paris-Midi* columnist likened the aggressive German buying to a declaration of war. Soon, he wrote, the Germans "will stop buying Picassos. Instead they will loot the Louvre."[23]

In a sense, the columnist was right. When war broke out a few months later, the Kaiser's army would march into France and quickly threaten Paris—provoking a rare evacuation of the Louvre. But it would not be until a generation later, during the run-up to a different war, that the columnist's words would prove eerily prescient. Under Hitler, the Germans would stop "buying Picassos"—and all modern art—in favor of the Old Masters and the "Aryan" realism sanctioned by the Nazi regime. And in Stalin's Russia, avant-garde art would be rejected and shunned in favor of a new Socialist Realism. Then, both countries would notoriously loot museums all over Europe.

It was one of the more striking paradoxes of early-twentieth-century culture: The countries that were the leading champions of modern art and modern artists in the years before World War I would become, two decades later, their most violent antagonists. In both Russia and Germany, artists once embraced as apostles of the future would be punished and driven into exile. Not a single one of the Picasso collections that Kahnweiler helped form in Germany would survive the Nazi period; in Russia, Shchukin's Picassos and Matisses would disappear into government storerooms. By then, it would be largely up to the United States, a nation that had begun the century indifferent, if not outright hostile, to modern art, to protect the work of Picasso and his contemporaries—if it still could.[24]

But all that would come later. In 1913, France was the overwhelming source of the new art and Germany and Russia its dominant consumers. The United States was not in the game. While civic leaders in the young American republic devoted huge sums to building treasure houses of the past, their counterparts in two of Europe's dynastic empires were busy amassing the art of the new century. If the art world of today looked anything like it did then, the world's greatest Picasso collection—and its

premier museum of modern art—would likely be in Moscow or Berlin, not New York.

Following his summer in Céret, Picasso was no longer thinking much about the United States. Under the careful tending of Kahnweiler—who came to see him nearly every day—his star was rising quickly in Europe. There were new buyers like Shchukin, who were prepared to go wherever his Cubist experiments took him. And regardless of sales, Kahnweiler was steadily investing in his work. Meanwhile, there were few signs that other Yankee connoisseurs were following the Steins' early lead. Fernande Olivier, who kept almost as careful track of Picasso's new patrons as she did of his interactions with other women, sensed the American absence better than anyone. Alongside the Russian Shchukin, there was now a stream of Germans, Austrians, Hungarians, and Swedes, and even a few Japanese and Chinese, coming to his studio. But as Fernande watched the new band of enthusiasts, she noticed that one nationality was conspicuously absent. "Picasso," she concluded, "was neither successful nor well-known enough for Americans."[25]

4

FRENCH LESSONS

Quinn's first journey to Paris began with a desperate woman and a revolver. It was the beginning of September 1911, and he was waiting for Augustus John, the prominent Welsh painter, at Charing Cross Station. Having arrived in London a week earlier, Quinn had persuaded John to cross the Channel with him and introduce him to some galleries and artists in the French capital. According to their plan, they would spend four or five days in Paris; then they would drive to the south of France, to take in the Provençal landscapes and light that had inspired Van Gogh and Cézanne.

In theory, John should have been an ideal guide. Though his own, fairly conventional portraiture did not quite live up to his extravagant reputation—Virginia Woolf had named a new era in British culture after him—he was knowledgeable about the new art and had been going regularly to Provence to paint. He also had connections in Paris: Four years earlier, he had met Picasso at his studio, and probably saw *Les Demoiselles d'Avignon*. (Picasso was clearly amused by the velvet-clad, earringed Welshman, whom he called "the best bad painter in Britain."[1]) But John was a complicated character with a decidedly raffish streak. While courting attention and patronage from the Bloomsbury intellectuals, he led a dissolute, nomadic existence with various women and

wives and unintended children. He also had a habit of leaving a trail of chaos wherever he went.

On the day of their departure from London, the particular chaos in question was Frida Strindberg, the neurotic Austrian second wife of Swedish playwright August Strindberg. A spurned paramour of John's, Madame Strindberg had a vivid sense of drama, and as Quinn and John met on the platform, they found her waiting for them, firearm in hand. She insisted on going with them to France, or, she said, she would take her own life. Apparently, it was not the first time she had made such a threat, and after a struggle, they managed to escape her. But Quinn was terrified. ("Carnage," he scrawled in his journal.) Then, when they reached the ferry, they discovered that she not only was very much alive but had somehow managed to rejoin them. It was a harbinger of what was to come.[2]

In Paris, Quinn hoped they could escape Strindberg and plunge into art. But he was immediately detained by one of his most important legal clients, a large, elderly southerner named Thomas Fortune Ryan, an insurance magnate who needed him on an important business errand. Like many other American millionaires, Ryan enjoyed Paris but had no taste for modern art. Instead of going to see the work of Henri de Toulouse-Lautrec, Quinn and John ended up taking Ryan to the Bal Tabarin cabaret, whose dancers Lautrec had once painted. (Ryan chewed on an unlit cigar in mild amusement as he took in the entertainment, while John promptly picked up an Algerian woman.) In the end, they managed only hurried visits to a couple of art galleries. And although Quinn was fascinated to hear about Gertrude and Leo Stein and their art-filled home—he wrote in his diary that they collected "nothing but new men"—he and John made no attempt to visit.[3]

An even greater missed opportunity was Picasso himself. After all, Quinn had been asking John about Picasso throughout the spring, even as he tried to make sense of the perplexing drawings he'd seen at 291. It's tempting to imagine what Quinn might have made of an encounter with Picasso at a point when he had yet to buy a single avant-garde painting: Nearly all of his previous art buying had involved English, Irish, and American painters he had a personal connection with. Appar-

ently, though, John, who by now relied on Quinn's heavy purchases of his paintings, was not particularly inclined to steer the lawyer to work that was far more advanced than his own. In fact, it would take another decade before Quinn finally met the artist whose work would one day occupy the center of his vision of modern art.

But Paris was not a total loss. One day, John took him to see Ambroise Vollard, the shrewd, inscrutable post-Impressionist dealer, who was a towering presence in the Paris art world. To Quinn, he must have seemed formidable. A few years older than the lawyer, Vollard was tall and somewhat lumbering, and had a curious way of shutting one eye. He had been a mentor to several generations of artists and had been an early supporter of Picasso. He was also notoriously cagey, especially with people he didn't know. Though he had an extraordinary collection of Cézannes and early Picassos, they didn't, during their visit, get much beyond Renoir and Monet. Still, Quinn was intrigued, and left with a sense of unfinished possibility.

For now, though, they had run out of time. With Strindberg having discovered their hotel, John was in a hurry to get out of Paris, and they set out for the south of France in a big 75-horsepower Mercedes, which they had borrowed from Ryan, along with his German driver, Ewald Brenner. "We shall throw her off the scent by means of the car," John said.[4]

It was not a trip that afforded much time for reflection. There were hurried stops in cathedral towns along the way, and they argued—and often disagreed—about Baudelaire, Wagner, Oscar Wilde, and the fifteenth-century frescoes of Avignon. (Quinn was awed by the murals' fresh and luminous colors—"paint looks like tar compared to them," he told John—but John dismissed any relevance to contemporary art.) Unused to such intense company, John was quickly worn out, while Quinn was frustrated at how little they managed to see. To keep John happy, Quinn found himself plying him with "champagne for lunch, champagne for dinner, liqueurs of all kinds, vermouth, absinthe, and the devil knows what all." When they reached Provence, John took Quinn to his usual haunts, including, at one point, a whorehouse, which Quinn found squalid and repulsive: "No kick," he wrote.[5]

The woozy tour was not helped by Brenner's driving. One night, while descending a mountain road in the Cévennes, they encountered a dense fog, and Quinn lost his nerve. Convinced they were heading off a cliff, he opened the door and flung himself out of the car. They found him lying in a field beside the road, dazed but miraculously unscathed. Still, the drive haunted him for the remainder of the trip. In a letter to Joseph Conrad that fall, he recounted the recurring nightmares he had about "stone houses, fences, trees, hay stacks, stone walls, stone piles, dirt walls, chasms and precipices advancing towards us out of the fog." For all his interest in the new art, the landscapes that had inspired several generations of modern painters had instead been reduced to instruments of terror.[6]

At this point, Quinn might have been justified in giving up on French modernism altogether. Picasso's drawings had left him nonplussed. Paris had been illusory. They had nearly been held at gunpoint by a possessed Austrian woman; then he had nearly broken his neck trying to experience the great landscapes of the south in the company of a Welsh reprobate. He had gotten no closer to Picasso and Matisse than hearing rumors about the Steins, and he had so little time at the Paris galleries that he returned to New York with nothing more than a few Manet drawings.

If France had largely refused to give up its secrets, however, the misadventure with John made Quinn all the more intent on unlocking them. Disoriented and unnerved, he withdrew to his hectic law work, and for several months thought little about modern art at all. But even the Impressionists he had seen at Vollard's had sharpened his senses and he was now naggingly aware of the insistent provincialism of much of the American art world. "Some of these American artists paint as though Constable and Turner and Monet and Manet and Renoir had never exhibited a picture," he told John Sloan. Going back to the Metropolitan, he was struck by the almost total absence of good nineteenth-century paintings, let alone more recent work. "Aside from its old things," he wrote Augustus John, the museum "would be negligible among the gal-

leries of the world."[7] Meanwhile, the Metropolitan was the richest museum in the world, yet apart from its Old Masters, he thought there were probably not more than twenty paintings out of its hundreds that were "worth wall space."[8]

The spring after his French excursion, Quinn fell in with a group of young New York artists who were intent on shaking things up. Led by Walt Kuhn and Arthur B. Davies, they had founded a new society, the Association of American Painters and Sculptors, with the aim of promoting the work of American artists who defied the academic teachings of the conservative National Academy of Design. But Davies and Kuhn also shared Quinn's impatience to, as he had put it, "bring the post-Impressionists over here." At first, Davies wanted to exhibit some European work alongside the new American art that would be their primary focus. But with Quinn's encouragement, they soon began to conceive of a far more daring project.[9] It was the unlikely beginning of what would become one of the most legendary, if poorly understood, art events of the twentieth century.

In July 1912, Quinn incorporated Davies and Kuhn's association, which now had the aim of staging a single large-scale show in New York the following winter. That same month, Quinn received a letter from Cologne, Germany, from an art dealer friend who had just seen an extraordinary exhibition. Staged by a group of German enthusiasts called the Sonderbund, the show aimed to be a comprehensive survey of international modern art and was filled with post-Impressionist, Cubist, and Futurist paintings, including eighteen Picassos and more than one hundred Van Goghs. If the art in it could somehow be brought to the United States, the dealer told Quinn, it would "give America the exhibition of its life." Quinn, fascinated, must have informed Davies, who soon after obtained the Sonderbund catalog from Birnbaum. "I wish we could have a show like this," Davies told Kuhn. There would still be American art, but now their primary objective was to provide a sweeping view of the new art movements that were conquering Europe. Importantly, they were also determined to sell the works in the show directly to the public, to demonstrate that there was a market for modern art in New York.[10]

From the start, it was a quixotic venture: The association had no building and no budget. It also didn't have any art. They would have to raise the funds they needed, acquire the paintings from Europe somehow, and rent an exhibition space large enough for the huge presentation they envisioned. A still greater obstacle was that Davies and Kuhn knew almost nothing about the new art they wanted to show. Until now, Davies had primarily been known for his pastel landscapes, some of which were strewn with unicorns; Kuhn was so unfamiliar with the "freak cubists," as he called them, that by his own admission, he was starting from zero. But they were determined to pull it off, and Quinn encouraged them to aim as high as possible.

Then, just as these plans were getting under way, Ryan dispatched Quinn back to Paris on an urgent business matter. The circumstances were hardly more favorable than during his earlier trip. Pinned down with work, he had almost no time for art; he later told Conrad that he found the city "hateful to me and everything in it."[11] As soon as he could steal a few hours, however, he headed straight for Vollard's. Though the secretive dealer liked to hold back from clients, Quinn, on this second visit, won his respect. By the time he left, Vollard had agreed to relinquish what would soon become three of the most important post-Impressionist paintings to cross the Atlantic: a dramatic Cézanne painting of his wife, Hortense; one of Gauguin's final Tahiti scenes, painted a year before the artist's death; and a searing Van Gogh self-portrait, also from his final years. For Davies and Kuhn, these paintings would serve as crucial anchors for their show.

Shortly after Quinn returned from Paris, Kuhn set out on his own last-minute art-gathering trip to Europe, where he was later joined by Davies. With crucial help from friends in Paris, they were improbably successful, managing to borrow more than three hundred works from many leading artists and dealers. Even Kahnweiler, who did not have any major American clients at the time, agreed to contribute a few Braques and Picassos. "All of the big names of the last twenty years and of today are going to be represented," Quinn reported to Jack Yeats, the artist brother of W. B. Yeats. "They will have a room for the Futurists. Also a room for the Cubists."[12] Meanwhile, they gathered hundreds of

works by American artists to show alongside the European art. As one of the few Americans with a large contemporary art collection of any kind, Quinn himself became the show's biggest lender, furnishing dozens of his English and American paintings, along with the Cézanne, the Van Gogh, and the Gauguin that he had just acquired from Vollard.

But lining up the art was not the only challenge Davies and Kuhn faced. The association had planned the show to open in February 1913, which gave them only weeks after their return from Europe to stir up public interest. Drawing on his experience bringing Yeats and other literary figures to the United States, Quinn knew they would need to prepare the ground as much as possible. "Our show must be talked about all over the U.S. before the doors open," he told Kuhn. While Kuhn began writing artists and newspapers around the country, Quinn himself began to court members of the political and cultural elite. "I am going to have the mayor of the town, the governor of the state, and United States Senator Root at the opening," he told friends.[13]

In fact, Quinn remained skeptical of some of the newest work that Kuhn and Davies were planning to introduce. It was less than eighteen months since his first, flailing excursion to Paris—a trip during which he had met no artists, seen little art, and acquired almost nothing—and even his second trip had failed to expose him to the contemporary art scene. "Personally I don't understand or sympathize with cubism," he confided to one British friend during the final preparations for the show. But he also recognized that challenging prevailing tastes, including his own, was precisely the point. "American art needs the shock that the work of some of these men will give," he argued, in an interview for one art magazine. "Our art has been too long vegetating."[14]

Not least for Quinn was the opportunity to take the battle to the conservative forces that he believed were holding back American culture. By bringing the new and strange art directly to the public, he felt, they could outflank the Old Master dealers and the men of the Metropolitan, who seemed to resist modern art of any kind. And as he discussed the show's publicity campaign with Kuhn and Davies, he told them they "should not apologize or explain but should attack."[15]

5

A GLIMPSE
OF THE
LADY

*I*n February 1913, the young journalist and critic Jeanne Robert Foster visited the Manhattan headquarters of the "Fighting 69th," an Irish American infantry regiment that had served with distinction in the Civil War and the Spanish-American War. The 69th Regiment Armory, the brigade's sprawling home, had been known, since its completion seven years earlier, as one of the city's more unusual buildings. Styled as an oversized Beaux-Arts mansion with a two-story mansard roof, the Armory took up an entire block of Lexington Avenue. It also featured a soaring, vaulted main hall that was two hundred feet long and nearly 130 feet tall.

The cavernous expanse had been designed as a staging ground for military exercises. But as one of New York's largest indoor spaces, it had quickly found other uses as well. Shortly after the building was finished, the hall hosted an indoor lawn tennis championship; a few years later, a little-known Swede shattered the world indoor marathon record on a small track installed around its perimeter. Now, however, the giant enclosure had been procured for a far more controversial purpose: displaying the more than thirteen hundred works of modern art that Kuhn and Davies had spent the fall and winter gathering. Fueled by the extraordinary publicity effort that Quinn had urged on, the show had already

attracted wall-to-wall attention in the press, and Foster decided she needed to see it.

In fact, despite its seemingly anodyne title, the International Exhibition of Modern Art had struck New York like cannon fire. Although there were many more paintings by American artists, the core of the show was the three hundred artworks that Kuhn and Davies had gathered in Europe—including dozens of avant-garde paintings and sculptures that were wildly unlike anything previously seen by the public. At a time when the circulation of images was highly limited and color reproductions of modern painting virtually nonexistent, the unveiling of this new art, right in the center of Manhattan, carried a raw force that is almost impossible to imagine a century hence. Thousands of people were lining up to get in; there were traffic jams on Lexington Avenue from morning till night. Already a lively debate had erupted over whether the works were to be taken as sheer entertainment or were a dangerous threat to civilization itself. (Royal Cortissoz, one of the city's most prominent critics and a staunch conservative, worried about these "foolish terrorists" who were trying to "turn the world upside down.") Perhaps no work captured the show's radicalism with more visceral power than Marcel Duchamp's *Nude Descending a Staircase,* a kinetic Cubist work that observers likened to an explosion in a shingle factory or a "dynamited suit of Japanese armor." Even as it attracted huge crowds, the painting, like others in the show, left visitors baffled and critics riled.[1]

Foster wasn't baffled or riled, however; she was fascinated. Though she had seen very little of the new work, she had read about some of the new schools of art, and understood that the artists in the show were "art revolutionists" who were trying to capture some of the forces that were giving shape to the new century. She also understood that the show's organizers were laying out a bold challenge to the American public. In visiting the Armory, she hoped to write a lengthy essay in *The American Review of Reviews,* the literary and current-affairs magazine where she worked. Amid all the smoke and fury, it was time, she felt, for a more considered appraisal.

Along with the art, she was curious about the prominent lawyer who had been one of the show's driving forces and who had formally intro-

duced it to the public. She had never met Quinn, but she had followed his outspoken statements in the press and his rousing, if somewhat over-the-top, opening night speech, in which, before an audience of four thousand guests, he described the show as "the most complete art exhibition that has been held in the world during the last quarter century." She had also been warned about Quinn's reputation with women. As a talented critic who was well known for her beauty, Foster was definitely Quinn material, and her friends thought she might be his next target. As she entered the exhibition, she wondered whether she would run into him.[2]

Inside the packed drill hall, Foster was confronted with a big opening gallery that led into a series of partitioned octagonal spaces, each one crammed with paintings. The hall's two side flanks had been divided into six galleries each; these appeared to be filled mostly with American art. It was the central corridor, however, that drew visitors to the main attraction. In it was a series of larger spaces that loosely traced the history of European modernism from the nineteenth century to the present. At the start, there was a sampling of historical paintings and Impressionist works, from Goya and Delacroix to Renoir and Monet. Beyond was a gallery filled with works by Cézanne and Van Gogh, including the works recently acquired by Quinn, and another gallery featuring a broad assortment of French modernists. Foster was immediately taken by Cézanne, whom she found a towering presence in the show. But she was even more interested in the work of his contemporary followers.

The climax of the show was the galleries at the far end of the hall, where the newest French art had been installed. At first, Foster was as bewildered as anyone else by the paintings and sculptures that filled these spaces. They represented a disorienting array of movements, including post-Impressionists, Pointillists, Fauvists, Futurists, and Cubists; many of the works seemed violent or even offensive in the way they defied nature. A "runaway horse has not four legs but twenty," she wrote. A nocturnal scene was painted with "orange stars bobbing in a green sky." A supposed human figure resembled the "pleasing patterns of a rug."

But Foster was a quick study, and her impressions began to shift

even as she stood in the galleries. Confronted by Francis Picabia's irides-
cent Cubist work *La Danse à la source,* she initially saw "a meaningless
jumble of pink and red geometrical forms." After gazing hard at it for a
few minutes, though, she found it suddenly resolving "into two dancing
figures audaciously composed of blocks of color." Romanian sculptor
Constantin Brancusi's *Mlle Pogany,* a breathtakingly simplified head in
smooth white marble, had been ridiculed by one critic as a "hard-boiled
egg balanced on a cube of sugar." But Foster noted that Margit Pogany,
the sculpture's subject, was herself a dancer, and after examining the dif-
ferent sides of the work, she observed that Brancusi had reduced "the
movement of the conventional ballet to its simplest form, an ascending
spiral." And then there was the notorious *Nude Descending a Staircase.*
At first blush, she wrote, Duchamp's disorienting painting appeared to
be an almost indecipherable "arrangement in browns." Yet if one under-
stood the work as a sequence of six partly superimposed images of a
figure in movement, she observed, it was not so difficult to "catch a
glimpse of the lady."[3]

 As she lingered in the show's Cubist gallery, she finally spotted John
Quinn. She needn't have worried about attracting his attention. He was
deep in conversation with a large, distinguished-looking man with a
mustache, clearly an old friend. With them were several of the artists
who had organized the exhibition. As they peered at one startling pic-
ture after another, she kept hearing Quinn's companion exclaim "Bully!"
in an unmistakable high-pitched twang. It was former president Theo-
dore Roosevelt. The scene left a singular impression on Foster. For
whatever else might be said about him, there was nothing usual about
Quinn. Here was a man who surrounded himself with young artist ren-
egades and embraced the most challenging new work, but who also
seemed to enjoy improbable proximity to the established seats of power.
It was a combination that she was unusually well equipped to appreci-
ate.[4]

At thirty-two, Jeanne Robert Foster already had a career behind her that
was, in many ways, even more remarkable than Quinn's. The daughter

of a lumberjack and a schoolteacher, she had been born into poverty in the Adirondacks. She also had been born with a speech impediment that nearly prevented her from getting an education at all. With the help of a friend of her mother's, however, she quickly overcame this barrier, and she proved to be such a quick learner that at fifteen she became the teacher of her one-room school. Already standing out among her peers, she soon after received a marriage offer from a businessman in Rochester, New York, who had roots in the town where she taught. It was an unprepossessing match—the man was older than her father—but she evidently decided that it would be her best path out of rural poverty. Like Quinn, she had greater ambitions for herself. "I feared the usual life," she recalled later.[5]

In fact, the marriage proved unexpectedly liberating. Foster had almost nothing in common with her feeble, insipid husband, but Matlack Foster sought little more than companionship. He also had connections in New York City, where they began to spend time. During one such trip, Foster was spotted on the street by a *Vanity Fair* editor, who was utterly captivated by her large eyes and delicate features. At the time, fashion magazines and newspapers were filled with color illustrations of elegant women, and with her husband's permission and a series of aliases, she began to model. By the early years of the new century, her likeness, rendered by celebrity illustrators such as Harrison Fisher and Charles Dana Gibson, was appearing in *Cosmopolitan, Vanity Fair,* and the fashion pages of *The New York Times*—even on the inside of cigar boxes. In 1903, she was selected as the Harrison Fisher Girl of the year. Sometimes she posed as heroines from short stories and popular novels, which Fisher was often commissioned to illustrate. Almost overnight, she had become one of the most sought-after faces in the country.

But Foster, impatient to develop her restless mind, soon grew bored with modeling. At first, she worked briefly as a fashion editor for the Hearst papers; Fisher had to warn her to stay away from William Randolph Hearst, for whom she was an all-too-apparent target. It was during a prolonged sojourn in Boston to care for her typhoid-stricken sister, however, that her intellectual interests began to move in uncanny parallel with Quinn's. Finding herself with spare time, she enrolled at the

Harvard Extension School—which, in contrast to the college, admitted women. Soon she was attending the lectures of William James and George Santayana, the philosophers Quinn had studied with a decade earlier; she also took a course with Charles Townsend Copeland, a dazzling literary scholar, who introduced her to English novels and Irish satire and awoke her to the imaginative power of prose. "The characters of history materialized, and fiddled, and danced, and shuffled to the music of his voice," she wrote. In turn, Copeland quickly spotted her own talent. "You may . . . think of writing as a probable means of success," he told her.[6] Soon after, she began selling articles to magazines and newspapers.

From her mother, an activist for women's rights who later joined the Socialist Party in upstate New York, Foster had acquired a powerful social conscience, and she soon began reporting on poverty, education reform, women in the workplace, and, in one major article, the condition of women in state prisons. At the *Review of Reviews,* her work was sufficiently impressive for her to be dispatched to Europe—an exceedingly rare opportunity for any female journalist at the time, let alone a onetime mountain girl who had grown up with little advanced education at all. Soon she was investigating tenement housing in Glasgow and reporting on the Czech independence movement. Living alone in New York City while her elderly husband stayed with her parents, who had settled in Schenectady, Foster also began to adopt Quinn's habit of quietly bucking social convention. Amid her growing writing career, she began a secret affair with Albert Shaw, the magazine's editor, who was also stuck in an unfulfilling marriage. It was yet another way to avoid the "usual life." The relationship would gradually cool, but Shaw recognized her unusual discernment for contemporary literature and art—including the modernist poets and writers who were gaining fame in Europe. Eventually he made her the magazine's literary editor.

By the time of the Armory Show, Foster was not only heavily engaged with the new writing that Quinn had long been championing, she was also personally acquainted with many of Quinn's friends. A few years earlier, she had met John Butler Yeats, the artist father of William Butler Yeats, who was living in New York under Quinn's patronage.

Struck by the stunning young woman who had reported all over Europe, the elder Yeats took her on as a protégée and began to coach her on her poetry. (He admired her intensity of feeling, he said, but worried that the "love motive" was sometimes overworked.) "She is extraordinarily pretty and clever," he wrote to W. B., who would soon meet Foster himself.[7]

Foster had also cultivated Lady Gregory, the Irish playwright, whose modern theater troupe, the Abbey Players, had brought Synge's controversial *The Playboy of the Western World* to the United States in 1911 with Quinn's assistance. During the tour, Foster organized a reception for Lady Gregory at the National Arts Club. (Unknown to Foster, Quinn was having an affair with Lady Gregory at the time.) Six months before the Armory Show, Foster had even traveled to Dublin, where, armed with introductions from John Butler Yeats, she met many members of Quinn's Irish circle.

Given all their shared connections, it is remarkable that Foster and Quinn had never met. Now she was getting her first glimpse of him—standing in front of a Cubist painting with the former U.S. president. As he had promised his friends in the weeks before the opening, Quinn had been bringing as many important political figures to the show as he could. Already he was busy creating the irresistible legend that would one day surround the exhibition: Even former heads of state had been awakened to the potency of the new art. In fact, though, TR had known Quinn for years and was one of the few political figures who responded to Quinn's invitation. And while he took in the show politely, he was hardly persuaded by what he saw. ("The lunatic fringe," Roosevelt wrote after his visit, "was fully in evidence, especially in the rooms devoted to the Cubists and the Futurists, or Near-Impressionists."[8]) As Foster herself recognized, her own readers were highly skeptical of the new art, and it would take much more than this one show to change American taste.

Today, the Armory Show is often regarded as a watershed in American culture. According to the standard account, on the eve of World War I,

through shock and awe, modern art conquered the country. Artists were awakened to the work of the European avant-garde; collectors, for the first time, were given the opportunity to acquire advanced modern paintings. "It is quite natural," the exhibition's leading historian has written, "to think of the Armory Show as the turning point in American art of the twentieth century." In the most heroic retelling, the United States had been set, virtually overnight, on an inexorable path toward world dominance in twentieth-century art. What is generally lost, however, is the extent to which the show's extravagant reputation—and even the words that have been used to describe it—originated with Quinn and his fellow organizers.[9]

From the outset, Quinn had done everything he could to portray the exhibition as a transformational event. In his opening night speech, he not only described the show as "epoch-making in the history of American art," but also suggested it would change the course of American history itself. Whether or not Quinn's claims were true, they set the tone for an event that seized the city's attention with titanic force—and did much to shape the subsequent legend. By size alone, the show was overpowering, and the vast drill hall augmented the dizzying sense of novelty. On many days, the crowd in front of Duchamp's *Nude Descending a Staircase* and other controversial works was so large that, as with the *Mona Lisa* today, it was hard to see the art at all.

Quinn contributed much to the hype. He went to the Armory almost every night of the show's monthlong run, hosted artist dinners at the newly opened Vanderbilt Hotel, attended parties, talked to journalists, and gave personal tours to important guests like TR. Midway through the show, he and the other leaders of the association staged a huge beefsteak dinner for the New York press corps at Healy's restaurant—a utensil-free, men-only event in which the guests, wearing white aprons, were given giant cuts of beef while getting another earful from Quinn about modern art. On the evening of the final day, Quinn himself led the association artists and their friends on a snaking victory march through the Armory's great hall, with a fife-and-drum band and a dozen Irish policemen in tow. As they passed the Duchamp, they paused to cheer the nude woman on her vertiginous descent. Then they gathered

in the captain's room for thirty quarts of Quinn's champagne. At the party, Quinn stood up and proclaimed the end of the ancien régime, likening the show's triumph to the sinking of the Spanish fleet at Santiago de Cuba in the Spanish-American War.[10]

For all this posturing, however, the actual impact of the Armory Show was far more ambiguous. Critics, for the most part, were negative; some, like Cortissoz, went further, insinuating that many of the avant-garde works were socially deviant and politically dangerous. The reaction of the country's leading collectors and art patrons, including many supposed progressives, was hardly more heartening. The Washington patron and museum founder Duncan Phillips was so horrified that he walked out. "The Cubists are simply ridiculous," he declared. "Matisse is also poisonous." Gertrude Vanderbilt Whitney, the heiress and sculptor, stayed away from the show entirely, complaining that "a chunk of marble is not a statue." Even Dr. Albert C. Barnes, the fearsome Philadelphia tycoon who would one day compete with Quinn for modern paintings, was largely unmoved, and ultimately decided that Cubism was "dead."[11] Instead of waking people up, the exhibition seemed to cause many to circle the wagons. On the day after the closing, a *New York Times* editorial warned that what was shown at the Armory "is surely part of the general movement, discernible all over the world, to disrupt and degrade, if not to destroy, not only art, but literature and society, too."[12]

Far worse was to come when the show traveled on to Chicago and Boston. In theory, Chicago should have offered a rare opportunity. Unlike in New York, Davies and Kuhn had arranged for the show to be installed in the city's main museum, the Art Institute of Chicago, thus obtaining the imprimatur of the cultural establishment. Even before the show opened, however, the local press had whipped the public into near hysteria. The director of a local medical institute diagnosed several of the European artists as suffering from locomotor ataxia—the inability to control one's body movements; civic leaders denounced the "indecent, vulgar, and obscene" works that were defiling the museum. Finally, the newly formed Illinois State Vice Commission, set up to root out prostitution, opened an investigation into the corrupting influence of "dis-

torted nudes" in the show—a step so extreme that Quinn at first refused to believe it. ("Do you think that vice commission was a joke or was it in earnest?" he asked one of his friends.[13]) Such was the public outcry about the show that the Art Institute's director took an unplanned vacation and disavowed any involvement in it.

But the most disturbing attack came from a group of students from the Institute's own art school. Among the show's most controversial paintings were several large Matisses, including the androgynous *Blue Nude,* the almost savagely aggressive early 1907 canvas that seems to have helped spur on Picasso's *Demoiselles* a few months later.[14] Outraged by these Matisses, the students took matters into their own hands and, on the last day of the exhibition, staged a ritual execution of the artist on the steps of the museum. As visitors filed out of the Institute's lofty Tennessee-marble-clad entrance hall, they were confronted by shouts of "Kill him!" and "Burn him!" Surrounded by a crowd of onlookers, the students led the "accused" in front of a mock jury and pronounced him guilty of capital crimes against art. Then they threw copies of the offending paintings on the ground and set them on fire. It was an elaborate burlesque, but the rancor was real. The *Chicago Daily Tribune* ran a banner headline, STUDENTS BURNING FUTURIST ART AND CELEBRATING CUBISTS' DEPARTURE, accompanied by a four-column-wide picture of the mob with the smoldering remains of the three ersatz Matisses. Only by strenuous effort were the show's organizers able to talk the students down from burning the artist himself in effigy.

For Quinn it was a bitter reckoning. The Matisse riot amounted to the first organized act of violence against modern art in the twentieth century, and it had taken place in America's second-largest metropolis. In his opening speech in New York, Quinn had asserted that "American artists—young American artists, that is—do not dread, and have no need to dread, the ideas or the culture of Europe." Yet young students from one of the country's premier art schools had proven to be the show's most hostile opponents. Less than two years after Matisse was proclaimed a "grand master" in Moscow, his paintings were being condemned to hellfire in Chicago. "This thing of trying to educate Chicago was a ridiculous thing," Quinn lamented to the expatriate American

sculptor Jacob Epstein. "There isn't likely to be great art produced in this country in five hundred years, and perhaps not even then."[15]

By the time a rump version of the Armory Show opened in Boston, the art was considered so beyond the pale that the press and the public did their best to ignore it altogether. In the end, even some of the artists in Davies and Kuhn's association turned against the show. "So disturbing was the exhibition to the society of artists that had sponsored it that many members repudiated the vanguard and resigned," the midcentury art historian Meyer Schapiro observed.[16] In fact, the Association of American Painters and Sculptors itself was remarkably short-lived, and would never put on another show. Two years later, Frederick James Gregg, who had been the Armory's chief publicist, would sum up the experience in *Vanity Fair:* "The International Exhibition of 1913 surprised New York, disgusted Chicago, horrified Boston."[17] It was a dismal end for a show that was supposed to transform American taste.

Even more dispiriting were the sales. One of Quinn and his friends' primary aims was to demonstrate that ordinary Americans were ready to buy moderately priced modern art, just as their counterparts in Germany and elsewhere had been doing. Yet despite the huge crowds they managed to attract—some three hundred thousand people in three cities—very few avant-garde artworks found takers; in Chicago and Boston, there were hardly any sales at all. In fact, with few exceptions, the most active buyers were those who had sponsored or supported the show in the first place.[18] Along with Davies, Stieglitz, and a few other diehards, many of the purchasers came from a small coterie of wealthy women whom Davies had persuaded to make financial contributions to the show; one of them was Lillie Bliss, a Manhattan heiress who would one day loom large in Davies and Quinn's plans for modern art in New York. But these were generally small efforts. As would so often be the case in his modern art ventures, Quinn found himself the dominant figure on both sides of the ledger, serving dubiously as both the biggest lender and the biggest buyer.

By the end of the show, Quinn had spent close to $6,000 on more than two dozen oils and sculptures, and many more minor works. Nor was he particularly daring in his choices, having only just begun to collect

modern art. Left unsold were a museum's worth of artworks by Van Gogh, Braque, Picasso, Brancusi, Fernand Léger, Pierre Bonnard, Edvard Munch, and many others, some of which could be had for a few hundred dollars or less. The lone exception to this neglect was an innocuous Cézanne landscape, which Metropolitan Museum curator Bryson Burroughs managed to purchase under the noses of his trustees, who were none too pleased about it. Of the four Picassos in the show, however, the only one that sold was a minor watercolor—a small, uncharacteristic, inoffensive picture of two trees—which Davies, the show's co-organizer, bought for himself.

Yet Quinn was not so easily defeated. If the Armory Show had failed to change America, it had at least conquered the sensibility of its chief backer. "After seeing the work of the Cubists and Futurists," he wrote George Russell, "it makes it hard to stomach the sweetness, the prettiness and cloying sentiment, of some of the other work." He was beginning to find the "radium" he sought, and by the end of an evening at the Armory, he often found himself almost intoxicated. "When one leaves this exhibition," Quinn told Russell, "he goes outside and sees the lights streaking up and down the tall buildings and watches their shadows and feels that the pictures that he has seen inside after all have some relation to the life and color and rhythm and movement that he sees outside."[19]

Nor was Quinn alone. A small but determined group of initiates came away with the sense that the new art was accomplishing something that had been entirely absent in American culture. "How timid seemed our poetry and our drama and our prose fiction," the Columbia philosopher Joel Spingarn wrote after seeing the show, which he called "one of the most exciting adventures" he had experienced.[20] Among the converts, not least, was Jeanne Foster. In the lengthy essay she wrote for the *Review of Reviews,* she observed that some of the art had transported her "to regions where there is more actual reality than can be found in the objective, visible world." To her, many of these artists were seeking "the inner meaning behind the bodily form—the divine essence in nature."[21]

In the end, Foster left the Armory without talking to Quinn. Yet clearly he had left a strong impression. In her review, she pointedly quoted him—not in his gloating claims for the show's importance, but

in his more sober reflection on the many works in it that fell short. But her main interest was to consider—among the hundreds in the show—the half dozen or so artists whom she felt had succeeded. She singled out the vibrating colors of Seurat and the purposeful naïveté of Matisse. She dwelled on the remarkable Van Gogh *Self-Portrait,* which, unknown to her, belonged to Quinn. ("The bristling red hair, the greenish eyes, the pallid skin boldly and loosely brushed in as if with rapid, nervous strokes, depict the emotional stress that finally shattered the mind of the artist who desired to paint symbols of eternity," she wrote.)

She paused on Brancusi and she made a point of highlighting the artist whom the catalog referred to as Paul Picasso. Though he was not well represented, she identified Picasso as "one of the most gifted" of the show's numerous Cubists. "He has the audacity of a gamin combined with great mastery of technique," she wrote. Then she also noticed, shoved between some late-nineteenth-century French masters, an obscure artist named Henri Rousseau, who painted, "without much technical skill, strange beasts in combat in tropical forests." Almost to the man, she had identified the artists we would recognize today as the leading European figures in the show. She had also hit upon the artists who would soon come to obsess Quinn.

6

CUBISM IN CONGRESS

*I*f the Armory Show did not lead to the broader cultural shift he had hoped for, Quinn quickly brushed aside the setback. His ambitions were bigger than any one show. In his alliance with Kuhn and Davies and their supporters, he had acquired a lively circle of like-minded enthusiasts, and he was at last laying the ground for the "collection of modern pictures" he had been talking about since 1911. Though he didn't yet own any of their work, he had discovered the magic of Picasso and Brancusi and he planned to pursue them in the years to come. Above all, in the larger battle for modern art, he had already set his sights on a different and potentially more important constituency: the political class in Washington.

It was hardly an obvious target. In 1913, even more than today, getting senators and representatives to take an interest in art of any kind was something of a fool's errand. Improving American taste had never been a high priority for the government, and the nation's capital was a cultural desert, with the National Gallery of Art still nearly a quarter century away. Quinn himself viewed the mediocre statues in the rotunda of the U.S. Capitol as an indication of how little esteem the country's leaders had for aesthetic beauty. ("Anyone, after looking at these horrors, could see what Rodin was after," he complained to one European

friend.) That Congress might be persuaded to promote the cause of advanced modern art in the United States—including works like the Matisses that were causing art students in Chicago to riot—was almost unthinkable.[1]

Yet throughout the winter and spring, even as the Armory Show was startling visitors with Duchamp's visual puzzles and Picabia's strange geometries, Quinn had been shuttling back and forth to Washington, trying to persuade Congress of the strategic value of international modern art. Specifically, he wanted Congress to rewrite the tax code to encourage the import of contemporary art from Europe. To Quinn, there were powerful grounds for his appeal: According to existing U.S. law, works that were less than twenty years old were subject to a punitive import tariff that didn't apply to any other category of art. Not only did the tax discourage dealers from selling modern art; it also served to reinforce the assumption that living art was not a legitimate part of American culture. As Quinn saw it, as long as the tariff was in place, the country would never be able to measure up to the advanced nations of the world.

Now he had launched a quixotic one-man campaign to change the law. At the time, few in Congress knew anything about, or had any interest in, the post-Impressionists and their radical followers. And since the modern art market itself was virtually nonexistent, few people other than Quinn and his artist friends had reason to care. Among the $900 million worth of European goods that entered the United States every year, modern art occupied such a tiny fraction that it was easy to imagine him being dismissed as an eccentric crank. But Quinn had never been lacking in self-assurance, and he was utterly convinced that sheer force of argument would get him very far. "No man in the United States could have presented the merits of free contemporary art to that Committee with half the lucidity I did," he boasted to the critic James Huneker, after his first appearance before Congress that spring, "and I have no doubt of the result."[2] As he soon discovered, however, actually changing the law would require taking on powerful interests in both New York and Washington.

Though he had only recently begun to collect advanced modern art,

Quinn's frustration with the tax code was not new. A few years earlier, upon returning from a trip to Dublin laden with contemporary Irish paintings, he had been chagrined to discover that he faced more than $500 in customs duties—a significant sum at the time—despite the minor value of the paintings themselves. Meanwhile, some of the country's richest collectors were bringing in Old Master paintings that were a hundred or a thousand times more valuable duty-free. This anomalous situation was owed to a 1909 tariff law that had eliminated import tariffs on historic art. As Quinn knew well, the law had been largely created for J. P. Morgan, the financier and rapacious art collector who had powerful contacts in the government. Faced with an estimated $6 million tax bill, Morgan had threatened to leave the vast collection of Old Master paintings, sculptures, and other treasures he had amassed in Europe—the greatest private art hoard in the world at the time—to British rather than American museums. Soon after the law passed, he brought in some $60 million worth of art to the United States, much of it destined for the Metropolitan, where he was chairman.[3]

What rankled Quinn was what this extraordinary tax break left out. Since Morgan and his wealthy friends disdained modern art, and members of Congress were intent on retaining an art tax of some kind, the 1909 law imposed a tariff barrier exclusively on contemporary paintings and sculptures. In theory, this provision was designed to protect contemporary American painters from foreign competition: Sheltered by the import tax, so the argument went, American artists—like American industries—would have a better chance of competing with their more advanced European counterparts. But to Quinn, these rationales were just a fig leaf: If the government wanted to raise money, it was the lucrative Old Master trade it should be taxing. "If they taxed old art it would bring in twenty or fifty or a hundred times more revenue than modern art," Quinn observed.[4] Clearly the law was catering to powerful dealers like Joseph Duveen, who were making a fortune selling sixteenth- and seventeenth-century paintings to the country's elite.

In effect, Washington was helping rich men buy Rembrandts and Velázquezes, while actively discouraging adventurous collectors like Quinn from pursuing Cézannes and Van Goghs. (One reason Stieglitz

had limited many of his 291 shows to inexpensive drawings was the exorbitant cost of bringing in paintings.[5]) Worse, by separating the historic paintings collected by museums from the daring art of the current era, the tax reinforced the perception that the work of living artists was not a legitimate form of high culture. But it also seemed unlikely that Quinn could do much to change the situation. "I think that a tariff on works of art is monstrous," he had written one British dealer in 1911, "but while it is the law I shall have to conform to it."[6]

A few weeks before the Armory Show, however, Quinn had found an opening. Woodrow Wilson was coming to office promising a sweeping overhaul of protectionist trade policies. For years, steep tariffs had been justified as a way to protect American industry from foreign competition in everything from steel to sugar. To Wilson and other Progressive Era politicians, however, the trade barriers were mainly serving to enrich big corporations while raising the cost of consumer goods. So intent was Wilson on reform that he asked Congress to begin working on a new tariff law before his inauguration, and appointed Oscar Underwood, the powerful chairman of the House Ways and Means Committee, to lead the effort. Quinn happened to be friends with Underwood, and soon after Congress convened in January, the congressman agreed to allow him to appear before the committee, in his capacity as legal representative of the Association of American Painters and Sculptors, the artists' group behind the Armory Show.

Enthralled by the prospect of shaping policy, Quinn was initially tempted to propose that the government tax old art *instead* of modern art: a sort of sweet revenge on the tycoon class. But he quickly saw that it would backfire. For one thing, he was facing a group of legislators who in all probability had very little sympathy for contemporary work of any kind, let alone the Cubist and Futurist works he and his friends were at that moment unleashing on New York. Moreover, such a move risked turning the entire established art world against him. "I was warned by a dealer that there would be hell to pay," Quinn recounted to a friend shortly before his departure to Washington. "All the rich men would be down on me and the Duveens, the Seligmans [*sic*], the Knoedlers and the rest of them would be hot at me."[7]

In the end, Quinn took a different tack altogether. He did not mention the Armory Show and the controversial new art it was bringing to the country. Instead, he approached the tax question as a matter of lofty principle. Like other forms of civilizational advancement, art was a matter of education not commerce, he told Underwood's committee, and therefore *all* art should be "free"—exempt from duty. Appealing to the national interest, he argued that the tax was hindering progress. "New art movements are in the air in many countries of Europe," he argued. "We alone seem to be behind the times." He also said that the existing law discriminated against ordinary people, who could not afford Old Masters but might otherwise buy contemporary art—an argument that Underwood found compelling. "In other words," the congressman summarized, "we gave rich men their class of art free and to the poor man or the man of moderate means we declined to give it free." Quinn had found his mark. For a committee already disposed to eliminating gratuitous tariffs, Quinn's appeal to the edification of the common man hit home. When the House presented its draft bill later that spring, the modern art tax was gone.[8]

The Senate, though, was another story. Many senators were less sympathetic to tariff reform in the first place and saw no compelling economic reason to change the art tax. Moreover, western senators tended to regard fine art as an East Coast luxury good, and since powerful interests were blocking a tax on historic art, modern art was a natural target. In its own version of the reform bill, the Senate not only upheld the modern art tax but extended it back to art *fifty* years old or less. Then, in late June, a group of Democratic senators, adhering to the party's traditional position on taxing luxuries, decided also to raise the duty itself to 25 percent. For Quinn, it was a devastating setback: If the Senate prevailed, there would be a punishing tax on every foreign painting and sculpture from Manet forward. More or less the entire modern movement, including the Impressionists, the post-Impressionists, and their followers, would be rendered so expensive that dealers might stop selling them altogether.[9]

Up to this point, Quinn had kept his Washington campaign quiet, fearful of setting off a countereffort by the big dealers. But now it was

war. To prevail in the Senate, he knew he would need as broad a coalition as possible. Setting aside his law work, he began an intense publicity campaign against the Senate bill, drawing on the skills he had perfected when he brought Yeats and other foreign writers to the United States. Turning his office into a makeshift lobbying operation, he contacted dozens of university presidents—including Princeton's, Harvard's, and Yale's—who he knew would support the free circulation of knowledge. He reached out to museums, even the conservative Metropolitan, which was glad to endorse the concept of "free art" for all. He recruited prominent authors, scholars, collectors, and artists to write statements of support. And he sent copies of his briefs to Congress to dozens of newspaper editors across the country, most of whom knew nothing about the art trade but were glad to write editorials against an apparently elitist Senate bill. "On Monday the *World,* independent, and the *Tribune,* republican and protectionist, had strong editorials against it," Quinn recounted to New York senator James O'Gorman at the end of June. "On Tuesday the *Morning Sun* and on Tuesday evening the *Evening Sun* and the *Herald* had a column of interviews with artists and [modern] art dealers against it. On Wednesday, the *Times* and the *Herald* had editorial protests against it. The *Globe* and other evening papers have protested against it. The *Philadelphia Ledger* and other leading papers are against it." If nothing else, it was a formidable display of Quinn's ability to rally public opinion around an issue about which few Americans had reason to care. "The whole press of the country is up in arms against the Senate amendment," Quinn wrote O'Gorman. "One might as well tax religion, or science, or medicine."[10]

Finally, in mid-September, Quinn went to the White House to make a direct appeal to Woodrow Wilson. After meeting with Wilson's secretary, he delivered a huge binder to the president containing what he called "disinterested evidence" against the art tax, the accumulation of a summer of nonstop advocacy. Included were statements Quinn and his friends had obtained from several hundred American artists; a petition he had helped organize, signed by some two hundred officials of public museums; statements by dozens of college presidents and education experts; editorials and articles from more than three hundred newspapers

and magazines; and formal endorsements from the American Federation of Arts, the Free Art League, and Quinn's own Association of American Painters and Sculptors. In an accompanying letter, Quinn told the president, "in urging Congress to make art free," these organizations were supported by "the enlightened public opinion of the entire country."[11]

A few weeks after his meeting at the White House, the House and Senate committees jointly convened to draft the final version of the Underwood tariff reform. Though he was not permitted to attend the meeting, Quinn traveled to Washington to follow the outcome. Despite his efforts, he knew the Senate remained dug in on the art tax, and he feared that in the end, the "damned Senate amendment," as he called it, would be enacted. It was an enormous bill, covering many sectors of the economy, but when the joint committees came to the matter of art, debate over the provision dragged on for nearly two hours. Underwood held firm, however, and the letters, documents, and briefs that Quinn had furnished made for a powerful, and seemingly unanswerable, show of force. In the end, the Senate gave in: There would be no more tax on foreign art.

For Quinn, it was an improbable triumph. As he later admitted to friends, almost from start to finish, it had been his "fight" and his alone, financed and run entirely out of his own office. In reality, few if any of the museums and institutions—let alone the press—had paid any attention to the modern art tax until he asked for their endorsement. Only a tiny number of Americans had any interest in contemporary art from abroad, and Congressman Underwood came from a state—Alabama—that was as far from the art trade as any in the union. Yet he had managed to convince Congress that there was overwhelming public support for his view. In a final coup de grâce, Underwood, sensing Quinn's mastery of the issue, told the joint committees that he was asking the New York lawyer to draw up the art paragraphs in the final bill. Since Quinn was already in Washington, he and Underwood met that evening and they hammered it out. Thus, it was Quinn who wrote the new tax law on art. If J. P. Morgan had shaped the previous tariff, this one would be all Quinn's.[12]

Still, as Quinn saw it, the larger "art fight" was just beginning. As a matter of legal principle, the tariff reform was a breakthrough. No longer could the federal government treat a Picasso or Matisse any differently than the most prized Rembrandt or Holbein; modern artworks would at last enjoy the same status in law as their historic predecessors. More important, though, were the possibilities the reform created for the market itself. For the first time, new art could be brought over from Europe and shown to the American public, without penalty. Dealers could sell it, collectors could buy it, and museums could acquire it. In theory, the ground had been laid for a new art scene.

In his closing remarks to the Senate committee, Quinn laid out what he saw as the larger importance of the law. For the first time, the United States would be able to compete culturally with its European peers; by opening the spigot to new art from across the ocean, the tariff reform would "do more than anything else to spread culture and the love of true art throughout the country." In the long run, he added, it would "make New York City the art centre of the world."[13]

The question was how. In the months after Quinn's victory in Washington, there were few signs that much had changed in the American art world. The Art Institute of Chicago, fresh from the Armory scandal, was hardly charging forward into the modern era; in New York, the Metropolitan was as set in its ways as before. During the Armory Show, there had been a glimmer of promise, when a curator from the Metropolitan had boldly acquired a Cézanne landscape, the museum's lone purchase. But the purchase proved highly controversial on the board, and as little mention of it was made as possible. It seemed unlikely to be repeated for the foreseeable future. "The Met ought to have a dozen good Manets, ten or a dozen good Daumiers, it ought to have half a dozen at least or a dozen of good examples by Degas," Quinn complained to his friend Judge Learned Hand. "It ought to have a dozen Cézannes. It ought to have examples by Van Gogh and it has none. It ought to have some good Gauguins and it has none."[14]

As Quinn reflected on the situation, he realized that it would take

much more than the tax code to change people's minds about modern art. What the country needed was a new kind of museum altogether, one that approached the art world as a dynamic, evolving thing. Instead of devoting itself to the past, his imagined institution would be firmly anchored in the present, taking the cause of living art as its primary mission. And it would have the task of sorting out the very best of the new work of the present age. It would be a place to show the new art, but also to acquire the best examples of it and build a collection, just as conventional museums, like the Metropolitan, did for historic art.

That winter, Quinn began to outline his ideas to friends and contacts in the art world. "I have long had in view a *modern* museum," he wrote to John Cotton Dana, the prominent librarian and museum leader who was a leading innovator of public education. As he explained, alongside a continual exhibition program devoted to new art and new artists, such a museum would "purchase and receive bequests of examples of the work of living artists." Looking to European models, he also imagined that such a museum could act in a complementary way to the historic collections of the Metropolitan. As he put it, it could "act as a feeder to the Metropolitan in much the same way as the Luxembourg does to the Louvre."[15]

It was a seductive idea, but it was also absurdly impractical. For a country whose museum leaders still saw themselves almost exclusively as custodians of the treasures of past centuries, a "modern museum" of any kind would be a difficult sell. To model it on the Luxembourg Museum in Paris, Europe's first state museum of modern and contemporary art, seemed almost a fantasy. Who would pay for such a museum when it was far from clear whether the art that was supposed to go in it would have any lasting value in the first place? Once again, Quinn was finding his ideas far ahead of what could actually be done. And yet, on a small scale, he was determined to try.

In the early years of the century, a number of progressive social movements had been spearheaded by a rising generation of prominent New York women, and in many ways, modern art, in its associations with cultural change, was a natural extension of their interests. Several of these women had taken an active interest in the Armory Show and Quinn

wondered if they might be persuaded to support modern art on a more sustained basis. One of the most prominent was the socialite and progressive activist Mary Harriman Rumsey, the eldest daughter of railroad tycoon E. H. Harriman and the founder of the Junior League, the national women's organization to promote social welfare in American cities. She was also married to a prominent sculptor, Charles Cary Rumsey, and was anxious to learn more about the new art movements in Paris. Another was Alice Brisbane Thursby, a vivacious and cultivated supporter of the arts with whom Quinn had had an earlier romance. The daughter of a prominent social philosopher and the sister of one of the country's leading newspaper editors, Thursby was so enthralled by the Armory Show that she told Quinn she was going to Paris to see "all the exhibitions and look up talent."[16] Even more taken with the Armory Show was Lillie Bliss, the heiress and collector who would one day transform the American art world in ways that Quinn could scarcely imagine. Though she remained cautious in her own collecting, she also shared Quinn's impatience with the conservative trustees of the Metropolitan and the city's woeful neglect of modern art.

In the months after the tariff reform went through, Quinn and his artist friends began talking to several of these women about setting up a permanent exhibition space, or "Art Room," to show modern art. Quinn drew up a prospective budget and they began looking for a suitable top-lit gallery on Fifth Avenue to house the venture. Quinn also recruited Walter Pach, a loyal associate who had spent years in Paris and had helped organize the Armory Show, to serve as its director. As usual, Quinn was moving with headlong speed. By December—just two months after the passage of the tariff act—he and Pach were envisioning a continual series of shows of avant-garde European and American art. Meanwhile, there was talk of Rumsey enlisting the support of several of her society friends and perhaps even her mother, who had inherited the bulk of the Harriman fortune.[17]

As was so often the case with Quinn, though, he had gotten ahead of himself. He quickly discovered that the venture would be difficult and expensive and would require constant management. Mary Rumsey, for all her glamour and energy, was not prepared to be directly involved in

the project; nor was her mother, in the end, willing to spend any of her own vast fortune on it. None of them had the time or expertise to run such an institution, which seemed unlikely, in any case, to make any money.

Even apart from these limitations, the plan faced formidable obstacles. For nearly a year, Quinn had pursued his "art fight" with reckless abandon, from his nightly visits to the Armory to his full-throttle campaign in Washington, and he was dangerously behind on his law work. Even now, alongside his primary work in finance, he had taken on an important obscenity case, involving a new novel that had fallen afoul of Anthony Comstock's Society for the Suppression of Vice. To his friends, Quinn's reserves of energy had an almost terrifying quality. "I envy you your power," Conrad had written him, after hearing about the tariff victory.[18] According to the novelist, it was Quinn's "mental mastery" that had seemingly allowed him to expand his activities without limit. But the truth was, Quinn was exhausted, and after several months of struggle, he was forced to concede that the Art Room—and his larger ambition for a permanent modern art space in New York—was too much for him to handle. "I had absolutely no time for it," he told Thursby.[19]

Quinn's ideas made sense. He had detected, correctly, a gap in the city's—and the country's—art culture that urgently needed addressing. He had also intuited, presciently, that many of New York's leading progressives were women, and that their support would hold the key to bringing a new kind of institution into being. But the country simply wasn't ready. There was still scant knowledge of the new art in New York, even among his forward-minded friends. Quinn himself had yet to buy his first Picasso. For the foreseeable future, the center of gravity of the new art seemed destined to remain firmly in Munich and Moscow.

7

THE CHESS
PLAYER AND
THE SHOWMAN

So many people had converged on the Hôtel Drouot, Paris's main auction house, that even the double-sized room was not large enough to contain them all. It was an unusually distinguished gathering as well. A whole group of German art dealers had traveled to Paris for the sale—from Berlin, Munich, Düsseldorf, and Dresden. Vollard was there, too, along with several members of parliament, a curator from the Louvre, and various figures from the beau monde. Newspapers in the French capital had long been anticipating the event, and several journalists were on hand to watch. "It has piqued the curiosity of the public for nearly a month," one reported.[1]

Such overwhelming attention was not to Kahnweiler's taste, and he was glad to remain in the background, though he had offered to make bids for several of his Moscow clients. But he had much at stake. For the first time in its history, Drouot was staging a public auction of modern and avant-garde art, and a number of the nearly 150 lots were by his own artists. Until now, the works of Kahnweiler's painters had been largely invisible in France, since he shunned exhibitions and catered to foreign clients. But here, alongside works by Van Gogh, Gauguin, and other post-Impressionists, were paintings by Derain, Vlaminck, and Picasso, including several of his most important pre-Cubist paintings. In

effect, the sale would be answering the question of whether the new art that Kahnweiler had quietly been backing for nearly seven years had any lasting market value.

Kahnweiler needn't have worried. Fueled by aggressive bidding from the German contingent, the auction took Paris by storm. "I'm not going to pretend that all of these paintings were equally deserving," one startled reporter wrote. "But all, or nearly all, of them attained prices that were five or six times what they were originally bought for."[2] When the auctioneer came to Picasso's large circus painting *Family of Saltimbanques,* a Rose period masterpiece from 1905, there was such competition that the winning bid, from the Munich dealer Heinrich Thannhauser, went for about twelve times what the painting had sold for six years earlier. As soon as the hammer went down, Kahnweiler rushed for the exit: He was determined to be the first to deliver the news to Picasso.

By the spring of 1914, Kahnweiler's attempt to turn the unheralded work of Picasso and his friends into an international boutique business had begun to achieve improbable results. Not yet thirty, the dealer had gained control of a group of highly unusual artists: the explosive Fauvist painters Maurice de Vlaminck and André Derain; the Cubist pioneers Braque and Picasso; Fernand Léger and Juan Gris, with their own variants of Cubism; and the picaresque Catalan sculptor Manolo. Of the figures the dealer regarded as true leaders of the new art, only Matisse, who was slightly older and had an arrangement with another dealer, had eluded him. A century hence, it would be easy to identify these men as the towering figures of the early twentieth century, but at the time he started, Kahnweiler was nearly alone in thinking so.

Within the Parisian art world, the "Kahnweiler Establishment," as his artists were known, had acquired a mysterious aura. With their exclusive contracts, they were free to follow their art wherever it took them and virtually ignore the conventional art world. Avoiding shows, they hung together and continually challenged one another with their newest canvases. On weekends, Kahnweiler would join Picasso and his friends at the Cirque Medrano or the Lapin Agile, or go sailing with Vlaminck, with whom he shared a small boat. He ran the gallery so discreetly that he didn't bother installing a telephone; sometimes, there

were so few visitors that he would play chess with Braque and Derain in the afternoon. To outsiders, it almost seemed that the public was actively shunned. But by Kahnweiler's own estimation, the number of people who "got" Cubism was tiny—no more than a few hundred in the entire world, he thought, and that was probably a generous estimate. In any case, popular acclaim was not what he was seeking. "We were sure of victory," he said. "We were sure of ourselves."[3]

In fact, his low-key approach, and his concentration on the German and Russian markets, had proven remarkably effective. Though he relied on a small number of specialist clients, he was starting to make money, and, as the Drouot auction underscored, a real market for avant-garde art was emerging—at least in Central and Eastern Europe. In 1913, a Russian collector who was a rival of Shchukin's paid Kahnweiler 16,000 francs, or slightly more than $3,000, for a single Picasso. Meanwhile, the three Picasso oil paintings that the dealer sent to the Armory Show, priced at a fraction of that amount, failed to sell at all.[4]

What Kahnweiler hadn't anticipated was that his solitary, single-minded gamble on the new art would draw interest from French society—and from another young entrepreneur with a dramatically different worldview from his own. A small, dark-haired, high-strung man who was not much older than Kahnweiler, he was a Paris-born art trader with a discerning eye and an unusual genius for marketing. He also had significant capital, and shortly before the Drouot auction, he had opened a huge gallery in one of the city's most fashionable neighborhoods. Here, he was setting out to promote modern art on a hitherto unimagined scale. For the time being, he showed no interest in Cubist work, but his method presented a formidable new challenge. And though Kahnweiler could not know it, this new entrant would one day be vying with him for control over his most important artist: Pablo Picasso.

"Monsieur Paul Rosenberg," the critic Louis Vauxcelles began his widely read column in Gil Blas, "young and audacious director of the very beautiful gallery that has just opened at 21 rue La Boétie, has kicked off . . . with a sensational Lautrec show."[5] Though what he wrote was rarely profound, Vauxcelles was a man of unusual influence. During the

years of Picasso's and Matisse's first breakthroughs, the sylphlike writer with pince-nez glasses and a carefully groomed goatee lorded over the French art press, contributing to nearly all the major Paris newspapers while editing the art pages of *Gil Blas*. Such was his authority—and ubiquity—that when he described a new art movement, his words generally stuck. It was Vauxcelles's cutting remark that Derain, Vlaminck, Matisse, and their fellow colorists were a bunch of *fauves,* or "wild beasts," that produced the term "Fauvism"; and it was his jibe, a few years later, that Georges Braque was reducing the world to "cubes" that led to "Cubism." (Vauxcelles had been reviewing a small Braque show at Kahnweiler's, and it may have been his caustic remarks, in part, that led the dealer to renounce Paris exhibitions altogether.)

But Vauxcelles could be a powerful advocate when he wanted, and in the early weeks of 1914, what excited him was the huge modern art concern that was improbably taking shape on an elegant street at the heart of the city's Right Bank. Ostensibly, the critic was writing about Rosenberg's "wondrous" inaugural show, a major group of paintings by Henri de Toulouse-Lautrec. Though the troubled artist had died in 1901 at age thirty-six, he had cast a long shadow over the avant-garde for his frank depictions of the Paris demimonde; Picasso had gone through a Lautrec phase early in his career. Now Rosenberg had gathered, for the first time, many of his most provocative paintings in a museum-like retrospective. To Vauxcelles, the painter's "drugged out streetwalkers" and "melancholy priestesses of Lesbos" amounted to an astringent commentary on modern city life. "Lautrec depicted what he saw and what he saw was not cheerful," he wrote. "He is neither moral nor immoral."

But Vauxcelles was equally impressed by the *way* these paintings were presented. Situated on a street primarily known for its Old Master dealers, Rosenberg's gallery occupied a high-ceilinged, marble-fireplaced townhouse that had been carefully outfitted in the most up-to-date style. Shown with the Lautrecs were new sculptures by Alfred Jean Halou, a popular disciple of Rodin's, as well as furniture and objets d'art by Paul Iribe, a young designer who would later become Coco Chanel's lover and work in Hollywood with Cecil B. DeMille. Clearly, it was a revelation to see the "Baudelaire of painting"—as another critic described the

down-and-out Lautrec—in such a chic setting.[6] The overall message was unmistakable: Even the most outré works of art could be at home in a bourgeois townhouse, or what Vauxcelles called "an abode of modernist elegance."

Rosenberg had not arrived at this formula casually. Like Kahnweiler, he came from an assimilated, upper-middle-class Jewish background and was precociously assured in his own sense of taste. Like Kahnweiler, he also harbored international ambitions, and saw himself on a larger mission to back the small number of new painters who he felt would be recognized by future generations. He also shared Kahnweiler's unusual willingness to play a long game, and if necessary hold on to paintings for many years until a market developed. During his apprenticeship, Rosenberg had been stunned to discover how many of the most successful late-nineteenth-century galleries had left no enduring legacy. Many of them had completely vanished, he wrote, and their names were not "linked to that of any great artist."[7]

Yet in almost every other way, Rosenberg was Kahnweiler's opposite. Where Kahnweiler actively spurned Parisian society, Rosenberg was a close student of the manners and tastes of the Right Bank social world and believed that it had to be conquered rather than ignored. Characteristically, while Kahnweiler had married a woman from the provinces and by his own admission had no taste for money or luxury, Rosenberg, in the same year that he opened his big gallery, had married into a Parisian family more elevated than his own. Nor did Rosenberg share Kahnweiler's intellectual proclivities. Where Kahnweiler tracked the minute evolution of his artists' work and would soon write the first history of Cubism, Rosenberg saw himself as a connoisseur businessman, a man who could tell in an instant if a painting had the intangible qualities of greatness, but who rarely had much to say about an artist's methods or approach. Above all, the two men held categorically different views about how to build the avant-garde market—and where to build it.

Born in 1881, Rosenberg was Picasso's exact contemporary, yet he inhabited a world that was entirely unknown to the Spaniard and his bohemian cohort. Together with his brother, Léonce, he had been groomed from an early age to take over his father's business selling late-

nineteenth-century art to the city's bankers and aristocrats. The Paris of Rosenberg's youth was a city of bibelot-filled drawing rooms, cultivated manners, obsessive fashions, the opera. It was a culture led by the great Jewish banking dynasties from Central Europe—the Rothschilds, the Ephrussis, the Kanns, the Camondos, the Cahen d'Anvers—whose literary salons and art-filled homes were part of the belle époque world depicted by Marcel Proust.

Rosenberg's father was not quite part of this set, but he had traded paintings with many of these families and was versed in their tastes. "We had close social and also family ties with Charles Ephrussi, a man with a very artistic temperament and refined taste," Rosenberg wrote. (It was Rosenberg's father who acquired Manet's remarkable still life *A Bundle of Asparagus* from Ephrussi, a painting that was decades later evoked in Proust's *The Guermantes Way*. "There was nothing else in the picture, just a bundle of asparagus exactly like the ones you are eating now," the Duc de Guermantes exclaims.[8]) He had fallen early and hard for Manet and Renoir as well as several of their more radical successors. In 1892, when Rosenberg was eleven, his father took him to a small gallery to see a group of paintings by an obscure, recently deceased artist. The paintings were violently colored, with thick brushstrokes, and Rosenberg found them somewhat terrifying, but his father, who did not know the artist, was completely taken. In fact, they were attending the first Van Gogh show ever attempted in Paris. Although there was hardly any market for them, he began buying a series of Van Goghs, including the now celebrated interior *Bedroom in Arles*. Rosenberg's mother worried that her husband was ruining the family, but these enthusiasms soon proved farsighted, and he was able to pass on to Rosenberg a strong position in the market.[9]

Amid this aesthetic education, the young Rosenberg was also exposed to the rampant anti-Jewish prejudice that coursed through the French art world. A common charge in the late-nineteenth-century press was that "energetic Israelites" were using art to gain entrée to the most aristocratic circles; men like Ephrussi were derided as operators and financiers who manipulated prominent artists to flaunt their own status. Soon the attitude spread to modern artists themselves. By the

1890s, despite the crucial patronage the Jewish elite had given Renoir and Degas, both were openly endorsing the virulent anti-Semitism of the time. When Émile Zola published "J'accuse . . . !," his celebrated open letter to the French president defending the falsely convicted Jewish officer Alfred Dreyfus, Renoir was outraged. "They come to France to earn money, but if there is any fighting to be done they hide behind the first tree," Renoir ranted to Julie Manet, the painter's niece. "If they keep getting thrown out of all countries, there must be a good reason for it."[10] Decades later, on the eve of World War II, Rosenberg would have to confront the terrifying monster these currents had created. An entrepreneur at heart, however, he did not let politics interfere with the art he loved, or the clients who frequented his gallery. Notably, he became the aging Renoir's loyal dealer and friend, and would remain so until the painter's death in 1919.[11]

Finding he had a shrewd mind for the trade, Rosenberg rapidly expanded his father's business in nineteenth-century art. But he also found it stifling. He had trained in London and was eager to break into new markets abroad; he was also impatient to venture into more daring modern art. "I was tormented by the idea of selling paintings I did not truly like," he said.[12] By the time he opened his new gallery, in early 1914, he had accumulated significant capital and was ready to explore the riskier terrain of the twentieth century.

At the time, most of the dealers engaged with the new art occupied simple, barren spaces that were as inhospitable as they were austere. Kahnweiler's gallery was so small he had room to hang only a few paintings at a time; Ambroise Vollard, the gray eminence of modern art dealing, presided over what Kahnweiler himself described as "a funny little hole in the wall with nothing but an old frame in the window."[13] Most of these dealers didn't expect—or want—to reach a large audience and felt that connoisseurs knew where to find them.

By contrast, Rosenberg conceived his whole enterprise as a kind of public performance. In a short manifesto he circulated at the time of his Lautrec exhibition, he argued that avant-garde galleries all suffered

from the same flaw: The art was presented in cold isolation, without a context to which viewers could relate. The absence of a welcoming setting only made the innovative canvases more unsettling. By evoking what he called "the atmosphere of a private home," Rosenberg believed his gallery could make challenging art as appealing as the elegant zebrawood furniture he was showcasing alongside it. It was a risky strategy: By presenting the work of avant-garde painters as a kind of "style," the dealer was in danger of obscuring the radical new ideas and approaches they sought to harness. In later years, Kahnweiler would grumble that his rival was little more than "an interior decorator." But Rosenberg was more sophisticated than that. He understood that taste for the new was something that had to be nurtured, and saw his own work, in part, as leading the public gently forward.[14]

One way that Rosenberg approached this delicate task was by continuing his flourishing trade in Monets and Renoirs. In part, this was a matter of sheer business calculation. Since the market for new artists was unproven, he needed the reliable profits that his expensive nineteenth-century paintings could bring. But the mix of classic and contemporary artists served another purpose as well: Rather than presenting the newest painters as breaking with the Western tradition, he sought to connect them to it. Such a notion was at odds with the avant-garde purism of Kahnweiler, who couldn't imagine selling Cézannes, and it also challenged the way that Braque and Picasso thought of themselves. But it was an approach that would prove remarkably effective for modern art in the long run, not least in the United States, where there was very little context for understanding it. Even Quinn would come to realize that the "shock" of the Armory Show was not perhaps the best way to make the new art stick with the public.

But these were matters for the future. For Picasso, Braque, and their fellow artists, Kahnweiler was their uncontested impresario; that Rosenberg, an erstwhile nineteenth-century specialist who catered to an utterly different clientele, might be able to challenge him was not even in question. As the spring unfolded, Kahnweiler had new reasons for optimism. His patient strategy had begun to bring Picasso's work to cities all over the Continent. His artists, or at least their early works, were for the

first time being sold at Paris's main auction house. And he was beginning to make a little money. Increasingly convinced by the long-term staying power of his artists, he paid no attention to the political tensions and surging nationalism that seemed to be spreading across Europe. As a German Jewish émigré in Paris who sold paintings by a Spanish bohemian to Russian industrialists and Czech connoisseurs, he could not conceive that the cosmopolitan Europe on which his entire business depended was about to be torn apart.

8

END OF AN IDYLL

*J*eanne Foster was not thinking about war when she arrived in Britain at the end of July 1914. She was on assignment for the *Review of Reviews,* which had sent her to investigate poor housing in London, Manchester, Birmingham, and other cities, as well as to pursue several literary projects in Dublin and in the Scottish Isle of Arran. On one of her first evenings in London, however, the startling news was broadcast all over the country: George V had instructed his ministers to go to war. Though it was close to midnight, she rushed to Piccadilly to gauge the public reaction; to her surprise, the streets were filled with young Londoners in straw boaters, singing and waving flags. "One might have thought a holiday had been declared instead of war," she wrote in her diary. Swept into the crowd, she followed the mass of people slowly making its way to Buckingham Palace. A few minutes after she reached the front gates, the king and queen came out on a balcony and bowed to wild cheers. By the following morning, when Foster left her hotel, she saw soldiers in the streets and young men lining up to enlist. All over the city, there were posters declaring, "To Hell with Serbia!"[1]

Sensing the enormity of the moment, Foster abandoned her housing investigation. There was a war to report on. Equipped with her Ameri-

can press credentials and her insistent charm, she talked her way into British military installations, embedding with army battalions as they prepared for deployment and touring the new "white winged airships" that were being tested at a grass airstrip on Salisbury Plain, the military training ground near Stonehenge. In Hyde Park, she interviewed and photographed the fresh-faced members of the London Rifles, a regiment that was on its way to the front lines in France; later, she would learn that, down to the man, none of them had survived the Battle of the Marne. She also witnessed the first zeppelin attack on London, which resulted in the deaths of a number of schoolchildren. With trains all over the country commandeered for the war effort, it was often difficult to travel, and at one point, chasing down an important story in Cambridge but unable to get a seat, she took a harrowing ride on the roof of a train car, ducking under overpasses as she went. In between dispatches, she found time to look at paintings at the National Gallery of British Art (now the Tate Gallery) and study the sculptures of Salisbury Cathedral, but she discovered that her whole relation to art and monuments had changed. "One seemed before to live outside history," she wrote in her diary. "Suddenly, history is in the making everywhere."[2]

In Avignon, in the south of France, a group of painters were having their own reckoning with world events. Earlier that summer, Picasso, Braque, and Derain had decamped to Provence, in what had, for several years, become an almost annual ritual. Often working in proximity, they had grown used to pursuing their work on their own terms. Spurring one another on, they shared ideas, opinions, and humor; frequently, their paintings ended up in one another's hands. Matisse later claimed that his own first real encounter with Cubism was Braque's 1908 landscape *Houses at l'Estaque*—which he saw in Picasso's studio. That summer, Picasso and Derain were collaborating on a fourfold panel of still lifes, which they painted on a group of tiles that had come loose in Derain's kitchen.[3]

Along the way, their personal lives had become deeply entwined as well. Derain and Braque boxed together; Braque and Picasso traded

recipes. ("Picasso and I do a lot of cooking," Braque told Kahnweiler during an earlier sojourn in Provence.) It was Picasso, in fact, who had introduced Braque and Derain to their future wives: Marcelle Braque, known as Blond Tobacco for her chain-smoking habits; and the dark-haired and sharp-witted Alice Derain, who would later attract the admiration of John Quinn.[4]

More than most artists, they were able to pursue their art largely oblivious to the outside world. With Kahnweiler's all-encompassing contracts, none of them had to think about sales or shows: He would take care of that. And although he paid very low fixed prices and was stockpiling much of what he bought, his purchases were guaranteed, providing a level of economic stability that was almost unheard of among their peers. He also trained them to think—like he did—of the long term and not worry about critics. "I advanced them money so that they could live. They brought pictures," Kahnweiler said. "And the people who were interested in them came to see them." The arrangement was a remarkably pure way to make art.[5]

For Picasso, the summer of 1914 also began in a moment of rare tranquility. Two years earlier, amid a stormy breakup with Fernande, he had fallen deeply in love with a waifish, dark-haired woman named Eva Gouel, and their relationship had—almost for the first time—brought a remarkable equilibrium to his emotional life. Petite, demure, and quietly radiant, Eva was a striking counterpoint to the tall, blustery Fernande, and her calm, self-effacing presence had inspired some of his most intricate work, including the analytical Cubist masterpiece *Ma Jolie,* whose title was a coded dedication to her. "I love her very much and I will write this in my paintings," he had told Kahnweiler.[6] Though Eva had a complicated past and there were resentments among Fernande loyalists, she ingratiated herself with Picasso's circle; even Fernande herself, before she was replaced, had found her appealing.[7] "Pablo is very happy," Gertrude Stein observed after seeing the new couple together.[8] Such was Eva's capacity for empathy that when she and Picasso hired a housekeeper in Avignon, she ended up doing the work herself. ("My cleaning lady is so chummy with me that I can't ask her to do anything," she confided to Stein.[9])

Certain that Eva was the one, Picasso had taken her to Barcelona to meet his conservative family in early 1913. They had decided to marry that spring, but the death of Picasso's father, and Eva's fragile health, put the plans on hold. Still, she called herself Madame Picasso and he referred to her as *ma femme*—my wife—and it was clear to his friends that she was unlike any of his other women. In Avignon, Eva talked of settling down in a more permanent way. "It's high time we felt a bit more at home somewhere," she wrote Stein, recounting how they had found a "quite Spanish-looking" house to rent for the season. Picasso sent Stein their new address, with a drawing of an imaginary dog, Saucisson, on the day they moved in.[10]

As Picasso reunited with Derain and then Braque, who was staying in nearby Sorgues, none of them was particularly concerned with international events. "I saw Derain. He is very happy to be here and is looking forward to having a good season," Braque reported to Kahnweiler in the middle of July, two weeks after the assassination of the Austrian archduke in Sarajevo had pitched Europe into crisis.[11] A week later, as the French prime minister visited St. Petersburg to reaffirm France's alliance with Russia, and Austria-Hungary, with German support, prepared to issue an ultimatum to Serbia, Picasso wrote the dealer, "I'm only doing big canvases; at least that's all I think about."[12] By the end of the month, the whole of the Continent was teetering on the edge, and yet on the morning that France announced a general mobilization, Braque, unaware, wrote Kahnweiler to tell him that his painting was going well and that he was "quite content to be finally settled in my own place."[13]

Hours later, as the news of the war finally reached them, the Avignon idyll crashed into reality. As Frenchmen, Braque and Derain would have to report for duty; as a foreigner, Picasso needed to secure his residency papers—and his livelihood. Racing back to Paris with Eva, he stayed just long enough to put his affairs in order and empty his bank account. Then they returned to Avignon, arriving in time to accompany Braque and Derain to the train station.[14] Derain left Picasso his dog,

Sentinelle, to look after while he was at the front. For the three friends, it was a decisive parting. Though the friendships would remain, the free-spirited days of banding together and painting what they wanted were over; history had caught up with them. Later, Picasso would say of Braque and Derain that he "never found them again."[15]

Hoping that the war would be over quickly, Picasso and Eva decided to remain in Avignon. But they were now cut off from nearly all of their friends, with not only Derain and Braque but also Vlaminck, Léger, and most of the others in his circle on their way to the front. "Really it drives one to despair," Eva wrote.[16] Over the next few weeks, as the Germans rapidly advanced on the French capital, Picasso also began to fear that the art he had left behind—in his studio and at Kahnweiler's gallery— might be in danger. "I am always worried thinking about Paris about my house and all my things," he wrote Gertrude Stein in September.[17] Meanwhile, he heard nothing from Kahnweiler, who seemed to have vanished even as the war started. In fact, the dealer's predicament was far worse than anything Picasso could imagine.

In late July, just as he did every year, Kahnweiler had locked up his gal- lery and departed with his family for the summer break, leaving Paris and his enormous stockpile of paintings behind. Having finished his most successful season yet, he was in a triumphant mood, and couldn't imagine anything getting in the way of a holiday in the Bavarian Alps. It was true that some of his artists and friends in Paris had expressed vague concerns about the European situation. Derain was apprehensive about the consequences of Sarajevo. Vlaminck, who remained in Paris, had speculated that a German invasion might be imminent. Even Pi- casso had urged Kahnweiler, at the very least, to apply for a French pass- port. "In case there is a war it will get you out of hot water," he told him.[18] To Kahnweiler, though, all that was extravagant alarmism. "Up to the last minute, I didn't want to believe it," he said.[19]

While the Kahnweilers were basking in the mountains above Mu- nich, the magical European peace that had held since the late nineteenth century was abruptly ended. On July 30, Russian troops went to war

against Germany's ally Austria-Hungary, making it almost inevitable that Germany would join in. For Kahnweiler, it was a particularly dangerous situation: As a German citizen, he knew he would be drafted if they stayed a moment longer in Bavaria. That night, just hours ahead of the German declaration of war, he raced Lucie and their daughter, Zette, across the border to Switzerland.[20] From there, they decided to board a train to Italy, which for the moment was not involved in the war.

Only as they began the long southward journey through the Swiss Alps did Kahnweiler begin to see the danger he was in. If Germany went to war with France and Russia, his entire world would collapse. He thought about all that he had built over the past seven years—his improbable breakthroughs selling Picassos to Moscow and staging exhibitions in Munich and Berlin. Everything he had staked on these artists had depended on a common European market. Now, from one day to the next, it was gone. For a moment, as they rumbled across the vertiginous mountain passes of the St. Gotthard railway, he imagined the train pitching into a precipice. "It really seemed like European civilization had stopped," he said.[21]

When they reached Rome, Kahnweiler tried to carry on as if nothing had changed. They checked in to a hotel on the Pincio where they'd stayed on a previous trip and talked about the art they were going to see. Even now, he was trying to will the war out of existence. But events were overtaking them by the hour. Trying to keep up, newspapers were printing special supplements throughout the day and selling them in the streets. Kahnweiler took to dashing out of their room at ten-minute intervals to check for the latest edition. Finally, in late afternoon, the dreaded announcement came: Germany and France were officially at war.

Paralyzed with indecision, Kahnweiler anguished over what to do. In theory, sitting out the war somewhere abroad should have been his best option. After all, he was a committed pacifist, and as long as Europe's armies were fighting each other and his artists were at the front, there would be little he could do in Paris. But there was a more urgent problem with his absence from France: He was cut off from his gallery and all of its precious contents. When the Kahnweilers had gone on va-

cation, he left behind an almost unimaginable cache of artworks. Not only were there more than seven hundred paintings in total, including well over one hundred pictures by *each* of his leading painters: Braque, Derain, Vlaminck, Gris, and Picasso; the works also spanned the five or six years during which these artists had utterly transformed Western art. It was the Cubist story and much of the Fauvist story, told by the movements' leading figures. As Vlaminck put it, "a young German of twenty-five" had somehow come "to possess the work of the greatest French painters of the day."[22] Today, such a trove could easily stock the collections of several world-class museums. If ever a single basement could contain an entire epoch of art history, the cellar of Kahnweiler's little tailor's shop on rue Vignon was it.

The dealer needed his paintings, but how would he get them? Over the next few days, he wrote to as many of his friends in France as he could. As a German national, he knew it would likely be impossible for him to return to Paris. Juan Gris, who was a Spaniard, reported that the French authorities had been summoning foreigners to the town hall in the place where he was staying in the south of the country; he also thought the situation was worse in the capital. "Some have even been threatened with expulsion," he wrote Kahnweiler.[23] One alternative for the dealer was to enlist in the French Foreign Legion: If he agreed to fight for France, he would be allowed to return to Paris. But taking up arms against his own country seemed as unthinkable as fighting for Germany itself. Finally, Kahnweiler considered enlisting as a medic in the French army, but even this seemed to go against his pacifist principles. Slowly, he confronted the reality that he was going to remain exiled until the war was over.

As long as Kahnweiler was separated from his gallery and his bank accounts in Paris, though, there was nothing he could do. He couldn't sell his paintings; he couldn't even pay his artists, including Picasso, to whom he owed a large sum for his latest batch of paintings. At the same time, Kahnweiler was cut off from his clients in Russia and Germany, where he was now officially a draft dodger. The far-flung European network that had brought him such success was coming back to haunt him. Yet he still had one more card to play—in a country that was not

involved in the war and which potentially had a large new market for his artists.

In the years when Kahnweiler was aggressively expanding in Central Europe, he had paid little attention to the United States. The country was far away, and he had few connections there; and the reaction to the paintings he had sent to the Armory Show had hardly given him confidence that Americans were ready for his artists.[24] A few months before the war started, however, two young Americans had turned up at Kahnweiler's gallery with a bold proposal. Robert J. Coady was an Irish American painter with an idealist streak; his business partner, Michael Brenner, was a Lithuanian American sculptor who was based in Paris and had met Picasso and other members of his circle. With money provided by Coady's mother, they were planning to open a modern art gallery in New York called the Washington Square Gallery. According to their plan, Coady would run the gallery in New York, while Brenner would serve as its Paris agent. They were deeply interested in Kahnweiler's artists and were prepared to purchase a substantial number of his paintings. They also hoped to serve as his agents in the United States.

Kahnweiler was agnostic, but Coady and Brenner agreed to buy a minimum of 2,500 francs' worth of art and cover all related costs up front, and in the spring of 1914, he signed a contract with them giving the Washington Square Gallery exclusive American rights to the artists in his stable. At the time the war started, Kahnweiler had sent them an initial consignment of artworks, and they were planning shows of Juan Gris and Picasso for the coming winter. Could the Washington Square Gallery provide a refuge for Kahnweiler's operations?

As the German invasion of France loomed, Kahnweiler got in touch with Brenner, who was still in Paris and about to return to the United States. As Brenner took in Kahnweiler's difficult situation, he sensed an extraordinary opportunity. The dealer was now cut off from his gallery, and amid the onset of war, the European art market was virtually frozen. Hundreds of paintings by Braque, Picasso, Gris, and Derain were simply sitting there in Paris. "Let me take them to New York," he told Kahnweiler.[25] Going further, Brenner suggested that Kahnweiler could come to New York himself and run his business out of their gallery.[26] It

should have been a tantalizing prospect. The United States was a wealthy neutral power, and the paintings would be out of harm's way, where Kahnweiler could access them. And they would be arriving at a moment when Quinn and his friends were trying to give advanced modern art a permanent foothold in New York. Moreover, from what Kahnweiler had heard from his own sources in Paris, it would not be too difficult for Brenner to get the paintings out of France. "I could easily, if I had wanted, have had my things moved out of rue Vignon by friends," he recalled.

But Kahnweiler would have none of it. For all his readiness to take huge risks on new art, he was oddly inflexible in his own affairs. Just as he had refused to let the talk of war interfere with his annual vacation, he could not quite imagine, even now, with the German army rapidly advancing toward Paris, abandoning the city where he had built his trade. Somehow, he still believed that the war would be over by Christmas and that he would soon be back on rue Vignon, selling to his old clients in Moscow, Prague, and Berlin.

In the end, he balked at sending even some of his paintings to New York. "No, no, we mustn't do that," he told Brenner. "We must leave them where they are. Anyway, nothing will happen to them!"[27]

THE GRAND ILLUSION

Henry McBride, the New York *Sun*'s adventurous art critic, was a man of uncommon experience. Having spent his adolescence in a boardinghouse in southern Pennsylvania, he had worked variously as an illustrator for seed catalogs, a teacher of immigrant children on the Lower East Side, and a cattle inspector on transatlantic ships before becoming a newspaper columnist in his midforties. Unlike nearly all his peers, he also knew the contemporary Paris art world. He had been to Matisse's studio and had at least passing familiarity with many of the artists of Picasso's generation. And having watched the Armory Show at close hand, he was acutely aware of the peculiar unease that many Americans seemed to feel around modern art.

During the first winter of the war, however, what struck McBride as he wandered around the city was not the familiar resistance to advanced work. To the contrary, it seemed to him that the "wild men" of Paris had suddenly taken over Fifth Avenue. There were the Matisses—three roomfuls—at the erstwhile conservative Montross Gallery. Farther uptown, the Bourgeois Gallery, run by an émigré Frenchman, was showing Van Gogh and Cézanne along with Braque, Derain, and a number of American modernists. At the Washington Square Gallery, though they had managed to get only a single consignment from Kahnweiler,

Robert Coady and Michael Brenner were giving the city its first good look at Juan Gris and Diego Rivera. And on East Forty-fourth Street, the new Carroll Galleries, directed by a fashionable young woman named Harriet Bryant, seemed to be surveying the whole course of French modernism from Van Gogh to Picasso.

"Who shall say the return of Cubism is bad for business?" a stunned McBride asked his readers. He had just watched a steady stream of "white whiskered gentlemen and lovely ladies in Persian costumes" filing into the Carroll Galleries' latest show. This was hardly the crowd that frequented Alfred Stieglitz's 291. Though Bryant was showing some of the most daring recent paintings and drawings from Paris, she seemed to attract the same Midtown crowd that frequented Delmonico's, a bastion of the New York establishment on the same street. People left the restaurant with every intention of heading up Fifth Avenue, McBride wrote, but "some invisible force" pulled them into Bryant's avant-garde gallery instead. "Isn't that strange?"[1]

By all appearances, the sudden gallery boom was a powerful validation of Quinn's and his friends' efforts to bring modern art to New York. In part, it was the war that did it. As Quinn's friend Frederick James Gregg argued in *Vanity Fair,* Paris, Moscow, and Berlin had gone "out of business" as far as new art was concerned, leaving New York as the place where "paintings and sculptures are viewed, discussed and purchased."[2] At the same time a small but growing number of foreign artists, men like Francis Picabia and Marcel Duchamp, had decided to sit out the fighting in the United States, pushing Americans themselves to extraordinary new work. Arthur Davies, the erstwhile landscapist, was absorbing so many new ideas that, according to McBride, he was now putting "post-Impression, cubism, dynamism, and even disintegration . . . all in one picture."[3] But the new crop of galleries was also indebted to Quinn's campaign to repeal the modern art tax, which had overnight eliminated a significant barrier to exhibiting and selling new paintings and sculptures from Europe.

Much harder to account for, though, was the "invisible force" that was shifting public taste and apparently sustaining the scene. After all, Stieglitz had been showing many of the same artists for several years and

had rarely made any sales, and the Armory Show, for all the interest it had attracted, was hardly a commercial success. Yet now, apparently, New Yorkers were not only attending numerous shows of the new paintings but actively buying them. Such was the speed of the transformation that Gregg somewhat breathlessly announced that Quinn's prediction to Congress was already coming true. New York, his *Vanity Fair* article proclaimed, was now "the world's new art center."

In fact, there was another, more straightforward explanation for the boom: the activities of Quinn himself. By now, the lawyer had a growing reputation as the city's leading promoter of modern art, the man who had backed the Armory Show and almost single-handedly persuaded the U.S. government to change the tax code. Throughout the winter and spring, as New Yorkers marveled at the explosion of modern art exhibitions, the proliferation of new galleries, the foreign artists flocking to the city, and the growing coverage of the new scene by progressive magazines and critics, it was not difficult to find Quinn's hand in almost every part of it. Just as he had done with the Armory Show, he talked up the shows, got his critic friends to write about them, and subsidized the modernist journals that covered them. When European painters arrived in the United States, it was Quinn who found them jobs, bought them dinner, and if necessary, provided them with funds—or, in Duchamp's case, a restorative week on the Jersey Shore. ("Duchamp looked thin so I invited him to go down to Spring Lake as my guest," Quinn explained.[4])

What hardly anyone seemed to realize, though, was that Quinn was also the main driver of the market. When the Montross Gallery staged its big Matisse exhibition, not only did Quinn urge his critic friends to write about it and his professional contacts to go see it, he also took home the two most important paintings in it. It made the show look like a commercial success, despite few other sales. Returning to the same gallery a month later, he single-handedly saved a show of challenging new American art, spending $2,800—an enormous sum for contemporary art at the time—on a whole cache of works by Davies, Kuhn, Charles Prendergast, and Morton Schamberg, among others. Further such large-scale purchases followed throughout the spring: Other people may have attended Montross's shows, but it was Quinn who bought.

At the Washington Square Gallery, Quinn's support proved to be a lifeline. Already in the spring of 1914, with the gallery barely open, Quinn had acquired from Coady and Brenner a series of Derain and Picasso prints that had come in the first shipment from Kahnweiler.[5] Soon, he would also buy several Cubist still lifes by Braque, Gris's mathematically inspired *Man in a Café,* and a Derain self-portrait.[6] And Quinn was buying more and more from Stieglitz as well, including a pair of Brancusi sculptures that laid the ground for what would soon be the most important avant-garde sculpture collection in the world. Still more intense, though, was his activity at the upscale Carroll Galleries, whose business so intrigued Henry McBride. In February, when the gallery put on a show of the American modernist Maurice Prendergast, Quinn took home sixteen paintings all at once, more or less assuring the show's success. And in March and April, Quinn bought four Fauvist works by Raoul Dufy, Duchamp's *Chess Players,* a work by the Cubist theorist Albert Gleizes, and three Cubist paintings by Jacques Villon, nearly all of them from a single exhibition.[7]

Sometimes, Quinn's frenzied buying stood in for the market itself. In the middle of 1915, Marius de Zayas, the Stieglitz associate who had organized the 1911 Picasso show, decided to open his own gallery, called the Modern Gallery. Observing the apparent success of the new crop of dealers, he was confident that, unlike 291, his enterprise would be able to "pay its own way" by bringing the best new art to mainstream collectors, or what he called "the purchasing public." With financial backing, de Zayas was able to mount an impressive series of small shows devoted to Van Gogh, Picasso, Braque, Derain, Brancusi, and Marie Laurencin— the avant-garde painter known for her elegant, elongated figures who was part of Braque and Picasso's circle before the war—but he was mistaken about the purchasing public. "In the three years of its existence," he later wrote, "there were only two buyers, Arthur B. Davies, who knew all there was to be known about buying pictures, and John Quinn, who just bought and bought."[8]

Yet nothing better captured the extraordinary lengths to which Quinn was prepared to go to spur the new trade than the mysterious bulk sale of Picassos from the Carroll Galleries in the spring of 1915.

At the time the war started, Picasso's work had utterly failed to gain traction in the United States. There was Stieglitz's disastrous 1911 exhibition, with its eighty-one unsold drawings. At the Armory Show two years later, the only Picasso to find a buyer was the small watercolor acquired by Davies. And in the fall of 1914, Stieglitz had shown a new group of works by Picasso and Braque—works he had gotten from the exiled painter Francis Picabia—that produced such dismal results that he had been forced to make embarrassing excuses. (According to McBride, he blamed the total lack of sales on the fact that "all the millionaires have moved uptown."[9])

In the second week of March, however, Harriet Bryant opened the third and most ambitious of her shows of French modern art. By her gallery's own account, the show set out to provide "a complete survey of the evolution of Cubism from its beginnings to the present day."[10] However extravagant the claim, the show was filled with advanced work by artists who were still largely unknown in New York. Starting with a few post-Impressionist paintings by Van Gogh and Gauguin, the show went on to present works by a half dozen leading Cubists, including Roger de La Fresnaye, Albert Gleizes, Jean Metzinger, Jacques Villon, and others. The centerpiece, though, was an exceptional group of Picassos, spanning from his Blue period to analytical Cubism, all of which were appearing in the country for the first time. McBride, who had tried unsuccessfully to meet Picasso in Paris before the war, was floored. Just consider, he asked in his *Sun* column, "the gravity of the public exhibition of seven Picassos in New York."[11]

McBride was not the only one who was impressed. Critics and visitors flocked to the show, which was accompanied by an elegant bound catalog, printed by one of the city's top printers, with an essay on the seven Picassos by Gregg. ("If anybody is not able to see their intrinsic beauty and power," he wrote, "so much the worse for him."[12]) That the gallery had managed to bring over such recent work from Paris during wartime—paintings, not drawings—was all the more surprising. Still, given New York's previous track record with Cubism, few expected the Picassos would find buyers. Surely, this would be a show to acclimatize the public rather than to generate sales.

But then came the bombshell. Shortly after the opening, the Carroll Galleries announced that five out of the seven Picassos had already been bought by an anonymous collector. Observers of the city's art scene were tantalized. Finding an American buyer for a single Picasso painting was rare enough; selling a group of them, before they had been seen by critics and the public, was almost unimaginable. Even rival dealers were baffled. After all, there were only a handful of serious collectors of twentieth-century modern art in the entire country—people like Quinn and Davies—and they were well known. Fresh from his own most recent Picasso failure, Stieglitz was determined to solve the mystery. One day in mid-March, he decided to go see Bryant in person.

In both decor and clientele, the Carroll Galleries was as different from Stieglitz's Spartan 291 rooms as Paul Rosenberg's Right Bank emporium was from Kahnweiler's rue Vignon storefront. Occupying an airy former design studio, the Carroll Galleries exuded a sense of refinement and glamour, a seductive Peitho to 291's fearsome Prometheus. The walls were lined with gray silk, and the two main rooms were spacious, with artworks laid out in an uncrowded display; the whole place seemed to have a sort of studied affluence about it. "The spots of color upon the silvered walls had that indefinable air of being smart, and important and the real thing, even before the spots were examined in detail," McBride wrote, after one visit to the gallery.[13] In many ways, the look was everything that Stieglitz, in his anticommercial purism, resisted.

Yet Stieglitz could not but have a certain grudging admiration for Bryant, the gallery's young and enterprising proprietor. Slim, tall, and smartly dressed, she was an early forerunner of the art world power woman—a type that, a century hence, would become a fixture of the international gallery scene. At the time, though, she was virtually one of a kind, the only major female art dealer in New York. And though she had no prior experience in the art world, she also appeared to be remarkably successful. Try as he could, however, Stieglitz was unable to make any headway on the Picasso mystery. Soon after, he sent another associate to make inquiries, but Bryant told both of them that she was under strict orders not to mention the buyer's name.

What Stieglitz couldn't pry out of Bryant was what Quinn had pri-

vately relayed to his close friend, the critic James Huneker. "I hope you have seen the Picassos," Quinn wrote to him, a few days after the show opened. "Strictly *entre nous,* I have bought five of them but that is very very confidential."[14] At first glance, Quinn's insistence on anonymity was puzzling. After all, his activities in the modern art world had long been well known, and he had never objected to publicity. Moreover, he had been especially eager to get attention for this show in particular, urging as many of his contacts as possible to go to it, sending out copies of the catalog, praising Gregg's essay on Picasso, and calling the paintings "the best pictures that have been shown in this city this winter." Yet apart from Gregg, Huneker, and a few other close friends, he told no one that he had already arranged to buy the five Picassos back in late February, more than two weeks before the show opened.[15]

But Quinn had another motive for secrecy about the Picasso sale. At other galleries, he had rapidly established himself as the city's dominant player. In this case, however, he was doing far more than that. As his advance purchase made clear, he had prior knowledge of what Bryant was showing. Not only was he accounting for the lion's share of her gallery's sales; he was also closely involved in the gallery's operations. The reason he was able to buy the Picassos so early was that he himself had procured them from Ambroise Vollard in Paris and arranged for them to be in the show. At the Carroll Galleries, Quinn was not just the chief client. Much as he had been at the Armory Show, he was also the gallery's chief backer.

Quinn's involvement with Bryant's enterprise had begun in 1914, a few months after the collapse of his initial plans to establish a permanent exhibition space for modern art on Fifth Avenue. That spring, he had met Bryant, an attractive interior decorator who ran her own design studio in Midtown. Impressed by her poise and her understanding of affluent taste, he decided to help her transform her studio into a new kind of art gallery. Despite her lack of art world experience, the arrangement seemed to offer considerable advantages: Quinn had contacts in Paris and knew many artists; Bryant was at home among uptowners and had a talent for creating stylish and inviting spaces. She could be responsible

for the day-to-day management of the gallery, while he supervised the operation from behind the scenes. For additional modern art expertise, he enlisted Walter Pach, a trusted associate who knew Paris and had assisted Kuhn and Davies with the Armory Show. The new venture would not be the museum-like space that Quinn originally envisioned, but it would offer the chance to pitch living art to an entirely new audience.

But then the war started, and almost immediately threatened to derail their plans. Improbably, the Germans had reached the outskirts of Paris within weeks; as British and French casualties quickly reached the tens of thousands, Quinn began hearing from friends in Europe about the unfolding horror. It also put a stark new perspective on the artists Quinn wanted to show, many of whom were now in the fighting. "The war is indeed horrible, tragic, awful beyond words," he wrote the director of the Contemporary Art Society in London, who was trying to create a fund for painters and sculptors serving in the war. "If later on your suggestion of raising a small fund seems to be practicable, I will do what I can."[16]

At first, given the circumstances, gathering artworks in Paris seemed out of the question. But staging shows in the United States, Quinn felt, would be another way to support threatened artists, and after the French stopped the German advance at the Marne, he decided it was calm enough to send Pach to Europe. (To reduce the expense of the trip, they shared costs with the Montross Gallery, for which Pach had agreed to select the Matisses.) Still, the wartime mission was risky, and Quinn supplied Pach with $1,100 in gold, as well as a letter of introduction from former U.S. president Teddy Roosevelt.[17] In the event, the journey went smoothly, but with so many galleries shut and most artists at the front, Pach had considerable difficulty getting art. Complaining that Pach's initial Paris haul amounted to "chicken feed," Quinn eventually persuaded Vollard to relinquish the Picassos and other paintings, which, together with other sources, provided the makings of Bryant's three French shows that winter.[18]

Almost immediately, the Carroll Galleries attracted notice—as much for its unusual look as for what it contained. In its first show, the gallery announced that it aimed to put the new art "in surroundings that have none of the deadness of a museum, or the baldness of an ordinary gal-

lery," but that "suggest life itself and places where people live."[19] The atmosphere was enhanced by the gallery's socially adept proprietor, and critics like McBride had taken notice. Though it would be several years before Quinn would meet Paul Rosenberg, his and Bryant's efforts to domesticate the avant-garde were remarkably similar to what the French dealer had set out to do a year earlier in Paris.

By the time of her third French exhibition, the one with the seven Picassos, Bryant was getting frequent attention from the *Times,* the *Sun,* and *The Evening Post,* as well as from magazines like *Vanity Fair* and *Puck.* She also was spending more and more time with Quinn. In February, while they were planning the Cubism show, he took her to a marionette performance in Little Italy; soon after, he invited her on a motoring trip to Rye, New York, together with another lady friend, Belle da Costa Greene, the remarkable librarian and director of J. P. Morgan's rare book collection. Later, Bryant joined Quinn and a small group of his friends for a getaway on the Jersey Shore. Such was their closeness that spring that at one point he felt it necessary to dispel rumors—however accurate they might be—that they were romantically involved.[20]

In reality, however, the gallery was hardly selling any art. Overwhelmingly, it was Quinn's purchases, and Quinn's alone, that accounted for what little commercial success Bryant had. Again and again, when a show reached the end of its run, she found herself saddled with large quantities of artworks; again and again, Quinn would acquire a large portion of them. Even after buying the five Picassos, Quinn came back two months later and bought one of the remaining two in the show, another striking Cubist picture. And at the end of the season, when Bryant was still left with a large inventory of unsold works, Quinn swooped in and bought five André de Segonzacs; five sculptures by Raymond Duchamp-Villon; nine Dufys; a porcelain panel, a ceramic nude, and two paintings by Georges Rouault; and three works by Auguste Chabaud, a Frenchman he put in the lesser rank but nonetheless felt he had to support since he was fighting in the war. ("I know this isn't the way to buy pictures," he told Pach.[21])

By late spring, Quinn was accumulating advanced art at a frightening pace. Almost every week, a fresh load of artworks was delivered to his ninth-floor apartment; the paintings accumulated in stacks in his

guest bedrooms, the sculptures lined the hallways or cluttered desks and tables. Despite the accelerating pace of his acquisitions from Bryant's gallery, he did not slow down his purchases elsewhere. While he kept his Carroll Galleries Picassos secret from Stieglitz, he did not hesitate to buy frequently from Stieglitz himself, including, that summer, yet another important Picasso, an earlier Cubist watercolor from the artist's "African" phase.[22] "I think I have bought more modern art this year than anyone else in America," he wrote Vollard.[23]

What was perhaps even more striking, though, was the modest resources with which Quinn had achieved this dominance. As a top Wall Street lawyer with an almost legendary capacity for work, he was handsomely compensated, if not at anything close to the multiples that someone in his position would enjoy today. At times, he would receive payments of $10,000 or more for a case, a considerable sum. Yet Quinn could not come close in spending power to a figure like the Philadelphia collector Albert Barnes or the Washington, D.C., patron Duncan Phillips. He had to pay his law partners, and despite his continual earnings, he could often just barely keep up with his general cultural patronage and his art purchases, which usually amounted to no more than a few thousand dollars each. Even in later years, when his earnings grew, he would complain that "Renoir is beyond me in price."[24] Indeed, in the letter to Vollard boasting of his success, he also informed the dealer that he needed "a month or two" before he could pay the first installment on the six Picassos he had bought that spring for 21,500 francs, or about $3,800. "Collections have been very slow here," Quinn explained.

If Quinn's buying spree had come at a bargain, it was also yielding dramatic results. With extraordinary speed—and despite a war and the virtual impossibility of travel—Quinn was beginning to amass a distinguished, if uneven, collection of avant-garde art. Vollard's Picassos alone were an exceptional catch, including three of the artist's most important Blue period paintings, as well as a Rose period masterpiece and two important Cubist works. At the same time, Quinn's own art education was progressing rapidly. If during the Armory Show he had begun to feel an unformed attraction to the bracing abstractions of Picasso and Braque and the dazzling colors of Derain and Matisse, now he was beginning to

understand these artists as seeking to lay out important new pathways for art itself. As he explained to one acquaintance, the works on view at the Carroll Galleries were difficult, but they also captured the complexity of an era in which there were no longer any easy, comforting truths. "They are not story-telling pictures, they point no moral, they are not part of the 'uplift' and the artists are not interested in any movement outside of painting or sculpture," he wrote. "But they are alive."[25]

As the year wore on, however, Quinn began to have nagging doubts that his broader strategy was succeeding. For many of the American artists he supported, he knew that his purchases were often the only thing separating them from destitution. "The advanced men, the courageous, younger, progressive, honest fellows, are not bought at all," he wrote the expatriate sculptor Jacob Epstein that summer. "Some of them have said that I saved the art season last year."[26] For the European artists, the brutal truth was that other American collectors were hardly more prepared to spend money on them than they had been before the Armory Show. "As you know, some of the very wealthy men here buy the so-called Old Masters," Quinn told Vollard. "But it has been very difficult, if not impossible, to sell modern art this year."[27] For all his effort, Quinn was no longer making the market. He *was* the market.

The experience of the Carroll Galleries was especially illusory. Almost as rapidly as Bryant captivated New York society, her star seemed to fade. For all of Quinn's own purchases, she was still unable to pay many of her artists, and the gallery quickly ran into financial trouble. Much of the fascination with the gallery had owed to its elegant spaces, but overhead was enormous and she struggled to keep up the lease. In June, having barely finished her first season, she was forced to vacate the Forty-fourth Street space and seek a smaller and more affordable location downtown.[28] Meanwhile, Quinn was left with the growing headache of placating his artist friends in Europe, who had often received nothing for their contributions to the gallery. It was the beginning of a long and expensive unwinding of his involvement—with Harriet Bryant, and with the modern art trade.

. . .

By the late spring of 1915, the war in Europe was beginning to touch the United States as well. A few weeks after the end of the Carroll Galleries' Cubism show, Quinn met Lady Gregory's nephew, Hugh Lane, a brilliant young Anglo-Irish art dealer who had sought to bring French modern art to Ireland and who was visiting New York on business. Quinn and Lane were unusually well matched—Lane affectionately called him "my rival"—and during Lane's two-week stay, they dined with Quinn's friends, went to auctions together, drove out to Sleepy Hollow with Harriet Bryant, and talked endlessly about art. (Lane was skeptical about Quinn's Picassos but came around to his Gauguins, as Quinn put it, "after the champagne had some effect."[29]) The night before Lane's departure, they dined again, and Quinn urged Lane to prolong his visit and postpone his return: Lane was scheduled to sail on the *Lusitania,* and Quinn had heard from contacts in Washington that Germany was threatening to torpedo the British liner. They talked it over, and decided such an extreme act was unlikely. Seven days later, Lane drowned with more than eleven hundred fellow passengers when the *Lusitania* was sunk.[30]

The atrocity rode Quinn hard. He blamed himself for Lane's death, but he also turned violently against Germany, developing a hatred that would never subside. In later years, he would even refuse to buy German modern art, a rare blind spot in his prescient collecting activities. At the same time, however, the *Lusitania* disaster drew him more firmly than ever into the French camp. He was furious at the Wilson administration for failing to come to the aid of the French and the British, and he was increasingly conscious of the fact that many of the artists whose works he had been championing were risking their lives at the front. "Of the nine living artists represented here, Picasso is a Spaniard and is not in the war," Bryant had noted, in the introduction to her Cubism show that spring. "Six of the other eight . . . are fighting for the land of art." Several of them had already been injured. "Derain has been wounded and returned to the trenches, and de La Fresnaye has been wounded twice and is either still in the hospital or has returned to the front." It was uncertain, she added, "whether any or all of these artists" would "survive this war."[31]

CUBISTS AT WAR

B y the fall of 1914, the breakup of Picasso's old circle was devastatingly complete. Not only were most of his fellow painters now in the army, but many of those who were not, like Francis Picabia, had fled the country. In all the time that Picasso had been in France, he had never experienced such a rupture. When he had painted the *Demoiselles,* he had alienated his closest friends; now, there was no one even to alienate. Adding to the sense of isolation was his immigrant status, which brought anxieties of its own. Though he had lived and worked in Paris for ten years, he remained a Spanish citizen, and as a man of military age who was not fighting for France, he was now regarded with suspicion, a person who lacked a legitimate place in the national order. Notably, Juan Gris, a fellow Spaniard who was stuck in a different part of the south, was threatened with expulsion.[1]

Above all, though, was the collapse of the unique arrangement that had sustained Picasso's life in art. Day after day, while he and Eva lingered in Avignon and watched French troops preparing for war, he expected to hear from Kahnweiler, but no news came. For years, the dealer had subsidized his and Braque's ever deeper excursion into Cubism when hardly a collector would go near their work. And Picasso had come to depend on his letters, his daily visits, his continual purchases,

and even, at times, his efficient management of Picasso's messy personal affairs. Two years earlier, when Picasso broke with Fernande and, telling no one but Braque and Kahnweiler, abruptly ran away with Eva to the Pyrenees, it was the dealer who moved his things out of Fernande's apartment, while Braque rescued Frika, Picasso's beloved spaniel-shepherd mixed breed, and had her shipped to Céret, where they were staying.[2] But now Kahnweiler was abroad somewhere, apparently cut off by war, and he owed Picasso a large sum of money. All at once, Picasso's single source of security was gone.

Meanwhile, Eva's health was deteriorating again. She had long suffered from what she vaguely described as *angine,* or bronchial inflammation. But now it appeared that the operation she had had earlier in the year, for what was more correctly called cancer, had been unsuccessful.[3] By October, Picasso was increasingly unnerved and they began to contemplate going back to Paris for treatment. "We saw a doctor here but not knowing him we do not feel altogether confident," he wrote Gertrude Stein. Finally, in mid-November, they returned, and found the city utterly transformed. As Eva had been warned, it was "like a village, nobody in the streets after eight P.M."[4]

The art world was especially dark. During the opening weeks of the war, German troops had advanced so rapidly on Paris that French forces commandeered taxi drivers to drive soldiers to the front. On the night of September 1, with the capital under threat, French officials also took the unprecedented step of evacuating the Louvre, giving curators a few hours to load 770 of the most important paintings and sculptures, including the *Mona Lisa* and Poussin's *The Rape of the Sabine Women,* into special train cars bound for Toulouse, a designated safe haven in the south. For the works left behind, the government sandbagged all the windows, and later, because of the threat of chemical warfare, distributed gas masks to the staff. The museum would not fully reopen for five years.[5] The day after the Louvre evacuation, the French government itself had left the city and set up temporary headquarters in Bordeaux. For many Parisians, the flight of the nation's leaders and its treasures was a heavy blow to morale, but it also showed how much the country's art was implicated in the war. Less than three weeks later, the German

army shelled and largely destroyed the thirteenth-century Reims Cathedral, in what quickly became an infamous symbol of cultural destruction.

Along with Paris's museums, the city's art galleries had been shuttered, and, like their artists, dealers of military age were mobilized. Just months after he had staked his career on his huge new gallery, Paul Rosenberg was posted to French military headquarters; his brother Léonce, who had already become an important Cubist patron, joined the flying corps. Following the Louvre's lead, many dealers also sent their inventories out of Paris for safekeeping. Galerie Bernheim-Jeune, which represented Matisse and other modern artists, sent fifty-four crates of paintings to Bordeaux for storage.[6] Vollard, while taking advantage of the chance to sell Picassos to Quinn in New York, ultimately decided it was prudent to store much of his art in the Loire Valley.

But what about Kahnweiler? In Paris, Picasso found the rue Vignon storefront locked up like the other galleries. Yet something else was not right. The dealer had never come back, and at the Banque Française, where Kahnweiler did his banking, Picasso learned that the gallery's account was empty. In fact, as he soon discovered, unlike the other dealers' inventories, Kahnweiler's had never left Paris, including the most recent batch of paintings Picasso had given him at the start of the summer, for which he had not been paid. If he couldn't get the money he was owed, Picasso was determined to get his paintings back. But though they were close at hand, these works were completely inaccessible—to Picasso or anyone else.

Caught in Rome when hostilities broke out, Kahnweiler initially thought he could ride out the war. Finding himself simultaneously exiled from France and Germany, he had prolonged his stay in Italy, moving his family to cheaper accommodations in Siena, where they spent the fall. It was a delicate situation. Cut off from his artists in France and his clients in Germany and Eastern Europe, he had very little money. And as a German draft dodger, he risked prosecution if his activities became known to the German authorities. Even with his own relatives in Germany he felt it necessary to communicate via third parties. Still, he assumed his treasured Paris stock was safe. The gallery, at this point,

contained the sum total of his efforts, hundreds upon hundreds of avant-garde paintings by the select group of artists he had boldly staked his career on. But he was not particularly concerned about bombs, and as long as he kept up with the rent, he figured, everything would be fine. As he had told Michael Brenner, whatever difficulties he faced personally during the war, the paintings would be there waiting for him.

It was a disastrous miscalculation. Along with other innovations such as machine guns and poison gas, the Great War proved to be a watershed in the treatment of private property—including modern art. For more than half a century, international treaties and Western legal doctrines had endorsed the principle that private businesses were sacrosanct, that the personal assets of foreign nationals were inviolable in war as much as in peace. As one legal scholar put it, among civilized countries, the practice of seizing private property during conflict was considered "as obsolete . . . as the enslavement of the enemy's women and children."[7] In 1914, however, Germany had more financial interests abroad than any other country, and Allied governments viewed its global economic might as a central part of its threat. Barely a week into the war, Britain passed the first of a series of laws aimed at confiscating enemy-owned assets. And at the end of September, the French government followed with its own decree, specifically targeting German businesses and property in France. In the fall of 1917, the United States would join in too, with the passage of the Trading with the Enemy Act, legislation that was shaped in part by John Quinn. By the end of the war, the law would be used to seize nearly half a billion dollars of German- and Austrian-owned assets.[8]

Since Kahnweiler was a German national, everything he owned—his gallery, bank accounts, personal property, and paintings—was now fair game. Even so, it took the French government some time to track down German assets in Paris, and Kahnweiler might still have arranged with friends to rescue his paintings. But he didn't like the idea of sneaking around the authorities, and he sat tight. "I behaved stupidly, out of respect for the law," he said.[9] Finally in December—months after he turned down Brenner's offer to move his inventory to New York—the French authorities seized his rue Vignon property and all of its contents.[10] No matter how tenuous the link between Picasso's and Braque's

Cubist still lifes and Germany's military-industrial complex, every last artwork in Kahnweiler's storerooms was now in the possession of the French state. And by the summer of 1914, that amounted to a staggering quantity of art: 135 Braques, 132 Picassos, 111 Derains, and 215 Vlamincks, along with dozens of Juan Grises and Fernand Légers, sculptures by Manolo, and paintings by the Dutch French artist Kees van Dongen. In fact, these paintings were of comparatively little economic value, since the market for avant-garde art—and particularly Cubist art—remained tiny, but in hindsight it was an astonishing haul. Had he been able to hold on to these works, Kahnweiler's strategy would have gone down as one of the greatest art wagers in history. By the end of his long life, this prewar stock would be worth more than a billion dollars and many of the paintings would be in museums around the world. "Had it not been for the war," Fernande Olivier later wrote, "he would have become the most important dealer in Paris and extremely rich too."[11]

At the time, though, it was hard for Kahnweiler to see how much was riding on the seizure. For seven years, he had been buying up the entire output of his artists and storing most of it, based on little more than his own conviction that what they were doing would one day be highly valued. This trove contained the stories of Cubism and Fauvism and, in a sense, the foundations of twentieth-century art. Now the core production of the leaders of the Paris avant-garde, during the crucial years in which they had changed history, was out of circulation and would remain so for most of the next decade. Not even in World War II was an entire school of art made to disappear in this way.

Caught up in the fighting, most of Kahnweiler's artists were hardly aware of what had happened to his gallery. But Picasso, at loose ends in Paris, was in a rage. He couldn't get his paintings back, and, with the market effectively moribund, he also couldn't sell any new work. Blaming everything on Kahnweiler, he sought help from a French lawyer to try to get his paintings out of sequestration. He got nowhere. A few weeks after Picasso's return to Paris, Kahnweiler had moved his family from Italy to neutral Switzerland, where, with the help of a friend in Bern, he planned to stay for the duration of the war. Even now, Kahn-

weiler continued to hope he could reclaim his paintings and reconstitute his group of artists when the war ended. But he had no money to pay Picasso, and in the first months of the war, he had already managed to turn his most important artist against him.

Amid these troubles with Kahnweiler, Picasso also watched the darkening war. In Paris, there were wounded soldiers in the streets and frequent air raids; during the opening months alone, some three hundred thousand Frenchmen had been killed. "I don't ask for anything other than for this war to end and you and all our friends to return in good health," Picasso wrote Guillaume Apollinaire, who had joined an artillery regiment, at the end of December.[12] But the war didn't end, and soon Picasso was reduced to serving as a courier of dismal news among his dispersed cohort. "Derain . . . should be leaving soon for the front," he wrote Apollinaire in April, who was already in the trenches. "The painter Doucet"—an artist Picasso had met in Avignon just weeks before the war—"has been killed."[13] Later, when Apollinaire received a shrapnel wound, Picasso did a moving charcoal drawing of him wearing his Croix de Guerre, his head wrapped in bandages.

No one concerned him more than Braque, who had embraced the war with a fierce patriotism. Trained as a machine gunner, he had quickly distinguished himself, and by the spring of 1915, he was leading a platoon near the Belgian border. In May, however, his men were caught in a firefight, and a piece of German shrapnel went clean through his helmet and into his skull. Knocked out from the sheer force of the projectile, he collapsed in the no-man's-land between the two sides. So certain were his men that he had been killed that they informed the military command.[14] Then, a full twenty-four hours later, a group of stretcher-bearers stumbled upon him, unconscious but still breathing. No one seemed to know whether he would survive.

"Braque is wounded. That's all I know," Picasso told Henri-Pierre Roché, his well-connected friend, who was working at the military high command in Paris. He begged Roché to try to find out what happened. "You know my friendship for Braque," he wrote.[15] As Picasso would

soon learn, Braque had been temporarily blinded by the attack and holes had to be drilled in his skull to relieve the pressure. After he was finally transferred to a Paris hospital, his wife, Marcelle, asked Picasso to come with her to see him: She was too terrified to go alone. In the end, Braque was okay, but for nearly a year, he would be unable to pick up a brush, let alone paint.

Picasso was not the only one following the morbid progress of artists at war. In New York, even as he was buying contemporary paintings in quantity, John Quinn was acutely aware that the country from which most of them had come was being torn apart. "I could read scarcely anything else or think of anything else," he told one acquaintance, a few months into the conflict.[16] From his Irish friend Maud Gonne, who had been volunteering in an overwhelmed French field hospital, he was receiving grisly reports of "poor mangled, wounded creatures" who were being patched up only so they could be returned to the front. "It is race suicide," she wrote him. "Every kilometer of advance means the loss of 30,000 to the attacking army and about half that number to the defenders." He also knew that many of the dead and wounded belonged to the same generation of writers and artists whose work he found so electrifying. By May, Gonne was writing to him that "all the young art and intellect of France is being killed in the trenches."[17]

The war left Quinn deeply conflicted. He admired the valor of the French and loathed President Wilson for his refusal to join the Allied cause, even after the sinking of the *Lusitania*. Yet he also believed it was a murderous stalemate that was likely to continue for years, and hated the idea that so many young men, including those whose work he had championed, were being sacrificed in battle. "It would be a damned monstrous idea," Quinn wrote to Gonne, "if all creators of beauty . . . were to turn themselves into soldiers."[18] Already in the spring of 1915, amid his intense season of art buying in New York, he had begun to view his efforts as part of the war effort, and he began sending messages of support, and sometimes money, to artists who were in the fighting.

In early June, the avant-garde sculptor and platoon leader Henri Gaudier-Brzeska was huddled in a putrid trench near Vimy Ridge, a few kilometers from where Braque had been hit three weeks earlier.

Just twenty-three years old, he had already been twice promoted and decorated for bravery for his daring raids on the German line. After days of intense fighting, however, the Germans had brought in mechanized artillery, and he was losing men by the hour. "It is a gruesome place all strewn with dead," Gaudier-Brzeska wrote to his friend Ezra Pound, in a brief letter. As German machine guns crackled around him, he stood up from time to time to lob one of his dwindling supply of grenades. Addled by days of incessant close-range combat, he was worried that his senses were dulling and that he might be making himself an easy target. But he had something else on his mind, too: the maverick New York lawyer who had been interested in the direct-carved sculptures he had left behind in London. "Have you succeeded with Quinn?" he asked. It was among the last words Gaudier-Brzeska wrote. Two days later, while leading another charge on the German line, he was shot in the head and died instantly.[19]

Even as men like Braque and Gaudier-Brzeska were becoming casualties, the war was feeding on their art. One cold evening during the first winter of the conflict, Picasso and Eva were walking with Gertrude Stein and Alice Toklas down the Boulevard Raspail in Paris when a French military truck drove by, pulling a large cannon. As they watched it rumble past, Picasso was astonished by the cannon's appearance: It had been painted in overlapping splotches of grays and greens in what looked like a crude pastiche of analytical Cubism. "We're the ones who did that!" he exclaimed.[20]

He wasn't entirely wrong. At the beginning of the war, a group of artists in the French army had begun experimenting with using modernist techniques to disguise artillery. By the summer of 1915, the effort had turned into the world's first camouflage brigade, the Section de Camouflage, which was given the job of disguising French military hardware. An artist himself, the unit's commanding officer believed that the innovations of Cubism were ideally suited to the task because, as he put it, "Cubists don't paint things to look the way they are."[21] (For his part, Picasso concluded that earth tones were not very effective, and that

the army should have mimicked his more colorful art. "Even when painted gray, artillery and cannons are visible to airplanes because they retain their shape," he wrote Apollinaire at the front. "Instead, they should be painted very bright colors, bits of red, yellow, green, blue, white, like a harlequin."[22])

Quinn was as intrigued by the new camouflage as Picasso. In the months after Gaudier-Brzeska's death, he began corresponding with André Dunoyer de Segonzac, another artist at the front whose paintings had been shown at the Carroll Galleries. They quickly became friends, with Segonzac sending Quinn drawings of his experiences at the front, and Quinn replying with his usual meandering disquisitions on the international situation. (Quinn's letters were popular with Segonzac's platoon, the artist later reported, because he gave a far more unalloyed view of the war than they got from the French papers.[23]) Then, in late 1915, Segonzac wrote that he had been assigned to the Section de Camouflage. Quinn was fascinated to learn about the unit, telling Segonzac that he was glad that his art was being made "useful," though the idea of a brigade full of artists made him fear even more for their safety.[24]

The military potential of modern art was not lost on the Germans either. Almost at the same moment Segonzac was learning to disguise French guns, the German Expressionist Franz Marc was holed up in a hayloft near the Western front painting army tarpaulins with nature-mimicking patterns; as he wrote his wife, he was applying everything he'd learned "from Monet to Kandinsky" so that German armaments would remain unrecognizable from two thousand meters away.[25] A few weeks later, Marc was killed at Verdun. For his own deployment, the Swiss-German artist Paul Klee was assigned to a military airfield near Munich, where he painted lozenge patterns on German biplanes so they would blend in with the sky.[26] Today, it is hard to imagine Picasso-inspired cannons firing at Klee-painted biplanes, but seemingly no aspect of contemporary European culture was spared the reach of a war that had upended civilization: Even as the French government was locking up Kahnweiler's Cubist paintings as enemy assets, it was applying Cubist ideas to its artillery and turning actual Cubists into platoon leaders.

. . .

Back in Paris, Picasso spent much of 1915 contending with an unfolding personal tragedy. Following a second operation at the start of the year, Eva's health had continued to decline. "Eva has been in the hospital for nearly a month . . . and I've been very worried," he wrote Apollinaire in February.[27] By late fall, she lay dying, uncomplaining as always, in a nursing home near the Bois de Boulogne. At many points in the long arc of his life, Picasso's self-absorption could render him maddeningly aloof, or even callous. Not with Eva. Throughout her decline, he sought the best medical advice he could find; as her illness entered its final stage, he crossed Paris on the Métro every morning to be with her. He sat with her, and sketched her on her deathbed, a haunting, disturbed geometric portrait from which all signs of animation seem to have been extinguished.[28] Then she was gone. "My poor Eva is dead," he told Stein.[29]

As the Battle of Verdun got under way, the artist entered one of the darkest periods of his life. He had never wanted for company and was usually the center of it. Yet at the Café Rotonde that winter, he would show up in the evening in a worn-out brown raincoat, take a table by himself in a back room, and watch people come and go, saying nothing.[30] Only eighteen months earlier, he and Eva had been with Braque and Derain and their wives in the blithe world of Avignon. Now, his friends were at war, his dealer was gone, his lover was dead. He found he could no longer work and live in the studio he had shared with Eva, and soon he abandoned Montparnasse entirely for a house in the suburbs. One acquaintance, after visiting him, thought he was going to "dump Cubism" altogether.[31]

The visitor was wrong about Cubism, but Picasso's world was changing. What Picasso did not know, and what he would not learn until after the war, was that he already had acquired an important new patron on the other side of the Atlantic. A year after a record season of buying in New York—a year after he had bought his first group of Picassos from Vollard—Quinn's thinking about modern art had begun to shift in im-

portant ways. By now, he had bought a huge number of paintings of varying quality by American and European artists. "Too many," he told the critic James Huneker. He had poured money into the city's art galleries, funded modernist journals, sent money to France, written letters to artists in the trenches. He was running up debts and concerned about his expenses. "It has nearly busted me," he said.

Now he was also beginning to wonder if he was casting his net too broadly. Many of his purchases, it seemed to him, had done far more to "help artists along" than to further the cause of great art. He had, it was true, supported the work of some of the most daring new Americans. The pioneering abstractionist John Marin, he conceded, was "one of the most intellectual painters we have." But when he stood back, it was unclear what it added up to; there was a lack of rigor in the choices. He had an urge to narrow, to concentrate on the far more select group of painters and sculptors who were doing something dramatically new. Among them were several of the artists whom Jeanne Foster had singled out in her Armory Show essay, but also men like Gaudier-Brzeska, whose work Quinn had been pursuing with even greater intensity ever since Pound had written him about his tragic death on Vimy Ridge. These were the artists who ultimately mattered, whose work, he felt, held more than flickering interest. As he told Huneker, "Picasso and Matisse will be remembered."[32]

Yet for all Quinn's efforts, these artists had made little headway in the United States. Quinn had been almost the only one to buy Matisses at Montross, and the only one to buy Picassos from the Carroll Galleries. Even in Europe, during his abbreviated life, Gaudier-Brzeska had sold hardly a single sculpture. As for the Cubists that Harriet Bryant had tried to introduce to New Yorkers, their most important work had been confiscated by the French government, and many of them were themselves in the trenches. Helpless to stop the violence, and frustrated by the faltering progress of his "propaganda work" in New York, Quinn began to conceive of a different project—one that was geared less toward promoting art in the present than preserving its best examples for the future.

A NEW
BEGINNING

"**M**y god! I thought you were an old lady!" Quinn exclaimed as he opened the door.[1] Standing before him was an unblemished enchantress in her midthirties who might have stepped out of one of his Laurencins. It was a few weeks after the Armistice, and Quinn was getting his first look at Jeanne Foster. Though they had never met, he had invited her over for dinner in gratitude for nursing old man Yeats—W. B.'s father—back to health.

Just as the war was ending in Europe, John Butler Yeats had fallen dangerously ill, and Quinn, fearful that it might be Spanish flu, had hired the best nurse he could find to care for him. But Yeats, who was nearing eighty, was an obstinate man and utterly refused to be tended to. Instead, he had insisted on the company of Foster, his poet friend, and so Quinn telephoned her to go see him.[2] She and Quinn had spoken almost daily since then, as she monitored Yeats's recovery, but Quinn had no idea that she was two generations younger than Yeats himself.

Standing in his doorway, Foster was amused. Here was the genius-hunter she'd heard so much about, fumbling. In fact, as he later confessed to her, Yeats had sent him an adoring pen-and-ink sketch of her, but he simply didn't believe it. He thought the old man was being fanciful. To the contrary, she was even lovelier in the flesh.[3] He led her into

his apartment—past Brancusi's *Mlle Pogany* and other smooth marble forms that stood in the hallway, past the stacks of newly arrived books, past the rows of paintings turned to the wall—and they began to talk.

Almost immediately, there were flashes of recognition. Foster had met most of the Irish, English, and American writers in Quinn's circle. She'd written about Irish dramas he supported, books he helped publish, paintings and sculptures he owned. She'd been to Dublin and seemed to know Paris better than he did. She also seemed to have a razor-sharp mind and spoke fluent French. No wonder Yeats craved her company. Here was the new beginning Quinn desperately needed.

By the final years of the war, Quinn's accelerating professional and personal entanglements had nearly driven him into the ground. Whether self-willed or not, he now woke up to a multiheaded hydra of duties, expectations, and involvements, encompassing law, politics, finance, literature, and art. As the Wilson administration finally prepared to join the Allies in the war—a step Quinn had called for since 1915—he had taken on a series of colossal government projects, from negotiating tax policy for the wartime munitions industry to designing sanctions against German-owned corporations. (On the day the United States entered the war, Quinn was lunching at the British embassy with Henri Bergson, the French philosopher, and Sir Cecil Spring-Rice, the British ambassador.) Still mired in Ireland's independence struggle, he recruited two leading Irishmen, the critic George Russell and the Irish statesman Sir Horace Plunkett, to help him write a 183-page treatise on the ideal shape of a new Irish constitution, which he then sent to British prime minister David Lloyd George and his powerful foreign secretary Arthur Balfour.[4] In Washington, Quinn was also being pulled back into his old "art fight": In an effort to raise war revenue, Congress was threatening to undo all his efforts back in 1913 and reinstate the art tax. And in New York itself, drawing on his growing connections to France and Britain and his considerable rhetorical powers, he had been giving speeches to rally politicians and business leaders to the Allied cause.

Meanwhile, his cultural activism continued unabated. Despite what he'd told Huneker about narrowing his field of view, he was supporting exhibitions right and left, bailing out insolvent galleries and painters to

an extent that baffled his own beneficiaries: "You will certainly die with your cheque-book in hand," Ezra Pound told him, "paying the debts of some irrelevant artist."[5] He was working constantly on Alfred Knopf, who had now started his own publishing house, to take on the writers he had been discovering in Europe. ("I do not know if it is great poetry or not," Knopf wrote him, a few days after Quinn sent him a copy of T. S. Eliot's "The Love Song of J. Alfred Prufrock." "I do know that it is great fun and I like it."[6]) And to stir interest in James Joyce's work, Quinn had written, in *Vanity Fair,* one of the first American appreciations of *A Portrait of the Artist as a Young Man.*

Especially consuming was *The Little Review*, the modernist journal run, with frequent assistance from Pound in Europe, by the brilliant but not-at-all business-minded Margaret Anderson. (Its motto was "Making No Compromise with the Public Taste.") As Anderson's principal backer, Quinn found himself continually writing checks to support some of the most incisive new prose in the English language, including work by Djuna Barnes, Mina Loy, Wyndham Lewis, W. B. Yeats, and Sherwood Anderson. Yet nearly as often, he found himself defending *The Little Review* in court, on the multiple occasions when it ran afoul of censorship laws for publishing allegedly obscene fiction. "Don't burn your candle so fast, dear Quinn," an Irish friend warned him in the fall of 1917. "We only get one each."[7]

That winter, it finally caught up to him. For weeks, he'd been having stomach cramps, which, ascribing them to overwork, he simply ignored. By January 1918, however, he was seriously unwell, and suffering from rectal bleeding. When he at last found time to see a specialist, the verdict was dire: a malignant tumor in his lower abdomen. Quinn was incredulous, but a second opinion concurred, and the only option was to try to remove it as soon as possible. He was given five days to prepare for the operation and told he might not make it. There was barely time to gather his thoughts.

For Quinn, the situation was as unimaginable as it was terrifying. A vigorous forty-seven, he had, only a few months earlier, felt almost invincible. Now, apart from confronting the prospect of his own imminent demise, he found himself taking stock of his life. Despite his

formidable and varied career, there was a decided chaos to the garden he had sown. Many of his most cherished plans and projects were undone, or half done, or never quite started. Opting for independence, he'd turned down prominent judgeships and political posts; instead, he pursued the unforgiving finance work that had supported his interests but left little lasting legacy. In his cultural ambitions, he had not come close to creating a permanent beachhead for modern art in the United States, or even building the exceptional personal collection he sought. And for all his romantic conquests, his fierce resistance to emotional attachments had left him remarkably alone. He felt "like a man going over the top," he told one friend, invoking the gruesome trench warfare of Europe, but in his case he was staring at death without a platoon to back him up.[8]

In the days before the operation, Quinn raced to put his affairs in order. Drawing up a short will, he resolved to leave to his remaining relatives, his sister and her young daughter, as much as he could. (His other surviving sister, having joined a convent, was provided for.) His estate was depressingly meager. Though he was handsomely compensated for his law work, he had poured so much of his earnings into his cultural pursuits that he was constantly behind in his own finances. Still, he did have his sprawling collections of art and books. Already he had amassed the most significant pile of modern paintings and sculptures in the United States, even if, as he saw it, the sum total was hardly enduring. Far better, he reasoned, to have everything sold off to provide *something* for his sister and niece. In the event of his death, he instructed his executors to liquidate the entire collection.

In the end, the will did not have to be invoked. Not this time. Led by one of the best doctors in New York, the operation went off unexpectedly well and the tumor was removed. "A miracle of successful surgery," Quinn wrote to Joseph Conrad two weeks later.[9] Nonetheless, he faced a long and painful convalescence, starting with five weeks in the hospital and months of slow rehabilitation at home after that. When he did return to the fullness of life, he was ready to act on feelings that had set in the year before. "You will do me a great favor, if you spread the legend that I am a changed man," he had told John Butler Yeats. "That I murder poet-asters [*sic*] on sight; that I have no interest in the drama; that I

have ceased taking any interest in artists or writers; that I have given up being the defender of the oppressed; that I don't give a damn if all of Washington Square is indicted and tried and convicted."[10] The universe was finite. From now on, he would rigorously limit where his energies were spent, but he would be all the more determined to pursue those things that mattered.

It was in this frame of health and mind that he found Jeanne Foster on his doorstep. At the time, Foster herself was in a moment of transition too. Following her war reporting, she had returned to New York, where she managed to publish two different volumes of her own poetry in quick succession. (The second volume, called *Neighbors of Yesterday,* hugely impressed John Butler Yeats, who read it in a single sitting and told her, "*You* have something to say."[11]) She also had become something of a literary patron of her own, discovering and mentoring a teenage Russian-born poet named Marya Zaturenska, who would decades later win the Pulitzer Prize. And though she continued to be burdened with her elderly, ailing husband, the marriage had long ago been reduced to an intermittent caregiving arrangement, from which she escaped as often as she could. Now that the war was over, she was impatient to re-engage with Europe.

As they talked, Foster was fascinated by the intensity of Quinn's enthusiasms, and when he asked her if she would like to help him find publishers for the new writing he was receiving from London and Paris, she immediately said yes. Over the coming months, as they discussed Eliot, Pound, and other writers, they found other affinities. Already initiated into Quinn's aesthetic world, Foster soon became enthralled by the sweeping assuredness of his judgments and his rapid absorption of almost anything new, but also his fearsome reputation in the legal world and his perpetual distemper with ordinary life. At one point, he gave her a copy of his friend Joseph Conrad's autobiographical sketch, *A Personal Record;* concurring on Conrad's "incomparable" talent and his "freedom from sentimentality," Foster remarked that he wrote "primarily for those who are passionate beyond passion."[12] She might have been talking about Quinn himself.

For his part, Quinn was disarmed to find someone whose restless

spirit and sharp outlook so often anticipated his own. In his earlier con-
quests, Quinn had known a number of exceptional women. Alice
Thursby, the vivacious daughter of a prominent social philosopher and
the sister of one of the country's leading newspaper editors, had had a
nomadic upbringing in the United States and Europe. Lady Gregory,
stunning even at eighteen years his senior, was the aristocratic play-
wright and guiding light of the Irish Renaissance. May Morris was an
accomplished modern designer and the daughter of William Morris,
one of the founders of the Arts and Crafts movement. Yet until he met
Foster, he had never encountered someone so thoroughly self-created
like himself—a woman who had come from mountain girl poverty to
the most advanced end of culture purely by her own drive. With Foster,
the new art and literature was not merely a sport; it was nourishment for
the unquiet mind. "You are not trapped by life. You are free," she told
him.[13]

Collaborating first over literature, and then, more and more, paint-
ing and art, Foster soon became Quinn's secret weapon. In contrast to
his abrasive impatience and exacting, if sometimes impossible, demands,
her quiet poise could win over skeptical publishers and unpaid dealers;
and her French and her frequent transatlantic travel gave him coveted
insights into the emerging postwar scene. Sometimes, she assisted with
Quinn's legal dealings as well, reading briefs to him at breakfast, which
he would then commit to memory—he liked to appear in court without
any notes—or supervising a French legal team he was collaborating
with on a case. ("These lawyers seem much in awe of you," she reported
from Paris at one point.[14]) For much of her adult life, Foster had been
pursued by men who tried to wrest her away from her marriage; but
Quinn, for all his outsized ego, cherished her independent spirit. When
Foster had to leave him, briefly, to look after her elderly husband in
Schenectady, Quinn told her he had no right to be angry, but was "writh-
ing like a man in hell." She told Quinn he was everything to her. "Love
me or love me not, it makes no difference," she said. "To have found you
is enough for me."[15]

Only gradually, though, did Foster realize that she was also leading
him into a crucial new phase of his career as a patron. A few months

after they met, Quinn received a letter from the painter Segonzac, who had recently been discharged from the French army. After the war, Quinn had tallied with bitterness the artists and writers who had been lost, among them Gaudier-Brzeska; the poet Apollinaire, who had died of Spanish flu even as the war was ending; and Duchamp's brother Raymond Duchamp-Villon, whom Quinn regarded as one of the greatest sculptors in the world. Others, including the brilliant Cubist Roger de La Fresnaye, had returned in such poor health that it was unclear whether they would ever make art again. But Segonzac had survived, and he said that he had seen Picasso, Braque, Derain, and Léger, who had also come through okay, and that a new school of art was emerging, something he called Purisme.

Quinn was fascinated by the report. By now, he owned a large number of paintings by Derain and Picasso, and several of Braque's Cubist still lifes, and he was familiar with Léger. He understood, if on a purely instinctive level, that they were part of the group that was upturning the rules of painting and was writing what he described as a new chapter in the "history of the development of art."[16] He was excited by Segonzac's impression—however simplifying it was—that a new school was, as Quinn put it, "coming into life" from the wreckage of war.[17] Here was the drama of creation he longed for in New York. But the letter also made him wincingly aware that he lacked a personal rapport with any of these artists and had still seen remarkably little of their work.

What Quinn lacked was in Paris itself. Without establishing himself in Europe, it would be very difficult for him to sustain the kinds of friendships—among artists, critics, and dealers—that had undergirded his activity in New York. But he also knew this was out of the question. Even before the war, his incessant work obligations had severely limited opportunities for transatlantic travel. ("Personally, if I didn't have to be on this side, I'd give almost anything to be in Paris," he'd written Congressman Underwood after the passage of his tariff reform.[18]) By now, it was nearly seven years since he last visited the Continent, and he was newly constrained by his precarious health. What he needed was someone already *in* Paris—someone who shared his gift for connections, his decisive taste, his anticipatory interest in new art and new artists. Not

even Foster, for all her talents, could do that. And besides, he wanted her here.

Then, in the late summer of 1919, Quinn made a serendipitous discovery. An unusual Frenchman he had met in New York during the war was about to return to France. Henri-Pierre Roché was a tall, red-haired man in his late thirties who had been sent to the United States on a wartime economic mission for the French government but whose primary interests lay elsewhere. A man of deep acquaintance with the world, he spoke many languages and was disarmingly earnest and enthusiastic. (Among his idiosyncrasies in English was to close any conversation with "good, good, excellent.") He also seemed to know a great deal about the Paris art scene. One Sunday in early September, Quinn invited him over for lunch.

When they had first met, Roché had learned about Quinn's unusual interest in modern art, but since Roché was in New York, there was little he could do to help him. With Roché headed back to Paris, however, Quinn was anxious to talk about his paintings and explain his dilemma.[19]

For Quinn, Roché was an improbable match. Not only did he share Quinn's deep interest in modern art, he also had a gift for meeting people and seemed to know nearly everyone in Paris. Before his arrival in New York, he had been a regular boxing partner of Derain and Braque; he had also been friendly with Picasso since the artist's days with Fernande at the *bateau-lavoir*. It was Roché who first brought Gertrude and Leo Stein to Picasso's studio back in 1905; Roché who had helped Picasso find Braque when Braque had been shot at the front; Roché who, when Picasso was hard up during the war, had introduced him to Jacques Doucet, the prominent Parisian fashion designer, and persuaded Doucet to buy several paintings.[20] Along with his social proclivities, Roché was also intellectually omnivorous, and there was seemingly no artist or writer of interest—in France or anywhere else—who had escaped his attention. "He had done a great many things," Gertrude Stein observed. "He had gone to the austrian mountains with the austrians. He had gone to Germany with the germans and he had gone to Hungary with the hungarians and he had gone to England with the english. He had not gone to Russia, although he had been in Paris with russians."[21]

Along the way, Roché pursued his other great vocation: women. In the meticulous diaries he kept nearly every day and would continue to keep for more than fifty years, Roché recorded his prodigious love life with remarkable candor. "My desire [is] to write the story of my life one day," he wrote in his diary around the time of his meeting with Quinn, "like Casanova, but in a different spirit."[22] In his diaries, he developed an elaborate system of code names for his various partners—Wiesel, Big-eye, Maho, Cligneur ("winker")—as well as for his own penis, which he referred to as "p.h.," for *petit homme* or "little man." (Alternatively, he called it *"mon God."*) Yet he did not see himself as a conqueror. To the contrary, he was fascinated by relationships and their complexities, and many of his overlapping attachments endured for years; somewhat like Quinn, he maintained friendships with former lovers years after an affair had cooled. He also had a predilection for sharing his partners with friends. "This one is one certainly loving, doing a good deal of loving," Stein wrote. "Certainly, this one is one who would be very pleasant to very many in loving."[23]

Only occasionally did Roché's extraordinary libido get him into trouble. Before the war, he spent extensive time in Germany in particular, where he had shared a series of women with the German writer Franz Hessel, his close friend. In Paris, foreigners were frequently seen at his apartment, and he kept up a continual correspondence with friends and lovers, often in German. A few weeks after the war broke out, he was falsely denounced as a spy and taken to the Conciergerie, the notorious French prison, pending charges of treason. In the end, he was held for two weeks before he could clear his name. (Finding himself incarcerated with an assorted group of con men, beggars, and Alsatian waiters, he quickly made friends with all of them. "On the tenth day," he wrote, "we received the news, tapped through the walls, that the war was going well, but the prisoners in the neighboring cell needed tobacco."[24])

Notwithstanding the arrest, the French authorities decided that Roché's unusual talents would be useful to the war effort, and after a stint at French military headquarters, he was dispatched to the United States to assist with a Franco-American industrial commission. Bored by the government work, he soon plunged into New York's wartime art

scene, making friends with Duchamp, playing chess with the exiled painter Francis Picabia, falling in love with the patroness and salon host Louise Arensberg, and starting a short-lived Dada magazine called *The Blind Man* with a free-spirited young American named Beatrice Wood. It was amid this activity that, in the spring of 1917, Roché had attended a large gathering of artists and writers hosted by Quinn. Now, two years later, they were finally becoming properly acquainted.

Before they sat down to lunch, Quinn wanted Roché to see his paintings. As they wandered through the apartment, Roché was stunned. In room after room, there was hardly any furniture. Instead, everywhere he looked were thick standing rows of paintings, turned nose to the wall. In a front bedroom were the Irish marine pictures that Quinn had collected in his youth; another room contained the big Augustus Johns and works by other British contemporaries. There were a huge number of paintings by new American artists, like John Marin and Charles Prendergast and Walt Kuhn. And then, in several back bedrooms, the heart of the collection, dozens of paintings by the French and European moderns. Though Quinn had only a small number of works by Van Gogh, Gauguin, and Cézanne, each one, it seemed to Roché, was a masterpiece. And then, perhaps most surprising, came a series of important works by the painters he knew in Paris: Braque, Matisse, Derain, Dufy, Picasso. As he would later describe it, these were *toiles de combat,* canvases you could go to battle with.[25]

Yet Quinn was deeply dissatisfied. As he showed Roché different paintings, he confided that he felt that much of what he owned was second-rate. Several times, as he got out a particular work, he told Roché, "I would like a better version of this." He also mentioned a series of exceptional works he wanted, *needed.* Then he asked Roché if he could help him. What Quinn was proposing was for Roché to be his "informant," finding and telling him about paintings, in exchange for a commission on each painting Quinn bought. Aware that Roché himself collected, on a small scale, works by many of the same artists, he added that he wanted Roché to show him the paintings that he would be

tempted to buy and offer Quinn the opportunity to buy them first: a hard bargain that was at the same time a flattering endorsement of Roché's taste. Roché didn't know what to say. He had already dabbled in the modern art trade, linking artists to collectors as he maintained his vast social network in Paris. He also needed a new vocation, having finished his wartime mission for the government. Clearly, the lawyer had a powerful sense of what he wanted but it seemed unclear how much Roché would be able to do. Some of the paintings Quinn wanted were so scarce, or hidden away in artists' studios, that they were likely unattainable.

After the lunch, Roché thanked Quinn for the offer and they agreed to stay in touch. Then, the night before his departure for France, he received a letter from Quinn, restating the lawyer's interest in collaborating with him. "I am going to try to limit my purchases, as much as possible, to first-rate examples," Quinn wrote, ". . . to works of museum rank or what we refer to here as star pieces." He also outlined his proposed method. It would be up to Roché to cultivate artists, identify standout paintings, and send him black-and-white photographs, along with careful descriptions; then Quinn would make his own judgment. He warned that he would likely reject most of Roché's suggestions. "I may not be interested in many of the things you write about," he said. More gamely, he suggested that whatever came of their work, Roché had gained a place in his circle. "I shall be glad to hear from you, when you feel in the mood for writing," Quinn wrote, adding that he hoped to find him "enjoying life as much as possible."[26]

The next morning, as he waited for his boat to leave New York harbor, Roché read the letter again. What Quinn proposed was almost comically impractical. He would not only have to stand in for a difficult American collector who disliked most of what was offered; he would also have to persuade leading Paris artists and dealers that this New Yorker, who rarely came to Paris and might take months to make up his mind about any given work, was sufficiently important that they should covet the chance just to get their canvases into his hands. Having been to Quinn's apartment, though, he sensed how closely his tastes aligned with his own. He also found Quinn almost as interesting as his paint-

ings. With the boat still at the dock, he scrawled out a short reply and put it in the mail: "I quite approve your plans."[27]

What Roché did not know was that Quinn's ambition to create the first museum-like collection of advanced modern art in the United States faced a personal obstacle as well. As she began to see Quinn, Jeanne Foster wondered if he was more ill than he let on. With his morbid fear of disease and death, Quinn never mentioned cancer to anyone. But he wore a brace, and there seemed to be other lingering effects of what he referred to as his ulcer operation, or simply, "the trouble." Foster was sure there was more to it, and a few months after they met, she asked his doctors, who told her that they were sure that he had no more than six years to live.[28] It amounted to a very short span for a project that, by Quinn's own account, would require "more time and involve more patience" than anything he had undertaken.[29]

DO I KNOW
THIS MAN?

A few weeks after Roché returned to Paris, a journalist named Georges Martin set out for an appointment in a chic Right Bank neighborhood. He was on assignment for *L'Intransigeant,* France's leading conservative paper; it was raining, and a characteristic gray cloud cover hung over the city. Nevertheless, he couldn't help pausing to admire the *très bourgeois* feel of the district. Nearby, amid small boutiques and prim apartment houses, was the Latinville patisserie, the place where Proust's faithful housekeeper, Céleste Albaret, would go late at night to acquire "something with chocolate" for her employer.[1] Farther up the street was the Salle Gaveau, the coveted modern recital hall that had managed to render Louis XVI–style neoclassicism in reinforced concrete. The Lycée Condorcet, the prestigious training ground for the country's professional elite, was a few minutes away.

Reaching the doorway of a classic six-story Haussmann building, Martin walked into the foyer, where a modern elevator whisked him to an apartment that took up the entire fourth floor.[2] A maid promptly answered the door, informing him that the man he had come to see would appear momentarily. Then she ushered him into a dining room with parquet floors, a round Louis Philippe table, and gauze-curtained windows. A parakeet chirped in a cage on a side table, and the walls

were carefully hung with bright colored pictures in ornate gilded frames. The whole ménage struck Martin as almost painfully fashionable: like a Georges Lepape illustration from the pages of Paris *Vogue*.

But the pictures in those golden rectangles were not decorative scenes of the beautiful life; they were startling Cubist abstractions. After a few minutes, a small, spry man emerged, freshly shaven, a dark forelock sweeping across his forehead. He was wearing silk pajamas. Picasso was about to give his first solo exhibition in Paris since well before the war and Martin had come to talk to him about it.

The artist was thirty-eight, but Martin thought he might pass for a decade younger: a *jeune maître*. Immediately, he led Martin through a pair of doors into a pair of large adjoining rooms. Here, there were also ample windows and elegant moldings, and each room was endowed with a marble fireplace surmounted by a tall mirror. In absolute contrast to the fastidious order of the dining room, however, a state of utter chaos reigned: They had entered Picasso's studio. Casually propped on a heap of canvases was a gnarled, desiccated wooden Christ, perhaps from some medieval Spanish church; a group of ancient carved figures, possibly from Senegal or Polynesia, seemed to be communing with a series of strange Cubist sculptures. Dominating the whole mess was a large, curiously formal portrait of a young, very pale woman seated and holding a fan, her hair carefully parted in the middle.

As Martin surveyed the room, he began to ask Picasso about his métier. Picasso offered a brisk and curiously anodyne life story. "Success came little by little," he said, blandly. "I sold my works to dealers, and now you can find my pictures hanging next to Matisses and Cézannes as far away as Moscow." Unmentioned were his precarious early years in the filthy *bateau-lavoir,* when he had eaten meals on credit and rummaged in trash cans to feed his dog. He didn't talk about his checkered history with exhibitions, his struggles during the war, or the fact that, for much of the past five years, he hadn't had a dealer at all. Nor did he tell Martin that most of his Cubist paintings had been sequestered by the French government in 1914 and had been seen by no one for years, or that the brief appearance of his *Demoiselles d'Avignon,* which remained in his personal possession, at a group show during the war had left the

public cold. ("He has painted, or rather daubed, five women who are, truth be told, all hacked up," *Le Cri de Paris* had written.[3]) To hear Picasso tell it, he'd had a steady upward trajectory among the arbiters of *bon goût* almost from the moment he arrived in Paris. And now, he continued pleasantly, "an exhibition of my drawings is about to open at a dealer here on rue La Boétie, a neighbor of mine."[4]

Picasso must have been enjoying his own performance. Gone were the old brown raincoat, loose green sweater, and ill-fitting blue trousers he'd worn during the dark days of the war.[5] Gone was his old circle of radical poets, louche Spaniards, and avant-garde hangers-on; he hadn't spoken to Gertrude Stein in two years. Even his old Cubist friends had lost touch with him. Do I know this man? Braque wondered aloud after seeing a photograph of Picasso in his new getup.[6] In Picasso's domestic arrangements, Frika, his beloved German shepherd half-breed, had long since been succeeded by Lotti, a Pyrenean sheepdog. And in place of his quiet, unassuming Eva, he now had an imposing wife, the Russian ballerina Olga Khokhlova—the sitter in the large portrait that Martin couldn't take his eyes off.

In almost every respect, Picasso's existence had shifted 180 degrees from before the war. It was a metamorphosis as dramatic for his social identity as the *Demoiselles* had been for his art. And in no small way, the transformation owed to yet another part of his new life: his new dealer, Paul Rosenberg. It was Rosenberg who had planted Picasso and Olga in the heart of Right Bank society, finding them the apartment on rue La Boétie and then, with studied choreography, reintroducing him to the public. If before the war, Picasso's world had been sustained by the austere, antibourgeois, publicity-shy Kahnweiler, now it was shaped by the taste-making showman Rosenberg, who lived next door to him.

With remarkable speed, Picasso had become the focal point of Rosenberg's strategy. Though the opening of his huge gallery, back in the spring of 1914, had been exceedingly ill timed, the dealer had been carefully positioning himself for the reemergence of the Paris art world after the war. Almost as soon as he had completed his own military service, he had begun to prepare for the postwar boom that he was confident would be coming. In 1917, with museums still shuttered but the public starved

for culture, he had mounted an improbably resplendent show of classic late-nineteenth-century paintings to raise money for disabled war veterans. Featuring a distinguished group of works by Cézanne, Corot, Manet, Renoir, Van Gogh, and others, the show was attended by some of his own military superiors and did much to raise Rosenberg's profile. As he reestablished himself, he also began to move more decisively into twentieth-century art. It was amid this activity that he had joined forces with Picasso.

By the end of the war, Picasso enjoyed substantial name recognition in Paris, but much of his most important work remained obscure. He was, as his friend and biographer Pierre Daix later put it, a "celebrated unknown."[7] During the war, Picasso had gained some help from Rosenberg's brother, Léonce, who had briefly tried to corner the market in Cubism following Kahnweiler's exile. But Léonce's efforts had largely come to nothing, and aside from Picasso's old circle, which had largely disintegrated, and the handful of connoisseurs who collected him, few in France knew much about the artist's development since his early Blue and Rose period paintings. He was ripe for reinvention, and Paul Rosenberg, who was a far shrewder judge of the market than his older sibling, seized the opportunity. "We're going to see a lot more of each other," he told Picasso.[8]

Picasso was a ready accomplice. The dispersal of his old group, the break with Kahnweiler, his own helplessness in the face of his friends' sacrifices, and especially the death of Eva had exacted a heavy toll, and he had spent much of the war trying to get his life in order. At first, responding in the only way he knew how, he had plunged into a series of impetuous liaisons that invariably ended badly. Within the course of a year, he had proposed to two different women, both of whom bluntly rejected him for more stable partners. ("Picasso had decided to marry me," one of them later wrote. "I was not altogether sold on the idea."[9]) Yet a third, a Martinique native, had abandoned him in a matter of weeks, unable to cope with his gloom.[10] At thirty-five, the man who had once gathered around him all the poets and painters of Montmartre, and a seemingly unending stream of women, was beginning to wonder if he was doomed to solitude.

But then he'd been given an unlikely fresh start in one of the Continent's last remaining bastions of high-culture frivolity. A few months after Eva's death, Jean Cocteau, the wealthy and insistent young poet and Parisian dandy, turned up at Picasso's studio while on leave from the war. Picasso had met Cocteau the previous summer, but this time he came with an extravagant proposal: He was desperately trying to persuade Serge Diaghilev's Ballets Russes to produce a modernist ballet he had written called *Parade,* and he hoped to enlist Picasso to design the sets. Catering to Parisian society, the Ballets Russes had little connection to the bohemian circles that Picasso frequented. During the war, it had also suffered financial setbacks—including a disastrous tour of the United States, where it had almost been shut down by the police for alleged indecency. But Diaghilev's troupe was known all over Europe and it was one of the few going cultural concerns at the time; the commission also would bring Picasso some income. Gradually, Picasso was won over to Cocteau's idea, and in early 1917, he and Cocteau traveled with the ballet company to Rome to begin working on the production.

For Picasso, the project provided the seeds of a new life. Shortly after he arrived in Rome, he became entranced by the young Ballets Russes dancer Olga Khokhlova, a slender, dark-haired, classically featured woman from St. Petersburg. She had been selected for the troupe by Nijinsky himself some years earlier and seemed to be a rising talent; she also was hard to get. The daughter of a czarist colonel, she seemed to come from a more elevated background than some of the other dancers, and she kept her distance from the men in the company. When Diaghilev learned of Picasso's interest, he warned him that her parents would never approve. But Picasso was unshakeable. By the time the troupe went down to Naples for a series of performances in late April, Picasso was accompanying Olga on long carriage rides in the shadow of Vesuvius. After a long engagement, they were married in a private ceremony in Paris during the final summer of the war.

The real transformation, however, began with the honeymoon, which he and Olga spent as guests of the Chilean socialite Eugenia Errázuriz in the south of France. An exacting woman with an unusually advanced taste in art and design, Errázuriz had met Picasso shortly be-

fore he began making sets for the Ballets Russes. Her help had proven especially crucial in Picasso's courtship of Olga, who came with expectations that were completely new to him. ("Olga likes tea, caviar, pastries, and so on," Picasso confided to a Catalan friend. "Me, I like sausage and beans."[11]) And in the weeks after their marriage, staying at the luxurious Errázuriz villa in Biarritz, Picasso had his first sustained encounters with the social set that would soon dominate his life. Among them were Coco Chanel, the Old Master dealer Georges Wildenstein, and Wildenstein's neighbor and sometime business partner, Paul Rosenberg.

In Biarritz, Picasso was fascinated to watch Rosenberg, almost dancing with energy, ply Eugenia's rich friends with modern art. "He's sold all his Rousseaus," Picasso reported to Apollinaire.[12] That anyone could do a brisk business with Henri Rousseau, the late self-taught artist whom Picasso adored, in this war-stricken country seemed remarkable. It also was pertinent. With his marriage to Olga, he could no longer rely on handouts from people like Madame Errázuriz and occasional one-off sales; he desperately needed a regular dealer. Soon Picasso was showing Rosenberg and Wildenstein his recent work, which ranged from large Cubist still lifes, to his jazzy and possibly Chanel-inspired *Bathers,* to a majestic, neoclassical *Pierrot.* Raising the stakes, he also agreed to paint the dealers' wives.

For Picasso, the portraits of Madame Wildenstein and Madame Rosenberg were a delicate undertaking. These elegant and very Parisian women were far less adventurous than Errázuriz; if they didn't like the pictures, it might wreck his chances with the dealers. Sensing that he should err conservatively, he turned Madame Wildenstein into something like Ingres's *Comtesse d'Haussonville;* then, in an even more bravura painting, he depicted Madame Rosenberg with her plump young daughter Micheline ("Miche") on her knee, a work that seemed to draw on everything from the Madonna-and-child tradition of Renaissance painting through to Renoir. The performance was a blatant display of his range and skill, but it worked. Soon after the Madame Rosenberg painting was finished, Rosenberg took it back to Paris, where it created a stir. "Everyone knows that *Picasso* did a portrait of my wife and daughter," he wrote him.[13] Picasso had found a new dealer.

. . .

For Rosenberg, taking on Picasso was by no means an obvious move. The market for his work remained tiny. Upended by war and revolution, many of Kahnweiler's most important clients were no longer active. Forced into exile by the Bolshevik regime, the onetime avant-garde fanatic Sergei Shchukin took refuge in France, but he was a changed man. Having been stripped of his fortune and briefly imprisoned, he was so embarrassed by his destitution that, according to one story, when he saw Matisse in the street, he crossed to the other side.[14] Moreover, Cubism itself was broadly out of favor in Paris, and there was little consensus on what kinds of modern art were going to succeed with the postwar public. Rosenberg's own brother, Léonce, had gone nearly bankrupt investing in the paintings of Picasso and his friends during the war. And dealing on the level that Rosenberg preferred, with large-scale gallery shows and continual promotion, was far more expensive than Kahnweiler's lean operation before the war. It might be several years before Rosenberg's investment in Picasso would begin to pay for itself, and that was only assuming that he would, in the end, be able to build a market.

Nonetheless, Rosenberg was utterly convinced about Picasso, and, in keeping with his preferred practice, devised an approach that was the exact opposite of Kahnweiler's. First, unlike Kahnweiler, he did not agree to buy all of Picasso's output, but only to have first right of refusal on his paintings. Picasso would be handsomely paid for whatever the dealer bought, but it would be up to Rosenberg to decide what to market and sell. At the same time, Rosenberg would center his operation around frequent, event-like shows, for which he insisted on wide latitude over what to show and when. Significantly, while he bought a large number of Picasso's Cubist paintings soon after they formed their alliance, he decided to devote his debut show instead to drawings and watercolors that the artist had created in a neoclassical style. Here was a radical artist, Rosenberg seemed to be arguing, whose gifts could nevertheless appeal to uninitiated viewers: More challenging work could follow in due course. Sometimes, he gave Picasso more specific instructions about what to paint. During their second winter together, he urged Picasso to

produce a whole series of Harlequin paintings, which he felt would be more likely to draw in a wary public.

Even more unusual, though, was Rosenberg's stage-managing of Picasso's private life. Not only did the dealer set up Picasso and Olga in a model rue La Boétie apartment adjacent to his own, he also went to great lengths to help the couple craft an appropriately upscale lifestyle in it. Thus, while the dealer kept careful watch over Picasso's work, Margot Rosenberg schooled Olga in the finer arts of household management and society hosting.[15] In public, the Rosenbergs took the Picassos to the opera and the theater; at home, the Rosenbergs suggested decors and furnishings, counseled the Picassos on where to shop, and attended to other needs. Margot was known to send Picasso pairs of the espadrilles she knew he preferred at the beach; and when Picasso and Olga went to London with the Ballets Russes in 1919, the Rosenbergs took care of their parakeet. (Unfortunately, the dealer proved far less adept at nurturing tropical birds than modern artists, and the creature dropped dead within a few days. "I fear you will accuse me of negligence," he wrote Picasso, protesting that he had done everything he could to keep it *soigné.*[16])

By the time that Georges Martin was profiling him in the pages of *L'Intransigeant,* Picasso had cemented an alliance with Rosenberg that was virtually without parallel in the history of modern art. Ordinarily, Picasso would have bridled against a dealer telling him what to paint and where and how to live. It went against nearly twenty years of defiant bohemianism, and it also was at odds with Picasso's career-long mistrust of the art market. (Even as he was joining Rosenberg's gallery in the fall of 1918, he was telling Rosenberg's brother Léonce that "the dealer is the enemy."[17]) Yet the war had left Picasso profoundly changed. With his marriage, he desperately needed financial security, but he also was impatient to reassert himself creatively. With Rosenberg's lucrative support, he could continue to pursue his radical experiments privately, even as he gained new audience for his paintings in Rosenberg's gallery. If securing the dealer's powerful backing meant living a bit like a marionette in a glass box, it was a bargain Picasso was prepared to make.

In turn, Olga had her own reasons for embracing the curated life-

style that Rosenberg laid out for them. From her conservative upbringing in St. Petersburg, she was far more in tune with upper-middle-class mores than her free-spirited predecessors, Eva Gouel and Fernande Olivier. But she was hardly the grasping minor dancer that Picasso's biographers have made her out to be. Perhaps as important, as the researcher and archivist Thomas Chaineux has recently shown, was the personal tragedy she was escaping. Her courtship with Picasso had played out against the violence of the Bolshevik Revolution. Along with the wrenching destruction of the Russia of her childhood, the upheaval had left her cut off from her White Russian family, who were now on the wrong side of the war. Though she feared the worst, she was unable, for several years, to make any contact.[18] Marriage itself was a form of consolation, and she welcomed the distractions of Parisian society. Soon both Picasso and Olga had fallen into the Rosenberg orbit.

In fact, Rosenberg's plans for his new artist went well beyond the salons of rue La Boétie. Like Kahnweiler before him, he had his sights on other countries, though his reading of the international market was almost the opposite of Kanhweiler's. By the end of the war, Central and Eastern Europe seemed to hold little promise for the modern art trade: Germany was bankrupt and Russia was in the throes of establishing a Communist state. By contrast, Scandinavia and London seemed to have growing markets. And then there was the country that Rosenberg had been watching with interest throughout the war: the United States. As Rosenberg knew well, for several decades, American collectors had been spending unimaginable sums on old European paintings and they were starting to be interested in nineteenth-century modernists. The country also appeared to be obsessed by art. By 1920, the number of American art museums had more than doubled since the start of the century, and nearly every self-respecting city seemed to be building a well-endowed public gallery.[19] Granted, these museums were overwhelmingly historical in emphasis, but Rosenberg saw no reason why Europe's most important contemporary art couldn't make its way onto their walls as well.

In the early summer of 1920, Rosenberg began to conjure a large-scale assault on the United States. What he had in mind was characteristically ambitious—and characteristically over the top. He was going to

organize a landmark show of Picasso's work in one of America's leading cities that would, in a single onslaught, win over the public to the artist and conquer the American market. As he told the artist, the show would include both Cubist and non-Cubist work, and he hinted, grandly, that he would collaborate with an institution such as the Metropolitan Museum in New York or the Art Institute of Chicago. "Think of the *retentissement* [resounding impact] that it will have," he said. "In one of the most beautiful museums in the country, next to the Verrocchios and Pollaiuolos and the great *chefs d'oeuvres* of past eras." Rosenberg had yet to explore the idea with American partners, and for the time being, it was not much more than an extravagant fancy. But throughout the summer, he kept bringing it up with Picasso, who had gone with Olga to Juan-les-Pins in the south of France. "I hope you've been getting a good rest," Rosenberg wrote in mid-July, "because I need a large number of canvases for the big show I am planning in the United States." He added, with his usual hyperbole, "I am now placing an order for 100—deliverable this fall!" In another letter, a few weeks later, he pleaded for more works, telling him, "Don't forget the American show!" And by late August, he was anxious that Picasso hadn't returned to Paris. "Haven't yet had enough of the pines [of Juan-les-Pins]?" he wrote. "Don't forget that the walls of all the museums of America are empty and avid to show Picassos."[20]

Reading Rosenberg's letters at the modest, somewhat overgrown house he had rented in the quiet beach town in Antibes, Picasso did not think much of this grandiose project. Olga had just learned that she was pregnant, and they were enjoying a blissful escape from the social pressures of rue La Boétie. Amid frequent swims in the sea, Picasso had been taking lots of photographs and playing with new approaches, such as his almost Surrealist depiction of giant figures at a beach with shrunken heads. The notion of huge numbers of his paintings filling some stately museum on another continent could only provoke amusement. After all, he had yet to be given a museum show in Europe itself, and what few attempts had been made to show his work in America, even on a small scale, had fallen flat. Whatever the twitchy dealer was planning, it could wait. For much of the holiday, Picasso's output mainly consisted of some

racy drawings of Nessus, the wild centaur from Greek mythology, assaulting the naked wife of Heracles.[21]

In fact, Rosenberg's American plan was almost ludicrously farfetched. He had not bothered to assess whether there was interest in such an exhibition, and he seems to have been wholly ignorant of the conservative forces that continued to hold sway at the Metropolitan and the Art Institute. Yet for all his naïveté, his determination to bring Picasso to the United States was real and would shape his efforts for years to come. Already, he had set up a partnership with Wildenstein, the Old Master dealer, to promote Picasso's work internationally. Wildenstein was not really interested in avant-garde art, and for all practical purposes, it was Rosenberg who handled Picasso. But Wildenstein could offer something else: a branch gallery in New York. In theory, then, Wildenstein could provide Rosenberg the foothold he needed to begin promoting Picasso's work in the United States, if no museum were ready. First, though, Rosenberg would need to find a few Americans who supported his ideas. It was around this time that he received a letter from Henri-Pierre Roché, who had sometimes worked with him as an art agent, about an unusual friend of Roché's in New York. The man was wary of art dealers, Roché wrote, but he already had a large number of avant-garde paintings and was gradually assembling a premier collection. "I will bring him to you if he comes to Paris," Roché wrote. He added, "His name is John Quinn."[22]

13

IN PICASSO'S GARDEN

Roché was sitting down to lunch with one of his former mistresses when the telephone rang; he was at her home, but the call was for him. It was his mother. "Mr. Quinn is in Paris," she said. He wanted Roché to meet him at 2 P.M.

Roché held the receiver in startled silence. For nearly two years, he had been corresponding with Quinn, and Quinn had shown no interest in traveling to Europe. Just a few weeks earlier, Roché had urged, in one of his letters, that he come to France to meet his artist friends, but the letter had gone unanswered.[1] Now, on an exceptionally hot Tuesday morning in July 1921, he had simply turned up. Rapidly finishing his meal, Roché excused himself and rushed out.[2]

For Roché, finding art for Quinn had become something of a vocation. In Paris, it had given him a pretext for rekindling old friendships and cultivating new ones. It was also an education in taste, training him to identify the exceptional works that might appeal to his demanding patron. As he had earlier told Quinn, he felt like a dog scaring up "some big birds" for Quinn to shoot or not, as pleased him.[3] Nearly as important, though, was the question of money. For all his worldliness, Roché, at forty-two, continued to live with his mother, and the work for Quinn was finally bringing him closer to taking control of his baroque personal life.

Since his return to Europe, Roché's existence had revolved around two women in particular: Germaine Bonnard ("Mno"), a longtime French companion with whom he had a largely untroubled open relationship; and the stormy and conflicted Helen Hessel ("Luk"), the German journalist with whom he was madly in love. A strong blonde, Helen was the wife of one of Roché's closest friends, the writer and translator Franz Hessel, and he had been spending months at a stretch with the Hessels and their young children in a town near Munich. (Their triangular affair would provide the material for Roché's late-career novel *Jules et Jim* and the François Truffaut film based on it.) Roché dreamt of having a child of his own with Helen but feared that his own finances were too precarious for it. With his work for Quinn, however, he had new hope. "Quinn is buying everything," Roché wrote in his diary the previous autumn, after helping him acquire several of Picasso's most important recent paintings. "I am finally earning money. I will have the 'right to be a father.' "[4]

At the moment of Quinn's arrival, in fact, Roché was on the cusp of setting in motion his grand plan. Helen had agreed to divorce Franz that summer, and Franz had told Roché to go ahead and have a child with Helen if they felt they were "in the right." Roché had gained the approval of his mother and—with some difficulty—even sworn himself to celibacy with Germaine and his other mistresses. As soon as the divorce went through, he planned to go to Germany to be with Helen. He had even converted a large part of his French savings into German marks. Fueled by Quinn's Picasso habit, Roché was going to settle down. In order to do that, however, he needed to be available for Quinn at a moment's notice. For the next six weeks, he would do almost nothing else.

Shortly after the phone call from his mother, Roché found his American patron at the Bernheim-Jeune gallery. He was looking at Matisses in the company of a striking woman he introduced as Mrs. Foster. Roché was immediately intrigued—"Good and gentle (Will they marry?)" he mused in his diary—but Quinn was all business: "Activity, galleries, paintings," Roché wrote.[5] It was Quinn's first trip to Europe in nearly a decade, and he counted on meeting as many artists and writers as possible. Foster, in her own playful, gracious way, was also formidable. She

knew Paris well, was knowledgeable about the theater scene, which she followed in French, and had already been complaining to Quinn about what she called the "stupid made-to-order Bohemianism of Montmartre."[6] For Roché, it was the beginning of some of the most intense weeks of his life.

Over the next few days, the three of them visited the studios of Derain, Dufy, Segonzac, Duchamp. They met Roché's friend Marie Laurencin, whose paintings Quinn had been buying for several years. They dined with the composer-eccentric Erik Satie; shared cold grog with the art critic and anarchist Félix Fénéon; and examined late Cézannes with Ambroise Vollard. One morning, taking a rattling taxi out to Issy-les-Moulineaux, on the outskirts of Paris, they visited Henri Matisse. Conversation did not come easily for the painter, and with cool formality he showed them his house, which was filled with art, old furniture, and violins. When Quinn described the large number of Matisses that he had in his apartment in New York, however, the painter relaxed and began to talk about his winters in Nice, where the locals thought he was mad because of his habit of working all day and going to bed at nightfall. "I follow the sun," he told them.[7]

They saw a good deal of André Derain and his spirited wife, Alice—"a very beautiful woman," Quinn observed—including an evening at Foottit's Bar, a popular night spot run by a retired English clown. They had an extravagant lunch with Pound, who was trying to write music for a modern opera based on François Villon's fifteenth-century poems; and a terse encounter with Joyce, who was struggling to complete *Ulysses* in his dark, barren apartment: "Quite a misanthrope," Roché decided.[8] During a series of visits, Georges Braque showed them his latest paintings, and also the long dent in his skull from his German shrapnel wound. ("Put your finger in it and see," he told Quinn, and Quinn found he could fit the length of his little finger in the depression.[9])

One evening, Roché took Quinn and Foster to dine with Brancusi at his studio in the Impasse Ronsin, a Left Bank cul-de-sac. Quinn had been fascinated with the sculptor since the Armory Show, and during the war, he had quickly become his leading patron. They had corre-

sponded frequently, and at times, when Quinn was worried about Brancusi's health or livelihood, he had fronted him money. And with Roché's help, Quinn had accelerated his purchases of Brancusi's work. Until now, however, they had never met. Brancusi occupied a rambling building at the end of the street, and when the group appeared, they found him amid a forest of wood columns and chunks of marble. Broad-shouldered, with a white-streaked beard and thick, black curly hair covering a strong, square head, the artist was nearly as striking as his sculptures. "Like an elderly faun," Foster observed. He also was fond of food and drink, and on the stove he had built in the studio, he made them a hearty soup followed by broiled chickens, which they consumed with grappa, white wine, red wine, and cognac. As they sat at his large stone table, he told stories about farmers, Roman architecture, and his boyhood in Romania, with Roché translating. The meal ended with a no-name champagne, which Brancusi, lacking flutes, served in oil cruets.[10]

On a blistering hot Saturday morning, Quinn, Foster, and Roché drove to Fontainebleau, where Picasso and Olga were renting a house for the summer. Europe was suffering from a record drought, and as they made their way south, they could see farmers already beginning the dry harvest. Several hours later, after they traversed the Forest of Fontainebleau, they arrived at a plain-looking stone house enclosed by a high wall. When they pulled up, they could see someone waving at them from the window and indicating a green door in the wall. Entering through the door, they found themselves in an enclosed garden with a dry fountain and a large catalpa tree. Then the man they had seen at the window appeared. It was Picasso.[11]

A few moments later, they were joined by a dark-haired woman in a soft blue gown and rose-colored lip paint. Radiant and svelte, Olga Picasso showed few signs of her recent pregnancy, though Foster detected a certain fragility in her beauty. (In her diary, Foster wrote, "delicate nerves, delicate heart.") With Picasso, Roché translated for Quinn; but Olga knew some English and, unlike Picasso, had direct experience of the United States. Though it has been almost completely overlooked by Picasso scholars, Diaghilev had brought her to America with the Ballets

Russes in 1916, and she performed in numerous cities on the East Coast and across the Midwest. "New York, Boston, St. Paul, St. Louis, Cleveland," she said, rattling off some of her itinerary.[12] It was a curious point of connection between the Ohio-born Quinn and the ballerina from St. Petersburg. To Picasso, of course, Middle America had little meaning, but he was intrigued to finally meet the mysterious New Yorker who had become his most discriminating patron.

Unusually, Quinn's interest in Picasso's work extended to dramatically different styles. In the previous year alone, he had bought four Cubist paintings, including two of Picasso's most important late masterpieces, *Harlequin with Violin (Si tu veux)* and *Girl with a Hoop.* But he had also acquired the completely contrasting *Two Nudes,* a large—almost life-size—work that Picasso regarded as the most important statement of his recent monumental style. (Quinn told Picasso he liked to call it the "Bronze Women" because their powerful, statuesque forms reminded him of archaic Greek sculpture.) Along with the distinguished paintings he had already amassed at Central Park West—standout Blue and Rose period paintings as well as works from the early phases of Cubism—these works already positioned Quinn by 1921 as the leading Picasso collector in the world.[13] For Quinn, Picasso's continual, restless development was important in itself.

At Fontainebleau that summer, Picasso was exploring several modes all at once. At the time of their visit, he was laboring on a large archaic painting, *Three Women at the Spring,* whose simple carved monumental figures, though deeply classical in inspiration, were suffused with an animate, Mediterranean earthiness. ("The flesh is of the color of flesh that has lived freely under the sun," Roché later commented.[14]) Yet he would also produce two different versions of an extraordinary Cubist masterpiece, *Three Musicians,* whose collage-like ensemble brought a poignant new grace and lyricism to the synthetic style he had evolved in the late years of the war. Meanwhile, he was pursuing other works in yet a third idiom, including a series of "maternity"-themed paintings inspired by Olga and their new child.

As Picasso and Quinn talked, the group gathered around a table for tea, *foie de canard,* and *baba au rhum.* When Olga brought out Paulo,

who was now five months old, Picasso lit up. Amid this domestic idyll, Roché could not help but think of Helen. Before they left Paris that morning, he had received a worrying letter from her saying that Franz had new misgivings about the divorce, which was supposed to take place in a few days. Roché now wondered if they would go through with it, and if he would ever find the same contentment with Helen as he witnessed in Fontainebleau. "Am I moved by the example of Picasso . . . ?" he wrote. Quinn, watching the artist with wife and child, was less convinced. He admired Picasso's current serenity but was skeptical that it would last. "I do not recommend to you, my dear Roché, to go and do likewise," he told him afterward. "It is a serious business: a very wonderful happiness if it is a success, but hell if it is not."[15]

As the French sojourn unfolded, Quinn kept his own collecting ambitions firmly in view. From Braque he took two exquisite Cubist still lifes. At Derain's studio, he asked the artist to do a portrait of Jeanne, and Derain began sketching her on the spot. He bought a Cézanne *Mont Sainte-Victoire* from Vollard, another series of Dufys, and a few more Segonzacs; he talked to Fénéon about finding an exceptional Seurat. A few days later, returning to Bernheim-Jeune, Quinn bought another large Matisse, a portrait of the artist, seen from the back, sitting at his easel painting and carefully studying a nude woman draped on a chair next to him.[16] And then there were meetings with the two men who, more than anyone else, had given shape to Picasso's career: Rosenberg and Kahnweiler.

A visit to Rosenberg's gallery had been one of the essential aims of Quinn's trip. Over the previous year, he had come to regard the dealer as a crucial access point to both Picasso's work and the modern art market itself. Unlike many of his counterparts, Rosenberg spoke English, and though they had never met, the dealer was unusually accommodating of Quinn's singular methods, his purchasing from a distance, his habit of paying for works in installments, and his requests to send them back, or exchange them, if they did not, in the end, meet his standards. For his part, Rosenberg was fascinated by the supremely self-assured New

Yorker and had begun to view him as a potential ally in his own plans for modern art in the United States.[17]

A few days after their visit to Fontainebleau, Quinn and Roché went over to rue La Boétie. Rosenberg greeted them with his usual high-keyed exuberance and began bringing out paintings. To Roché, who went to the gallery often, it seemed that he was showing them every Picasso he owned. But the dealer had something else on his mind as well. As they looked at the paintings, Rosenberg mentioned the American project he had hatched the previous summer, his plan to stage a major Picasso exhibition in New York or Chicago. He told Quinn he was now thinking of opening his own branch gallery in Manhattan, and wondered what Quinn made of the idea.

Quinn was characteristically blunt. "New York is ruinously expensive," he told Rosenberg. Recalling his own disastrous experience with the short-lived Carroll Galleries, he noted that rents were staggeringly high in the most desirable neighborhoods. Huge amounts of money, he told the dealer, would be swallowed up in operating costs alone; many of the modern galleries that opened during the war had shuttered without ever turning a profit. In his own estimation, he said, Rosenberg would have "25,000 or 50,000 dollars of capital sunk, absolutely lost in the first year or two, and the business almost nil."[18] As for a Picasso show, he thought the timing was poor, with the U.S. economy in a postwar slump and collectors generally skittish. Quinn advised him to wait a year or so, and suggested he make arrangements through an existing New York gallery rather than try to launch his own. Rosenberg thanked Quinn for his advice, and they agreed to stay in touch: Quinn's Picassos alone would be a crucial draw in any such venture.

While Rosenberg was plotting his entry into the U.S. market, Picasso's old dealer, Kahnweiler, was clawing his way back in France. In February 1920, after more than five years in exile in Switzerland, Kahnweiler had finally returned to Paris. With his usual methodical resolve, he had prepared the way by resuming contact with as many of his old artists as he could, and then, with a French business partner, opened a new gallery called the Galerie Simon, just a few blocks from Rosenberg's. Despite his now straitened finances, many of the old crew

remained loyal. He was able to buy works from Derain and Vlaminck, and he began representing, on a limited basis, Braque, Gris, and Léger. Shortly before his arrival, Kahnweiler also wrote Picasso a long letter in an effort to reconcile with the artist, though here he was, initially at least, unsuccessful.[19] At the same time, he recruited several of his artists and other French friends to try to negotiate for the release of his paintings seized by the French government. Just as he had refused to believe that a war was possible in 1914, Kahnweiler could not imagine that the government would not, in the end, return to him what was his. Tenacious as ever, he was beginning to rebuild himself.

In the aftermath of an exceptionally brutal war, however, French officials were in no mood to restore German assets. By 1920, France and Germany had reached an impasse over war reparations, and since the Treaty of Versailles authorized liquidations of enemy property, the stridently anti-German French government resolved to raise what revenue it could by selling off what it had seized. Even so, it has long been a mystery why France would take vindictive action against a pacifist art dealer who had not fought for Germany and whose Cubist paintings would hardly make a dent in government coffers. But there was more to the story. As the Picasso scholar Vérane Tasseau has recently discovered, in the spring of 1920, the French sequestration commission alleged that Kahnweiler had spied for Germany during the war, that he had been guilty of "suspicious activity in Italy and then in Switzerland" and was therefore a "dangerous enemy of France." Not long after this report, in January 1921, the state confirmed its plans to liquidate all of Kahnweiler's paintings for the benefit of the state in a series of public auctions.[20] Then, a few months later, it appointed an expert appraiser to oversee the sales: Léonce Rosenberg.

In theory, Léonce should have been a natural ally of Kahnweiler's. Though they were only two years apart in age, Léonce made for a stark contrast with his younger brother Paul. While Paul was wisplike, delicate, and dark-haired, Léonce was tall, robust, and blond, and where Paul had natural instincts for business and calibrated his shows to what he felt the public could take, Léonce was an uncompromising idealist who was determined to show the newest work regardless of the pros-

pects for selling it. Like Kahnweiler, he was also something of an intellectual and was fervently interested in Cubism. Shortly before the war, he had become one of Kahnweiler's few major French clients, acquiring some twenty Picassos, ten Braques, and five Grises. Then, when Kahnweiler went into exile, Léonce rescued many of his artists—including for a time Picasso—giving them contracts, despite an almost nonexistent market. His efforts had even won praise from Kahnweiler himself.

But no one was buying Cubist work, and by the end of the war, Léonce was nearly bankrupt. And when the government made its ruthless decision to liquidate Kahnweiler's stock, as a leading Cubist expert, he was glad to serve as the chief appraiser. By Léonce's own account, the Kahnweiler auctions would stir new interest in Cubism and reignite the market. But it was hard not to see another motive, too: Having invested heavily in these artists, and watching Kahnweiler reestablish himself in Paris, he knew he would be outgunned if Kahnweiler got his paintings back. Sensing a fraught situation, Paul Rosenberg kept his distance from the auctions—and from his own brother. But with his growing control over Picasso, he was arguably the greatest beneficiary of the state's decision, which, at least as far as Picasso went, largely sidelined his most formidable rival.

In public, Kahnweiler kept his head down, but privately he was fuming. "The Rosenbergs are bastards," he told Derain.[21] Other artists agreed—at least as far as Léonce was concerned. At the first auction, which took place a few weeks before Quinn's arrival in France, Braque was so angry at Léonce that when he arrived, he immediately accosted him and punched him in the face, in front of the entire crowd. (One of the witnesses was Matisse, who, as soon as he understood what was happening, shouted, "Braque is right! This man has robbed France!"[22]) Worse, the auction itself, coming at a time when the country's economy was still reeling, produced dismal results and seemed to confirm the view of conservative critics that Cubism was a failed movement.

But Kahnweiler was not done yet. The sequestration authorities had forbidden him from bidding on his own paintings, but he formed a consortium of friends to bid for him and was able to reacquire a small but significant number of works. He refused to give up on Picasso, making

further overtures to his estranged former artist. And he began to formu-
late a new international strategy of his own. A few days after their visit
to Rosenberg's, Roché took Quinn and Foster to meet Kahnweiler at the
Galerie Simon. ("He is intelligent, but German," Roché had warned
Quinn, mindful of his residual wartime antipathy.[23]) Steady and serious
as ever, Kahnweiler apparently showed little sign of his recent setbacks.
For his part, Quinn was intrigued by the dealer's deep knowledge of
many of the artists he liked, and Kahnweiler showed them several
Braques and Derains he had on hand.[24] In the end, Quinn decided to
purchase from him a remarkable hybrid work of art and theater, for
360 francs, or about $26: a limited edition of Erik Satie's absurdist dance-
play, *Ruse of the Medusa,* which Braque had illustrated with Cubist
woodcuts.[25] By now, Quinn had met both Satie and Braque, and he was
delighted to have a work that demonstrated the breadth of the new art.
(More than twenty-five years later, the play would acquire a cult follow-
ing in the United States after it was performed by John Cage, Merce
Cunningham, and Buckminster Fuller at Black Mountain College.)
Kahnweiler didn't yet have many of the big paintings that Quinn was
now hunting, but he had a good rapport with Roché, and the visit ce-
mented a friendship that would one day prove crucial to Quinn's goals
for his collection.

Around the margins of his packed days with Quinn and Foster,
Roché was also coming to a turning point in his own life. One morning,
a few days after the visit to Fontainebleau, Helen had sent Roché a tele-
gram stating that she had gone through with the divorce. Yet Helen's
letters were filled with misgivings, and Roché was once again with Ger-
maine constantly. He promised Helen he would remain faithful until
they were reunited in Germany, but Helen was herself unreliable and
Germaine was loyal, tender, comprehending. (Two days after they got to
Paris, Foster, who was fascinated by the occult and had some training as
a palm reader, offered to read Roché's and Brancusi's palms. It is hard to
know what the empirically minded Quinn made of this, but Roché re-
corded in his diary that she saw "two women, the first without any chil-
dren, calm and happy; the second, with children, but without calm or
happiness."[26])

Paralyzed with indecision, Roché increasingly sought escape with his American friends. He was tantalized by Quinn, the strength of his attitude and taste, his emotional reserve, their deepening connection over art and artists, and what had become a shared project to bring the most exceptional examples of modern art to the United States. "I feel for him a simple and profound friendship," Roché wrote. At the same time, he found Foster deeply unusual, and they began to spend increasing stretches of time together, sometimes without Quinn, who often left them when he had other business to attend to. "Beautiful talk with Mrs. F . . . alone . . . She is delicate, good, generous-spirited, I like her very much," Roché wrote one day.[27] Foster was somewhat enthralled by Roché's earnest urbanity. "Soft, generous, gracious. Sunlight on his face," she wrote after one long drive with him. "A French gentleman."[28] Quinn himself took pleasure in Foster's kinship with his trusted friend and encouraged their company. Once again, Roché seemed to be forming the kind of intricate triangle in which his social relations worked best. As he grew close to both Quinn and Foster, he also gained insight into their own intense bond and its mysterious incompletion. ("He is suffering like I am," Roché speculated at the end of Quinn's stay. "He would like to have a child with Mrs. F. as I do with Luki."[29])

As his departure approached, Quinn insisted that the three of them drive to Verdun, to experience for themselves the ravages of the war. For Quinn in particular, the devastated landscape was overpowering. "The most impressive thing I have ever seen," he wrote later. The drive was strenuous, the heat was intense, and when they got there, the detritus of battle, the buried trenches and crumbling fortifications, was, as he put it, "horrible, unspeakable, unforgettable."[30] Along with visits to the Hindenburg Line and the Argonne Forest, they inspected the skeleton of Reims Cathedral; they also stopped at a cemetery that contained more than ten thousand American war dead. For Quinn, the journey confirmed what he had felt from the beginning—that the war against France was ultimately a war against the United States.

In mid-August, after nearly six weeks abroad, Quinn sailed for New York. He had met nearly all the artists he was most passionate about, formed important new friendships, acquired astonishing paintings, and

made hopeful plans for future conquests. He had also forged a crucial relationship with Picasso, the artist whose work he regarded, more and more, as a sort of touchstone of his collection. Not least, he now enjoyed a privileged position with nearly all of the modern art dealers in Paris, including Vollard, Bernheim-Jeune, and the Norwegian émigré dealer Walther Halvorsen, as well as Rosenberg and Kahnweiler. For the first time, the project he had outlined to Roché back in 1919—to acquire the most exceptional paintings and sculptures by the defining artists of the Paris avant-garde—was beginning to seem plausible, especially if, as he sensed, the American public was at last prepared to embrace the new art.

Yet he was filled with foreboding. After so much time away, he faced a fearsome season at his office, with new uncertainty in the financial markets and a pile of unattended work. And now he would be unjustly separated from Jeanne, who was staying on in Paris, and with whom social constraints at home required their relationship to remain private. (Roché, watching their final embrace, wrote in his diary, "He kisses Mrs. F. as he leaves. I love it."[31]) He had the nagging sense that he had been in something of a dream world, and that it would be a long time before he enjoyed such freedom again. He also wondered whether he had the energy to keep fighting. "Many people think I am a man of immense vitality, that I like to do things, and that I love to be busy," he wrote one of his European friends, around the time of his return. "The exact contrary is the truth."[32]

In fact, though he could not know it, he was about to face one of the biggest art fights of his career.

14
KU KLUX CRITICISM

ew York was seemingly a different place from the city that Quinn left when he set out for Paris six weeks earlier. Since the previous winter, the U.S. economy had been teetering into recession, and in late August 1921, it tumbled. The double-barreled shock of the flu pandemic and the winding down of wartime industry had caused a severe decline in output, and the stock market hit rock bottom, having lost nearly half its value in eighteen months. A new round of corporate mayhem was looming and Quinn was suddenly finding it difficult to collect his clients' fees. Even the federal government dramatically slashed a large payout to Quinn, who had, in February, successfully defended the constitutionality of the Trading with the Enemy Act before the U.S. Supreme Court.[1] With regret, he'd been forced to turn down, for lack of funds, two exceptional Matisses that Walther Halvorsen had shown him in Paris; explaining why he couldn't give Margaret Anderson yet another $1,000 for *The Little Review,* he told her, "These are panic times."[2]

In other ways too, American society was in turmoil. A few days after Quinn's return, ten thousand armed coal miners in West Virginia staged a violent union uprising, leading to a five-day shootout with federal troops. The papers were full of stories about rising Klan violence in the south and the "corruption and terrorism" of Red rule in Moscow. An

ugly xenophobia was setting in, with much of the ire directed against new immigrants from Eastern Europe who were allegedly bringing in communist ideologies and fomenting labor unrest. Amid growing hostility toward the Continent, Congress was raising tariffs on European goods again and accusing Britain and France of welshing on billions of dollars of war debts. (Quinn, having seen the devastation of Verdun, took the exact opposite view, arguing that the United States should forgive its wartime loans so that France could stand a chance of recovering.)

At least, he assumed, the country was finally coming around to modern art. A few months before he left for Paris, Quinn and his friend Arthur Davies had scored a major coup with the Metropolitan Museum. With the help of Lillie Bliss and Gertrude Vanderbilt Whitney, they had convinced the archconservative institution to host a loan show of advanced French paintings, the first modern art show in its history. Given the innocuous title *Loan Exhibition of Impressionist and Post-Impressionist Paintings,* the show was hardly radical; as the chief lender, Quinn had been thwarted in his efforts to get Metropolitan curator Bryson Burroughs to include Cubist pictures. ("I do not think the inclusion of three blue things by Picasso . . . would be at all representative," he complained to Burroughs, when he came to Quinn's apartment to select paintings. "Particularly as you apparently do not want to include any of Picasso's abstract work, beautiful and decorative though it is."[3])

Still, Quinn managed to get a number of his important paintings in the show, including two Gauguins, a Van Gogh self-portrait, a Toulouse-Lautrec, a half dozen Derains, a Vlaminck, four or five Matisses, and Picasso's daring 1906 *Woman Plaiting Her Hair,* as well as a series of early Blue period Picassos. Enhanced by Bliss's stellar collection of Cézannes and other post-Impressionist works, the show's overall quality was exceptionally high. "There are no scraps in that exhibition," he wrote Ezra Pound at the time of the opening, in May, "no 'pretty little small thing' no 'lovely little thing' but all important things."[4] In the catalog, Burroughs, despite his qualms about Cubism, hailed Picasso as an "artist of extraordinary skill and powers of assimilation." For the first time, the country's most important art museum seemed to be taking Quinn's paintings seriously.

As far as Quinn knew, New Yorkers were embracing them as well. At the time he left for Europe, the show seemed to have captivated the city. *The New York Times* observed that more than fourteen hundred people had attended the opening, and that many of them were seeing post-Impressionist paintings for the first time. A writer for *Town and Country* found the exhibition "rich enough in material to provide discussion for the rest of the summer," and noted, for those who found the art unsettling, "there is always the Egyptian Daily Life room to cool off in." The art press was even more laudatory. "The show is amazing," declared *The Arts*. "There has probably never been a finer public exhibition of modern French art in the world."[5] The outpouring of interest seemed to bear out progressive critic Forbes Watson's call that spring that the museum should recruit Quinn and Davies to help it start buying modern art. At last, the old American hostility to the followers of Cézanne and Van Gogh was breaking down.[6]

About a week after his return from Europe, Quinn discovered how wrong he had been. The day after Labor Day, a group of self-described "citizens and supporters of the Metropolitan Museum" launched a scathing attack on the show in the *Times* and other newspapers around the country. In a four-page, carefully printed manifesto titled "A Protest Against the Present Exhibition of Degenerate 'Modernistic' Works in the Metropolitan Museum of Art," the citizen-protesters conjured up the familiar canards about late-nineteenth- and early-twentieth-century modern art: that it subverted the rules of nature; that it threatened public morality; that it was a dangerous foreign import; and that it was deviant and pathological. (To support their arguments, they cited such medical experts as Francis X. Dercum, the prominent neurologist who had treated President Wilson, and Charles W. Burr, a professor of mental diseases at the University of Pennsylvania, who had warned that looking at such art could arouse "unhealthy feelings" in the viewer.)

But to this cauldron, the protesters also added something new: "We believe that these forms of so-called art are merely a symptom of a general movement . . . having for its object the breaking down of law and order and the . . . destruction of our entire social system." The movement in question was Bolshevism: In displaying these paintings, they argued, the Metropolitan was unwittingly promoting a form of "Bolshe-

vist propaganda" that was being foisted on an unsuspecting public by a "clique" of European dealers. In essence, the show was part of a European plot that aimed to use the "influence and authority of the Metropolitan Museum and other American Museums" to promote "degenerate" art. For perhaps the first time in a major public forum, modern art was being linked to early-twentieth-century social theories about radical politics and racial decline.[7]

At another moment, the pamphlet might have been dismissed as crude conspiracy mongering. For one thing, it was unsigned, and it seemed likely that it was the work of a hysterical fringe. To Quinn, the notion that the artists he had just dined with in Paris might be Bolshevik agents rather than French patriots was bizarre. "No one," he told John Butler Yeats, "could be more French than Derain, who was born in the city of Paris and is proud of it; Braque, who was born almost within the shadow of Notre Dame . . . ; Matisse, who is French of the French; and Cézanne, who was as French as Foch or Poincaré."[8] (He might have added that Picasso's wife, Olga, came from a czarist family who were themselves being persecuted by actual Bolsheviks.)

In the fall of 1921, however, the United States provided fertile ground for paranoia about foreign subversion, and it didn't take long for leading cultural figures to join in the protest. The day after the letter was circulated, Joseph Pennell, an archconservative member of the American Academy of Arts and Letters, gave his own devastating assessment of the show in an interview with the *Times*. "Post-Impressionism is not an outgrowth of Impressionism at all, but is pure degeneracy, the same form of degeneracy that brought on the war," he said. Singling out Quinn as the animating spirit behind the show, he accused him of undermining American values: "I am not dictating to Mr. Quinn what he should and what he should not buy . . . but an exhibition of this form is positively dangerous to the teaching of art in America."[9]

For Quinn, Pennell's attack was sobering. By now, he was unsurprised by efforts to censor the writers he supported and denigrate the artists he collected. But the protests against the post-Impressionist show went further. After years of unrelenting effort to bring the United States to the forefront of twentieth-century art and literature, Quinn found

himself being denounced by a pillar of the cultural establishment. Meanwhile, the museum itself remained largely silent, limiting itself to responding feebly that the show was near the end of its run and had not previously caused protest. The show that was supposed to herald the Metropolitan's belated embrace of modern art had instead left it slinking away from an unwanted controversy. The reactionary tendency, which Quinn had been confronting off and on ever since the Chicago attack on the Armory Show, was apparently thriving after all. It made him wonder whether the country's flat-footed museums would ever change.

In fact, both Pennell and the protesters were drawing on a well-established strain of American conservative thought. Already at the beginning of Quinn's career, the pseudoscientific concept of cultural degeneracy had gained wide currency in the United States. In his influential 1895 book *Degeneration,* the Hungarian doctor and intellectual Max Nordau had argued that modernist culture—from the ideas of Nietzsche, Ibsen, and Zola to the work of the French Impressionists—was an outgrowth of the social and racial decline of the late nineteenth century. In his strained interpretation, the rapidity of modern urban life—"the shocks of railway traveling . . . the perpetual noises and the various sites in the streets of a large town . . . the constant expectation of the newspaper"—had led to the physical degradation of human populations over time, a process that in turn was producing rampant crime, addiction, and deviant behavior, including subversive new forms of cultural expression.[10] In fact, modernist writers and artists *were* inspired by the gritty life of rapidly expanding cities and the accelerating tempo of information. But Nordau could see these influences only as pathological. "Degenerates are not always criminals, prostitutes, anarchists, and pronounced lunatics," he began his 560-page tome. "They are often authors and artists."[11]

Nordau's thesis gained considerable attention in Europe, but it was in early-twentieth-century America—where the "degenerate" artists and thinkers he was writing about were little known—that he found his largest audience. Selling more than six hundred thousand copies, the American edition of *Degeneration* became one of the most influential books of the late 1890s and early 1900s, contributing to persistent fears

among American intellectuals about "decadent" European influences threatening American values. Modern and avant-garde art, with its disorienting strangeness, was a natural target for these concerns. Even before the Armory Show had opened, one New York critic warned that the art that would be shown was "European intellectual degeneracy carried to its lowest depths."[12] Such was the popularity of Nordau's theories two decades after their initial publication that a close friend of Quinn's, the critic James Huneker, felt it necessary to write a long magazine takedown of Nordau in 1915.[13]

The stakes in this debate were not minor: By the time Huneker was writing, Nordau's ideas were finding eerie echoes in American anxieties about racial purity. Among the American writers informed by *Degeneration* was the conservationist and eugenicist Madison Grant, who wrote his influential book about racial hygiene, *The Passing of the Great Race,* during World War I.[14] By the time of the post-Impressionist exhibition, the eugenics movement—which stressed ways to prevent human degeneracy through forced sterilization, immigration controls, and racial separation—had gained wide currency in American universities and even in government. At the very moment that Quinn was confronting the protest over "degenerate" art at the Metropolitan, the city's other great museum, the American Museum of Natural History, was preparing to host a huge international eugenics congress, in which scholars from dozens of countries were presenting new research on degeneracy. To mark the occasion, the organizers had commissioned a life-sized sculpture called *Average American Man* that was meant to use art to show the effects of degeneration on the Nordic race.

For Quinn, the effort to link the exceptional paintings in the Met exhibition to theories about cultural and racial decline was abominable. "If I were choosing a group of men to accompany me on an expedition to the North Pole, I do not know where I could get three better or stronger men than Matisse, Braque and Derain," he told one New York friend. "And these are the men that old fossils like Pennell call decadents."[15] But he also found himself virtually alone to defend the show. Most of the city's progressive art critics seemed to be out of town, and his fellow lenders, including Lillie Bliss, were loath to be drawn into the

controversy. It would be up to him to respond. Realizing that there would be little to be gained by getting into a public feud with Pennell, he concentrated his counteroffensive on the unnamed protesters.

In a series of interviews Quinn gave the *Times,* the *Herald,* and the *Tribune,* he observed that all important art movements had been attacked in their time. "A new way of stating truth and depicting beauty is always a scandal to some men," he said. He deplored the protesters' extreme language and suggested that they were exhibiting the same tendencies they purported to decry. Finally, he took on their anonymity. On the same day the protest erupted, the *New York World* began publishing its groundbreaking, multipart exposé of the Ku Klux Klan and its campaign of racial terror, and Quinn saw an apt, if extravagant, analogy. "This is Ku Klux art criticism," he told the *Times.* "Let these Ku Klux art critics stand up and take off their masks. . . . Then, if they are worthy of answer, answer will be given." Obviously, no one was suffering personal violence in the attack on the Metropolitan, but amid the roiling tensions of the time, Quinn's words seemed to have their desired effect: Nothing more was heard from the protesters or Pennell himself, and the controversy soon died down.[16]

For the time being, Quinn and his supporters seemed to have the upper hand. "I have had a good laugh in reading about our friends' art as degenerate," Roché wrote him from Paris. "But better still in reading your answer . . . which must have routed the enemies."[17] "I think it did the job," Quinn told him in response.[18] Still, like the ritual burning of "Matisses" in Chicago, the Metropolitan controversy had set an ominous precedent. Cowed by the dispute, the trustees of the museum had little interest in giving more play to modern art; indeed, it would be years before the Met would again attempt to exhibit paintings like these. Nor was it the last time that the modern art world would be threatened by charges of Bolshevism and racial and moral degeneracy. Although scholars in recent decades have overwhelmingly focused on Nazi Germany, the racialized attack on modern art was not an innovation of Hitler but began years earlier, in the United States.

More immediately dismaying for Quinn, though, was the apparent failure of the post-Impressionist show to lead new patrons to modern

art. In October, he received a letter from Léonce Rosenberg, who was desperate to find foreign buyers for his unsold stock of Cubist paintings. In particular, he wanted to know if any of the other lenders to the show would consider such works. A few weeks later, Quinn sent a devastating reply. Mrs. Harry Payne Bingham, he wrote, was "very rich" but bought "nothing later" than Cézannes and Manets. William Church Osborn, a director of the Metropolitan Museum, was "perfectly hopeless from your point of view." Mrs. George Vanderbilt "would not know art if she saw it outside of jewelry and dresses." Harry Payne Whitney was "a great polo player, rich man, personal friend of mine. . . . Buys many kinds of art but not cubistic work."[19]

Even among Quinn's own tiny group of avowed modernists, hardly anyone seemed to be buying avant-garde work. That winter, Walter Arensberg, who with Quinn had been one of the city's most adventurous collectors, had suffered severe financial losses and was moving to California. ("I was very sorry to hear of his misfortune, for he was one of the few men here with money and courage to buy modern art," Quinn told Roché.[20]) Arthur Davies continued to collect, but his funds were limited. And Quinn's wealthy friend Lillie Bliss, for all her spectacular Cézannes and interest in modern art, remained hesitant about Picasso and Matisse. There was the exception of Albert Barnes in Philadelphia, who was buying up whole tracts of Renoirs, Cézannes, and Matisses, but Barnes was allergic to Cubism, and Quinn, whether by envy or sheer loathing, could see him only as an undiscriminating tyrant. ("If I had the money of that *brute* Barnes . . . ," he would complain to Roché, after hearing yet again of Barnes's "ravages" through the Paris market.[21]) As far as Quinn could tell, the current "crop" of American collectors simply wasn't ready for the new art, and a new crop was "not yet in sight."[22]

In fact, though he did not know it, the Met exhibition did provide a spark to at least one young American. At the time of the show, Alfred H. Barr, Jr., was not a collector at all but a cerebral Princeton undergraduate with a photographic memory and a fascination for taxonomy. Though he had not grown up around art, he had recently decided to major in art history and was rapidly consuming the available curriculum. Like its peers, Princeton did not teach art more recent than the

nineteenth century. But one of Barr's professors was Frank Jewett Mather, a former newspaper critic who was something of a radical by Princeton standards. He let students smoke in class and was curious about twentieth-century art. He also had taken a particular liking to Barr, who showed an uncommon facility for analyzing paintings and seemed to have already assimilated large swaths of Western art history. At the end of the term, Mather decided to take his brilliant young protégé to see the post-Impressionists in New York.

As they wandered through the Metropolitan, Mather greeted the newest work in the show with skepticism: He tended to dismiss Matisse's paintings as "irresponsible nightmares" and was hardly more forgiving about the early Picassos, though he had previously acknowledged what he called their "grim power." For Barr, though, it was an altogether different experience. Not only was he moved by the formidable group of landscapes and portraits by Cézanne, an artist he would later compare in complexity to the seventeenth-century French master Nicolas Poussin. He also was excited by the later paintings in the show: the extraordinary colors of a Derain window, the simple lines of Matisse's *Cyclamen,* the startling, flattened perspective of Picasso's *Woman Plaiting Her Hair.* Here was an art that was continuing to evolve, and whose story was not yet finished. As Burroughs, the Met curator, had written in the catalog, "The battle about the later painters, Matisse, Derain, and Picasso, still in the prime of life and work, wages furiously, with the decision still in doubt." After seeing the show, Barr wanted to learn more about these painters and the war they were fighting. Though he did not know it yet, in a few years, he would be joining the battle himself.

15

DANGEROUS LIAISONS

One afternoon at the end of November, Roché went to see Picasso at his rue La Boétie apartment. He had just returned to Paris after several months away, and he was impatient to see what Picasso had been painting since their meeting in Fontainebleau in July. Following his adventures with Quinn and Foster, Roché had spent the fall in Germany, where he and Helen, now divorced from Franz, pursued an intense, erotic affair, which they had turned into a literary pas de deux in dueling diaries and letters. But the relationship proved highly unstable, and he had come back to Paris alone, nearly broke, deeply conflicted, and uncertain of whether she was carrying his child. ("Your love is too perfect to have children," Franz had written to them, shortly before Roché left.[1])

Seeking escape, Roché had plunged back into the Paris art world and his work for Quinn. But even this was proving precarious, as he discovered in a chance encounter a few nights earlier. After attending a long Anglo-American press banquet, Roché had gone to a dance hall where, around 1 A.M., he happened to run into Halvorsen, the Norwegian dealer, who told him that Quinn wasn't buying the two big Matisses. Roché would be out a handsome commission. "A sum of money that disappeared for me," he wrote in his diary.[2] Quinn, who had not written to him all fall, was evidently in one of his periodic retreats from the

chase. Now Roché would have to try to rekindle the lawyer's interest with new Picassos.

When Roché arrived, Picasso seemed to be in excellent form. Olga served tea and they looked at some photographs they had taken during Quinn and Foster's visit. Then Picasso and Roché went into his studio to look at paintings. As Picasso began to bring out pictures, it was clear that there was an immense variety of new work from Fontainebleau: Cubist clowns making music, beguiling, richly colored, collage-like; several very large canvases, including the three ancient women, whose splendidly robust figures reminded Roché of the big *Two Nudes* that Quinn already owned; small pictures that were exceedingly simple and direct—a pear, a jug. And there were exuberant variations on the mother-and-child theme, clearly inspired by Picasso's new life en famille. Nor had he been any less productive since their return to rue La Boétie. He was experimenting with small-format paintings of giant bodies, whose proportions conveyed a sense of almost uncontained immensity, pressuring the edges of the canvas; he was also playing with a new approach to Cubist still lifes, using flat swaths of luminous color.[3]

By the end of the afternoon, Roché was dazzled. "Very big and very small canvases that I love intensely," he wrote in his diary.[4] Having known Picasso since the *bateau-lavoir* days, he was long accustomed to seeing whatever he was working on, but it was unusual to find such a torrent of new ideas all at once, and over the next few weeks, Roché made a point of stopping in to see him whenever he could. "Picasso has worked magnificently in Fontainebleau and in Paris since he is back," he reported to Quinn after several of these visits.[5]

As Roché saw more and more of the new work, though, he began to sense that something was not right. For all this fecundity, the paintings were piling up in Picasso's studio, unknown to the world. Meanwhile, Picasso barely mentioned Rosenberg, though the dealer's gallery was next door. Finally, Picasso told him what was going on. The paintings were piling up because Rosenberg had stopped buying them.

Roché was startled. How could such an important body of work be ignored by the man who, more than anyone else, now had a vested stake in Picasso's career? After all, Rosenberg could reach Picasso's studio within minutes; surely he would have been excited by the paintings that

Roché had seen. It also went against the dealer's character: Ever since their alliance began, he had breathlessly awaited each new canvas, showering Picasso with letters and messages and badgering him about his progress. ("I remind you: My harlequins!!!! My harlequins!!!! . . . Keep in mind that I need paintings," he'd written in one typical appeal the previous January.[6]) At the same time, the Rosenbergs had brought Picasso and Olga ever more tightly into their family life. The previous spring, when Olga gave birth to Paulo just weeks after Margot gave birth to Alexandre, the Rosenbergs' second child, Picasso and Rosenberg became godfathers to each other's sons. In May, the dealer had put on another Picasso show in his gallery, and as recently as July, he had written Picasso at Fontainebleau to say he needed "a lot of canvases."[7]

Since Picasso's return to Paris, however, the honeymoon had come to an end. In fact, over the nearly three months since, the dealer had hardly set foot in Picasso's studio. For Picasso, the neglect was unnerving. His whole ménage was predicated on the dealer's steady purchases, and his life with Olga would be unsustainable without them. Roché wondered if the dealer was having financial difficulties; Picasso himself suspected that he was reluctant to pay the prices they had agreed upon. "I know the value of my paintings," he told Roché. "Ros. is slow in recognizing it."[8]

In fact, there was another reason for Rosenberg's withdrawal: the postponement of his high-stakes strategy to bring Picasso to the United States. Already the previous winter, he had retreated from his initial idea of doing a Picasso show at the Art Institute of Chicago in 1921, after Quinn—from whom he wanted to borrow paintings—warned that he would be setting himself up for failure. (Through Roché, Quinn had recounted how in Chicago the Armory Show had been "treated as a joke, laughed at, ridiculed."[9]) Then Rosenberg had come up with his alternative plans for New York. When he asked Picasso to prepare "a lot of canvases" in Fontainebleau, he explained he needed them for the show he was organizing "in New York this winter."[10] But four days after Rosenberg sent this letter, he had met Quinn and Roché in Paris, and Quinn had advised him not to attempt any American show at all, given the current economic situation.[11] Taking Quinn's advice, Rosenberg had reluctantly put the venture on hold, which also meant he no longer felt any urgency to invest in more Picassos.

Given the abysmal market in Europe and the barriers he faced in the United States, Rosenberg had reason to wonder if he was making too big a bet on Picasso. While he had few illusions about France's ravaged economy, he had long counted on finding new buyers overseas, and building a huge inventory of Picasso's work made sense if it allowed him to stage large-scale exhibitions and establish Picasso internationally. But after two and half years of heavy investment and constant promotion, he had been able to do neither. He had already organized several well-received shows in Paris, and Picasso was more visible than ever. But when it came to selling his work, Rosenberg had one major client and one alone: John Quinn. As he frequently told Picasso himself, business was "miserable."[12]

Where Rosenberg feared failure, Roché saw opportunity. Roché knew that Quinn prized the close friendships he established with artists, and that he often preferred to buy works straight from their studios, just as he liked to receive manuscripts from writers and poets he admired before they were published. Roché was aware that Quinn had proceeded this way with Brancusi and Derain, among many other artists, and, having built a personal bond with Picasso over the summer, he would especially covet such a relationship with Picasso as well. With Rosenberg officially in control, though, it would be a delicate affair. During one of his visits to Picasso's studio in early January, Roché finally decided to ask him outright: What if Picasso offered some of his new paintings directly to Quinn?[13]

Picasso was intrigued. Not only did he face new uncertainty about his income; after three years on rue La Boétie, he had begun to chafe at being a kept man. There was the controlling eye of Rosenberg and the constant expectations of Paris's fashionable set; it had become a refrain among his old circle that his best work was being squeezed out by ballet sets and society balls. By contrast, Quinn seemed to come from a different universe. Driven by personal passion rather than social advantage, he was a man who, as Roché had explained, didn't bother hanging his collection, who, as Picasso himself put it, simply "loved paintings."[14] Here, then, was a chance to get important work into the hands of a defiant connoisseur, and the prospect of two-timing his dealer must have appealed to Picasso's natural sense of mischief. He told Roché he was glad to try it.[15]

After the meeting, Roché, now in the heat of conquest, dashed off a letter to Quinn. "I am going to tell you something most confidential about Picasso and Paul Rosenberg," he began. He described the extraordinary pictures Picasso had shown him and Rosenberg's slowness to buy them. Then he outlined his plan. "Seeing him now and then, and seeing those pictures still in his home, what happens with Paul R., I have spoken to Picasso about the eventual possibility of selling pictures directly to you," he wrote. In addition to giving Quinn rare access to unknown works, Roché noted that such an arrangement would help Picasso as well, since both of them would be avoiding Rosenberg's commission. "You and he would profit by it," Roché said.[16]

In New York, Quinn was quickly seduced by the idea. "I do not want to buy many pictures this year for reasons I told you," he wrote Roché. "But I should be glad to make an exception in Picasso's case."[17] Having secured Quinn's interest, Roché went back to Picasso's studio to select some paintings. Picasso already had three in mind: his monumental *Three Women at the Spring,* the first version of *Three Musicians,* and a smaller Cubist still life. The choices themselves were remarkable. The first two were not only the twin peaks of his summer in Fontainebleau; they were easily among the most important paintings he had completed since the war. They would surely be paintings that Rosenberg would covet, if he were buying, and Picasso's readiness to offer them secretly to Quinn suggested his unusual respect for the American. Even his prices were attractive. "This picture I'm willing to sell to Mr. Quinn for 50,000 francs," he told Roché, referring to *Three Women*. From Rosenberg, he noted, it would cost "at least 70,000 francs." Picasso seemed all but ready to jump ship for Quinn.

But not even Roché had anticipated how complicated Quinn could be. In addition to detailed descriptions of the paintings, Quinn insisted on getting large-format, high-quality black-and-white photographs, a step that Picasso was adamantly against. Picasso didn't like the idea of an outside photographer documenting paintings he hadn't shown to anyone, and if a professional photographer came to his studio, Rosenberg might find out. "The paintings ought to be photographed outdoors in the courtyard," Roché told Quinn, "and Rosenberg's private windows

are facing this courtyard." Even doing the shoot inside carried risks. Though the dealer had stayed away, he was unpredictable. "Ros. may walk in at any hour," Picasso warned.[18]

Having spent years in bedrooms belonging to other men, Roché was sanguine about the risks, and he was determined to find a way to satisfy Quinn's demands. Then he remembered the gifted young American artist and photographer he'd met in New York during the war. Part of the Dada scene around Marcel Duchamp, Man Ray had recently settled in Paris and was taking photographs to support himself. Roché knew he could count on Man Ray's absolute discretion—"keeping silent, delivering all proofs and plates to Picasso," as he told Quinn—and asked him if he would take on the job.[19] Man Ray had never met Picasso, but he quickly agreed and a few days later went over to Picasso's apartment. Thankfully, there were no interruptions by Rosenberg, and the photographs came out well. When Man Ray was done, Picasso allowed him to take his portrait. They became friends.[20]

By the end of the month, Roché's risky plan seemed against all odds to be working. He had established a backchannel to Picasso. He had worked out exceptional prices for several of his most important paintings and enlisted one of the greatest photographers in Paris to document them. He had also sent Quinn lengthy appraisals and, together with Picasso himself, written careful descriptions of the colors on the backs of Man Ray's black-and-white photos.[21] And they had managed to keep the whole business secret from Rosenberg next door. No other modern art patron could come close to such an arrangement: A man thousands of miles from Paris had been given the chance to outfox one of the city's most powerful dealers literally in his own backyard.

Yet Quinn was in no hurry. Even after sending him Man Ray's photographs, Roché had gotten no reply. Meanwhile, Rosenberg had started coming to Picasso's studio again—paradoxically because *he* now wanted new paintings to show Quinn. "Ros. has come and asked Pic. to deliver his pictures," Roché wrote to Quinn. "Pic. has refused, waiting for your decision, of course without telling Ros." But Picasso could not hold out on his dealer forever.[22] Finally, in the second week of March, Roché sent a cable to Quinn: "PICASSO EXPECTING DECISION."[23]

In New York, Quinn had been distracted, as usual, by a variety of other pressing matters. He and Foster had been deeply preoccupied with the final illness and death of their close friend John Butler Yeats, having stood in for his family, including W. B., who were all in Ireland. (Foster would eventually arrange to bury him in her own family plot in upstate New York.) At the same time, Quinn was immersed again in law work. And even as he dallied on the new Picassos, he regretted that he had missed the second auction of Kahnweiler's seized inventory. "I should have commissioned you to use your discretion in buying some important Derains and Braques and Picassos," he told Roché in late February.[24] But now that he had this extraordinary new chance with Picasso, he hesitated. A few hours after he received Roché's cable, he sent his terse and disappointing answer: "HAVE DECIDED NOT TO PURCHASE LARGE PAINTING THREE FIGURES OR ABSTRACT PAINTING OR STILL LIFE."[25]

For all his efforts, then, Roché had come up empty. Quinn wasn't ready to take any of the paintings Picasso had personally selected for him, no matter how important they were. In fact, a few days earlier, Quinn had sent Roché a letter—it hadn't yet reached Paris—in which he explained that he was reluctant to buy Cubist works from black-and-white photographs, even if it was Man Ray who took them. He also was concerned about the dimensions of the two large paintings. "I haven't the room, simply haven't physically the room, for another painting of that kind," he wrote. He asked Roché to offer Picasso a 30,000-franc advance on an undefined future purchase. "I am sure there will be no shadow of difference between Picasso and me."[26]

Picasso was puzzled—and intrigued. According to his own Spanish sense of honor, he refused the money, but he seemed to gain a new respect for his singular patron. Over the next few weeks, he showed Roché dozens of older paintings he had kept aside in his studio, including a rare early self-portrait he had never offered to anyone, and other Blue period works. "He intends to keep them until I hear from you," Roché wrote Quinn.[27] Soon they were engaged in elaborate negotiations for a whole series of works; in May, Roché wrote in his diary that he was "swimming in business" between Picasso and Quinn.[28] At one point, Picasso offered to send *Three Musicians* to New York, without any com-

mitment to buy, just so that Quinn could see it. "Picasso and his wife like you much," Roché reported.[29]

Remarkably, amid this growing entente with Picasso, Quinn continued to court Rosenberg as well. No matter how deep his loyalty to the artist, he was determined to have access to the best paintings, and by early April, he learned from Roché that Rosenberg was starting to buy again. (Characteristically, Roché was in bed with everyone, often going straight from Picasso's studio to Rosenberg's gallery, where the dealer would show him all his latest acquisitions.) By the end of the spring, Quinn was pursuing separate groups of works from both Picasso and Rosenberg. From Picasso direct, he bought *Three Women at the Spring* after all, together with a number of early paintings from Picasso's personal collection, even as he took other important Fontainebleau paintings and an earlier Harlequin from Rosenberg. While the rest of the world balked, Quinn was building a virtual monopoly over Picasso's work, having effectively established first right of refusal with both the artist and his dealer.

In fact, despite Quinn's many distractions, the Picassos were only one part of his accelerating activity in Paris. From Brancusi he took yet another batch of sculptures—the Romanian being one of the very few artists for whom almost everything he created seemed to satisfy Quinn's criteria of greatness. There were new Derains and Braques; and he was in constant touch, often through Roché, with most of the artists he had met the previous summer. Among his various dealings, Félix Fénéon was guarding a pair of particularly choice Seurats for him; Alphonse Kann, the great French connoisseur whose art-filled villa he had visited with Roché and Foster, was preparing to relinquish to him one of his best Dufys. Quinn also began a new push to acquire major works by Henri Rousseau, managing to acquire three of his major paintings over the course of a few months. And he continued to acquire an extraordinarily heterodox range of indigenous sculptures from many remote regions, which, following the pioneering shows of Alfred Steiglitz and Robert Coady, he had come to regard as a counterpart to what the modernists were doing. By one later assessment, Quinn would acquire as much first-rate contemporary art in 1922 as "any private individual in the world."[30]

As Quinn considered his collection against the weight of history, he also began to form more programmatic ideas about the great artists of his time. Outlining his personal pantheon to friends, he placed at the very top Picasso, Matisse, Derain, and Braque; just beneath them was a second tier that included Georges Rouault, André Dunoyer de Segonzac, and Raoul Dufy, with Constantin Brancusi, as a sculptor, in a category of his own. These in turn were followed by a broader group of exceptional modernists, including the Cubists Roger de La Fresnaye, Juan Gris, Jean Metzinger, and Jacques Villon, and the Cubist-influenced Marie Laurencin. Supporting them were a select group of modernist progenitors, led by Cézanne and Seurat and followed by Gauguin and Van Gogh.[31] Perhaps most strikingly, next to Cézanne and Seurat, he also placed Rousseau, a figure who seemed to stand apart, yet whose importance for Quinn seemed to equal or surpass any of the others'. As he put it to one friend, Rousseau was "a naive mind, a pure mind, an artistic saint, a man who has had an enormous influence upon the great living artists."[32]

By twenty-first-century standards, Quinn's exceedingly narrow view of modern genius—let alone the hubris of trying to rank artists in order of importance—seems distinctly old-fashioned. Among other things, his German hatred left him blind to the innovations of Paul Klee, Oskar Kokoschka, Wassily Kandinsky, and many other German and Austrian modernists whom Roché admired and whose innovations would later be widely acclaimed. But at a time when no such hierarchy existed, indeed, when there was hardly any systematic study of modern art at all, his choices were remarkably prescient. He was defining the core of what he took to be an enduring movement, and for the most part, he was right. And he was also acting on it, by giving chase to single exceptional works by as many of these leading figures as his income would allow.

By the spring of 1922, Quinn, though he was an ocean away, had acquired an almost magical presence in Paris. In February, while Picasso was reserving his best new paintings for him, James Joyce, from a different corner of the city, was cabling him, with laconic gratitude: "ULYSSES

PUBLISHED. THANKS."[33] If Quinn needed an opinion about a late Cézanne he was considering at Vollard's, Derain was glad to oblige. When he required a large-format photograph of a Picasso or Braque that no one had seen yet, Man Ray was ready to cross Paris to take it.[34] So eager was Brancusi for Quinn's reactions to his latest works that he would study his letters line by line; one day that summer, Roché found the sculptor in his studio holding the lawyer's latest dispatch—"scratching his head, using his dictionary, jumping now then from marble blocks to wood blocks, hot, excited, and asking me to read it once with him so that he be quite clear about it."[35] As they came to know Quinn and his exacting taste, his artist friends also gave considerable thought to their works in New York: Brancusi designed special bases for him to use with his sculptures, and on one occasion, Picasso spent hours at an antiquarian market searching for the perfect frame for a painting he was sending him.[36]

In the international art world, the legend of Quinn's collection continued to grow. One day, Kojiro Matsukata, Japan's leading connoisseur of French art, turned up on his doorstep; on another, Emil Gauguin, the painter's son, came to offer him Gauguins that had remained in the painter's possession. (Quinn decided his own Gauguins were better.) Among a small but growing number of young acolytes, an invitation to see Quinn's Picassos was not to be missed. "From a most unlikely looking corner were drawn a dozen paintings that simply swept me off my feet," Sheldon Cheney, an aspiring critic who went on to write one of the standard primers on modern art, wrote, about an evening at Quinn's. "Picasso of the Harlequins, Picasso of the 'blue period,' Picasso the Cubist (and all Cubism rose in my estimation), Picasso painting great structural women almost without color."[37]

Despite vows to the contrary, Quinn also continued to provide the backbone of almost every modern art exhibition in New York. That winter, when the Hungarian dealer Joseph Brummer wanted to stage a pair of ambitious shows devoted to the work of Derain and Vlaminck, he relied on two sources: Kahnweiler in Paris and Quinn in New York. (Through Quinn, Kahnweiler was belatedly discovering the potential of the United States, or at least of one New York collector.) Later that spring, when a new space called the Sculptors' Gallery put on a show of

"Contemporary French Art," arranged by Arthur Davies, it might have been better described as a raid on Quinn's apartment: Along with a selection of his Braques, Picassos, Derains, and Matisses, the show featured twenty-three of his Brancusis, including the celebrated *Golden Bird,* which Pound had already written about in *The Little Review* and on which Mina Loy would soon publish a poem in *The Dial.* Not in France itself could such a comprehensive show be found, and this was just a sampling of what Quinn had. Even Rosenberg was now borrowing from him to give his Paris exhibitions more luster.

For Roché, Quinn's paintings had begun to provide the sense of permanence that he found lacking in his own life. That spring and summer, even as he and Quinn were conquering the French art world, Roché had been abandoned by Helen, who had aborted his child and remarried Franz, barely a year after their divorce; Roché was no closer than before to finding an anchor for his restless existence. Yet as he pursued with Quinn what he had begun referring to as "our collection," he seemed to be building something of lasting value. Surely, the "museum rank" paintings and sculptures they were amassing at Central Park West would one day find their way into a prominent American institution. When Quinn hesitated about the size of some of the paintings Picasso offered him, Roché reassured him that someday, when Picasso's "name is quite made, museums may want them."[38]

And yet it was unclear if Quinn would be able to wait that long. By June, he was in precarious health again, and ruled out a repeat summer in Paris. By now, it was four and a half years since his cancer operation and if he was in denial, Jeanne knew that he was on an increasingly limited clock. But while he talked vaguely to Roché about retiring to a "little country place near Paris" where he could install the best of what he called his "French things," he also couldn't quite imagine stopping.[39] Even that summer, when his doctor advised two months' rest, he had difficulty getting away for a short vacation with Jeanne in the Adirondacks, near the mountains where she grew up. During their stay, he gave up smoking, and came back more rested than he felt in years. But soon he was back in the fray, clenched and determined, on Nassau Street. He would have to double down in the time that remained.

16

DINNER AT QUINN'S

Rosenberg arrived in New York City in November 1923, a year and a half after Quinn and Roché began buying directly from Picasso. It was the dealer's first transatlantic crossing, and he was bringing with him nearly two dozen recent, large-format Picasso paintings. At last, he was carrying out his long-held ambition to launch the artist in the United States. The effort would begin with a three-week show at the Wildenstein Gallery in New York; then Rosenberg would take the paintings to Chicago, where he was going to show them at the Art Institute under the auspices of the Arts Club of Chicago. He aimed to stir up interest in the two metropolises that he, and many others after him, would see as holding the key to the coveted American art market.

Even now, though, Rosenberg was operating on blind confidence. Though the U.S. economy was far stronger than it had been in 1921, there were still few indications that interest in twentieth-century modern art was growing. Nor was Rosenberg particularly prepared for what he was getting into. For all of his prominence in Paris, he was, like Picasso, largely unknown in the United States, and while he had a firm grasp on the subtleties of Parisian upper-bourgeois mores, he had hardly any knowledge of American culture and American social dynamics. In New York, he found it difficult even to get appointments with promi-

nent collectors. Meanwhile, because of financial upheavals in France, the French franc was in free fall, threatening to make his already costly trip ruinously expensive. So dejected was he a few days after his arrival that he wrote to Picasso that he was "seized with homesickness" and took consolation in looking at Picasso's paintings and "imagining myself back on rue La Boétie."[1]

Still, the dealer counted on several advantages for his show. With the Wildenstein Gallery, he would be able to reach an established New York audience that was apart from the fledgling avant-garde scene. At the same time, he had decided to shun Cubism entirely, shaping the show around a series of large neoclassical paintings of saltimbanques, Harlequins, and other stock characters from Picasso's repertoire, works of almost calculated beauty and polish that would, he felt, be readily accommodated in any Manhattan townhouse. Above all, he had his friendship with John Quinn, whom he knew had had a central part in the American contemporary art scene for years. Surely, with Quinn's support, the show would be a success.

At the time of Rosenberg's arrival, Quinn was even more irascible than usual. Over the summer, he'd had a terrible, inexplicable falling-out with Joseph Conrad, his friend of many years, who had snubbed him during a visit to the United States. The matter had so upset him that he had resolved to auction off all of his cherished Conrad manuscripts, breaking a vow never to sell what he collected. ("Mr. Quinn has never been the same again," Jeanne Foster told a mutual friend, the writer Ford Madox Ford, in Paris, warning him never to speak of Conrad.[2]) Meanwhile, Quinn's legal work was taking him on multiple, harried errands to Washington and Albany and he was by now deeply unwell. He had lost weight during the fall, and could only tolerate a highly restricted diet.

Despite his general fatigue and physical discomfort, he had also just completed another strenuous voyage to Europe with Foster and Roché— his first since their trip to Paris and Fontainebleau two summers earlier. In the end, it had been a remarkable success, yielding, among other

works, another important haul of Picassos, a huge Matisse still life, another major Rousseau, and a striking Cézanne portrait of his father, which Foster had picked out at Bernheim-Jeune on an afternoon when Quinn was too done-in to venture to the galleries. They had even managed to introduce Erik Satie and Constantin Brancusi to the game of golf in the Bois de Boulogne. (Satie, in his bowler hat, jacket, and umbrella, watched and told jokes while Brancusi, with determined precision, hit the ball as hard as he could. Quinn later bought Brancusi a set of clubs.[3]) But the trip had left him wasted and depleted, and Foster had once again stayed on in Paris, leaving him alone in New York.

Nonetheless, Quinn agreed to help Rosenberg in various ways. With the collapse of the French franc, he offered to pay him in dollars for his latest purchases—a huge windfall for the financially strapped dealer. He also shared his legal expertise, incorporating Rosenberg's gallery as a New York company to facilitate American sales and avoid onerous taxation. As the show was getting under way, Rosenberg was effusive in thanking him, telling Quinn in his idiosyncratic English "how I appreciate your way of doing the things."[4] But Rosenberg ignored Quinn's advice about showing Picasso in New York. In their earlier conversations, Quinn had urged Rosenberg to present a "representative" selection of Picasso's work in different styles, and to include less expensive drawings, which he thought would have a better chance with an uninitiated public. He also warned him not to use the Wildenstein Gallery, which was primarily known for Old Masters. "They have clients who are not educated up to Picasso," Quinn told him. With painful speed, Rosenberg discovered how right Quinn had been.[5]

The Wildenstein Gallery was located in a five-story mansion on a part of Fifth Avenue known as Vanderbilt Row. The neighborhood was the very epicenter of the Gilded Age aristocracy, with much of the surrounding property owned by Astors, Vanderbilts, and Rockefellers. For anyone selling Rembrandts and Holbeins, the location couldn't be better. For Picassos, it was another story. Despite Rosenberg's efforts to tame his artist into a handsome matinee idol, Wildenstein's wealthy clientele stayed away. "Where in Paris one would be thronged with visitors," Rosenberg wrote Picasso, "very few people have come—in a city

of 6 million inhabitants." Meanwhile, the small coterie of New Yorkers who already knew about Picasso's work—the city's "Montparnassians" as the dealer put it—were baffled by the bland presentation. "They think that someone has changed *their* Picasso," he wrote, with seeming lack of self-awareness.[6]

As the exhibition continued, Rosenberg became more and more worried. He also realized he needed Quinn. If only he could tap into Quinn's modernist circle, he might stir interest in the show. Soon he found the opening he needed. He had long been determined to see Quinn's storied art collection, and given all the business they had done together, Quinn would surely be glad to oblige him. Such a meeting would provide an opportunity for Rosenberg to reengage him in his American Picasso venture. Contacting the lawyer again, he asked for a tour. "Rosenberg was very, very anxious to come see my things," Quinn wrote Roché. At first, pleading fatigue and overwork, Quinn delayed, but as the exhibition reached its final days, he saw he could wait no longer, and, at the last minute, decided to host a small dinner for Rosenberg and a few other friends at his apartment.

On a wet Wednesday evening in early December, Quinn brought together a characteristically lively group: Mitchell Kennerley, the flamboyant British American publisher, whose books Quinn had defended against obscenity charges in court; Dr. A.S.W. Rosenbach, a bibliophile and polymath who was one of the leading rare book sellers in the world; Muriel Ciolkowska, a brilliant poet and journalist who had lived in France for years and was close to James Joyce; and "El Greggo"— Frederick James Gregg—who had been Quinn's ally in the modernist cause going back to the days of the Armory Show. Rounding out the company were the two prominent art dealers: Felix Wildenstein, the émigré Frenchman who ran the New York branch of the Wildenstein Gallery, and Rosenberg himself.

Lubricated by two quarts of pre-Prohibition champagne, the dinner got off to a racing start. Rosenbach, who traveled to Europe constantly and reveled in Shermanesque marches through the London and Paris book auctions, was an exceptional raconteur. Madame Ciolkowska, who had arrived with him, more than held her own in the otherwise all-male

company. In between, while Quinn furnished acerbic comments about French politics and Irish writers, Gregg contributed his devilish wit and Kennerley his off-color humor. The art dealers seemed to be enjoying themselves too. Quinn had never met Wildenstein, who was the cousin of Rosenberg's Paris colleague Georges Wildenstein, but he was affable and worldly and mixed easily with the others. For his part, Rosenberg, too, seemed pleased to find himself among the friends of the most important Picasso collector in the world.

In reality, though, Rosenberg was not at all at ease. While his English was proficient, he found it difficult to follow the rapid cross talk, and as the evening progressed, he grew more and more agitated. At first, as the guests flew from one topic to another, he kept trying to steer the talk to the art world. Then, addressing Quinn directly, he began to tell him about several paintings he had brought with him from Paris that he was storing at Wildenstein's. "Mr. Quinn," he said at one point, "won't you come in to see me so I can show you a wonderful portrait of Madame Cézanne?" A few minutes later, Rosenberg tried again. "Mr. Quinn, why don't you come in and let me show you a wonderful Lautrec?" This time, the lawyer was stony; he could not abide the "shop" talk at dinner. Still, Rosenberg would not let up. Misreading Quinn's pique as distraction, he was determined to get his attention. "Mr. Quinn," he interrupted again, how about "some lovely Braques." The other guests began to notice it as well: Rosenberg seemed fixated on his paintings and could talk of nothing else.[7]

In fact, the dealer was facing a looming crisis. The show at Wildenstein's had gone nowhere; his high-end strategy was proving to be a disaster. No one was buying his Picassos, and the dozens of American collectors whom he assumed would be ready to follow Quinn into modern art had not materialized. Even to Picasso, he could not hide his bitter disappointment. "Your exhibition is a great success," he wrote him. "And like all successes, we have sold absolutely nothing!"[8] He still needed to go to Chicago, where sales were even less likely, and with the collapsing French franc, he was hemorrhaging money. Now, as the guests finished eating and he waited for Quinn to begin showing his paintings, Rosenberg was nearly desperate. He felt that it might be his

last opportunity to stir Quinn into action. As with New York itself, however, he fatally misjudged his host.

Around 9:30, Quinn began his familiar ritual. Many of his best pictures were stored in two back bedrooms, and he brought out the ones he wanted to show them, one by one. This time, though, he chose with special care: He didn't want Rosenberg to see the paintings he'd acquired directly from Picasso, to preserve the possibility of future such arrangements; nor did he want Rosenberg to know about some of his recent purchases from other private sources in Paris. One of these was Seurat's spectacular final painting, *Circus,* which had not been on the market but which Quinn had managed to acquire from Seurat's protégé, Paul Signac, after a prolonged secret negotiation. Kennerley and Gregg knew about *Circus,* but Quinn had ordered them to keep their mouths shut, and during the entire evening it remained in a back room under a cover.

Even so, as Quinn brought out some of the Picassos he had acquired in earlier years and many other paintings, it seemed to put Rosenberg on edge. Finally, he turned to him and brought up what was really on his mind:

"Mr. Quinn, why doesn't Arthur B. Davies come to see my Picasso exhibition?" he asked. Quinn was surprised and annoyed to be put on the spot about his longtime New York friend. He said he had no idea about Davies. But Rosenberg pressed on.

"Why can't *you* bring him?"

"I don't *bring* Davies anyplace," Quinn snapped. "He either takes himself or he doesn't go."

Rosenberg was disconcerted; surely Quinn's friends would want to see Picasso's new work. A little while later, as Quinn showed them more of his paintings, the dealer started in again. He asked Quinn if he would bring Miss Bliss to see his show. By now, Quinn was seething.

"I don't *bring* Miss Bliss."

The mood of the evening soured as the other guests watched the painful confrontation play out. After their exchange, Rosenberg finally let the matter drop. For both men, though, it was an explosive turning point. Having failed with Quinn, Rosenberg left the dinner feeling that he could not crack the city's obscure social codes and that he would be

unable to turn his show around. In the elevator down from Quinn's apartment, he confided to Kennerley that he had sold almost nothing and that he was "disgusted with America."

But it was Quinn who went radioactive. Rosenberg had ignored his advice about the show and then, having limited himself to a sterile group of living-room-ready Harlequins, priced the work far too high. Nevertheless, Quinn had incorporated his gallery, paid him handsomely in dollars, and, despite his vow not to entertain, invited him to dine with his friends and see his collection. Now, as Quinn's guest, Rosenberg was pressuring Quinn to rescue his show? If the Picasso venture was causing Rosenberg grief, it was his affair. Quinn was through.

The next morning, in a hateful letter to Roché, Quinn gave an eviscerating account of the evening in which he suddenly devolved into the ugly, tribal mindset of his Irish American working-class youth. He began benignly enough, telling Roché how anxious he was to hear from Foster in Paris. "I have not had a single word from her by cable or letter," he wrote. He knew she was returning soon, but this time their separation had pierced him with uncharacteristic force. But then he went on to describe the dinner and how he had reluctantly arranged it for Rosenberg, identifying each of the guests, who he knew would be of interest to Roché. "Rosenbach is a very fine man and a very amusing man," he wrote. "So is Kennerley. . . . Wildenstein is a perfect gentleman. But Rosenberg showed himself to be a cheap little Jew."[9]

A cheap little Jew. Here was Quinn letting rip all the latent prejudice of his time. Quinn, the progress-minded, cosmopolitan friend of writers and artists, the champion of innovation, the internationalist who railed against American provincialism and the benighted worldview of his fellow Irish Americans, the fearless modernist who fought against obscenity laws, blasted the intolerance of the Catholic Church, and ridiculed the eugenicist thinking of the country's conservative art critics—at a dinner of highly cultivated Jews and gentiles in his own home, he had succumbed to the same rank cultural attitudes that he had spent so much of his career seemingly defying.

The current ran deep. Amid the cultural and racial angst of early 1920s America, Jews had become a primary target of crude stereotypes,

with anti-Jewish policies extending from the country's elite schools, which began to severely limit the number of Jewish students, to exclusionary real-estate covenants, to the resurgent Ku Klux Klan, many of whose chapters fomented anti-Semitism alongside their campaign of terror against African Americans. The New York bar itself, in which Quinn's professional career played out, was notoriously segregated, with corporate law largely dominated by large Protestant firms, and Jewish firms operating on a second tier. Meanwhile, the country had had an influx of Jewish immigrants from Eastern Europe who were culturally apart from their highly assimilated Western European counterparts of earlier decades. Since Quinn's arrival in New York at the turn of the century, more than a million and a half Jewish immigrants had settled in the city's five boroughs, fundamentally changing local demographics and helping fuel a new anti-immigrant alarmism among the elite.

To a man as worldly as Quinn, such attitudes should have been deplorable. Irish Americans were as prone to prejudice as any other group, and had a long tradition of denigrating "Hebrews" and others, even as they found themselves on the receiving end of WASP disdain. But Quinn had come very far from his provincial roots and could barely hide his antipathy for Catholic narrow-mindedness; he had also sought a life among artists, publishers, impresarios, and critics, who were often Jewish. He was one of Alfred Stieglitz's most important clients; an early patron of the sculptor Jacob Epstein; a literary sparring partner with Alfred Knopf. He had socialized for years with Otto Kahn, the chairman of the Metropolitan Opera, with whom he had plotted various cultural projects; and he was friendly with Joseph Stransky, the director of the Philharmonic, who lent paintings to the Met's 1921 post-Impressionist show. In Paris, Rosenberg was only one of several art dealers he had longstanding ties with, including the Bernheims and Kahnweiler; he had also cultivated Alphonse Kann, from the great banking family, whom he regarded as one of the most discerning art collectors in the world. A year before the dinner with Rosenberg, he had enthusiastically supported the work of Swiss critic Albert Dreyfus, who was writing a major book in German about Picasso. It would have been hard to find many gentiles in New York at the time who had as many Jewish friends as Quinn did.

And yet he never quite did escape, and he was capable in moments of indulging in some of the era's most ferocious racial tropes. To Roché he complained about the Jews—"which is another word for international finance"—derailing the economic reconstruction of Europe; to Irish friends and salty correspondents like Ezra Pound, he could be more blatant, decrying the "million Jews, who are mere walking appetites, seven or eight hundred thousand dagos, a couple of hundred thousand Slovaks, fifty or sixty thousand Croats, and seven or eight thousand Germans" who were allegedly overrunning New York.[10] It was a confounding flaw, and one that was shockingly pervasive among the first generation of modernists. For all their promise to transform language and reinvent painting, the new artists and writers were often as susceptible to intolerance as others. Eliot wrote anti-Semitic poems; in later years, Pound would be drawn down the road of Italian Fascism. Among French artists, there was a current of anti-Semitism going back to Degas and Renoir in the late nineteenth century; it would continue on with the Fauvist painter Vlaminck, who later supported the Vichy regime. One day in late 1919, Clive Bell, the Bloomsbury critic and modernist aesthete, happened to be in Rosenberg's Paris gallery when news arrived of Renoir's death. When Rosenberg reacted with considerable emotion, it sent Bell into a bigoted rant. "This black jew, with the smutty tears on his cheeks," Bell reported to his mistress, Mary Hutchinson.[11] Bell may have been unaware of Rosenberg's close friendship with Renoir during the artist's final years, but his words were particularly ironic in view of Renoir's own complicated history of Jewish patrons on the one hand and anti-Jewish prejudice on the other.

Following the dinner at Quinn's, Rosenberg carried on valiantly with his Picasso plans, setting out for Chicago by train a week later. By now, however, he had few hopes for his show, and even before he got there, he began tempering Picasso's expectations. In a letter to Picasso, he described this second stop primarily as an opportunity to "meet people" and introduce his art; sales would likely be out of the question. "I doubt very much it will have the same success as in New York," he wrote, straining to put a good face on what had already become an unmitigated failure.[12]

Rosenberg's assumptions were not wrong this time. There were no

sales at all, and by the time he left Chicago, he could barely hide his exasperation with American culture. "I'm impatient to see you again, to speak with you and exchange ideas," Rosenberg wrote Picasso shortly before his departure. "The people here are so stupid!" When the dealer finally embarked for Europe again, around the turn of the new year, he had almost nothing to show for his hugely expensive transatlantic venture. A full twelve years after Stieglitz had tried it, a group of Picassos that had been brought to New York for exhibition were once again returning to Paris unsold. Only this time, they were major paintings rather than drawings, and the stakes were considerably higher. Perhaps the United States was not suited for modern art after all. "For selling your art, 21 Boétie is the only place," he told Picasso, ominously. "The atmosphere of a new continent is not hospitable to new painting. It is better suited to the art of the past."[13]

17

THE LAST
BATTLE

On the first day of February 1924, Roché joined Hermann von Wedderkop, the editor of Germany's leading avant-garde magazine, for a lunch of langoustes at Jean Cocteau's apartment. Then, finding himself near rue La Boétie, Roché decided to go see Picasso. Among other things, he wanted to ask him about the illustrations he had long promised for the German edition of Roché's *Don Juan*. When Roché arrived, however, Picasso was distracted by something altogether more urgent. He had just seen a very large, unknown painting by Henri Rousseau that had been discovered in someone's basement. Picasso said it was the best picture Rousseau ever made. He also said it made him think of John Quinn.[1]

For Roché, this was tantalizing news. For nearly four years—almost since he and Quinn had begun their collaboration—Quinn had been hunting for an exceptional Rousseau. He was fascinated by the painter's naïf portraits and pure, enigmatic jungle pictures, an attraction that was heightened by Rousseau's enormous influence on Picasso and his circle, who had revered him at the end of his life. By now, Quinn had managed to acquire several important Rousseau paintings, but the great, definitive painting he sought continued to elude them. Roché had consulted dealers, followed private leads, and obtained access to paintings that

were not officially for sale, but nothing he found had quite satisfied Quinn. He needed to see Picasso's painting right away.

The location of the mysterious work carried its own fascination. It was not being marketed by Rosenberg or one of the city's several Rousseau specialists. Instead, the painting had come into the hands of Kahnweiler, who continued to make up in connoisseurship what he could not in capital. And he had chosen to show it to Picasso before anyone else. Ever since his return to Paris after the war, Kahnweiler had persistently pursued his friendship with Picasso. His gallery was nearby, and Picasso liked to drop in and talk to him. Already the previous summer, Picasso had agreed to make him a series of new lithographs, several of which Quinn had acquired from Kahnweiler during his second trip to Paris.[2] Kahnweiler also knew Picasso's love for Rousseau, and giving him a peek at such an extraordinary painting was another way to signal his continued loyalty. For Picasso, the overture had come at an opportune moment. Just weeks earlier, Rosenberg had returned from his disastrous trip to New York and Chicago, and Picasso was furious that none of his paintings—none of the big neoclassical Harlequins that Rosenberg had demanded—had sold. Once again he had come up empty in the United States. He laid much of the blame on the dealer, telling friends that Rosenberg's high prices had "hurt him very much."[3] If he was not quite ready to give up on Rosenberg, he nevertheless took a mischievous glee in sending Quinn—Rosenberg's most important American client—to Kahnweiler. As Roché later told Quinn, Picasso was "flirting" with Kahnweiler again.[4]

Roché didn't need persuading. Kahnweiler's gallery, on rue d'Astorg, was less than five minutes from Picasso's apartment, and as soon as they were done talking, he raced over. The painting was still in the gallery's cellar storeroom and Kahnweiler took him downstairs to see it. At first it didn't look promising; the canvas was rolled up, and there were still cobwebs on it from years in storage.[5] As the dealer carefully unrolled it, however, Roché slowly began to absorb what he was seeing. A sheer, empty desert; a distant range of mountains; the night sky. A woman asleep; an enormous lion. The scene was inexplicably overpowering; it almost seemed to give off heat. Looking at it, Roché was seized with what he later described as "a bolt of love."[6]

As he came to his senses, Roché felt certain that Picasso was right: The painting had to go to Quinn. He also thought that the painting was dynamite. As soon as Kahnweiler cleaned it and displayed it upstairs in the gallery, all of Paris would be talking about it. And the price Kahnweiler was asking seemed moderate: 175,000 francs, or about $9,000. Roché guessed that it could easily sell for 200,000 francs or more. What could he do? Nine thousand dollars was still a lot by Quinn's standards, but it was not beyond his range. Roché also knew that Kahnweiler liked and respected Quinn from his visits to Paris. Using all of his persuasive arts, Roché pleaded—*insisted*—that Kahnweiler send Quinn a photograph before showing the painting to anyone else. He impressed on Kahnweiler that as soon as Quinn saw the photograph, he would surely take out an option—a nonrefundable payment to reserve a work for a fixed period of time. At length, Kahnweiler seemed to agree to the arrangement, though until Quinn purchased the option Roché had only the dealer's word.

That night, Roché couldn't stop thinking about the painting. When he got up, he immediately wrote to Quinn. "I have seen yesterday a Rousseau which has quite upset me," he began. "Kahnweiler has just received it. Picasso saw it there and told me to go at once, thinking of you." He said he couldn't describe it, but then tried anyway, writing and crossing out words. "The woman, lying at the foreground, she is dreaming of love, her face is 'inouï,' the lion is probably going to eat her, but perhaps he will walk away." The colors, he wrote, were equal to the composition: "They are a poem strange simple." He told Quinn he was sending a photograph as soon as he could get it and warned him, "If it is exhibited, it is sold." He also tried to convey the strength of his feelings. "I risk all my worth and all your confidence to back this picture," he wrote.[7]

Kahnweiler was glad to entertain interest from Quinn, particularly on Picasso's recommendation. But they would have to act quickly. For the time being, the painting was not yet ready to be displayed, but Kahnweiler recognized that it was a work of unusual interest and did not want to wait. For his part, Roché knew that the letter and photograph would take a week or more to reach New York, and his initial cables to Quinn had met with silence. A day went by, then another. Ratcheting up

the pressure, Kahnweiler told Roché that Quinn would need to buy a 10,000-franc option—about $500—to reserve the painting. Roché cabled New York again, this time referring to himself in the third person for emphasis: "PICASSO SAYS MOST WONDERFUL ROUSSEAU . . . ROCHE NEVER SAW MORE CONVINCING PICTURE."[8]

Still, no reply came from Quinn. Roché began to worry. Just as he feared, Kahnweiler decided to hang the painting, now cleaned and framed, in his gallery and already it was attracting attention. Reporting the news to Quinn, Roché cabled that the painting was "CREATING UNANIMOUS SENSATION." He urged him to risk an option even before seeing the photograph. Once again, though, he heard nothing. "Cabling John every day," he wrote in his diary, "anxious hasn't answered."[9]

By now, a week had gone by since Roché first saw the painting, and Kahnweiler gave him an ultimatum: Quinn would need to buy the option by noon the next day or he would open the work to other parties. Somehow, Roché would have to get Quinn's attention. That afternoon, he decided to take Brancusi to see the painting; his opinion would matter. But the sculptor would not be hurried. Roché arrived at his studio at lunchtime and Brancusi wanted to grill some steaks. Then, when lunch was finished, Brancusi said he needed to go to the bank, where they dealt with some complications involving a check he had received in dollars— from Quinn. The afternoon was getting on, and Roché kept thinking of the painting. But Brancusi needed a new coat. They made their way to the Boulevard des Capucines and, with the money from Quinn's check, bought him a magnificent *pardessus* at Old England, known for its British tailoring. They were now near the Opéra, a thirty-minute walk from Kahnweiler's gallery. They would have to get there in time to see the painting and cable Quinn. Crossing the center of Paris again, they finally reached rue d'Astorg. They went inside, and Roché led Brancusi to the big painting. For several minutes, Brancusi looked at it. Then he told Roché: He was *touché au coeur*. He also agreed with Picasso about where it should end up. As soon as they left the gallery, Roché cabled Quinn: "BRANCUSI'S OWN WORDS: FASCINATED ORIGINALIST ROUSSEAU. SOMETHING FOR FRIEND QUINN."[10]

The next morning, hours before Kahnweiler's deadline, Quinn at

last broke his silence. For weeks, he had been nervous and withdrawn. When Jeanne Foster arrived from Paris in late December, he had met her at the dock, and she was startled by how much thinner he seemed. Since then she had been with him constantly, and he had determinedly kept up his work. But he had ceased almost all of his other activity and the wasting continued. He had a habit of taking her on a weekly Sunday walk on the Palisades, or in the hills around White Plains, sometimes with their friend Gregg. But Foster noticed that the walks were getting shorter.[11]

In his narrowing view, Quinn was less inclined to get excited by a painting. He also hadn't received Kahnweiler's photograph or Roché's letter describing the work; he had no idea, even, of the painting's subject. His answer was cantankerous and noncommittal: "CANNOT DECIDE UNTIL SEE PHOTOGRAPHS. UNWILLING PAY TEN THOUSAND OPTION. TOO HIGH."

Still, he had never seen Roché so exercised about a work of art. Quinn asked him to make a counteroffer on the option, if only to prevent the dealer from selling the painting to someone else: "WOULD BE WILLING TO PAY FOUR THOUSAND TWO HUNDRED FIFTY FRANCS OPTION." Then, in a second, "confidential" cable to Roché, he wrote that he had "NO INTENTION" of making such a large purchase and that it would "STRAIN RESOURCES" to do so, though he "MIGHT POSSIBLY MAKE EXCEPTION THIS CASE." This was not at all reassuring, but at least not a definitive no. Roché relayed the counteroffer to Kahnweiler and awaited his answer.[12]

The next day, Roché was invited to lunch at the home of Jacques Doucet, the fashion magnate and avant-garde art patron. Now in his early seventies, Doucet lived in a townhouse filled with works by Picasso, Derain, Modigliani, and other contemporary artists, as well as thousands of modern literary manuscripts and printed books, and he was one of the few Parisian aesthetes whose advanced taste in art and prose rivaled Quinn's. He was also a great Rousseau admirer, having earlier beaten out Quinn for the *Charmeuse de Serpents,* one of the painter's most acclaimed works. Roché wondered what he would make of the Kahnweiler painting. It was a delicate matter. Doucet's wealth far exceeded Quinn's, and once he saw the painting, he might well want to buy it himself. But Roché was already deep in negotiations with Kahn-

weiler, and though they had not yet agreed on Quinn's option, the dealer, as a point of honor, would probably not go behind his back. Moreover, since Doucet had acquired the *Charmeuse,* it seemed unlikely that he would pursue a second big Rousseau. In balance, Roché decided that the chance to get Doucet's opinion was too good to pass up. He told Doucet about the Kahnweiler painting, and straight after lunch they went to see it.

At the gallery, even Roché was shaken by Doucet's response. The old designer was utterly transported, confessing that he found the painting "even more important and *surprenant*"—astonishing—than his *Charmeuse.*[13] Hurriedly, Roché cabled Quinn again: The owner of the greatest known Rousseau felt that the new painting was better. That same afternoon, Kahnweiler told Roché he was willing to accept the 4,250-franc option until the photograph reached New York. Everything now depended on Quinn. Each day, as Roché awaited a response from New York, he went to Kahnweiler's to have another look at the painting. On the tenth day, fearful that Kahnweiler's photograph might have been held up in the mail somewhere, Roché asked Man Ray to come take a new set of pictures of the painting. Then he sent Quinn another letter. "I hope and believe it will be, if you take it, one of your greatest joys as a collector," he wrote.[14]

On February 15, two weeks after Picasso had alerted Roché about the painting, Kahnweiler's photograph finally arrived at Quinn's apartment. As he examined it, Quinn was baffled. The black-and-white image was not particularly convincing; whatever power the composition had, it certainly wasn't evident here. He had spent too much on art the previous fall, and was not yet ready for another large purchase. His inclination was not to take it. Before he could get off a message to Roché, however, another cable arrived from Paris.

By mid-February, news of the huge, unknown Rousseau was rapidly spreading around the French art world. Dozens of people were coming to Kahnweiler's gallery each day to see it and a group of avid supporters had begun raising funds to donate it to the Louvre. For all of Roché's efforts, it was starting to look as if this one would slip away. But there was still one connoisseur he hadn't consulted, a man whose opinion might carry more weight than anyone else's.

Antoine Villard was a well-off landscape painter who had developed a passion bordering on obsession for Rousseau. Over time, he had amassed a dozen of his paintings, amounting to one of the largest and most distinguished collections anywhere. Roché had met Villard the previous spring, reporting to Quinn that he was "crazy about Rousseau, loves him, cannot stop speaking about him and his works."[15] Eventually, Roché had persuaded him to let Man Ray photograph all of his Rousseaus for Quinn. What would Villard, a man who lived and breathed Rousseau's work, think of Kahnweiler's painting? Roché needed his judgment immediately, and in the end, managed to convince him to see it that same day. In the new cable to Quinn—the one that arrived while Quinn was examining the photograph—he recorded Villard's response: "VILLARD PROCLAIMS THIS PICTURE GREATEST MIRACLE. IS DESPAIRING NOT POSSESSING IT."[16]

Quinn read it and the other cables again. He read Roché's letter. He looked at the photograph. Uncharacteristically, he didn't know what to do. He called Jeanne Foster and asked her to come downtown for a walk. They went down Broadway, a few blocks from Quinn's Nassau Street office. After they passed Trinity Church, it started to rain; they sought shelter under the el. As they stood there in the downpour, Quinn brought up the painting and told her about the cables from Paris. He knew he was not a well man and asked her to decide. She looked at him, at his frail frame and tired face. "Buy it," she said.[17]

Quinn was happy. Somehow, she had understood. They walked back, and when he returned to the office, he cabled Roché. Then he called his bank and ordered 175,000 francs to be sent to Kahnweiler the next morning. Not only had Quinn not seen the painting; neither he nor Roché knew its title. Six weeks after the sale, they learned from Kahnweiler that Rousseau had called it *La Bohémienne endormie—The Sleeping Gypsy*—but even Kahnweiler knew nothing of the painting's history since the time of its creation more than a quarter century earlier.[18]

In Paris, news of Quinn's coup spread quickly. Congratulations poured in from Picasso, Brancusi, and his other friends; Roché was ecstatic. Kahnweiler himself wrote Quinn that he was glad it had "gone in the collection of somebody who is able to appreciate it entirely."[19] Improbably, one of the most important paintings of the entire modern era

was not going to stay in Paris, where there was a legion of modern artists who admired it, numerous connoisseurs who coveted it, and even a world museum that might have received it. Instead, it was destined for an apartment thousands of miles away, in a city that was still deeply ambivalent about modern art. That Quinn was able to pull this off, for a moderate price, without even seeing the painting, was an extraordinary statement of the influence of one American and his ambition.

The morning after the painting's arrival, Quinn, in a letter to Roché, called it a "glorious victory." With the Rousseau, his collection now formed a remarkable, gemlike unity: the best Seurat; the best Rousseau; standout paintings by Cézanne, Gauguin, and Van Gogh; defining works by Picasso in almost every one of his major phases; a definitive series of Matisses; a sweep of Brancusis; singular works by Derain, Braque, Vlaminck, Duchamp, and many others. It was hard, though, not to see the irony. While the apparition of *The Sleeping Gypsy* in Quinn's living room left all of Paris seemingly in awe, the event passed largely unnoticed in New York. In fragile health, Quinn had kept the unveiling a private affair, inviting just a few of his intimates for the small celebratory dinner. And though he didn't know it yet, *The Sleeping Gypsy* would also be the last battle he and Roché fought.

In the weeks after the Rousseau arrived, Quinn struggled to carry on. By now he found it uncomfortable to sit in any one position for long, yet he still crawled to the office for a number of hours each day. Most evenings, Jeanne Foster came over to sit with him and talk, and, to the extent he could, he followed events in Paris and New York. In late April, a friend wrote to him about yet another Italian Renaissance show that had gone up at the Duveen Gallery. It sent him into a rage. "The god damned benighted, provincial country has not yet got beyond Rembrandt and the early Italians," he snapped. "These things belong in Italy. They don't belong in New York in the twentieth century."[20]

A few weeks later, Quinn received a belated diagnosis: advanced liver cancer. At the end of May, he stopped going to the office and canceled all plans for the summer. Foster, returning to his apartment after a

visit with her family upstate, was shocked to find him reduced almost to a skeleton. She did not leave his side from then on. Retiring mostly to his bedroom, he surrounded himself with the paintings he admired most. As was his usual practice, he didn't bother to hang *The Sleeping Gypsy*. Instead, he simply propped the enormous painting on a table next to his bed, between two east-facing windows, where he could watch it gradually fill with light from the glow of the sun rising over Central Park.[21]

In late June, in one of his last letters to anyone, Quinn dictated a long letter to Roché. "This letter is for you personally," he began. "I have cirrhosis of the liver." He said that he didn't think his case was as dire as his doctors thought, but that he had been put on morphine. He thanked Roché for giving the extra copies of Man Ray's photo of *The Sleeping Gypsy* he had ordered to a number of friends in Europe—Picasso, Brancusi, Erik Satie, Robert Delaunay, Wilhelm Uhde, Antoine Villard, Jacques Doucet. Quinn made one final dig at Rosenberg, for his "trickiness" in up-pricing Picasso's work. Then he said that, given his situation, he wouldn't be able to buy any more art for six months to a year. ("Of course," he added, "my refusal to buy paintings does not include the Braque if it comes off well and is a real masterpiece.") Finally, he told Roché not to worry about him and to keep everything he had said in confidence. "I don't want my condition to be told to anybody, not even Brancusi."[22] As a kind of defiant farewell, he wrote that he hoped that he and Roché would someday "have many long tramps and games yet and play out in the open."

As Quinn's strength dwindled, Foster was distraught. Their time had been cruelly short. And they had been truly free only in Europe, during those two trips. After their first sojourn in Paris in 1921, she had stayed behind, writing to him wistfully about the "lost years" of his life, his inability to escape his driven New York existence. She had also promised him she would never "give the 'wolves' a chance to tear your life work down."[23] But now, confronted with losing him, she began to wonder about that life work—all his plans and dreams, the projects that had pulled him, searching forward, in the few years they had been together. The wolves were still there.

He had never said much about what he wanted to do with all of his

art, and they never discussed it. He also had few living relatives, and she herself had no formal legal connection to him. But one day, as he drifted in and out of sleep, he turned to her and said that if anything happened to him, it would be terrible if his paintings were sold. Two weeks later he was dead.

John Quinn, 1921.

The International Exhibition of Modern Art, known as the Armory Show, at the 69th Regiment Armory, New York, February–March 1913. (Private collection / Bridgeman Images.)

Picasso and Fernande Olivier with their dogs Féo and Frika, Montmartre, Paris, c. 1906. (Gelatin silver print, 13 x 9.2 cm. Musée national Picasso, Paris.)

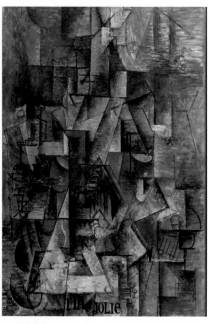

Picasso, *Ma Jolie* (*Woman with a Guitar*), Paris, 1911–12. (Oil on canvas, 100 x 64.5 cm. Acquired in 1945 through the Lillie P. Bliss Bequest, The Museum of Modern Art, New York.)

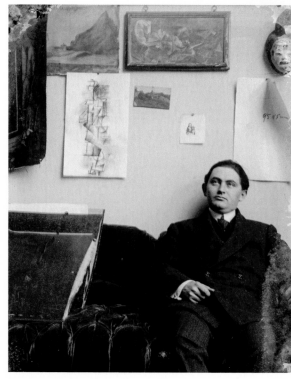

Picasso, photograph of Daniel-Henry Kahnweiler in Picasso's studio with *Standing Female Nude* (left) and other works, 11 Boulevard de Clichy, Paris, autumn 1910. (Glass negative, 12 x 9 cm. Musée national Picasso, Paris.)

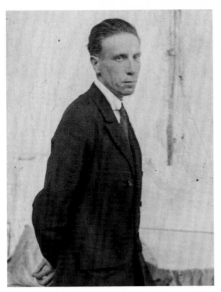

Constantin Brancusi, photograph of
Henri-Pierre Roché in Brancusi's studio,
8 Impasse Ronsin, Paris, c. 1925.
(Harry Ransom Center,
The University of Texas at Austin.)

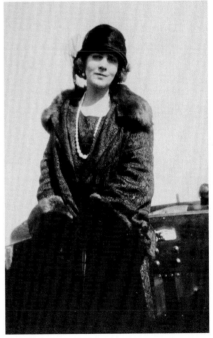

Henri-Pierre Roché, photograph of
Jeanne Robert Foster in Venice,
October 1923.
(Harry Ransom Center,
The University of Texas at Austin.)

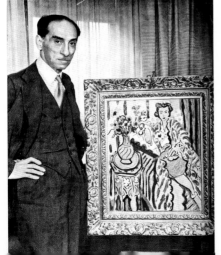

Paul Rosenberg with Henri Matisse's
1937 painting *Yellow Odalisque,* c. 1941.
(Courtesy of the Rosenberg family.)

Henri-Pierre Roché, photograph of Picasso, Jeanne Robert Foster, Olga Picasso, and John Quinn, Fontainebleau, July 9, 1921. (Harry Ransom Center, The University of Texas at Austin.)

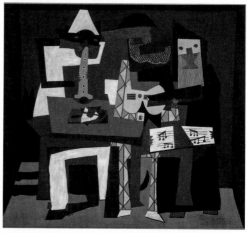

Picasso, *Three Musicians*, Fontainebleau, summer 1921. (Oil on canvas, 200.7 x 222.9 cm. Acquired in 1949 through the Mrs. Simon Guggenheim Fund, The Museum of Modern Art, New York.)

Picasso with Paul and Marguerite Rosenberg and their children, Alexandre and Micheline, with Alexandre's dog Diola and Picasso's dog Noisette, Boisgeloup, 1931. (Archives Olga Ruiz-Picasso, Fundación Almine y Bernard Ruiz-Picasso para el Arte, Madrid.)

Philip Johnson and Alfred H. Barr, Jr.,
on Lake Maggiore, spring 1933.
(The Museum of Modern Art,
New York.)

Peter A. Juley, photograph of
Margaret Scolari Barr seated at
a table by American designer
Donald Deskey in the Barr apartment,
2 Beekman Place, c. 1934.
(Gelatin silver print, 22.9 x 16.5 cm.
The Museum of Modern Art, New York.)

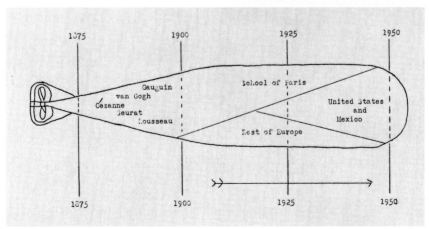

Alfred H. Barr, Jr.'s *Torpedo* diagram of an ideal museum collection of modern art in his
"Report on the Permanent Collection," known as the "Torpedo Report," 1933.
(The Museum of Modern Art, New York.)

Olga Picasso, Villa Belle Rose, Juan-les-Pins, summer 1925. (Archives Olga Ruiz-Picasso, Fundación Almine y Bernard Ruiz-Picasso para el Arte, Madrid.)

Marie-Thérèse Walter, Juan-les-Pins, July 27, 1932. (12.7 x 8.9 cm. Private collection.)

Picasso, photograph of Dora Maar in profile, Boisgeloup, March 1936. (Gelatin silver print, 24.1 x 18.3 cm. Musée national Picasso, Paris.)

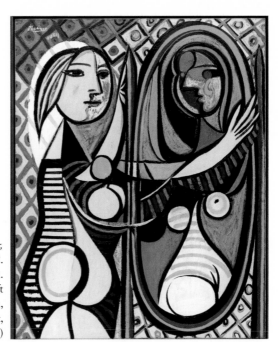

Picasso, *Girl before a Mirror,*
Boisgeloup, March 14, 1932.
(Oil on canvas, 162.3 x 130.2 cm.
Acquired in 1938 through the gift
of Mrs. Simon Guggenheim,
The Museum of Modern Art,
New York.)

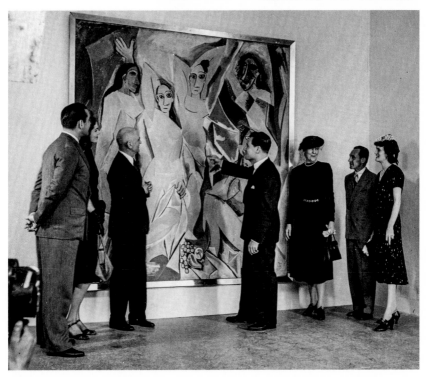

Picasso's *Les Demoiselles d'Avignon,* 1907, at the Museum of Modern Art in 1939.
Acquired the same year through the Lillie P. Bliss Bequest. Left to right: John Hay
Whitney, Mrs. W. T. Emmett, Jr., A. Conger Goodyear, Nelson A. Rockefeller, Mrs. John
S. Sheppard, Edsel Ford, and Elizabeth Bliss Parkinson. (The Museum of Modern Art,
New York.)

Andreas Feininger, aerial view of the new Museum of Modern Art, 1939. (Architects Philip Goodwin and Edward D. Stone. The Museum of Modern Art, New York. © Estate of Andreas Feininger.)

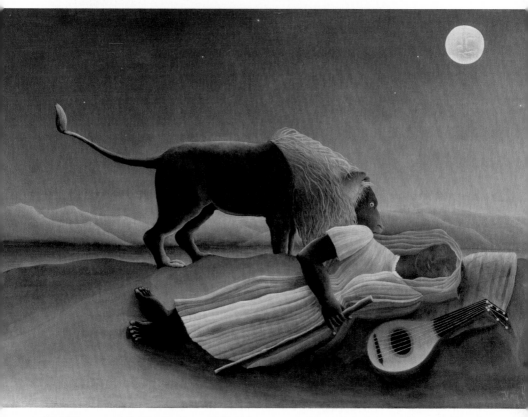

Henri Rousseau, *The Sleeping Gypsy,* 1897. (Oil on canvas, 129 x 200 cm. Acquired in 1939 through the gift of Mrs. Simon Guggenheim, The Museum of Modern Art, New York.)

Part 11

18

THE MAN VANISHES

In January 1926, Alfred Barr went up from Princeton to New York to see some paintings. For a brief period of time, the Art Center, a two-story exhibition hall on East Fifty-sixth Street, was offering a rare glimpse at one of the most unusual private art collections in the world. Many of the nearly one hundred works in the exhibition were by artists who were still scarcely known in the United States; a number of them were said to be among the most distinctive of their kind. For Barr, it was a crucial opportunity.

Four and a half years after his first fleeting encounter with Matisse and Picasso at the Metropolitan's controversial post-Impressionist show, Barr had become an aspiring scholar of modern art. Though he was barely out of college, he had gained a reputation at Princeton and Harvard for his brilliance and his quiet radicalism. Already the previous spring, despite only a single year of graduate coursework, he'd opted to take his general exams—and astonished his examiners by his performance. "One got the impression that he had thought deeply and ranged widely over the whole field," one of them wrote.[1] But Barr was bored with the curriculum and had taken to complaining openly about the universities' disdain for the current era. At Princeton, where he was now on a one-year teaching fellowship, there was still no course in

twentieth-century modern art; at Harvard, the post-Impressionists were completely ignored.² In fact, few museums in the United States had works by any of these artists, and much of Barr's own patchy knowledge came from back issues of *The Dial* and *Vanity Fair.*³ Now, however, there was an exhibition hall in New York that was apparently filled with their paintings.

Arriving at the Art Center, Barr quickly found that the show exceeded his expectations. It began with several dozen paintings by some of the most interesting and daring living Americans, artists like Max Weber, Alfred Maurer, John Marin, Marsden Hartley, and Charles Sheeler. Ordinarily, these canvases would have made a distinguished show in themselves. Here, though, they were merely a prelude to something else. As Barr went farther into the gallery, he found himself in front of a series of astonishing paintings by the modernists whose names went unmentioned at Harvard: Van Gogh, Seurat, Cézanne, Gauguin, Toulouse-Lautrec, Derain, Vlaminck, Dufy, Rouault, de La Fresnaye, and Picasso. There was a terrifically inside-out work by Braque, a green-and-gray cluster of fractured volumes from which emerged the contours of a large violin and a tall candlestick; and an enormous Matisse still life, transfigured by geometric structuring and bold swaths of color. Scattered among them were Raymond Duchamp-Villon's wittily abstract bronze woman, and Brancusi's *Golden Bird.* Then, at a certain point, Barr found himself ensnared by a supremely strange painting of a lion and a sleeping woman. It was by Henri Rousseau. He would never forget the encounter. "It made a profound impression on me," he wrote almost three decades later. "More than anything else in a show of wonderful pictures."⁴

Barr was getting his first—and, as it would turn out, only—sustained look at the art patronage of John Quinn. Officially titled *The Memorial Exhibition of Representative Works Selected from the John Quinn Collection,* the show was a small and imperfect sample of what had been found in the lawyer's apartment when he died eighteen months earlier. Left out were many of his most important Seurats, Picassos, Matisses, Bran-

cusis, Gaudier-Brzeskas, and other works, while the show also included lesser English and Irish works that Quinn had acquired earlier in his career. Yet as Barr took in the presentation, he began to appreciate the audacity of Quinn's project, and to understand that he had been up to something greater than simply buying paintings he liked. As Barr would later reflect, in the short time that he had pursued modern art, Quinn had managed to assemble "many of the best works by many of the best artists."[5]

Barr was not the only one impressed by the exhibition. "Eight square feet of Matisse with his blacks and burning reds and greens," Murdock Pemberton, the jaunty, Kansas-born critic wrote in Harold Ross's brand-new *New Yorker*. "Rousseau's great lion with mane of rope and asses nose. 'The Maternity of Picasso.' The haunting melodies of Redon's palette." In *The New York Times*, Sheldon Cheney, the art writer who had met Quinn a few years earlier, wrote, "America has plenty of great art collectors of the 'safe' variety. . . . John Quinn stands out from all those safe collectors as something of an epic figure." In a lead editorial, Forbes Watson, the editor of *The Arts*, a prominent arts magazine, argued that "any museum, desirous of acquiring contemporary art" should be envious of the paintings at the Art Center. "Perhaps more than any other American collector," Watson wrote, "Mr. Quinn ate, drank, argued, played and lived with artists actively engaged in promoting the cause of modern art."[6]

But if the exhibition conveyed the peculiar power of one man's unusual taste, it also gave Barr a visceral lesson in the limits of the American art world. For all the critics' interest, the excitement was short-lived. The show ran for only three weeks; and far from establishing the collection in the city's cultural firmament, it amounted to little more than a last-ditch effort by Quinn's friends to exhibit a group of works that would never be seen together again. A few days after the Art Center show opened, *The New York Times* reported that the estate of the late collector had sold fifty-two of his Picassos, together with many of his Seurats, to a Paris dealer.[7] A few months after the show, many of Quinn's most important remaining French paintings, including works by Cézanne, Derain, Matisse, Gris, Redon, and Rouault, were also sent back to

France to be auctioned at the Hôtel Drouot. Some of Quinn's final purchases, like Rousseau's incomparable *Sleeping Gypsy,* would be leaving the United States barely two years after they arrived. "See the show," Pemberton urged his readers. "For when the collection is dispersed you will not have the chance without traveling far and wide. There will be none left in New York."

For much of the previous year and a half, Quinn's friends had done everything they could to prevent this outcome. Already, the day after his death, Frederick James Gregg had argued in the New York *Sun* that the collection "ought to find a home somewhere in its integrity."[8] Soon after, Ezra Pound had written to Quinn's legal secretary urging that the paintings be kept in the United States and open to the public, a call that was echoed by Arthur Davies, Henry McBride, Walter Pach, and other members of Quinn's circle. Though he did not know Quinn well, Duncan Phillips, the prominent Washington, D.C., collector and founder of the Phillips Collection, went further: The collection, he said, should be kept intact as a "museum of modern art."[9]

But Quinn had left his own final intentions oddly unresolved. In Paris, Henri-Pierre Roché had long assumed, like Quinn's New York friends, that the immaculate big game works they were hunting were destined, as he put it, "for the Metropolitan or for some other museums of the U.S.A." Yet in a moment of distemper two years before his death, Quinn had privately dismissed the idea. He told Roché that he wanted to preserve the core modern and avant-garde works that they had assembled since the war. "What I have in mind is a certain selection of French works that are of museum rank and importance," he told Roché. "These are paintings I would never part with." But he also said that after so many years of struggle for modern art, he had lost faith in the United States. Anyway, the Metropolitan was highly unlikely to accept his paintings. "These Picassos belong in France," he had said.[10]

If Quinn hoped to preserve his most significant artworks, whether in France or the United States, though, his wishes were poorly understood. The main instrument for dealing with his assets was the hasty will he had drawn up back in 1918, at the time of his cancer surgery, and redrafted shortly before his death. But that document made no differen-

tiation among his paintings and sculptures and ordered that *all* the art he owned be liquidated to benefit his sister and her daughter.[11] It also did not seem to take account of the final six years of his life, when he and Roché had assembled a cohesive group of avant-garde paintings and sculptures. And while Quinn had grown increasingly disenchanted with the American art world after the "degenerate" art controversy at the Metropolitan, he made several later addenda to the will that seemed to conflict with the idea of a total liquidation. To start with, he wanted Seurat's final masterpiece, *Circus,* to go to the Louvre, as he had promised Seurat's protégé, Paul Signac. But he made no mention of the many other standout works that he had especially prized—Picasso's lyrical late Cubist masterpieces and his archaic nudes; Matisse's *Blue Nude,* which had once scandalized visitors to the Armory Show; Brancusi's *Golden Bird;* Derain's *The Bagpiper;* nor *The Sleeping Gypsy,* which, along with *Circus,* he had set up next to his deathbed.

In fact, in a separate set of instructions, Quinn *had* outlined a plan— a "possible contingency," as he put it—to keep his most important paintings and sculptures together. The core of the collection—perhaps several hundred paintings and sculptures—could be preserved for the public trust, he wrote, provided that Davies, his well-connected friend, could raise $250,000 to purchase them from the estate.[12] The quarter million figure was perhaps only half of what Quinn had spent, but the plan would create the nucleus of the modern museum that he had long envisioned, while ensuring that his sister and niece would be well cared for. In an era in which a single painting by Rembrandt or Gainsborough could go for several multiples of this figure, the amount was hardly extravagant. And Davies also knew several wealthy women—including Quinn's friends Lillie Bliss and Mary Sullivan—who understood the importance of Quinn's legacy.

Davies made an impassioned case. His own alliance with Quinn went back to the Armory Show, and he had followed his art conquests for years. During the wartime art boom in New York, he had gone on almost weekly rounds with Quinn to the galleries to select paintings. Later, he had organized the 1922 show of Quinn's paintings and sculptures at the Sculptors' Gallery, and then, in the final months of Quinn's

life, he had attended the small dinner at which Quinn had unveiled *The Sleeping Gypsy,* the keystone of his collection. Davies fervently wanted these works to stay together. But for all the sympathy his plan drew, he was unable to persuade the women to fund the project.

Meanwhile, Quinn's estate itself was in disarray. For one thing, he had never bothered to catalog what he owned, and no one was certain just what his apartment contained. Nor were his executors particularly interested in modern art. Quinn had intended his longtime legal secretary, Thomas Curtin, who had followed his purchases for years, to provide guidance, but Curtin died six months after Quinn. That left, as his remaining executors, a New York lawyer who had known Quinn for years but did not share his aesthetic tastes; and the National Bank of Commerce, for which Quinn had long served as legal counsel, an institution that was far more comfortable with monetary trusts than radical paintings and wanted to get rid of them as soon as possible. "We don't want Wall Street laughing at us as the Cubist bank," one of the bank's officers told a friend of Quinn's.[13]

Quinn's years of overlapping female relationships created problems of their own. Alongside Jeanne Foster, he left financial bequests to several women he had been with over the years. One of them was Dorothy Coates, a schoolteacher he'd had a desultory relationship with in the early part of his career, and who had pursued him for years afterward. (Foster referred to Coates as "the dragon," and Quinn, during his final illness, asked Foster and his caretakers not to let Coates see him under any pretext.) Shortly after the will was unsealed, Coates came forward with an explosive claim: She asserted that she was Quinn's common-law wife and was entitled to a much larger share of his estate; she also maintained, absurdly, that she "knew every picture he bought and its history." The case was eventually dismissed in Surrogate's Court, but not before it made sensational headlines. (GIRL CAN'T COLLECT FROM QUINN ESTATE, the *Times* had reported.)[14]

Left with no alternatives, the executors decided to liquidate the collection. At first they contemplated doing exactly what Quinn feared

most: putting everything into an enormous auction. Jeanne Foster knew better than anyone else that Quinn regarded his collection as a work of art in itself and had feared its dispersal in an unsympathetic world. "If anything happened to me and there was a sale of my paintings," he had told her during his final illness, "there would be a slaughter." As much as he loved his artists, he sensed, in his bitter decline, that they carried very little meaning in 1920s America. "The large Picasso nudes could hardly be given away now," he had told her. In desperation, Foster wrote to the executors, pleading with them to delay their plans and warning that many of Quinn's paintings were "fifty years ahead of popular taste."[15] But Foster had no legal standing with the estate and her influence was limited.

Still, there was Roché. Serendipitously, he had been invited to New York a few months after Quinn's death, to assist a prominent French theater director who was touring North America. Foster had warned him that the fate of Quinn's pictures hung in doubt and the trip gave him a perfect opportunity to meet with the executors and try to influence the outcome. Aware of Roché's close collaboration with Quinn and his expertise in the Paris market, they welcomed his help. After he met with them in New York, they asked him to evaluate the most important works in the collection; they also wanted his advice about their disposal.

That winter, Roché spent several days alone in Quinn's apartment, surrounded by all the paintings he had helped acquire.[16] For the first time, he could see the ensemble of works that the two of them had assembled. As he waded through the stacks and piles of paintings, turning them over one by one, his esteem for Quinn, the choices he made, the risks he took, grew further. "No other collection had this kind of concision and punch," he wrote.[17] Like Foster, he knew that auctioning the paintings in New York would be disastrous; only in Europe was their true value known. He advised the executors to delay any sales, and to consider holding them in Paris instead.

Then, looking at all of Quinn's Picassos, he had another idea. It was true, as Quinn had told Foster, that few people in the United States seemed ready for Picasso's big nudes, his Cubist still lifes, or even his Blue and Rose period masterpieces. But Roché knew at least one art con-

noisseur who had a deep interest in Picasso and had long followed
Quinn's exploits in the Paris art world. He also knew that this man stood
to lose almost as much as the Quinn estate if there was a general collapse
in prices for Picasso and other artists. He felt fairly certain that the man
would be more than eager to make an offer on Quinn's Picassos, if he
were given the chance. The man was Paul Rosenberg. What if Roché
engineered a private deal between Rosenberg and the executors?

In fact, Rosenberg had had his eye on Quinn's collection from almost
the moment he learned of Quinn's death, if not well before. ("Perhaps
you know that Quinn is dead and there's talk of selling his paintings!"
Rosenberg wrote Picasso in the fall of 1924.)[18] Rosenberg was intrigued
by Roché's plan, and in early 1925, Roché approached the executors
about a possible deal. "I presented you as the only man who has financial
interests that are identical with those of the estate," Roché wrote Rosen-
berg.[19]

The executors took their time, but in the end, the strategy worked.
By the time the memorial exhibition opened at the Art Center, the ex-
ecutors were anxious to get rid of the artworks as quietly and efficiently
as they could. Persuaded that Rosenberg was rescuing them from loom-
ing catastrophe, they let him walk away—for a significant discount—
with nearly all of Quinn's Picassos, as well as several important Seurats
and other paintings. For Rosenberg, it was a remarkable coup. Having
long fought with Quinn over how best to promote Picasso's work in the
United States, he was getting the last word: For the foreseeable future,
the center of the artist's work would be rue La Boétie, not Central Park
West.

When they learned of the Picasso sale, some of Quinn's friends were
furious. Here was an unparalleled sweep of works that told the story of
one of the leading modern artists through some of his most important
paintings. If ever there were a case for keeping the core of Quinn's col-
lection intact in the United States, it was the Picassos. Yet now they were
being scooped up and sent back across the ocean. In *The Dial,* Henry
McBride grumbled about "the immense loot from the Quinn Collection
that Mr. Rosenberg is taking back to Paris."[20] In *The Independent,* Gregg
wrote that the loss of Quinn's paintings was "likely to put us back by a

quarter of a century."[21] But Roché was certain he had done the right thing: The United States was not ready for these Picassos. Quinn had said so himself. In turning them over to Rosenberg, he was doing the best he could for Quinn and his estate, while saving Picasso from yet another American embarrassment. He also stood to gain a handsome commission on the deal.

That fall, the other post-Impressionist and avant-garde masterpieces that Quinn's executors had sent back to France were put up for sale at the same Paris auction house where Kahnweiler's own vast collection of Cubist works had been dispersed a few years earlier. The catalog for the sale was introduced by Picasso's friend Jean Cocteau. "John Quinn was one of the four or five people in all the world who discovered everything that vibrated, everything that moved," Cocteau wrote. Buoyed by Rousseau's *Sleeping Gypsy* and Matisse's *Blue Nude,* the auction attracted enormous attention. "The John Quinn Collection, which should be in a state museum, is now up for resale, its magnificent unity destroyed in the Parisian auction rooms of the Hôtel Drouot," Janet Flanner wrote, in one of her first French dispatches for *The New Yorker.* She added, "For forty-eight hours Mr. Quinn was better known in Paris than he had ever been known in New York."[22]

Flanner was not wrong. Although a few adventurous American buyers took an interest in his paintings, Quinn remained an enigma. In early 1927, after the cream of the collection had been sold in Europe, the remaining eight hundred paintings and sculptures were sold off in a four-day auction in New York. The sale attracted considerable attention and, owing to the sheer quantity of lots, yielded $91,570; though the amount still paled in comparison to the value of a single Gainsborough or Vermeer, it would stand for years to come as the most lucrative sale of modern art ever held in the United States. Yet it was hard to deny the darker story about American culture told by the dissolution of the Quinn estate. In New York, some Cubist and Futurist works went for as little as $7.50 apiece; Roché called the sale a "massacre" and estimated that it achieved about 50 percent of the purchase prices.[23]

Devalued and dispersed, many of the works would disappear altogether. Decades later, when an art historian attempted to trace the pres-

ent location of the paintings and sculptures that Quinn had collected, she concluded that three-quarters of them could no longer be found.[24] And once the collection was gone, there were remarkably few traces of Quinn left. Summoned home to care for her aging husband and her father, Jeanne Foster resigned from the *Review of Reviews* and withdrew to her family in Schenectady, where she kept a small private shrine to Quinn. Roché resumed his complicated life in Paris, deciding, finally, to marry Germaine, his demure and patient French love, while not quite abandoning his affair with Helen, his German torment. Even the apartment where Quinn had kept all that art turned out to have been merely a rental, and no known photographs of its cavernous art-filled rooms would survive. Soon his singular achievement was little more than a fading, exotic memory among those New Yorkers and foreigners who had had the fortune to be invited to his home, or to see the Art Center exhibition.

At least for Alfred Barr, though, the unusual show was less an end than a beginning. He was struck by what he called Quinn's "astonishing prowess" for finding the most interesting new art, when much of it was deeply unpopular. There was also a thrilling sense of freedom in his choices, the same freedom from traditional ideas and cultural restraints that seemed to be present in the new artists themselves. Reflecting on the show, he would call Quinn the country's "most emancipated" art collector. But he was also struck by his motivations. Here was a comprehensive vision of French modern art, told through its most inspiring examples, a vision that began with ancestors like Cézanne and Seurat, and continued through Matisse and Picasso to the present day. It was a story that was utterly absent from the country's museums. It was also a story that Barr himself desperately wanted to tell.

19

THE VERY
MODERN
MR. BARR

At the time he saw the John Quinn memorial show, there was little about Alfred Barr that suggested he was destined to transform the American art world. Physically slight to the point of frailty, he had large round glasses and boyish features that made him look even younger than his twenty-three years. He was also reserved and scholarly, and tended to speak in measured paragraphs followed by excruciatingly long silences. Outside of his studies, he limited himself to such serious pursuits as organ concerts, chess, and occasional tennis; he was not known for dating. Frequently, he was in precarious health. And where most of his Harvard classmates came from cosmopolitan backgrounds of wealth and privilege, Barr was a scholarship student who had grown up in a parsonage.

He also had had remarkably little direct exposure to the art that interested him most. In New York and Boston, works by modern and avant-garde artists remained scarce; and Barr's sole experience of Europe was a conventional sightseeing trip to Italy and France, which he had undertaken, on a shoestring, with a childhood friend at the end of college. (Like Quinn on his first trip to France, he had visited Chartres Cathedral.) As he confessed to his mother after starting graduate school, his own knowledge of modern painting was "woefully superficial"; when he

had a rare opportunity to see an actual abstract painting by Kandinsky, he initially dismissed it as "hashish."[1]

Yet, like Quinn, Barr sensed early on that an extraordinary cultural upheaval was under way, and mainstream resistance made him all the more intent on fighting for it. "It's . . . a feeling for the underdog," he once commented. "I like to see him win."[2] He also shared the lawyer's relentless self-drive and determination to master all that was new. By 1926, finding the material he absorbed from books, magazines, and other sources insufficient, he began asking J. B. Neumann, a modern art dealer who had recently arrived from Berlin, to import European publications for him; to many of his classmates, and a few of his professors, his intellectual precocity was somewhat terrifying. After meeting Barr in the late twenties, the British modernist Wyndham Lewis, Quinn's old friend, commented that "he looks like a defrocked Spanish Jesuit."[3] Philip Johnson, at the time a somewhat unfocused Harvard undergraduate, had the impression that "he was nearly God."[4]

In fact, Barr did have a religious background, though not in the denomination Lewis suggested. Born in Detroit in 1902, Alfred Hamilton Barr, Jr., came from a line of Presbyterian clergymen going back to the seventeenth century. When Barr was nine, the family moved to Baltimore, where his father became minister of the First Presbyterian Church; Barr was enrolled at the conservative Boys' Latin School, where he excelled. Early on, though, it was not religion but the natural world that gripped him. Equipped with an unusually analytical mind and a passion for taxonomy, he was drawn to butterfly collecting and birdwatching; in his high school newspaper—which he edited—he was described as a "born scientist with a real desire for things bizarre, grotesque, and occult." He also was fond of grand strategy, and liked to restage decisive battles like Gettysburg and Waterloo on his living room floor. By sixteen, he had graduated as "Head Boy" and won a scholarship to Princeton.[5]

In college, he planned to study paleontology, but he abandoned fossils after taking a course in medieval art during his sophomore year. Led by an innovative scholar named Charles Rufus Morey, the class catered directly to Barr's scientific bent. Rejecting prevailing understandings of art as an expression of national history and limited to painting and sculp-

ture, Morey sought to trace the common evolution of all art forms across huge sweeps of time and space. At the center of Morey's radical project was an effort to discipline the bewilderingly complex and poorly understood world of medieval art—a thousand-year morass—into a single, geneaological story, an approach that seemed to do to art what Kepler's laws had done to astronomy.[6]

For the empirically minded but visually stimulated Barr, the class made an indelible impression and soon after, he switched his major to art history. But the tools Morey offered seemed far more exciting when applied to the modern era. Inspired by his magazine reading and by John Quinn's post-Impressionist show at the Metropolitan, Barr began to seek out as much information as he could about the new art movements in Europe. By the time he had finished a year of Harvard graduate school, he could assert that he had already "passed through" most of the significant epochs of art, including Classical, Medieval, Renaissance, and Baroque, and that he was now mainly interested in an epoch that no one was teaching: the present. "Contemporary art is puzzling and chaotic," he wrote in one application for funding, "but is to many of us living and important . . . as a manifestation of our amazing though none too lucid civilization."[7] Like Quinn, he was beginning to sense that "living" art could often speak more powerfully than any historical masterpiece. It also was still awaiting its Kepler.

At Harvard, Barr socialized little, but he gradually fell in with an ambitious group of young men who shared his ardor for modernism. Beginning in 1925, Barr formed an especially important friendship with Jere Abbott, a brilliant young pianist and physicist who had studied music in Paris, and who had, on Barr's recommendation, decided to study art history at Harvard. In Cambridge, they became roommates and constant companions, and Abbott sometimes came to Barr's lectures to play polytonal pieces by Milhaud and Stravinsky for his students. Dazzled by Barr's genius, Abbott quickly embraced his ideas about modern art.

Most of Barr's professors, however, did not. In one of his first courses at Harvard, Picasso was held up to ridicule. "After the tittering subsided the professor told three funny stories," Barr complained.[8] Another

prominent faculty member had long tried to keep modern art out of the city's museums altogether. In one of Barr's first attempts to organize an exhibition on campus, he was unable to locate any works even by the founders of the modern movement. "It is actually impossible," he wrote in a blistering attack in *The Harvard Crimson,* to find "a single painting by Cézanne, Van Gogh, Seurat, Gauguin, masters who are honored the world over."[9]

Soon Barr was gaining a reputation as a young Jacobin. At Wellesley, he launched a controversial course in twentieth-century art, the first of its kind in the country. Showing up in mismatched suits, he asked his students to read James Joyce and Luigi Pirandello rather than art books, to visit factories and train stations rather than museums. (One assignment was to study the new Necco candy factory in Cambridge, which was one of the very few modernist buildings in the area.) Local critics, responding to his strident modernism and his disparagement of the local culture, began to savage him as "the very modern Mr. Barr of Cambridge and Wellesley."[10]

Like Quinn, Barr seemed to enjoy the controversy. "I have had some good fights over modern art," he told one friend.[11] His outspoken fervor did not endear him to the Harvard faculty, though. Seeking a travel grant to Europe—essential in a field in which much of what he was interested in could not be found in the United States—he was repeatedly turned down. By the late 1920s, Barr complained that he was living "hand to mouth," and his determination to become the country's first scholar of modern art was beginning to look distinctly unpromising. "I have no funds to travel with or buy books and material," he wrote.[12]

Still, he had at least one powerful ally: Paul J. Sachs, the associate director of Harvard's Fogg Museum. A small, courtly man from the Goldman Sachs banking family, Sachs was unlike other members of the faculty. He had come to Harvard after a fifteen-year career in international finance and regarded himself more as a connoisseur than as a scholar. As a distinguished collector of prints, he was well connected in the European art world; he was also deeply concerned by the state of American museums, which he felt had become stale repositories for rich men's treasures. He preferred to teach in the long living room of Shady

Hill, his large nineteenth-century estate near Harvard, where he could surprise students with unknown objects from his art collection, rather than in a classroom. In his pioneering "museum course," he set out to give a new generation of art scholars the combination of eye training, business expertise, and social skills he felt was needed to manage an elite public museum collection. Though Barr lacked the poise of some of his wealthy peers, Sachs recognized his unusual gifts, and quickly adopted him as a protégé.

Crucially for Barr, Sachs was also open to modern art. While he steered clear of Cubism and abstraction, he knew some of the modern dealers in Europe and felt that the movements they were promoting should be better known in the United States. As early as 1920, when hardly any Americans apart from Quinn were pursuing Picasso's work, Sachs had bought a Picasso drawing from Paul Rosenberg—initiating a transatlantic friendship with the dealer that would one day prove vital in ways that neither of them could imagine. Sachs also understood that Barr needed direct exposure to the European art world. And when Barr was unable to secure funding, Sachs paid for the trip himself.

Spanning an entire academic year, Barr's Wanderjahr in 1927–28 up-ended his understanding of modern art. For any ordinary American scholar of the time, it was natural to visit the art capitals of Western Europe. While Barr spent several weeks in London and Paris, however, his primary interests lay elsewhere. Where Quinn had sought to identify and support the most important artists of his time, Barr wanted to witness how these artists were changing civilization. Together with Abbott, who was paying his own way, Barr traveled to Holland, where the De Stijl movement had produced a flourishing scene of advanced design and architecture. Even more important, though, were the months they spent in two other countries farther east, the same two where Daniel-Henry Kahnweiler had first established the avant-garde art market a generation earlier: Germany and Russia.

In both the Weimar Republic and the young Soviet state, modernist ideas had taken hold to a degree that was almost unimaginable in the United States. In Germany, Barr found advanced museums in almost every town they visited. They also spent four days at the Bauhaus in

Dessau, where they met Walter Gropius and most of the other artist-leaders who were seeking to bring new aesthetic and design principles to everything from the color patterns of rugs to the shape of door handles. In Moscow, Vsevolod Meyerhold, the avant-garde theater director, showed them his Cubist stage sets and Sergei Eisenstein let them watch him edit *October,* his latest revolutionary film; they also visited the Museum of Modern Western Painting No. 1—the nationalized prewar collection of Sergei Shchukin—which housed the largest collection of Picassos and Matisses in the world. Even as America's biggest cities had yet to embrace contemporary painting and sculpture, Barr observed, "little German industrial towns such as Halle and Erfurt, Essen and Mannheim, Russian cities such as Witebsk and Kharkov, have galleries devoted primarily to modern art."[13]

But as they lingered in Moscow, Barr and Abbott also discovered something else: that modern art depended on political freedom. At the time of their visit, Joseph Stalin was just beginning to consolidate power over the Soviet state; during their stay, Trotsky was arrested and bundled onto a train for forced exile in Kazakhstan, part of the sweeping purge of the party's main opposition faction. To ordinary citizens, the ideological hardening was not yet apparent, and Barr and Abbott were able to move freely around the country. But already, a chill had descended over avant-garde art, which was seen as insufficiently socialist. In the years leading up to the Russian Revolution, Moscow had had one of the most dynamic art scenes in the world, with painters like Kazimir Malevich and Natalia Goncharova and sculptors like Alexander Archipenko pushing Russia to the forefront of abstract art. By the time of Barr and Abbott's visit, however, many of the country's leading artists had gone into exile or given up painting altogether. "That's all in the past," the painter Aleksandr Rodchenko told them.[14] They also discovered, despite the exhilarating work of Eisenstein and Meyerhold, a growing climate of censorship in film, theater, and public exhibitions. In fact, they were witnessing the final twilight of the Russian avant-garde. Shortly after their departure, the Shchukin museum would be shut down and most of its Matisses and Picassos locked away; over the next few years, Stalin would formally repudiate modern art in favor of So-

cialist Realism, and many modern artists and writers would be perse-cuted. Eisenstein would soon have trouble getting his films made; Meyerhold would eventually be executed.[15]

For Barr, the European sojourn provided a tantalizing sense of the promise, and peril, of the new art. He was fascinated by the extent to which novel aesthetic ideas were spreading across culture, and soon he was lecturing Wellesley undergraduates about Soviet cinema and the Bauhaus. But it was also his first exposure to the conflict between mod-ern art and antidemocratic politics. The rise of Stalin would not be the last time he witnessed up close the advent of a totalitarian regime and its consequences for a society with an advanced art culture. Years later, Barr would reflect that "painting and sculpture were perhaps the first arts to succumb to cultural tyranny."[16]

Barr returned to the United States in the summer of 1928 filled with ideas. Given all that he had experienced, he was more determined than ever to study modern art. Yet he soon realized how difficult this might be. Forced to take on a heavy teaching load, he had no time to begin his Ph.D., or even to assimilate what he'd seen. More ominously, his super-visors were less than convinced by his proposal to write about what he called "primitive" tendencies in modern art—a subject for which Pi-casso's work would be central. That fall, despite his stellar academic rec-ord, and unusual knowledge of Germany and Russia, both Harvard and Princeton declined to give him funding. It was a serious setback, and Barr thought he might have to rethink his plans altogether.

Once again, Sachs came to the rescue. "You must not be discouraged by your failure," Sachs wrote him in early 1929.[17] First, he suggested that Barr transfer to New York University, which seemed more likely to sup-port his unorthodox subject. A few months later, with Sachs's support, Barr was able to obtain a one-year Carnegie fellowship there to begin his dissertation. Just as he was preparing to transfer to NYU, however, Sachs wrote him with an even more unusual opportunity in New York, one that went to the core of John Quinn's unfulfilled legacy: Would Barr like to run a new museum that was going to be devoted entirely to mod-ern art?

20

"HAD HE LIVED
ANOTHER
DECADE..."

As origin stories go, the serendipitous founding of the Museum of Modern Art has long had the quality of a Stanley-Meets-Livingstone legend. In early 1929, with the stock market at dizzying heights, two New York society women were wintering in North Africa and the Middle East, respectively. One day in southern Egypt—"among the temples and pyramids," as one writer has it, or perhaps "in the desert sands," as another asserts—they ran into each other. Soon the talk veered from the Nubian tribes of Wadi Halfa to the Metropolitan Museum's persistent allergy to Van Gogh and Matisse.[1] *Something,* they decided, had to be done. Then, in the first-class tearoom of the boat back from Europe, one of the two ran into a third friend of theirs, also a committed modernist, who quickly concurred: It was time to start a new museum. By the time the three "adamantine ladies" reunited that spring in Manhattan, the project was well under way, and within six months, the thing was done. Amid the ruins of the ancient world, a home for the newest art was born.

It is a seductive tale, but little of it happens to be accurate. The three New York friends—Lillie Bliss, Abby Aldrich Rockefeller, and Mary Sullivan—were indeed the driving forces behind one of the most adventurous museum start-ups in a generation. But the plan was hardly concocted during a chance meeting in the shadows of Giza. (Bliss's and

Rockefeller's parties did have an unplanned encounter, but it was at the far more mundane port of Haifa, not in Egypt, and no pharaonic monuments were involved.[2]) Nor did the project have the unlimited backing that Rockefeller involvement suggested. The women had been tossing the idea around for several years, and far more important in inspiring their "great scheme," as it was later called, was the event that had shamed the New York art world back in 1926: the breakup of the John Quinn collection. More specifically, the plan was set in motion by the sudden death of Quinn's friend and ally Arthur B. Davies—in baroque circumstances that carried eerie echoes of Quinn's own demise.

It began with personal connections to Quinn himself. Bliss had quietly supported Quinn's efforts ever since the Armory Show, including the 1921 post-Impressionist exhibition. Though she was no radical, she had recently ventured as far as Picasso, and her magnificent Cézannes positioned her as one of the city's most important modern patrons. Sullivan, who was in her late forties, had even closer ties to Quinn: Raised in Indianapolis by Irish immigrant parents, she was, like him, not from an elite background and had made her own way in New York. A pioneering art teacher at Pratt, she had married one of Quinn's Harvard classmates, and for years, she had avidly followed Quinn's avant-garde patronage. Quinn was mindful of both women's interest in his ideas, and when he had instructed his executors to let his friend Arthur Davies try to raise $250,000 to save his collection as the nucleus of a new museum, it was Bliss and Sullivan he had chiefly in mind.

Although neither was able to come up with the funds, they quickly came to recognize that the dispersal of Quinn's Seurats, Rousseaus, and Picassos on the European market was a stain on the city. Bliss was already in her early sixties, and, like Quinn, she had no immediate heirs; she must have wondered about the fate of her own collection, given the Metropolitan's entrenched conservatism. In fact, despite years of advocacy by Quinn and his friends, the Manhattan establishment seemed hardly more ready for the new art than it had been at the time of the Armory Show. In 1928, Valentine Dudensing, one of the city's most progressive art dealers, confessed, "I do not want Picasso[s], because I don't know who to sell them to."[3]

Bliss and Sullivan were not alone in sensing a crisis. So did their so-

cially prominent friend Abby Aldrich Rockefeller, who had led progressive causes in the city for years. Around the time of Quinn's death, Rockefeller discovered modern art, and bought several drawings from the Quinn estate. By 1927, she had also made friends with Davies, who must have talked to her, as well, about his failed Quinn plans. At first there appeared to be little Rockefeller could do: She was married to Junior—John D. Rockefeller, Jr.—who, along with being the richest man in America, was dour and humorless and detested modern art. A collector of medieval tapestries and giant Kangxi urns, he refused to have strange new paintings in the public rooms of their eight-story townhouse; he also strictly limited what Abby was allowed to spend on modern art. At one point, the billionaire's wife found herself having to explain to a French cultural official why she had only a single small Matisse. "The only reason I have not more," she told him, "is my inability to acquire them."[4]

Then, in October 1928, Davies died of a heart attack in Florence, leaving behind a legacy of art and women that was nearly as messy as Quinn's. Though he had a wife and children in New York, Davies had been traveling with his secret longtime mistress, Edna Potter, with whom he also had a child. Bliss, as one of Davies's closest friends, was drawn into the cover-up. (In a panic, Potter asked Bliss for advice; Bliss told her, "You'll have to tell his wife." Soon after, Potter and Mrs. Davies, who had never met, joined forces to try to keep the story out of the papers.[5]) But Bliss and her friends were equally dismayed by the fate of Davies's art collection, which included works by Picasso, Matisse, Derain, and other artists that Quinn had pursued. Like Quinn's, Davies's paintings had no obvious home, and they, too, were liquidated and scattered at auction. It marked a sordid end to the circle around Quinn who had tried for so long to bring modern art to New York.

Davies's unexpected death spurred Bliss and her friends to action. It was finally time to do something about the plan that Davies had urged on them after Quinn's death. "His influence on these women," Bliss's niece said, "is what brought it all about."[6] As Bliss, Rockefeller, and Sullivan

gathered that spring under the sedate chandeliers of the Rockefeller townhouse, though, they quickly began to see the scale of the challenge they faced. If Quinn's collection had been saved and Davies were around to oversee it, they would have had the makings of one of the greatest modern museums in the world. Now they had neither. Even for three exceptionally determined women—even with the Rockefeller name—starting an entirely new kind of museum from scratch, without anything to put in it, was daunting.

But then Mary Sullivan told them about the museum man from Buffalo who had a colorful history with one of Quinn's Picassos.[7] A former military colonel as well as a lumber and railroad baron, A. Conger Goodyear had been a longtime trustee of the Albright Art Gallery, Buffalo's large museum. In the mid-1920s, the Albright was, alongside the Metropolitan, one of the country's most resplendent museums. Built with more than five thousand tons of Maryland marble, it occupied an opulent turn-of-the-century temple that was meant to evoke the fifth-century-B.C. Erechtheion in Athens; only the U.S. Capitol had more columns. Its galleries were filled with an increasingly ambitious assembly of classic European paintings and sculptures, and its giant, skylit sculpture court featured ancient works from Egypt, India, and Cambodia. But Goodyear had an unusual taste for modern art, and sought to bring more of it to the museum as well.

Goodyear happened to be in New York when Quinn's collection was being dispersed, and one of the paintings that most caught his eye was Picasso's *La Toilette*. Though it was painted only a year before *Les Demoiselles d'Avignon,* the works could not have been more different. Exquisitely serene, the full-length *La Toilette* depicts a young woman in the nude nonchalantly tying up her hair, while another woman, clad in a long blue robe and shown in profile, holds up a mirror for her; they stand before a warm but almost abstract background. The painting marked a high point of the reddish-tinted naturalism that Picasso had perfected during an unusually tranquil summer with Fernande in Gósol, in the Pyrenees, and captured its subject with unrestrained grace and beauty—as Alfred Barr later observed, here were a pair of demi-goddesses who seemed to be directly inspired by Athenian statuary.[8] By

the time Goodyear discovered *La Toilette,* it had just been sold to Paul Rosenberg in the controversial deal he made with the Quinn estate; in the normal course of things, it would have gone back to Paris with the rest of the Picassos. But Goodyear was determined to get it, and, with the support of the Albright's new director, William M. Hekking, who shared Goodyear's interest in modern art, quickly arranged to buy it. At the time, no major museum in the United States owned a Picasso painting, and Goodyear and Hekking thought it would make a bold addition to the Albright's collection.[9]

When *La Toilette* was unveiled in Buffalo, however, all hell broke loose. The nudity was too much for some of the other trustees; soon the controversy extended to Goodyear's larger plans to expand the Albright into modern art. "Not only the Picasso, but the other works acquired through Conger's influence, had offended them," Goodyear's son later wrote. The conservatives were led by the museum's architect, the man who had designed all those Athenian columns, and the Albright family, which had in large measure paid for them, and when Goodyear's board seat came up for renewal, they kicked him off. Around the same time he went through a divorce, and in the small world of Buffalo society, he was tarnished goods; soon after, he fled to New York City.[10]

For Rockefeller and her friends, Goodyear's efforts to bring Picasso to Buffalo took on a decidedly different cast. They were trying to create a museum for precisely this kind of art, and early Picasso, at least, hardly seemed cause for alarm. As Sullivan suggested, Goodyear might be just the man they needed. In late May, they invited him for lunch and asked him outright: Would he like to be chairman of a new museum they were planning? It must have seemed somewhat whimsical, given that none of them knew anything about running a museum, and they had no collection, or building, or staff, or as yet, funds: This was a very long way from the million-dollar Albright Art Gallery. Still, he was at loose ends after Buffalo, and he was intrigued by his socially prominent hosts. The next day, he accepted.

But Goodyear was an executive, not a curator. They would need an expert in modern art to direct the enterprise, someone who could organize shows at the highest level possible. At the time, not only were many

museums skittish about the paintings that Quinn had collected; their curators were often ignorant about modern art. True expertise, in Europe as well as the United States, came from the modern art market and the dealers and connoisseurs who engaged in it. "Mr. Quinn was advised by artists," one prominent New York critic had written during the breakup of the Quinn estate. "Who advises our museums?"[11]

Seeking additional help, Goodyear and Rockefeller recruited Paul Sachs, who knew more about museums than almost anyone in the country. As Sachs scanned the landscape, however, he was not hopeful. American institutions were notably weak in modern art. They could try to hire a director from one of Germany's advanced museums, but it seemed unlikely that one could be lured for such an experimental venture. Then he thought of his unconventional Harvard protégé. While it was true that Alfred Barr had never run anything, he had just spent a year investigating the newest museums and art schools in Europe and arguably knew more about modern art than anyone in America. He also was already trying, in his own teaching, to elevate avant-garde art to the same status as its historic precedents. Sachs told Goodyear and Rockefeller that if they didn't object to "a very young man," he had a perfect candidate in mind.

At first Rockefeller was underwhelmed. After meeting Barr, she told Goodyear she was disappointed that he didn't have a "more impressive appearance."[12] Nevertheless, she was struck by his intellectual potency, and she summoned him to the Rockefeller compound in Seal Harbor, Maine, for a more extended audition. Known as the Eyrie, the vast estate featured a half-timbered Tudor-style "cottage" with one hundred rooms and a staff of twenty-two. Perched on a verdant hillside, it overlooked a dramatic, rock-strewn natural expanse dropping down to the sea. It was an intimidating place to talk about the Bauhaus, but Barr was surprised to discover the extent of Rockefeller's enthusiasm for her project. During long walks together through the Chinese-inspired gardens, he told her some of his ideas about artists, movements, and schools, his experiences in Europe, even his observations about lighting and wall labels. Already he was thinking of the new museum as a laboratory for the kind of advanced art culture he had found in Germany. He also envi-

sioned a pioneering collection of exceptional works that could tell the story of modern art. (In theory, this part was an easy sell. "We must show only the best," Rockefeller said.[13])

Whatever she made of all of his ideas, Rockefeller was convinced by his energy and knowledge and gave him the job. He even persuaded her to summon his longtime Harvard roommate and devoted friend, Jere Abbott, to Seal Harbor as well, and after a brief interview, she offered him a job as Barr's deputy. Abbott had been about to begin a prestigious academic position, but he was willing to pass it up for this. ("I WOULD RATHER WORK WITH YOU ON THIS THING THAN ANYTHING I KNOW," he cabled Barr.[14]) For a student who, only a few months earlier, had been unable to secure funding for his Ph.D., it was a remarkable turnaround. But there was no time to celebrate. It was already August, and Rockefeller and her friends were determined to open later that fall. And they still needed to define the museum's formal mission. Once again, Barr turned to ideas that had originated with John Quinn.

In a draft position statement that summer, he set out to diagnose the crisis that the city faced. In previous eras, the most innovative artists were embraced by rich men and kings. "Popes bowed to Michelangelo, an Emperor to Titian," he observed. In contrast, the leading painters of the modern era had been greeted with "contempt and derision." By now, these attitudes had gradually shifted, with a growing number of international collectors and critics coveting the most important examples of the new art. He noted that while John Quinn had paid just $7,000 for Seurat's *Circus* ten years earlier, it would now be worth "not much less than $150,000, that is, if the Louvre to which Quinn bequeathed it decided to sell." Yet New York had spurned Quinn's paintings. In a remarkable echo of Quinn's complaint at the time of the Armory Show more than sixteen years earlier, Barr noted that "the Metropolitan, the foremost museum in America, owns no Van Gogh, no Gauguin, no Seurat, no Toulouse-Lautrec (men long dead) and among the living no Matisse or Picasso, no Segonzac, no Derain." As a result, he continued, some of the old prejudices had persevered: "Obtuse" viewers, even now, continued to regard any artist who followed the modernist tradition as a "madman, degenerate and (more absurdly) bolshevik." Such was the scale of the problem that only a new museum could address it.[15]

Back in 1914, in his initial plans for a "modern museum," Quinn had identified the Luxembourg in Paris as a model. He had called for a public gallery that would not only showcase the newest art but also build a permanent collection of the best examples, a notion that was completely alien to the nation's historically oriented museums. Later, he had set out to form such a collection of advanced modern art himself—the "magnificent unity" whose dispersal had spurred Rockefeller and her friends in the first place. That fall, as Barr and the founding committee presented their new museum to the public, they turned to these same principles. Already Barr was envisioning a museum that would collect premier works by the most important artists, as Quinn had done, while putting on a continual program of loan shows. "The Luxembourg . . . was founded in order to solve a problem very similar to that which confronts New York," Barr wrote in *Vanity Fair*. "It is . . . with an *ideal* Luxembourg in mind," he continued, that they were making "remarkable progress toward the foundation of a Museum of Modern Art."[16]

While he did not invoke Quinn explicitly, Barr made clear that the idea for their venture had its origins in the aftermath of the "riotous, epoch-making Armory Exhibition of 1913." Not only, then, would the museum set out to remedy the crisis posed by the dispersal of the Quinn collection. It would also take the form that Quinn himself had once advocated. In recollecting the founding of the museum decades later, Barr went further, imagining how Quinn himself might have contributed to the project. "Had he lived another decade," Barr reflected, "what a wonderful president of the Museum of Modern Art he would have made."[17]

Barr's plans faced formidable challenges. Along with Quinn in the flesh, they also lacked his paintings. They wouldn't have a single one of the dozens of Picassos and Brancusis that only a few years earlier had been in an apartment less than two miles from the Rockefeller townhouse; they lacked his *Circus* and his *Sleeping Gypsy*. For the time being, they would have to borrow the art they needed. Nor was it clear whether Rockefeller and her friends would be prepared to follow Barr into the later stages of Cubism, let alone the more recent movements in art, architecture, film, and design he had witnessed in Dessau and Moscow. "Now remember, Alfred, that we cannot get all the things that we want

at once," Sachs warned him when he accepted the job, adding that he would need to "follow the line of least resistance" with the board.[18]

Still, the economy was strong, and the long-overdue museum showed every sign of attracting wide support in the art world. "Funds must be raised, the co-operation of collectors, critics and dealers invited," Barr wrote in August. "But there is so much enthusiasm and interest in New York that these things will scarcely be lacking." He could not know that the world would look very different by the time the museum opened three months later.[19]

21

A MUSEUM
OF HIS
OWN

Three and a half months after Barr began his new job, an Italian
graduate student named Daisy Scolari invited her friend Agnes
Rindge down to New York City for Thanksgiving weekend. Rindge
was a brilliant young Radcliffe Ph.D. who was teaching art at Vassar;
Scolari was a svelte, dark-haired woman from Rome on a prestigious art
history fellowship at New York University. They had both heard about
the new museum that was stirring up an enormous fuss on Fifty-seventh
Street and they wanted to see it. For weeks, there had been lines of peo-
ple waiting to get in the building; a few days earlier, the museum had
announced it was adding special hours for art students, because the
crowds were too large for sketching. Rindge suggested they go together,
and one morning, they set out for Midtown.[1]

By its location alone, the Museum of Modern Art was unlike any
public art gallery in the world. At the time, the prevailing American
museum ideal was still some variant of a neoclassical temple, usually set
back from its surroundings or placed in a park. The new venue, by con-
trast, was halfway up a Midtown high-rise known as the Heckscher
Building, where its fellow tenants included a cigar company, a bank,
and several interior design firms. The museum had no presence at street
level, and, as the *Times* had explained, in order to reach its galleries, "you
take the elevator up to the twelfth floor."[2]

As Scolari and Rindge approached the entrance, the elevator line was spilling onto Fifth Avenue. When they finally got up to the right floor, they found themselves in a series of spaces that were as unusual as the museum's address. According to prevailing tastes, museum galleries usually featured elaborate moldings, columns, and paneling to create a luxurious setting; walls tended to be covered in rich red or dark green brocade. Here, everything was the exact opposite. Clean and Spartan, the rooms were completely devoid of decoration and color save for the paintings themselves. "If the walls were not totally white then they were the palest possible grey, absolutely neutral," Scolari recalled.[3] Even the rugs and few pieces of furniture were light gray. In fact, it was the beginning of an approach that would one day spread throughout the international art world: the so-called "white cube" gallery, in which walls, ceilings, and floors serve as neutral backdrops for pure contemplation of the art itself. By the late twentieth century, the approach would become so dominant that it would provoke a backlash. For Americans in 1929, though, it was utterly novel.

And then there was the art. Spread across every available wall in the museum's seven small galleries were nearly one hundred paintings by Cézanne, Seurat, Gauguin, and Van Gogh. Though these were founding figures of the modern movement, their work was still relatively rare in New York, and they had never been shown on this scale. For the two young art historians, though, as striking as the paintings themselves was the way they were hung.

In the early twentieth century, many museums displayed paintings in the popular "salon style," with paintings organized symmetrically by size and hung in vertical stacks that sometimes went up to the ceiling. It had a decorative effect as wall cover, but it was a terrible way to look at art. Here, instead, the paintings were mounted in a single row at eye level and arranged so that they told a sequential story. Even the wall labels were interesting. Rather than merely listing titles and dates, they provided crucial information about a work's significance and meaning. "Such a thing had never been done before," Scolari recalled.

Around the margins, there were indications that the whole operation was considerably more bare bones than its fresh look suggested. For one

thing, the galleries were small, crowded, and poorly ventilated; the windows had been papered over, and the existing spaces had to be divided up by partitions to provide enough wall space. Even so, they had run out of room: Two Cézanne self-portraits and a Van Gogh interior were hanging over closed doors. And the paintings themselves were all borrowed and would be going home the moment the show was over. If this was a museum, it was certainly doing a good job of hiding the fact.

Then, as they pushed their way into one of the larger galleries, Rindge recognized the thin young man who had installed the show: Alfred Barr. They had known each other since Harvard, where she, too, had attended Sachs's museum course, and she ran over to greet him. After they chatted for a while, she introduced her friend. "Of course you know Daisy Scolari?" she said. Scolari had already heard a lot about the young iconoclast from Harvard who was supposed to have been her classmate at NYU but had taken the museum job instead. They began to talk. Reticent and excited at the same time, Barr must have been distracted watching the crowds react to the paintings. But he found Scolari amusing. She had a way of anticipating his words with her own. He told her he hoped they would see each other again. And then she and Rindge left.

By outward appearances, at least, Barr's first show had been an improbable success. People were clogging the elevators at the Heckscher Building; the critics were almost unanimously positive. "If the exhibition has a flaw it is that of too great power," *Art News* declared. The *Times* put it more succinctly: "Quality disarms." More dramatically, *The Nation* asserted that the new museum marked the end of the "long and bitter struggle for modern art" that had gone on ever since the Armory Show, noting that modernism had finally found "acceptance by respectable society." To hear these critics tell it, Quinn's battle had been won.[4]

Barr knew otherwise. In large part, the response owed to the extraordinary care he and Goodyear had put into the selection of paintings: They had insisted on only the most outstanding works, and Barr had even letter-graded potential candidates. (Barr may be one of the few cu-

rators to have given Cézanne a B on some of his canvases.) But as he was acutely aware, there was another explanation, too. Despite all the fanfare, the works they had packed into the Heckscher Building were hardly very modern. The museum was showing the work of four late-nineteenth-century painters who were already internationally recognized, artists whom Quinn had once referred to as "men who are dead." This was certainly not the wild Cubist and Futurist work that had provoked bitter struggles at the Armory Show, and there was no guarantee that the public, or even his own trustees, would be equally receptive to the advanced twentieth-century art whose interpretation he saw as the museum's chief task. Meanwhile, they were using rented spaces and relying almost entirely on borrowed art. In many respects, they were hardly a museum at all.

Particularly threatening to Barr's plans was the sudden crisis the country was in. The Museum of Modern Art had opened on November 8, 1929, exactly ten days after the largest stock market crash in U.S. history. In a single day of trading, the market lost some $14 billion; by early November, nearly half of the overall value of the market had disappeared. Though the broader effects were impossible to predict, for anyone with significant investments, the impact had been immediate. It was difficult to imagine a less promising moment to start a new museum of any kind, let alone one devoted to a kind of art whose long-term value was highly uncertain.

Before the crash, Goodyear managed to recruit a number of wealthy donors—some two dozen in total—to contribute the $76,000 needed for the first year of operations. Even then, though, there was barely enough to pay for a staff of five people and cover their modest rent. Had Rockefeller and her friends begun planning their museum even a few months later, it is doubtful it would have opened at all.

Following the dire headlines, Barr must have worried if he had been right to abandon his Ph.D. At New York University, he had funding and, with his doctorate and contacts, would likely have landed a tenured position in one of the country's growing art history faculties. Now he was entirely at the mercy of the museum's donors, and everything would depend on their continued willingness to support it. Even before the

economic crisis, the founders had decided that the museum would rely entirely on art loans for its first two years: Like the inaugural exhibition, shows would be built around paintings borrowed from private collections and dealers that would be returned as soon as the shows were finished. At the cramped Heckscher Building, the museum was on an annual lease, and if the finances proved untenable, the whole operation could vanish as quickly as it had started.

As it was, the economic crisis was only one of the challenges he faced. In trying to set up the first full-fledged modern art museum in America, he also had to contend with the inherent conservatism of his own trustees. Rockefeller, Bliss, and the other founders may have thought of their tastes as modern by New York standards. But they were still catching up to Quinn, let alone the bracing new currents that Barr had witnessed in Germany and Russia. In opting to begin with the four "ancestors" of modernism, the museum had been able to draw from the trustees' own collections. But they would not be much help in supplying Cubist collages and Surrealist paintings. Bliss, who was the most forward-minded of the founders, owned just two Picasso paintings, one of which was the neoclassical *Woman in White;* Goodyear had only a few drawings. Even to attempt some of the shows he wanted to do, Barr would have to first persuade the people who had hired him.[5]

Already, Barr found himself being upstaged, at least in intellectual daring, by some of his old circle at Harvard itself. Over the previous year, an upstart group called the Harvard Society for Contemporary Art had started organizing shows in Harvard Square devoted to living avant-garde artists. The society was run by Lincoln Kirstein, a brilliant undergraduate who had been a protégé of Barr's, and two other undergraduates, and had ambitions, if on a far smaller scale, that closely paralleled Barr's own. On the same day the Museum of Modern Art opened its doors with Cézanne and Gauguin, the Harvard Society opened its own show of Derain, Picasso, and Matisse. Given the challenge of locating major works by these artists in the United States, the Harvard show was small and uneven. But it included such notable works as Derain's *The Bagpiper,* which had belonged to Quinn, and Picasso's large neoclassical *Bathers,* which they had managed to get from Paul Rosenberg. In

introducing the show, Kirstein made a prescient assessment of Picasso that might have been written by Barr himself. "Only the critic of fifty years from now," he wrote, "can fully appreciate how profoundly he has altered, controlled, and assimilated European painting of the first quarter of the twentieth century."[6]

If the Museum of Modern Art was going to change the way Americans thought about art, Barr knew he would have to quickly overcome his trustees' timorousness. That winter, for his third show, he finally presented a survey of some of the leading living modern artists, including Braque, Rouault, Vlaminck, Matisse, and Picasso. Yet even these works—which were again mostly borrowed from trustees and their friends—provided a peculiarly conservative view of modern art. "American collectors, as a rule, seem rather afraid of Picasso's strongest and most characteristic arguments," the French critic and artist Jacques Mauny wrote in *The Arts* after seeing the show. "They are somewhat like the tourists who order ham sandwiches when they visit Prunier's oyster bar."[7]

Barr agreed with Mauny's criticism. Already he was beginning to think about a far more ambitious show to give the full measure of Picasso's work. As with so many of his other ideas and plans, however, he was hampered by the severe limitations of what was available in the United States. Overwhelmingly, the artworks he needed were in Europe. In this respect very little had changed since the days when Quinn and his friends were seeking Brancusis and Rousseaus. Barr needed to go to Paris.

First, though, he had something even more important he had to settle: Daisy Scolari, the woman he had met at the opening show. Shortly after they met, Barr invited her to a tearoom near the museum. A few days after that, he asked her to dinner at a Chinese restaurant. Then she began coming to the museum. In almost every way, they were opposites. He chose his words with great care; she was quick-tongued and effervescent. He was reserved and strategic; she was energetic and unrestrained. To his physical delicacy, she contrasted natural athleticism. And while he had almost total recall but was hopeless with foreign languages, she could be somewhat scattered but spoke four languages flu-

ently. Almost immediately, they made a powerful connection. "I know of no pair more divergent in background, in emotional inheritance, or in outward manner," a mutual friend of theirs later observed, "and more devoted or more reliant upon the well-being of the other."[8]

Born in Rome in 1901, Margaret Scolari-Fitzmaurice was the daughter of an antiquarian dealer from the Veneto and a patrician Irish Protestant mother. The war began during her early adolescence and she experienced it directly: Her father died when she was fifteen and her mother volunteered in military hospitals. Still, she had a free-spirited youth. She attended a coeducational high school, where she had many friends; then she enrolled at the University of Rome, where she briefly studied medicine and then languages. She taught herself Greek, read Proust, and did a perfunctory course in art history, but she never finished her degree. Instead, she got a coveted job as a bilingual secretary at the American embassy.

In 1922, she witnessed Mussolini's march on Rome and quickly acquired a distaste for Fascism. But the new regime had little impact on her own existence. "I had nice clothes," she recalled. "I adored dancing and I danced three or four times a week, in the afternoon and at night." She and her friends often went skiing in the Italian Alps. After a few years, however, she decided she had greater ambitions, and through an embassy connection, she landed a job at Vassar teaching Italian to undergraduate coeds. "It was quite extraordinary," she said. "After having had this complicated life in Rome so full of young men and flirtations, to land in a female world . . . I can't say that I liked it much."

At Vassar, however, she began taking courses in art history, which fascinated her. Evidently, she was a quick study. Even though she had never completed her undergraduate degree, she was granted an M.A. for her work; then, a few months before she met Barr, she received a Carnegie Fellowship to New York University. By the spring of 1930, she had attracted sufficient notice to be offered a job on the art history faculty at Smith College in Northampton, Massachusetts. She was also promised the directorship of the Smith College Museum when the current director retired, the following year. Quite apart from her lack of museum experience, the second part of the offer was noteworthy as it

would put her on track to be one of the first woman directors of any museum in the country. In March, Scolari accepted the job, which was to begin in the fall. She also found a large apartment in Northampton, with sufficient room for her mother, who had been living alone in Rome, to join her.

By this point, however, she had become seriously interested in Barr. Throughout the winter, she had been making regular visits to the Heckscher Building, and then joining his crowd—Jere Abbott, Philip Johnson, the handsome young Tennessee poet Cary Ross, and the German émigré art dealer J. B. Neumann—for their gatherings after long days on the twelfth floor. The discussion was excited and freewheeling, and despite the financial crisis and the enormous constraints on the museum, there was an intoxicating sense of possibility. "You felt an unbelievable vibration," Scolari recalled. "It sort of centered around Alfred, but . . . everybody was adding their contributions, reminding one another of things and saying, 'We could do this.' 'We could do that.'"

Barr was inscrutable, but he, too, seemed to enjoy Scolari's company. He also had definite views, extending to her own name. When she and Barr attended an art history conference together, he found "Margaret Scolari" written on the program and crossed out the last three letters, so it read "Marga." "Why don't we do this?" he said. In his own awkward way, he was showing his deep affection, and it stuck. From that point on, she was "Marga" to all but her oldest friends.

By late winter, they were inseparable. "We fell insanely in love with each other," Scolari said. She was also twenty-nine years old—an age that at the time was considered advanced for a single woman. Still, uncertainty hung over their relationship. Confronting his feelings for her, Barr seemed unsure what to do. "More than naturally, he deeply hesitated about the idea of getting married, or marrying me," she recalled. As she was well aware, he did not have much of a history with women, and an overwhelming number of his close friends were openly, or somewhat openly, gay; both architectural historian Henry-Russell Hitchcock and Johnson had confided their boy troubles to her. ("You are the only one who knows about Cary and me," Johnson wrote her that spring, referring to Cary Ross.[9]) In New York, Barr continued to share an apart-

ment with Abbott, his devoted friend—a curious situation for the director and deputy director of a new museum. He also was incredibly driven and worried about the constraints that marriage might place on his work. "I deeply sympathized with him," Scolari recalled.

Then, at the beginning of May, to the surprise of almost everyone, Scolari and Barr announced their engagement. It was less than six months since she and Barr had met and less than six months since the museum had opened. All at once, it seemed, Barr had found a new vocation and a new life. For Scolari, though, the change was arguably even more dramatic. She told Smith College she would be turning down the job after all, and more important, forgoing the chance to run a museum of her own. Her mother would stay in Rome. "All this had to be given up," she recalled. From now on, she would be devoting herself to Barr and his museum.

22

THE PARIS PROJECT

*I*f not quite an elopement, Alfred and Marga's Paris wedding was hardly a traditional affair. Arriving alone in mid-May 1930, Marga checked in to an inexpensive hotel while she made last-minute preparations. They hadn't ordered any announcements yet, and she didn't have a wedding gown. Flanked by Henry-Russell Hitchcock, the young architectural historian, who had come to Europe for the summer, she went up and down rue Saint-Honoré shopping for a ready-made dress and hat. ("Mademoiselle is *not* going to marry *me*," the flamboyant, red-bearded Hitchcock announced to the shop clerks in his booming, Bostonian French. "*Moi,* I am the best man.")[1]

Finally Alfred arrived and they made hasty arrangements for the ceremony. To satisfy Alfred's father, they had agreed to have a religious rite at the American Church on the Quai d'Orsay, but they discovered that the church was closed for renovation. In the end, on a cool Tuesday afternoon, they gathered in the living room of the church's rector. The entire wedding party consisted of Marga's mother, who came by train from Rome; Hitchcock; and Cary Ross, who also happened to be in Europe.[2]

After the ceremony, Ross and Hitchcock took Marga's mother to the theater while the newlyweds went to look at some new flat-roofed town-

houses near the Bois de Boulogne. In the late 1920s, the French architect Robert Mallet-Stevens had caused a stir in Paris with his rectilinear brushed-cement dwellings, some with hanging gardens of purple geraniums and pink hydrangeas, which seemed to flout all the old rules of domestic design. In *The Architects' Journal,* one critic argued that "it would be hard to find a row of buildings anywhere more nicely calculated to shock the conventional lover of architecture." Alfred decided that Mallet-Stevens was not quite Le Corbusier, but it was a pleasant walk, and he thought the houses might be relevant for a show he was planning with Henry-Russell Hitchcock and Philip Johnson on modern architecture. When it came to exhibition scouting, he was not one to be deterred by a wedding, even his own. "Work begins," Marga noted the next morning.[3]

As he began his first European foray as director of the Museum of Modern Art, Barr was under enormous pressure to deliver. On the strength of art-in-a-skyscraper novelty and crowd-pleasing shows, their first season had merited unexpected acclaim. Lacking a collection, though, they were only as a good as the art they could borrow, and Barr had quickly burned through most of the best material owned by the trustees. Already *The New Yorker*'s Murdock Pemberton was lampooning the museum's reliance on its founders' personal collections, arguing that the shows were beginning to look like "Some Pictures We Thought Good and Some That Have Been Bought by the Directors." In Paris, Barr was determined to change that, and over the next six weeks, he intended to gather a year's worth of loans.[4]

The task was almost comically daunting. Paris was used to opening its doors to rich collectors and well-connected connoisseurs, and dealers like Paul Rosenberg were always on the lookout for museums that were prepared to pay handsomely for a prestigious Monet or Renoir. But Alfred was virtually unknown and had no funds to spend on art; he also was young and didn't speak French. Even his job carried limited prestige. "The name of the Museum of Modern Art seemed to work no magic at all," Marga observed. "Many had never heard of it."[5] At the Louvre, he needed a letter from his mentor, Paul Sachs, just to get an appointment. And when he could get through, many collectors were

wary of sending works on loan across the ocean, which was highly unusual at the time.

Undeterred, Alfred quickly established the high-stakes approach that would soon become a hallmark of his show making. First, from magazines, photographs, catalogs, and other sources, he sought to identify the most outstanding examples for each artist or subject he was interested in. Then he would seek them out, however formidable or resistant their owners might be. Like Quinn, if he found that a particular painting couldn't be had, it made him all the more determined to get it. And if, in the end, he could not get what he sought, he preferred to cancel a show than go with second-tier works. It was an absolutism that, when it succeeded, could yield improbable results: That summer, Alfred convinced the Louvre and Berlin's Nationalgalerie to make their first-ever loans to an American museum. But it also made the risk of failure all the greater. For the moment, though, there was very little competition and Marga was surprised how far his uncompromising stance seemed to take him. "In most cases," she wrote, "'fortune favors the bold.'"[6]

His plans were almost Alexander-like in scope. First, he would raid Paris's and London's leading collections to obtain pictures for a blockbuster pairing of Corot and Daumier—two more nineteenth-century "ancestors," who were more radical than generally recognized. Then, in a rapid march through Germany, he aimed to extract, from more than a dozen museums, a decisive selection of German modern art, a field so unknown in the United States that he had to make an elaborate case for it. At the same time, he was continuing to think about the groundbreaking survey of international modern architecture, sending Hitchcock and Johnson on advanced reconnaissance in Holland and Germany, where they careened around in Johnson's Cord convertible documenting factories, hospitals, workers' housing, villas, and other potential targets. A single one of these complicated shows should have consumed the summer—especially given that Barr had zero experience arranging loans in Paris and Europe. Yet for him, they were merely a prelude to an even bigger quarry: Pablo Picasso.

At least since the midtwenties, Barr had viewed Picasso as "the most

inventive intelligence in modern art."[7] At the time, this judgment was far from widely shared in the United States, even among modern enthusiasts. Only a tiny number of connoisseurs like Quinn, Davies, and a few others fully embraced Cubism, while—as Rosenberg had painfully experienced in 1923—Picasso's misunderstood neoclassical style turned off diehards who feared he was giving up on the avant-garde. And while Matisse's decorative interiors had begun to win a larger American audience, Picasso's continual shifts seemed to resist apprehension. Even Henry McBride, who had followed his work since the Armory Show and was one of the country's greatest modern art champions, admitted that "Picasso always was difficult, and, I suppose, always will be."[8]

For Barr, however, it was precisely the difficulty—the ways that Picasso's work was continually at war with the existing order, and with itself—that underscored his importance. Like Quinn, who had followed Picasso through all of his phases, he had come to view the artist as the elusive, complicated, throbbing center of the new art. He had absorbed and transformed the art that had come before him, from Greek antiquity and pre-modern Africa to El Greco and Cézanne; he had also laid out a series of new pathways for contemporary art. At the same time, he seemed to be guided only by his own inner compulsions, embodying what for Barr would become a defining quality of the twentieth-century artist: freedom. "In a world in which social pressures—democratic, collectivist, bourgeois—tend to restrict the freedom of the exceptional individual," Barr later wrote, "Picasso's art assumes a significance far beyond its artistic importance." Without Picasso, it was impossible to tell the story of modern art.[9]

Almost as soon as he and Marga were married in Paris, Alfred's thoughts turned to Picasso. He knew that the artist's ceaseless forays—whether his Cubist papiers collés or his recent Surrealist portraits—would have a crucial place in any number of the shows he wanted to do. At the same time, he hoped to gain insights into Picasso's current direction and influences, and the internal dynamics of the roiling art scene of which Picasso had often been the center. Above all, though, he was anxious to begin work on a project that he had already been entertaining for months: a large-scale exhibition devoted entirely to Picasso's own work.

"Ever since the beginning of the Museum of Modern Art, Alfred wanted to have a Picasso show," Marga wrote.[10]

But he also knew that getting together a group of noteworthy paintings would not be enough. Smaller group exhibitions, like what Lincoln Kirstein had just done at Harvard, were unable to capture the power of Picasso's work. And on the few occasions when the artist had been given a show of his own, it had confused the public. By the time of Quinn's death, the country was prepared to walk away from one of the greatest collections of his work in the world. Although a few of the artist's early Blue period paintings had begun to be better known, for many Americans, Picasso seemed to stand for everything that was wrong about modern art. Even Frank Jewett Mather, Barr's forward-thinking Princeton mentor, a man who wrote a whole book called *Modern Painting,* had dismissed Picasso's work as "less a struggle for liberation than a protest against prevailing styles."[11]

To pull off a cultural shift, Barr would need to offer something far more definitive: a sequential view of Picasso's art that captured the unfolding drama of modernism itself. To start with, he wanted to give viewers the tools to understand the issues Picasso was trying to solve at each stage of his development. Out of his vast output—thousands of artworks in an astonishing array of media—Barr aimed to gather several dozen of his greatest pictures, together with related material for each. With his usual urge to classify and order, he had already divided Picasso's career into thirteen distinct phases and counting, each of which he ranked in importance: Wartime Cubism and recent "Surrealism" got the maximum three stars; the ballet sets for Diaghilev got none. He planned to foreground such obscure but gravity-shifting paintings as *Les Demoiselles d'Avignon,* and even Picasso's little-known sculptures. Carefully laid out for the viewer, the show would transform the bewildering contrasts and abrupt shifts in the artist's work into a thrilling story of modern discovery.

A half century later, Barr's approach would seem so obvious that it wouldn't have occurred to anyone to question it. In 1930, however, no one had attempted such a show of a living painter. Not even in Europe. Who was to say that Picasso's work would endure, or that it had a sig-

nificance, as Barr put it, "far beyond its artistic importance"? It was one thing to show contemporary art, as museums in Germany had long been doing, but quite another to present it with the rigor and precision of an anatomy lesson. The German art historian Erwin Panofsky marveled that Barr was able to give controversial living artists the same weighty appraisal against history that other scholars reserved for Renaissance masters.[12] But Barr had been dead serious when he told his Harvard supervisors that he found "art of the present more interesting and moving than the art of the Sung or even of the quattrocento." And if there were living artists who were challenging the fundaments on which art had been based for centuries, it was essential, he felt, to take them as seriously as their historic predecessors.[13]

At the time the Museum of Modern Art opened, Barr knew more about Picasso than almost anyone else in the United States. Thanks to his visit to the Soviet Union with Jere Abbott less than two years earlier, he not only had a broad sense of Picasso's evolving art; he also had rare exposure, through the Shchukin collection, to his explosive breakthroughs before the war. ("The early Picassos are particularly valuable historically," he had written in his Moscow diary. "The development of cubism is here better illustrated than anywhere else."[14]) Yet even Barr knew little about Picasso's recent work. Crucial paintings were hidden in private collections in Europe; and as in Quinn's time, many others remained in the artist's personal possession. Above all, he had never met Picasso and had no particular sway with Paul Rosenberg. To have any chance of success, he would need the support of both.

23

"WHEN A PICASSO WINS ALL THE RACES . . ."

For the young director of an unheralded foreign museum, the summer of 1930 was not a particularly auspicious moment to attempt a show of one of Paris's most prominent artists. For one thing, in contrast to New York, Paris had been relatively unscathed by the initial months of the international financial crisis, and its burgeoning art scene bore little resemblance to the intimate world that John Quinn had known a decade earlier. Since the midtwenties, an influx of foreign capital, and an unrelenting vogue for modern art, had transformed the city's art quarters into a dense jungle of galleries and elegant shops, and Rosenberg was no longer alone in pursuing a high-end trade in avant-garde paintings. Rue La Boétie itself had become a kind of Gold Coast, with half a dozen major dealers competing for wealthy clientele. "The street has been given over to the most glamorous stores," Tériade, one of the city's leading art critics, had observed.[1] The local art boom added challenges of its own to an unproven New York venture that had hardly any art of its own and no money to buy it.

In theory, Rosenberg should have welcomed Barr's Picasso project. After all, he had been trying to bring the artist's work across the Atlantic—and to prominent American museums—for nearly a decade. But by the time Barr was getting started, Rosenberg was no longer

thinking much about the United States; he was squarely focused on his life in Paris. Since his disastrous effort to show Picasso's work in New York and Chicago in 1923, Rosenberg's ascent had been remarkable. Two years later, he was boasting to Picasso that "all the clients in the world are in Paris and occupy me from morning until night."[2] Soon he had lured Braque and Léger—two of the other leading figures from Kahnweiler's old stable—to join Picasso in his gallery; through the secondary market, he also built a growing inventory of Matisses and Derains. Fueled by the new European market, Rosenberg's dominance over the pioneer avant-garde generation had begun to rival Kahnweiler's monopoly before the war. By the late twenties, his decision to buy up Quinn's Picassos and bring them back to Paris looked increasingly astute. "Five of the greatest names in contemporary art are now on view at the Paul Rosenberg gallery," the critic for *L'Intransigeant* had written the previous spring.[3]

In contrast to his earlier ventures in New York, Rosenberg's activities in Paris had also become extraordinarily profitable. After his first show at the dealer's gallery, Braque bought an Alfa Romeo roadster; with Rosenberg's steady purchases, Marie Laurencin funded an obsession with Chanel couture. With the money he had accrued over the previous decade, Picasso had bought a château in Gisors, north of Paris. And Rosenberg himself had lately acquired a stable of thoroughbreds. "I've bought many fillies this season," he told Picasso. "I now own ten horses."[4]

Nor was it only the French market that Barr was competing against. In Paris, Rosenberg had come to be known as much for his curatorial talent as for his business acumen. Unlike Kahnweiler, Rosenberg was no intellectual. He did not aspire to analyze the sources of Picasso's art or the evolution of Braque's Cubism; he was a man governed by his eye and his shrewd instincts. Yet in more than one way, his innovative shows seemed to anticipate what Barr was trying to do in New York. In a large Picasso exhibition in the midtwenties, Rosenberg had introduced sleek modern picture frames, in place of the ornate gilded frames commonly in use, to give the paintings a clean and uniform setting; like Barr, he also preferred to hang paintings in single rows rather than stacked on top of each other in the traditional manner. And just as the Museum of

Modern Art had set out to do in its first few seasons, he continued to alternate more challenging shows of new art with distinctive presentations of classic modern paintings.

In Paris, Rosenberg was increasingly recognized as a shaper of French culture. Shortly after Alfred and Marga arrived, the critic Louis Vauxcelles wrote a front-page feature in *Excelsior,* arguing that "the most beautiful painting exhibitions of the last few years have been organized by—and at—Paul Rosenberg's gallery."[5] Rosenberg had also been named a Chevalier of the Legion of Honor, an unusual accolade for an art dealer. That same summer, even as Barr was desperately trying to locate paintings for his Corot-Daumier exhibition, the dealer opened a landmark Corot retrospective on rue La Boétie that included a catalog written by Élie Faure, a prominent French art historian, and was considered one of the most important shows ever done on the artist. In early June, the French president and the French secretary of beaux-arts came in person to see it. If Quinn had failed to impress Teddy Roosevelt at the Armory Show, Rosenberg was no longer having any difficulty with the leaders of France.[6]

Yet the greatest obstacles to Alfred's Picasso plans were arguably more personal: Despite such outward success, both Rosenberg and Picasso were going through turmoil in their own lives that had created new tensions on rue La Boétie—and new turbulence in their alliance. First was the matter of Picasso's faltering marriage. The critic for *L'Intransigeant* was not wrong in detecting a current of *romantisme tourmenté,* tormented romanticism, in the new paintings of his that Rosenberg had shown the previous spring. For years, the artist had been unable to reconcile his restless spirit with the expectations of his bourgeois household. As he rebelled, Olga found herself increasingly isolated and abandoned. Her dancing career with the Ballets Russes, which had once taken her all over Europe and North America, had been cruelly ended by a leg injury she had suffered just before their wedding, and she was now virtually cut off from her struggling family in Soviet Russia. She also began to suffer a series of physical and psychological troubles, sometimes spending months at a time in treatment.

As Olga and Picasso's relationship fell apart, she poured her energy into their ruthlessly ordered home—her domain—while Picasso sought

escape in the large studio he began renting on the floor above. They had violent arguments; while she was stirred to fury, Picasso was withdrawn and detached. More and more, he felt trapped in the existence that Rosenberg had set up for him, and he viewed Olga, however unfairly, as the embodiment of all that was stifling him.

Then, in early 1927, he met Marie-Thérèse Walter, a beguiling and very young blond woman of Swedish and German origin, at the Galeries Lafayette. "I am Picasso," he told her. She was seventeen and a half at the time, and he was forty-five; his name meant nothing to her. Nevertheless, she agreed to meet again. "He charmed me," she later recalled. Soon after, she began spending long hours at his studio posing for him, and by the following summer—she later insisted she was eighteen by then—they had begun an intense affair. "He told me that I had saved his life, but I had no idea what he meant," she said.[7]

Today, it is difficult not to view Walter's youth and their extraordinary age difference without alarm. By her own later accounts, she was deeply in love with Picasso, and though he clearly wielded enormous control, their relationship lasted, quite untroubled, for nearly a decade. Even at the time, though, he took unusual care to keep her presence in his life entirely secret. He withdrew almost completely from Parisian life, finding escape in his new passion and the private art it inspired. ("Give me a vision of a new Picasso," Rosenberg wrote him pleadingly in the summer of 1927. But the "new Picasso" was dominated by imagery of a young woman he did not want anyone to know about, not even his dealer.[8]) Having a few years earlier been an almost ubiquitous figure at Diaghilev's ballets and the parties of the beau monde, Picasso had virtually disappeared. "He does not answer letters on principle, and telephone callers are informed that he is not at home," the Count de Beaumont complained, a few weeks before Alfred and Marga's arrival in Paris.[9]

By the summer of 1930—three and a half years into Picasso's relationship with Marie-Thérèse—Picasso was spending less and less time in Paris. That spring, he had purchased a huge, rambling country house, the Château de Boisgeloup in Gisors, forty miles outside of the city. It was run-down and not even heated. But it suited the artist just fine: He would have ample space to pursue sculpture, his new passion, and he

could avoid the endless intrusions of Parisian life. Quite clearly, it was also a refuge from not only Olga but also Rosenberg, who soon began to refer to Boisgeloup as *Bois Jaloux,* the "jealous wood." For long stretches now, Picasso simply vanished from his dealer. ("You seem to have covered yourself in cubist colors that render you invisible," Rosenberg complained in one letter to Picasso, recalling the artist *camoufleurs* of the Great War.) For Alfred, it did not bode well for the show he hoped to pull off in New York.[10]

Nor was Picasso's bifurcated private life the only domestic crisis playing out on rue La Boétie. For all his recent triumphs, Rosenberg faced personal troubles that, in their way, were as complicated as his wayward neighbor's. For years, while he poured his energy into his gallery and his artists, his wife, Margot, had become increasingly discontent. The product of an elevated upbringing, she was eleven years younger than the dealer and strikingly attractive. In Picasso's 1918 portrait of her, she is a radiant young brunette with fine cheekbones, large green eyes, and an elegant Greek nose; despite her loose, informal robe and the young child on her lap, she is wearing a string of pearls and seems exquisitely comme il faut.

But Madame Rosenberg craved a position in society. A lover of opera, she cultivated a large circle of *admirateurs.* "You were beautiful, everyone found you amusing, you were wooed and desired by many men," Rosenberg wrote years later.[11] Initially, she had embraced their life in the art world, but she didn't share her husband's passion for modern art and quickly tired of his all-consuming work habits. Why couldn't they live like their neighbors, the Wildensteins? she asked.

Georges Wildenstein's gallery at 57 rue La Boétie was a late-eighteenth-century neoclassical pile designed by Charles de Wailly, the architect of the Comédie-Française and the Théâtre de l'Odéon. A specialist in expensive Old Master paintings, Wildenstein, like Rosenberg, came from an art-dealing family of Jewish background. But their temperament and character were as different as their taste in art: Rosenberg was small, high-strung, and driven; Wildenstein was large, assertive, and entitled. And while Rosenberg was a man of careful accounts who worked incessantly to the point of endangering his health, Wildenstein led an exuberant social life and managed to stay above the mundane

pressures of the art trade. He was also a decade younger than Rosenberg and owned one of the most successful racing stables in France.

Since 1918, the two men had been in a business partnership to market Picasso's work internationally: While Rosenberg had full responsibility for the artist, Wildenstein provided additional capital and the use of his New York gallery. But the partnership had gone nowhere—it was too soon for Picasso in the United States—and their proximity in Paris exposed other tensions. Wildenstein disdained Rosenberg as a striver who engaged in overzealous salesmanship; Rosenberg regarded Wildenstein as a playboy sustained by his father's large fortune. But that was not how Margot saw it. "Right before her eyes she had the model of the Wildenstein family," wrote Rosenberg's granddaughter, Anne Sinclair.[12]

In an attempt to appease her, Rosenberg resisted his financial prudence and indulged his wife with chauffeurs, cooks, maids, and clothes. He also took her to the fashionable resorts that the Wildensteins frequented. "It's a shallow existence," he complained to Picasso from one resort in the south of France. "Only snobs and we among them. But as you know, it's Margot who likes this." To keep up with the latest tastes, he also undertook frequent refurbishments of their home. "In addition to my work I have to finish the apartment, not for me, but for my wife, because that's what [she] wants," he wrote in another letter to Picasso. And in another, he complained, "Life is monstrously expensive."[13]

To fund their increasingly ostentatious lifestyle, Rosenberg drove himself harder at the gallery, which only increased Margot's unhappiness. Then, to his chagrin, she began to take an interest in the horseracing scene, in which Wildenstein was so prominent. "Margot would like to go to Deauville, I believe, only to see the [grand] prix," Rosenberg wrote Picasso in the summer of 1927. "I will consent, but with regret." Rosenberg had always suffered from delicate health, and soon the growing pressures of sustaining his lifestyle had given him ulcers. By now, though, he was too far in to stop, and resolved to build his own racing stable. He also began using the same celebrated jockey that rode for Wildenstein.[14]

A small but iron-gripped Breton, François Hervé had gained immortality in 1928 by winning the Prix du Jockey Club, the French equivalent of the Kentucky Derby, in a torrential downpour. Wilden-

stein and Rosenberg were soon in intense competition for his talent, and by the spring of 1929, Hervé was racking up victories for both owners. On two April weekends, he rode Rosenberg's Frelon II to victories at the Saint-Cloud hippodrome, west of Paris; then, on the following two weekends, he triumphed on Wildenstein's Kantana at Le Tremblay and Wildenstein's Charlemagne at Longchamp in the Bois de Boulogne. Then, on May 19, Hervé returned to Longchamp to race for *both* owners on the same day, riding Kantana to second place in the fillies' 1,600-meter course, and Frelon II to third in the colts'. For a novice owner, Rosenberg was giving impressive chase.[15]

The climax of the racing season, however, was the Deauville Grand Prix in late August, a glittering international social event whose guest list ranged from Arthur Rubinstein to the Aga Khan. The field included horses from many of France's top stables, including two of the Baron de Rothschild's. But in the end, Wildenstein, who entered three horses, came away with a rare first- and second-place sweep, attracting front-page headlines in Paris. For Rosenberg, who privately hated the Deauville scene, it must have been infuriating: For all his costly investment in horses, he could not, in the end, keep up with his rival. Shortly after the grand prix, he wrote Picasso that racing wrecked his nerves and that he longed to be looking at Picasso's Dinard paintings instead. "I must be going through hell to be happily anywhere but here," he wrote. Nonetheless, he was already planning his next season, suggesting he might name his new horses after his artists. "When a *Picasso* wins all the races," he wrote, somewhat desperately, "it will be excellent publicity for your work."[16]

As he set out to meet Picasso that summer, Barr was blithely unaware of the swirling jealousies on rue La Boétie. Nonetheless, he was instinctively wary of the big Paris dealers, and sought to find a way to Picasso that did not involve Rosenberg. An art purist, he believed, rather naïvely, that the museum could establish itself as an independent authority and keep the Paris dealers at arm's length. He also knew that some of Picasso's most important art was not esteemed by the market at all, and re-

mained unsold in his studio, as it had back when Roché and Picasso had privately selected works for Quinn. The best way forward, then, seemed to be to connect directly with Picasso and worry about Rosenberg later.

At first, the strategy seemed remarkably successful. A few days after his wedding, Barr approached Jacques Mauny, the artist and correspondent for *The Arts* who had visited the Museum of Modern Art the previous winter. Self-effacing and discreet, Mauny got on well with Picasso, and unlike the artist's society friends, remained in frequent touch with him. He told Barr that Picasso would soon be leaving for the summer, but that he would try to arrange a meeting before his departure. To Barr's surprise, Picasso told Mauny he was glad to meet him, and in mid-June, they went over to rue La Boétie.[17]

By the end of the twenties, Picasso's studio had become a disconcerting contrast with its fussy surroundings. Not long after he and Olga had settled in the rue La Boétie apartment, he began to feel stifled in the living room studio, and by early 1924, he was going house hunting with the indispensable Roché and contemplating leaving his dealer's neighborhood altogether. The following year, however, Rosenberg arranged for him to rent a second apartment, directly upstairs from his and Olga's apartment at 23 rue La Boétie, to use as a studio. It gave him new space and freedom, and he quickly transformed it into his private lair.

When they arrived at the fifth-floor studio, Barr found a series of rooms still outfitted with bourgeois moldings, marble fireplaces, and mirrored mantelpieces, and offering striking views, through a series of windows, of chimneys and rooftops receding back to the Eiffel Tower in the distance. But the place was nearly stripped bare of furniture and filled instead with the detritus of Picasso's work: piles of books and old newspapers, brushes, paints, pails, scraps of paper, cigarette butts, old mail—and stacks of canvases. On the day of their visit, Barr must have glimpsed a number of the many paintings that Picasso kept around the studio; perhaps he showed them his *Crucifixion,* a small, remarkable painting he had created that winter—a rare engagement with a religious theme that Barr would come to regard as one of Picasso's most unusual works. ("Its strange mixture of styles, its violent distortions, its richness of invention and the concentrated intensity of its color suggest

that it must have had some special significance to the painter," Barr later wrote.)[18]

For Picasso, the reticent young American must have presented an unusual figure. "In those early years," Marga recalled, "[Alfred] was so singular in appearance, distinguished, dark-haired, quiet, yet with a responsive face and eyes that really took in pictures."[19] It didn't help that Barr spoke very little and that he and Picasso didn't share a common language. Finally, with Mauny translating, Barr asked the question: What did he think about doing a major show of his work at the Museum of Modern Art in New York? Picasso must have been surprised. The new museum meant almost nothing to him. Still, he was intrigued. Following Quinn's death, his youthful fascination with America and Americans had lived on, spurred by his socializing with Gerald and Sara Murphy, the expatriate Jazz Age hosts, on the Côte d'Azur, and through his exposure to ragtime, tap dancing, Louis Armstrong, and other influences. After his earlier failures, he was also anxious for his work to find a larger U.S. audience. To Barr's elation, he was very agreeable to the idea and said yes.

As they left the meeting, Barr's mind was galloping ahead. With Picasso's support, he could now pursue his leading European patron, the wealthy Swiss-German industrialist Dr. G. F. Reber. Since Quinn's death, Reber had acquired a huge number of Picassos through Paul Rosenberg, including several that had belonged to Quinn; at his home in Lausanne, Reber had dozens of works by Gris, Braque, and Léger, as well as Picasso, and his collection itself was a powerful symbol of the extent to which the center of gravity of avant-garde collecting had shifted back to Europe. In addition to having a fanatical interest in Cubism, Reber also admired Picasso personally, and seemed likely to support any show the artist was involved in. Barr's intuition proved correct. When he wrote to Reber, the collector enthusiastically agreed to lend his Picassos to the museum. He also invited the Barrs to visit him in Switzerland before they returned to New York.

At this point, Barr had yet to obtain the support of Rosenberg or any of the other major Paris dealers who handled Picasso's work. Yet already, he felt that an impressive show was taking shape. With Picasso's and Reber's backing, the museum would have access to the artist's vast

personal stock and the greatest collection of his Cubist paintings outside of Russia, which was effectively off limits. On June 17, Barr excitedly cabled to Goodyear: "GREAT PICASSO EXHIBITION POSSIBLE PICASSO LENDING OWN COLLECTION PLUS REBER PLUS PERHAPS ROSENBERG." Goodyear didn't need to be convinced. "THINK PICASSO SHOW MOST DESIRABLE," he cabled back.[20]

For much of the rest of the summer, Alfred would be distracted by the other shows he was planning and had little time to think of Picasso. Before he and Marga returned to New York, however, they decided to make a quick trip to Lausanne. Dr. Reber's house, the eighteenth-century Château de Béthusy, might have come out of ancien régime France: It was situated in a large park in the heights above the city, and surrounded by orderly, tree-lined allées. While the furniture, crystal chandeliers, parquet floors, and Persian carpets were out of another era, the walls were entirely given over to Cubism: A library contained a series of Gris paintings above the rows of books; a music room included Picasso's *Still Life with Fish,* a very large late Cubist work, above the grand piano. There was a huge Léger mural in the dining room.[21] As Reber showed them his collection, they talked about the New York show, and he seemed entirely persuaded. He talked up his close ties to both the artist and to Rosenberg. He also said they could take virtually whatever they wanted from his walls. "REBER ENTHUSIASTIC LENDING THIRTY PICASSOS SUGGESTS NOVEMBER THIRTYONE," Barr cabled to Abbott in New York.[22]

As they left Switzerland, Barr's careful strategy seemed, almost improbably, to be working. At the start of the trip, he had never met Picasso and had few contacts in Paris. Now he was returning to the United States with pledges of support from both the artist and his most important patron to let him do the first Picasso museum retrospective anywhere in the world. Reber and Picasso had even agreed to a schedule, planning the show for the following autumn. It would give Barr more than a year to prepare, and much of the hard work was already behind him. Surely, with such prominent support, Rosenberg would not want to be left out and would lend him the other works he needed; after all, the Luxembourg Museum was not interested in Picasso and not even Rosenberg could stage the kind of show he was proposing.

24

THE
BALANCE
OF POWER

n the middle of June 1931, almost exactly a year after Barr and Picasso first met, a group of Paris's most powerful dealers and their wives gathered for a lavish private banquet near the Madeleine. Wearing evening clothes, they sat at an immense table, set for thirty; the dinner was accompanied by multiple vintages, served in crystal glasses of varying sizes. Surrounding them on every wall of the room, just a few feet behind the chairs, were more than a dozen Matisse paintings—riotous and spare still lifes, vivid portraits, reclining nudes, eye-conquering odalisques. Together with more than two hundred other Matisse artworks, they were about to be featured in a new kind of exhibition, one of the largest devoted to any living modern artist ever held. Neither Picasso nor Barr had been invited, but the gala meal—and the enormous show it celebrated—would have profound consequences for them both.[1]

The dinner was hosted by the owners of the Galeries Georges Petit, a large, storied exhibition hall on rue de Sèze, and it marked a new frontier in the alliance between the Paris art trade and the city's leading artists. Strictly speaking, the Galeries Georges Petit was not a gallery at all, but a for-profit corporation whose shares were traded on the Paris Bourse. In its scale and resources, it dwarfed what even the most ambi-

tious private galleries could do on their own. In fact, it represented a consortium of several of the biggest art traders in Paris and London, and it aimed to transform the way modern art was brought to the public. In essence, the dealers were leveraging their combined market power to assemble huge, museum-like shows of the same artists whom Barr was pursuing in New York. And they were doing so for patently commercial purposes: This was Rosenberg taken to another level.

The guests that evening underscored the ambition of the enterprise. Anchoring one end of the long table was Étienne Bignou, the mastermind of the Georges Petit Corporation and the evening's host, a compact, mustachioed rue La Boétie man who was known as an art market dynamo. Strategically seated among the guests were his business partners, the veteran dealer-brothers Jos Bernheim and Gaston Bernheim de Villers, who had a legendary inventory of post-Impressionist paintings; the organization's artistic director, Georges Frédéric Keller, a powerful international market player of Swiss-Brazilian background; and the British dealers Duncan MacDonald and A. J. McNeill Reid, whose gallery, Reid & Lefevre, was London's leading venue for French modern art. Each of these men had considerable clout of his own, and clients stretching from Central Europe to North America. But here they were joining forces.

At the center of the table was Matisse himself, the man of honor, as inscrutable as ever behind his distinguished white beard and round, thick-framed glasses, an artist literally surrounded by his paintings— and by men who saw them as raw untapped capital. Seated directly next to Matisse, however, was not one of the powerful dealers but a very conspicuous New York couple who had crossed the ocean for the occasion: Chester and Maud Dale.

In the late twenties and early thirties, the Dales were an almost ubiquitous presence in transatlantic high society. Maud Dale was an elegant woman in her fifties who wore cloche hats and haute couture, wrote about art, and organized occasional shows at the Manhattan branch of the Wildenstein Gallery. Chester Dale was a high-flying corporate raider who was seven years younger and several inches shorter than his wife but whose forceful personality, along with his flaming red hair and

strong blue eyes, gave him an outsized presence in any room. In New York, they lived on the top two floors of the Carlyle, the city's most luxurious Art Deco tower; they were known for riding around town in a chauffeured convertible that had been custom-built in Antwerp to Maud's design. (It had a speedometer in the back so she could watch the driver's speed.) For Barr, however, the couple were important for another reason: Chester Dale was a trustee of the Museum of Modern Art.

As Barr developed his plans for a pioneering Picasso show, the Dales should have been indispensable. Though they had been buying art for only a few years, they had already amassed one of the most important collections of late-nineteenth- and early-twentieth-century French modern art in the country. And while their tastes were not particularly adventurous, they had recently taken a strong interest in Picasso's early work. They also had enviable connections in the Paris art market: The previous year, they had dropped some $81,000 at Paul Rosenberg's on a large group of Picassos—an astonishing amount that was nearly equivalent to Barr's entire annual budget. But as the Matisse banquet now made clear, the Dales had other loyalties in play. Alongside his board seat at the Museum of Modern Art, Chester Dale had taken an ownership stake in the Georges Petit Corporation, and far from being an ally of Barr's, he would soon prove to be one of his greatest headaches.

Departing for Europe a few weeks before the Georges Petit dinner, Alfred and Marga had expected to spend much of the summer selecting art for the big Picasso show they were planning for the fall. Amid the growing economic crisis, there was much at stake in the project. During the spring, there had been a new round of U.S. bank failures, and the financial shock was bearing down on the museum. Already the trustees had largely suspended public fundraising efforts, deeming any such campaign tone-deaf; meanwhile, Rockefeller money had not been forthcoming, causing Barr to complain to Abby Rockefeller about her husband's "granite indifference" to modern art. While Barr was in Paris to assemble the coming season's shows, the trustees were trying to come up with a plan just to keep the museum afloat. Citing the "present emergency,"

Goodyear warned Sachs that they might have to "discontinue the activities of the museum entirely." A year and a half after opening, the Museum of Modern Art was on the verge of bankruptcy.[2]

Under the circumstances, Barr recognized that a landmark presentation of Picasso's work would carry special weight. Goodyear had long warned that they had to keep generating "very striking exhibitions" to justify their existence.[3] Given the controversy surrounding the artist's work and Barr's ambitious plan for it, the Picasso show was just the sort of undertaking that could assert the museum's unique value. In interpreting Picasso's work, they would be engaging head-on, for the first time, with several of the centermost currents of contemporary modern art. And the trustees had formally given their assent: The show had already been scheduled and they were now expecting it as the main event of the fall season—assuming Barr could come up with the art that he had promised.

When Alfred and Marga checked in to the Hotel Continental, across from the Tuileries, at the beginning of June, everything seemed to be in place. He already had Picasso's verbal agreement from the previous summer, and during a visit to the United States that winter, Reber had reaffirmed his own enthusiasm for the show and reassured Alfred that the dealers would be forthcoming, too. "We have the support, I believe, of the Wildenstein group, of the Bignou group, and I hope of Paul Rosenberg, so far as the great dealers are concerned," Alfred had written a few weeks before they left New York.[4] Almost as soon as they settled in, however, Alfred discovered how naïve his assumptions had been. First was the problem of Picasso himself. It was not a question of how many works he was willing to lend them; the artist could not be reached. He did not return messages and calls at rue La Boétie; he seemed to have disappeared. In fact, by now, Picasso was spending most of his time holed up at Boisgeloup, and when he did come back to Paris, he kept an extremely low profile.

Uncertain what to do, and increasingly concerned, Barr cabled Reber in Lausanne. It turned out that Reber had not had further talks with Picasso as he had promised in New York that winter. But with his usual confident manner, he offered to come to Paris immediately to work

things out. Soon after he arrived, Reber did make contact with Picasso. But Picasso was apparently distracted and over the next week he failed to make much progress. By now, Barr was getting anxious; the summer was advancing, and they would not be able to make arrangements with other lenders until they had spoken to the artist again. Still, he had the artist's earlier agreement, and there was no reason to doubt that they would eventually pin him down.

Meanwhile, the Matisse exhibition had opened at the Galeries Georges Petit and was quickly becoming one of the most talked-about events of the season. Featuring 141 paintings and 100 drawings, the huge survey was virtually unprecedented for a living painter; it also was the first Matisse show in Paris in twenty years. Despite his general withdrawal from public life, Picasso was a conspicuous presence at the show, attending the opening and attentively taking it in. Some critics were dismissive of the dealers' selection, which seemed to emphasize market-friendly works, but in size alone, it was difficult to ignore the commanding statement the show seemed to be making. "It not only confirms the reputation of a painter, that is, of a great painter," Tériade, the prominent art critic, wrote in *L'Intransigeant,* "but also that of a whole epoch of passionate experimentation."[5]

Finally, around June 20, Reber succeeded in having a longer meeting with Picasso. The artist said nothing about the Matisse show, but he was suddenly very definite about the Museum of Modern Art. Under no circumstances, he now told the collector, would he take part in a New York exhibition during the coming year. He was working on an important body of new work, he said, and he needed to complete it before anything else. As Reber recounted the meeting to Barr, he tried to reassure him. Picasso was merely postponing, he said, and would be glad to do the show later. But Reber said he couldn't lend any of his own paintings to an exhibition that Picasso did not support. Then he returned to Lausanne.

Barr was blindsided. It was just months before the most important show he had ever attempted was supposed to open, and he had now lost his two principal backers. Without Picasso, they would not have the sculptures and collages and many other crucial paintings he kept in his studio. Without Reber, they would lack many of the Cubist works that

Barr considered essential to any serious presentation of his art. And if Picasso was against it, Rosenberg would most certainly refuse as well. For all of his carefully laid plans, the show was off. Now he would have to face his trustees, who were expecting the show to anchor the fall season. Indeed, Goodyear himself was on his way to Paris to meet Picasso and help make the final selection of paintings.

As Alfred considered what to do, he was struck that Picasso's attitude had turned sharply. At the same time, he and Marga had been making frequent visits to the Matisse show and observing its dealer-driven approach and the extraordinary attention it seemed to be stirring up. Turning over the situation in his head, Alfred realized that it might not only be Picasso's new works that were keeping him from committing to a show in New York: There was also Matisse. For more than twenty years, the two artists had had an almost symbiotic rivalry, with each often responding to the other's latest challenge. As long ago as the spring of 1907, Picasso had taken the *Demoiselles* in a radical direction in part to respond to Matisse's notorious *Blue Nude*. For Picasso, seeing the huge Georges Petit exhibition—and the way it seemed to crown Matisse as the presiding eminence of the art world—was too much. Even at Rosenberg's, it had been several years since he'd had a major show of his own. It was silly, childish even, but he could not let such a show stand unanswered.

He needn't have worried. Bignou and his fellow directors at the Georges Petit Corporation were already looking for their next big play, and within days of Picasso's pulling out of the New York plan, Bignou offered him a big show of his own. Picasso readily agreed. Rosenberg was not a shareholder in the Georges Petit Corporation, but he knew Bignou and, amid a tightening art market, would be glad to contribute to a Georges Petit show, which would only give his artist greater exposure. Indeed, Bignou was prepared to let Rosenberg and Picasso have a major part in the show's organization. So Barr was not merely contending with an artist who was not ready. He was also facing a rival institution in Paris whose directors seemed to have considerably more clout with Picasso than he did. Worse, as he soon learned, one of his own trustees was actively helping them.

Among the early board members of the Museum of Modern Art,

none was as flamboyant, or as calculatedly self-interested, as Chester Dale. A self-made multimillionaire who never finished high school, he was an unlikely addition to the museum's board. He had no connection to the genteel world of Blisses and Rockefellers; he also had a volatile personality and a huge ego. Having taken over a number of companies and made them extremely profitable, he had little patience for institutions he couldn't control. The philanthropist Paul Mellon, who later worked with him, considered Dale a "hard-bitten stockbroker with a crisp turn of phrase and a taste for stiff martinis." To Henry McBride, he was simply an *enfant gâté*—a spoiled child.[6] Nonetheless, his large modern art collection made him attractive to the museum, and shortly before the museum's inauguration, Conger Goodyear recruited him to join the executive committee.

For Barr, the Dales were a maddening conundrum. If anyone could bring around Rosenberg, Bignou, and the other dealers to his projects, they could. But they seemed not in the least interested in the museum. Maud aspired to organize her own exhibitions and had little patience for Barr; Chester could not bear to be an appendage to the main forces that governed the museum. Next to the fawning attention they received in Paris, moreover, the day-to-day affairs of a fledgling institution with no money to spend on art held little appeal. As the summer unfolded, Barr began to suspect that the Dales were not only resisting his plans but actively undermining them: If Picasso was being courted by Bignou, then Dale, as his business partner, must have known about it.

Before Alfred could deal with the Dales' insurgency, however, he faced an even more pressing crisis. Already, people in the Paris art world were whispering about his Picasso troubles.[7] He needed a suitably ambitious replacement for Picasso as the museum's main fall event, and it would have to be arranged extraordinarily quickly. Then, one day at the Georges Petit show, he and Marga ran into Matisse himself, who was with his grown daughter, Marguerite. As they chatted, Matisse talked about the United States, where his son Pierre was an art dealer and which he had visited briefly the previous winter. (In New York, he had met the Rockefellers and had been taken aback when Mr. Rockefeller

had told him, politely and in perfect French, that despite his wife's en-
thusiasm, he had no taste for modern art.[8])

As they stood talking in a room full of Matisses, Barr was struck with
an idea. If Picasso was unwilling to do a New York show, why not bring
the Matisse retrospective instead? As a matter of principle, he loathed
the prospect of a show that originated with dealers: The museum's mis-
sion was to educate the public, not fuel the market. But Matisse was ar-
guably the one artist who could stand up to Picasso, and he knew that he
could significantly improve on the Paris show with his own, far more
rigorous selection of art. Matisse was delighted. He had not been happy
with the dealers' selection in Paris, and even feared that the show had
over-tamed him and tarnished his reputation. He looked forward to
Barr's corrective. Even Bignou was happy to help: A show that had
begun at Georges Petit and that would expose Matisse to new buyers in
the United States could only be good for him.

Still, before Barr could start the plan he needed the approval of his
trustees, and he knew any delay, at this late stage, would be fatal. He was
confident that Goodyear would support him, but he needed Abby
Rockefeller's approval to be on firm ground. On June 25—just five days
after Picasso's final meeting with Reber—he dashed off a terse cable to
the Rockefeller summer compound in Seal Harbor, Maine: "PICASSO
POSTPONES SUGGEST MATISSE . . . ARE YOU FAVORABLE." In fact, Rockefeller
was in New York City at the time, and the cable, after reaching its initial
destination, had to be rerouted to the Rockefeller townhouse on West
Fifty-fourth Street. When it was delivered, though, she immediately
concurred: If anything, she was more comfortable with Matisse at this
point than Picasso.[9]

It was an improbable rescue. Within days of being rejected by Pi-
casso, Barr had lined up the other towering figure of the Paris avant-
garde to take his place. The museum would get its first great one-man
exhibition after all, a chance to present a full-scale appraisal of an artist
whom Barr regarded with virtually the same reverence as Picasso. As
early as 1925, he had identified the two artists as leading two opposing
strands of modernism; now he could attack the Matissean strand with
the same clarifying authority he had envisioned for Picasso. So deft was

his countermaneuver that decades later, Matisse's own biographers were apparently unaware that the landmark show had materialized only as a hasty, last-minute substitute.[10]

As the summer progressed, the show came together with remarkable speed. Unlike Picasso, Matisse was businesslike and organized, and exceptional paintings were not difficult to get. They had far more works than they needed from the Georges Petit show, and they were supplemented by crucial works from Matisse himself, and from other collectors in the United States, Germany, Britain, and elsewhere. Barr didn't even mind that the Dales refused to lend three of the four Matisses that they had included in the Paris show.

While restricting the presentation to just seventy-eight exceptional paintings—about half the number included in Paris—he sought to offer a far more convincing view of Matisse's evolving art. Unlike the dealers' show, he would give prominent emphasis to early Fauvist works and the austere wartime paintings, including the disconcerting *Blue Nude* (1907)—one of the Matisses that had provoked art students to riot in Chicago nearly two decades earlier—and the boldly abstract *Moroccans* (1916), which Barr considered among Matisse's "most magnificent achievements." He also traced the artist's experiments in other media, including eleven striking bronzes spanning multiple phases of his career.[11]

By the time the exhibition opened in New York that fall, hardly anyone seemed to be thinking about Picasso anymore. Elegant, carefully distilled, and provocative, it was a formidable demonstration of Barr's show-making talents, and it met with mostly rapturous praise. As usual, Marga assisted in crucial ways: Along with Alfred's incisive introductory essay, the show's catalog, bound in simple pale-red cloth, included her fluid translation, the first in English, of Matisse's "Notes of a Painter." ("I am unable to distinguish between the feeling I have for life and my way of expressing it," he wrote.) The contrast with the Georges Petit retrospective was not lost on astute observers. "When you see this show, you get a far greater shock than you did in Paris," McBride wrote, in his New York *Sun* column. Matisse was not there to see it, but his art dealer son Pierre seemed to agree. "Barr has done his best and succeeded beyond my hopes," he reported to his father.[12]

. . .

If the Matisse exhibition had redeemed the museum for the time being, however, Barr could not let go of the events of the summer. He was determined to resume his Picasso campaign, and it was now clear to him that it would be far more difficult than he had anticipated. The artist's abrupt withdrawal had given him a new understanding of the dealers' influence, and—combined with their rival Matisse exhibitions—he began to sense that he was engaged in a larger struggle with the Paris market over modern art and its international public. As he had explained to Reber, Bignou had earlier been prepared to support the museum's Picasso show, because he thought the museum had Picasso and Reber on its side, and he had lacked time to "organize his forces." Once Picasso postponed, however, he was prepared to form a "temporary coalition" with Rosenberg—perhaps "on neutral ground," Barr speculated—in order to "secure the balance of power." The museum, with meager resources and no collection of its own, was at a distinct disadvantage from the Georges Petit Corporation and its powerful alliances. But Alfred had recently read Liddell Hart's *Decisive Wars of History,* with its theory of nimble, indirect warfare, which he debated at length with Philip Johnson. ("Strategy and battles interest them both," Marga observed.) He believed the museum had strategic advantages that could work in its favor.[13]

In mid-December, about a week after the Matisse exhibition closed, he drafted a formal invitation to Picasso to take part in a large-scale show at the Museum of Modern Art. In a calculated play at the artists' rivalry, Barr called attention to the Matisse exhibition, noting that the museum had organized it only *after* Picasso had postponed, but that nonetheless the show had been a *succès distingué,* a "distinguished success," impressing critics and drawing more than thirty-six thousand visitors. Even so, he continued, this was only a prelude to the *succès éclatant,* "explosive success," that the museum was certain now of bringing Picasso. Finally, he stressed that Picasso's work was far too little known in the United States and had never been properly presented. Clearly, he hoped that the one-upmanship between Picasso and Matisse

might work as well in New York as in Paris. If Picasso declined, he implied, Matisse would be allowed to dominate the American field.[14]

But the letter was never sent. While Barr awaited Goodyear's approval, the museum received confirmation that Bignou was going ahead with a huge Picasso show in Paris that spring, presumably backed by Rosenberg and Dale: a timeline that would preclude the museum doing a show first. For Barr this left the museum in an impossible situation: If it followed the Georges Petit show for a second year in row, it would give the impression that the Paris dealers were controlling the museum. Sharing Barr's concerns, Goodyear called Dale and told him that if the Georges Petit Corporation went ahead with its Picasso show in the spring, the Museum of Modern Art would regard it as an "unfriendly act." Dale responded by resigning from the board. To Barr, it was clear that the dealers had won. Despite all of his efforts, the Georges Petit group was preempting the museum with its Picasso show, and there was nothing that he or Goodyear or anyone else could do to stop it.[15]

Barr's views were not universally shared, however. In fact, except for Goodyear, the trustees did not see significant problems with doing Picasso in New York after the Georges Petit show. After speaking to Sachs and Rockefeller, Goodyear told Barr that "they both feel that . . . this would not really matter to us." Evidently, as collectors, they did not share Barr's curatorial purism and his skepticism of the art market; they also were far less sensitive to the extraordinary power that men like Bignou and Rosenberg had accrued over Europe's leading artists. By now, Barr himself, beleaguered by the negotiations, was willing to concede that they might have to give in to the dealers and let them go first.[16]

But in the end, even that proved impossible. What finally turned the trustees against the Picasso project was not the Paris dealers but something far closer to home: the global financial crisis. Faced with an increasingly dire economic outlook, the trustees were desperate to shore up the museum's finances and avoid unnecessary risks. Despite the success of the Matisse retrospective, the prospect of another show that relied overwhelmingly on loans from Europe and would be expensive to produce began to seem ill-considered. Finally, in late January, they delivered their stark decision. As Barr dutifully explained in a formal letter

to Picasso, "The president and officers of the Museum of Modern Art asked me to inform you, with regret, that it would be scarcely advisable and practical to organize this exhibition in New York, whether at the museum or anywhere else, during the financial crisis, which has become much more severe over the past year."[17]

He hoped the museum would be able to resurrect the show "in the future," he added, but the overall message was unmistakable. The project was indefinitely shelved. Privately, Barr was shattered. After nearly three years of struggle, his effort to stage a landmark Picasso show had come to nothing. Bignou had outflanked him, Dale had sabotaged him, Reber had proven unreliable, and Picasso was indifferent. Then his own trustees had given up on him. It would go down as yet another in a now long list of failed attempts to bring Picasso's art to the United States. Meanwhile, Barr had alienated his trusted Paris intermediary, Jacques Mauny, who felt personally disgraced by the affair. "I have even avoided to see Picasso ever since," Mauny wrote him that spring, "and I understand that you should be relieved in not having to continue the very unpleasant intrigues of last year." Barr was not at all relieved. Nor were Mauny's closing words reassuring. "You cannot be entirely free from the influence of French dealers," he said.[18]

25

DEFEAT

*I*n the weeks and months after the collapse of the Picasso show, Barr was not himself. He had always been physically delicate, but now his cheeks were sunken and his eyes were stinging and red. Unable to sleep, he was overcome with exhaustion; he complained to Goodyear that he was finding it difficult to work. By late spring, he was barely able to get through lunch with his old mentor, Paul Sachs. In a private note to Goodyear, Sachs warned that Alfred looked like he was "on the verge of a nervous breakdown."[1]

By early June 1932, Abby Rockefeller was so alarmed by his appearance that she sent him to her personal physician. After a thorough examination, the doctor found nothing wrong with him "organically"—the language at the time for a physical ailment. Observing his symptoms, however, he could not rule out other issues and referred him to a nerve specialist. Following his own analysis, the specialist delivered a sobering, if vague, diagnosis: Alfred was suffering from acute nervous exhaustion. He ordered him to stop working immediately and put him on Sandoptal, a recently introduced barbiturate. He also recommended that he take a full year of rest. Alfred was shaken but did not dispute the findings. "I think probably he is right," he told Rockefeller.[2]

For the trustees, it was a fraught situation. Since the museum's

founding two and a half years earlier, Barr had been the guiding force behind almost everything they did. He had come up with the shows, found the art, mounted it, distilled it for the public. It was overwhelmingly owing to his uncompromising standards and his genius for presentation that the museum had stood out from almost any other gallery at the time, even when it was showing Daumiers and Cézannes. Working on the fly, without art or an endowment, he had produced an astonishing sixteen loan exhibitions, nearly all of them well received, a number of them considered groundbreaking. It was hard to imagine going on without him. As Rockefeller herself said, "Alfred *is* the museum."[3]

The Depression was also in full swing and the financial pressures on the museum continued to grow. That spring, they had left the Heckscher Building and moved into a vacant five-story Rockefeller mansion on West Fifty-third Street, which provided both more space and a considerably cheaper annual rent of $8,000. (With the property not earning any income, John D. Rockefeller, Jr., was glad to offer his wife a heavily discounted lease, though he would not make it available for free.) Nonetheless, the operation was as precarious as ever. Abby Rockefeller was shocked to learn that Barr could pay his assistant just $20 a week; many of the staff, like Philip Johnson, worked without a salary at all. The prospect of paying Barr to be on leave would be a major commitment; they would also have to gamble that he would be fit to return to work once the year was up. With misgivings, they finally decided to send him home at half salary, in the hope that the remaining half would be enough to pay for a temporary replacement.[4]

The causes of Alfred's precipitous decline were complex. Partly, he was overcome by a nagging sense of professional failure. Despite the acclaim the museum had received, his own view of its future was bleak. Until now, he had often felt himself catering to his trustees, and very little of his own larger vision for the museum had been put into place. In painting and sculpture, they had yet to examine Cubism, let alone such recent tendencies as Surrealism or Constructivism. They had also ignored film, industrial and graphic design, theater, and photography—areas of ex-

plosive innovation that he had already introduced to Wellesley under-graduates in the late twenties. More daring art could be seen in many New York galleries.

Even more disheartening was the question of a permanent collec-tion. With the dispersal of John Quinn's paintings and sculptures loom-ing over the museum's founding, Alfred had long assumed that reassembling a defining sequence of modern masterworks would be one of his most important tasks. Tantalizingly, the initial makings of such a collection had finally come into view. The previous winter, Lillie Bliss had died, leaving her twenty-six Cézannes, along with paintings by Degas, Seurat, Toulouse-Lautrec, and a small number of works by Derain, Matisse, and Picasso, to the museum. Although there were few avant-garde paintings among them, Bliss allowed that they could be traded for others, and the collection would provide a distinguished foundation. Yet the museum was unable to claim the paintings, because of a seemingly insurmountable condition Bliss had placed on them: The trustees first had to raise a $1 million endowment. Bliss had rightfully judged that the museum needed to get on sound financial footing, and she viewed her paintings as a spur. But she had not anticipated the grav-ity of the Depression. As it was, the museum could barely afford its cur-rent operations.

Above all was his failure to bring off the Picasso show. Bringing to-gether, for the first time anywhere, the high points of Picasso's thirty-year career, the show would have been a defining statement of the museum's ambition to bring the story of contemporary modern art to the world. Even without Picassos of its own, the museum would have been able to assert itself as the leading interpreter of the most conse-quential artist of the twentieth century. Instead, Alfred had been played by the dealers and then routed by the museum's own financial weakness. And with their new austerity, it was unclear when he would be able to attempt such a show again. So much did the Picasso business weigh on him that spring that Marga was fearful of bringing it up.

And yet Alfred's debilitating depression was also driven by a more personal crisis. A few weeks after the Picasso show was canceled, Jere Abbott was offered a job at another museum, and the trustees, anxious to save money, encouraged him to take it. In fact, Abbott was leaving to

become director of the Smith College Museum—the same position that Marga had turned down eighteen months earlier. The irony could not have been lost on any of them. Even if pushed by the trustees, here was Abbott jettisoning Alfred to have a career of his own, while Marga had given up that very path in order to support him and his museum. For Abbott, Alfred's marriage seems to have become a growing obstacle in their relationship, and he evidently decided it was time to go his own way.[5]

Caught by surprise, Alfred was devastated. For nearly six years, Abbott had been an essential part of his existence. They had roomed together at Harvard; taught classes together at Wellesley; traveled all over Europe together; and jointly brought the Museum of Modern Art to life. It was Alfred who had persuaded Sachs to admit Abbott to Harvard's graduate program in 1926, Alfred who had persuaded Abby Rockefeller to hire Abbott as his deputy at the museum three years later. For his part, Abbott had had an almost reverential attachment to his brilliant friend. At one point, when Alfred was struggling financially and Abbott was supporting him, Abbott had written to his father, "I look upon paying his share of the rent as a sort of monetary compensation for his company, we get along very well together, his ability, much greater than meager mine, which I draw on continually, and his kindnesses in introducing me where the entre [sic] might have been difficult."[6] It was a personal and intellectual bond that in crucial ways seemed to capture an unresolved tension in Alfred's own life.

Until his marriage, some of Alfred's Harvard friends found his sexual identity ambiguous. At Wellesley, where he was only a few years older than his students, many of the coeds swooned over him, yet his own social circle was overwhelmingly male and gay. Philip Johnson was particularly close; he addressed Alfred as "Alfo" and signed his letters "love Pippi." Other gay friends included Henry-Russell Hitchcock, the architectural historian; Cary Ross, who had quickly become an indispensable extra hand at the museum; the composer Virgil Thomson; and Lincoln Kirstein, the brilliant editor of *Hound & Horn* and co-director of the Harvard Contemporary Art Society. For his part, Abbott was not openly gay, but he showed no interest in women; he and Barr also seemed to be more than friends. Hitchcock, observing the two men, referred to

what he called *"cette étrange ménage"*; Johnson regarded Abbott as Barr's fidus Achates, his faithful disciple. There is no indication that the relationship was anything but platonic, though it clearly carried special significance to both.[7]

Marga's own partnership with Alfred was hardly ordinary. They were deeply devoted to each other, and at the museum, he quickly came to depend on her social instincts and multilingual diplomacy. But there seemed to be little room for intimacy in their life, and they often spent significant time apart. Just weeks after their wedding, Alfred sent Marga to Rome to visit her mother while he made his scouting trip to Germany, for the German modernism show, in the gregarious all-male company of Johnson, Hitchcock, and Ross. ("Cary's marvelous to me and so is Phil and Russell like a big affectionate elephant! But oh gosh!" he wrote Marga from Berlin.[8]) If nothing else, it was a curious way to spend one's honeymoon. While these men were not anything more than close friends, they suggest an underlying dissonance in Alfred's emotional life that continued well into his marriage. Now, eighteen months later, as the Picasso show unraveled and Abbott left the museum, Barr seems to have found conjugal relations something of an ordeal.

A year after his health crisis began, Alfred alluded to his troubles in a long letter to Marga, who had, for the second summer in a row, gone to Europe on her own. At the time, he was convalescing at his parents' cabin in Greensboro, Vermont, where he socialized frequently with an attractive young woman they knew named Virginia, who was staying nearby. "I see . . . a great deal of [her] in one sense for we bathe naked at night often," Alfred wrote. "She has as you say a nice torso and very pretty breasts." Virginia was insistent on their swims, and he suspected that Marga had encouraged her. "Did you tell her to seduce me you serpent?" he wrote. Still, he wrote that he was unable to respond, or even to feel any desire to do so. Tormented by his inadequacy, with Marga or any other woman, he released Marga from any obligation of constancy. "I do not acquit myself so nobly as during those sweet nights on Madison Avenue," he told her. "This is partly due to a state of general fatigue which I may never conquer—and partly due to incidental circumstances."

If Alfred was trying to restore his energies in nightly exhibitionist

swims with Virginia, he seemed immune to the satyr-like urges that were, in those same years, spurring Picasso to new heights in his remarkable bather paintings, inspired by his secret trysts with Marie-Thérèse on the beaches of Dinard. The sensual world that Barr found so powerful in the art of Picasso seems to have been, in his own experience, more of a test of manhood in which he sensed his own shortcomings and emotional detachment. "If I could achieve the unfaltering vigor of Priapus himself," he wrote Marga poignantly, "it would not be for my own sanity or pleasure, but because your ecstasy in my arms is sweet to me beyond anything."[9]

Whatever the causes of Alfred's ravaged psyche, he could not escape Picasso. As he began his leave of absence in June 1932, he had resolved to go to Greensboro to get away from the stresses of New York while he adjusted to his new regime of sleeping pills and rest. But on June 16, almost at the same moment he stopped working, Bignou and Rosenberg opened their huge Picasso retrospective at the Georges Petit gallery in Paris—the show that had defeated his New York plans. Like the Matisse show, the dealers had launched it with maximum éclat, and the European press had exulted over the show's immensity and sweep. (Seeking to outdo Matisse, Picasso had characteristically made his show even larger—with 225 paintings in all—and taken a far more direct involvement in its installation.) For Alfred, it was a fresh reminder of his struggles of the previous year, but it also was an event he knew he should be witnessing. Quite apart from the opportunity to gauge the enemy's capabilities, it would provide crucial insights into Picasso's most recent work. He also knew that it would be vital, for any future campaign, for the museum to assert its presence and connect with the various players in Picasso's orbit. Somehow he needed to be there, but any trip, under the circumstances, was out of the question. Then he had an idea: Marga. *She* could go. They were already talking about spending some of his leave in Europe, when he was strong enough to travel, and if she went immediately, she could catch the final days of the show while he rested in Vermont.

With almost no time to plan, Marga locked up their apartment and

embarked for France. It would be up to her to represent the museum in the Paris art world, alone and without any official title. In part, she was thrilled by the opportunity. She was always much happier in Europe, and liberated from Alfred, she would be able to deploy her considerable charm and exercise her own judgment. Crossing on a large French liner, she reverted to her old social self, talking her way into the first-class lounge, where she caught up on art gossip with wealthy Americans and had long conversations with a cultivated French shoe merchant about Virginia Woolf and Katherine Mansfield. She also played deck tennis with a group of strapping young Parisians who were on their way home. ("How anxious these 3 tennis partners are to pay for my drinks which amount to 1 lemonade a day," she reported to Alfred.[10])

Yet her work in Paris required subtle diplomacy, and she had left in such a hurry that she had not had time to discuss strategy. Somehow, she would have to cover for Alfred, avoiding talk of his illness and the museum's precarious finances, while exploring future possibilities with the dealers. Moreover, the museum was not paying for her trip, and she would have to cut corners as much as possible. To save money, she was staying in the apartment of their friend Virgil Thomson, and when she decided to buy Alfred the first volume of Christian Zervos's *Complete Works of Picasso,* which had just been released, she wrote that she was avoiding all other luxuries to pay for it. "Please forgive me for having bought this," she wrote him, "I am getting no clothes at all." Above all, she needed to absorb as much as she could from the show itself. "I shall just send you my eyes in an envelope," she promised Alfred.[11]

As soon as she reached Paris, Marga went to the Georges Petit gallery. The show had already attracted enormous attention, and the building was thronged with visitors. As she entered the crowded rooms, though, she was perplexed. There was no apparent organizing principle, and the installation was just the kind of cluttered jumble Alfred hated. The pictures, too many of them, were vertically stacked on the walls; one room had distracting wallpaper that Marga described as "poisonous red." Many of the paintings were in oversized gilt frames. "The hanging is abominable," she wrote.

But then, in the largest gallery, she saw them: some twenty large canvases, all of them painted since the winter. Neither Cubist nor realist,

they were filled with an overpowering physicality; again and again, they depicted an anonymous young woman with bright, shoulder-length golden hair, often in various states of slumber. In many of them, the face and limbs of the woman seemed to merge with the curved armchair and flattened walls of the background with dreamlike power. To Marga, they had a sense of spontaneity that she had never detected in any of Picasso's earlier work. She found them intoxicating. "The effect is lyrical and voluptuous," she wrote. "The colors (soft ones and violent ones in immediate contrast) absolutely new to Picasso."[12]

As we now know, the inspiration for this astonishing new series was Marie-Thérèse Walter. For more than five years, Picasso had kept his lover carefully hidden from the world, and even in the show, her identity remained unknown. Yet for the first time, the public was able to see her image and the exuberant work it had inspired. Holed up in his studio that winter and spring, he had turned out a fresh large-scale painting of Marie-Thérèse day after day, for weeks on end; one of them, titled *Sleep,* he had executed in three hours on a single January afternoon, while she napped in front of him.[13] Though hardly anyone knew about her, Marie-Thérèse's pervasive presence gave the Georges Petit exhibition much of its incandescent power. "He seems to be animated by one of the most creative impulses of his life," Marga wrote.[14]

For nearly a week, Marga went to the Petit gallery every morning, and then again in the afternoon. In the exhibition rooms, Bignou was everywhere, enthusiastically engaging visitors in English and French, in apparent hopes of sales. "Very *gattamelata,*" Marga reported to Alfred—like a honeyed cat. Drawing the dealer out, she learned that it had taken him, Rosenberg, and Picasso a whole week to install the paintings. She ran into Reber, who, despite his promises to Alfred, had loaned numerous paintings to Bignou. She also met Matisse, who had few illusions about the show's true motivations. ("I do not have to respond to Picasso's exhibition," he later told his son Pierre, "since it has been made in response to mine.") Yet on all the days Marga visited, she never saw Picasso himself. "Pic. is away in his chateau," she speculated.[15]

Then, at the end of the run, Bignou invited her to the *décrochage,* the taking down of the show. When she arrived, the gallery was mostly empty, and some of the pictures were already on the floor leaning against

the walls. Eventually she spotted Bignou talking to someone at the other end of the gallery; she recognized the eyes. Waving her across the room, the dealer introduced her to Picasso and then left them alone. "They tell me you are Italian?" Picasso asked her. After a few minutes, he agreed to walk through the show with her. As they entered the main gallery, Marga pointed to one of the new pictures she found most intriguing: *Girl before a Mirror,* a hugely complex image of a woman standing and embracing her own reflection in a full-length mirror. He acknowledged it was one of his favorite pictures but as usual was maddeningly vague about his intentions. She didn't get much further with other paintings. Finally, she told him that his 1932 paintings reminded her of Giorgione, and that she was struck by the "recurrent voluptuousness" of the series, which seemed to please him far more than her other questions.

As they continued through the galleries, she casually brought up the United States. Did he have reservations about America, and would he ever consider visiting? He told her he had nothing against the country but didn't travel much. "I've never been to Germany," he said. Picasso got on well with Marga, an Irish Italian woman with whom he could communicate in French. But she could sense his wariness about the American art world. While they were talking, a woman from the Carnegie Institute in Pittsburgh, known at the time for its forward-looking stance on modern art, approached Bignou. She wanted to know if she could borrow some of Picasso's new paintings for a show she was planning. Bignou pulled Picasso aside, and at a certain point, Picasso looked at him coldly and said, "I will lend her nothing, do you hear? Nothing!" Bignou threw up his hands.[16]

As the *décrochage* wound down, there was still one other person Marga had not yet seen: Paul Rosenberg. As Alfred had predicted, Rosenberg had readily formed an alliance with Bignou and the other dealers of the Georges Petit Corporation, sensing a rare opportunity to show his leading artist on a larger stage. Not only had Rosenberg played a crucial part in the show's organization and contributed more paintings than anyone other than Picasso; he would also soon end up in control of many of the new paintings in it. Yet he was staying away. In fact, he was not even in Paris. "I'm leaving for the mountains," he had written Pi-

casso in an unusually terse message in the third week of July. Then, a few days later, he wrote to the artist again, saying that he was going to Switzerland, expressing regret that he could not see him before his departure, and providing him the name of the hotel that he called "my address for the time being, perhaps for a long time."[17] The two-paragraph letter was somber and precise; there was not a hint of the playful banter and hyperbole that had for years filled his communications with the artist. Rosenberg also made no mention of his family and dropped the characteristic "we" of his other letters; he referred only to himself.

In 1932, the tensions in the Rosenberg household finally snapped. The dealer belatedly discovered that there was something else that had driven his wife's obsession with the Wildensteins and their race horses: Margot had been having an affair with Georges Wildenstein. It was unclear when it started, but Rosenberg seems to have concluded that they had been carrying on for years. "Life became torture for me in 1923," he later wrote, in a handwritten, ten-page letter to his wife he intended her to read after his death. "I loved you with all my heart and felt I was losing you." If Rosenberg was correct, the liaison may have begun as early as his first trip to the United States, the two disastrous months he had spent in the fall of 1923 in New York and Chicago, when the dealer was collaborating closely with Wildenstein. While Rosenberg had been having his unsuccessful Picasso show at Wildenstein's New York gallery, Wildenstein was in Paris seducing his wife. As the relationship developed, Wildenstein apparently promised Margot he would marry her if she left her husband.[18]

Now, amid Picasso's greatest public triumph in Paris, Rosenberg had fled the city shaken and distraught. He immediately broke off his business alliance with Wildenstein and vowed never to speak to him again. Margot wanted a divorce, and the Rosenberg children were sent away to stay with relatives. Yet Rosenberg knew he could not walk away entirely: There were powerful social and family considerations in play, and even his own future in the art world was at risk. Under French marriage law, all property was shared equally; a divorce would tear apart not only his family but also his gallery and his personal art collection, on which his fortune, and his whole identity, rested. It would threaten everything

he had built, including his costly stock of Monets and Renoirs and Van Goghs, as well as his Picassos, Braques, Légers, Matisses, and other works. (In one dark interpretation of the affair, such a division of assets may have been exactly what Wildenstein intended: If he could get Margot's share of the Rosenberg gallery, it would dramatically expand his reach into modern art.)[19]

In the end, the Rosenbergs reached an icy détente. Margot gave up Wildenstein but refused, from that point on, to have any part in her husband's life in the art world; they would live apart together. Even without a divorce, though, there were far-reaching consequences for Rosenberg. In particular peril were his efforts in the United States, where he had founded a joint partnership with Wildenstein—the company that John Quinn had incorporated for him in 1923. After the exposure of the affair, the former business partners divided up their paintings and Rosenberg eventually bought out Wildenstein's share in the company for $200,000. But the rupture with Wildenstein also meant that he no longer had use of the Wildenstein Gallery in New York, which had been the cornerstone of his American strategy.[20]

Now Rosenberg would have to find new ways to reach the American market. Meanwhile, the Depression was belatedly reaching France, and he was selling hardly any paintings. Forced to cut back on the extravagant lifestyle he had led in the late twenties, he gave up his thoroughbreds; for the time being, it was all he could do to protect his inventory. The dream of an *écurie* Rosenberg had died almost as quickly as it started, without a Picasso ever getting to the starting gate.

In Paris, Marga knew as little about Rosenberg's troubles as she did about the identity of Picasso's mysterious muse. But as she quickly learned, the first great museum show of Picasso's work was not going to happen in New York, or anywhere else in the United States. It was taking place in Switzerland. While the Paris show was running, Bignou arranged to take it to the Kunsthaus Zürich, one of Europe's leading modern museums, that fall. Evidently, the Swiss shared none of Barr's qualms about ceding creative control to art dealers. As soon as she heard about it, Marga begged Alfred to come see it. "If you would only go to Zurich you could write the one fundamental article on Pic of the year," she wrote. "But what can I say? You must rest."[21]

26

"MAKE ART ... GERMAN AGAIN"

Two months after her own hurried departure, Alfred joined Marga in Europe, where they intended to spend the remainder of his yearlong recovery. In the early thirties, the sanatorium movement was at its height, and for a connoisseur of modernism with obscure health problems, the Continent offered any number of new treatments, often delivered in elegant, spa-like institutions. A year earlier, the white-painted, light-filled Zonnestraal Sanatorium, built in the Dutch town of Hilversum, set a new standard for high-modernist healthcare, while Alvar Aalto, the Finnish architect, was just completing his own elegant contribution to the genre in his campus for tubercular patients in south-western Finland.

Indeed, many modern artists, writers, and their patrons had spent time in restorative clinics. T. S. Eliot composed much of *The Waste Land* while recovering from a nervous condition in Lausanne in 1921; members of the Bauhaus had gone to the mountains above Lake Maggiore. Franz Kafka had multiple stays in sanatoriums in Switzerland, Germany, and Austria, as he experimented with various open-air therapies. Paul Rosenberg, with his ulcer, was constantly seeking "cures" at Vittel and other French and Swiss retreats. Some Europeans, à la Hans Castorp, the young engineer of Thomas Mann's *Magic Mountain,* seemed never to leave these facilities. Among the benefits of these sojourns—

along with up-to-date care, innovative diets, ample sunlight, and pristine outdoor settings—was the chance to escape the stresses and pressures of ordinary life, to go somewhere that was apart from the world.

For Alfred, however, very little of this medical culture was within reach. He and Marga were on an extremely tight budget, and sanatoriums were out of the question. So Marga was relieved to discover that a bottle of Sandoptal—Alfred's sleeping pills—cost half as much in Switzerland as in New York. In an effort to economize, they decided to spend the fall in Rome, where they could live with Marga's mother; perhaps later, they would seek treatment for Alfred in Austria or Germany. But quite apart from money, neither Italy nor the other countries they visited in the fall and winter of 1932–33 would offer much of a respite from world events. In a curious echo of Alfred's trip to Soviet Russia five years earlier, he and Marga soon found themselves witnessing one of the most violent upheavals in art and politics of the twentieth century.

Landing in Naples in late September, Alfred's immediate priority was not his health but seeing the second iteration of the huge Georges Petit show, which had just opened in Zurich. For Alfred, the experience was tinged with irony. Echoing what the Museum of Modern Art had done with Matisse, the Kunsthaus Zürich had taken the dealers' Picasso extravaganza but made it substantially its own, with a new, coherent arrangement and enhanced choice of works. It also employed a sleek, modern installation, featuring works hung in a single row at eye level, on clean white walls. There was a strong treatment of Cubism, and the show provided a balanced, if at times bewildering, view of Picasso's career.

It was not without flaws. As in Paris, crucial works such as the *Portrait of Gertrude Stein* and *Les Demoiselles d'Avignon* were missing and there were only four sculptures, all of them from the early years of his career. Moreover, as at the Georges Petit gallery, many of the works were for sale, and the commercial underpinnings of the show were apparent. In the show's catalog, Alfred ruthlessly penciled in letter grades for many of the paintings, giving out numerous B minuses and even a

few C's and D's, notably for some of the more conventional Blue period works. Out of the 221 oil paintings in the show, only 26, or less than 12 percent, merited A's, a select group that included a nude from the *Demoiselles* period, several Cubist still lifes, the two versions of *Three Musicians,* and *Girl before a Mirror.* (In Alfred's anguished state, even *The Three Dancers,* a crucial 1925 painting that he would come to regard as one of Picasso's most important works, achieved only a B plus.) Nonetheless, he could see that by collaborating with Bignou and Rosenberg, the Zurich museum had come close to doing what he had long been aiming at in New York.[1]

It was hard not to feel that he had been twice defeated: by the dealers in Paris and by the museum in Zurich. Now he would have to come up with something quite new if he were to attempt Picasso again. When Goodyear wrote to him a few weeks later, suggesting that they try to revive the Picasso project in 1933, Barr rejected the idea. "Do not think I have my heart set on a Picasso show next year," he wrote back. "It is quite probable that he is the most important living artist—but for that very reason both he and the Museum can afford to wait."[2]

In another way, though, the Zurich show seemed to mark a turning point in the status of the modern avant-garde in German-speaking Europe. On the one hand, it was a triumphant demonstration of continued Central European leadership in modern art, with the show organized by a Swiss museum and drawing on loans from Reber and other Swiss and German collectors, as well as on the Paris dealers and Picasso himself. Attendance was record-breaking, and several other museums in Germany and Switzerland tried, unsuccessfully, to take over the show when it closed.

Yet critical reaction was far from uniform. One local newspaper criticized Picasso as "typically bourgeois and decadent" and faulted the city for subsidizing it.[3] Then, at the end of the show's run, the renowned Swiss psychoanalyst Carl Gustav Jung wrote a lengthy attack on Picasso's art in the *Neue Zürcher Zeitung,* the city's leading paper, in which he diagnosed the artist as suffering from a mental disorder. "Based on my experience," Jung wrote, "I can assure the reader that Picasso's psychic problems, so far as they find expression in his work, are strictly analo-

gous to those of my patients." In Jung's turgid assessment, Picasso "follows not the accepted ideals of goodness and beauty, but the demoniacal attraction of ugliness and evil." The artist, he concluded, was afflicted with schizophrenia, characterized by his "paradoxical, unfeeling, and grotesque unconcern for the beholder." In such multiple-perspective works as *Girl before a Mirror,* Jung detected "lines of fracture" that apparently represented the diseased "conjunction of the light and dark anima." More broadly, in the strong public response to these paintings Jung detected what he called the "deadly decay" pervading modern society: "Picasso and his exhibition are a sign of the times, just as much as the twenty-eight thousand people who came to look at his pictures."[4]

Jung's article was quickly ridiculed by Picasso's supporters, and many pointed out his woeful ignorance of contemporary painting. Yet amid the psychoanalytical jargon, the attack drew on many of the familiar tropes of antimodernist critics: The new art was a dangerous symptom of deviance and social decline. And with Jung's imprimatur, it carried unusual weight. "A heavy blow has been struck against modern artists in general," one critic wrote. In fact Jung's diatribe was a harbinger of a far more dramatic shift in German attitudes, one that, as Alfred and Marga would soon witness, was about to erupt furiously into the open.[5]

After several months in Rome, Alfred was making only halting progress and retreating often to a dark room they had fixed up for him. "He was always very tired. And high strung," an old friend of Marga's who visited them at Christmas recalled. "Daisy and I would go off on trips. Alfred didn't go around much . . . he was very tired, very tired."[6] They decided to leave Rome and spent several weeks in the Tyrolean Alps, where Marga valiantly introduced him to skiing, but they were concerned that his sleep wasn't improving. Alfred considered continuing to Vienna for Freudian therapy. "European acquaintances feel that psychoanalysis is a natural step in curing insomnia if there is no apparent physiological cause," he wrote to a somewhat horrified Abby Rockefeller in early February. But then, in Alfred's beginner ski class, he met a Ger-

man woman who recommended a prominent "analyst doctor" in Stuttgart. Known for his innovative treatments for unusual disorders, Dr. Otto Garthe had recently cured a prominent violinist of stage fright; the woman was certain he would be able to "de-exhaust" Alfred. In early February, they decided to take the train to Germany to see him.[7]

At first Dr. Garthe seemed like an ideal solution. A charming, worldly man who was married to a sculptor and knew many writers and artists, he was just the sort of enlightened expert one might have encountered in one of the advanced clinics in Switzerland. He was open to new techniques and had a perceptive understanding of underlying issues; his holistic approach encompassed sensitivity to one's social and physical environment. Aware of their tight budget, he suggested they stay in a modest but well-run boardinghouse run by a woman he knew who happened to have a personal connection to Cézanne; his own house and medical studio was a modernist oasis, with prototype chairs, tables, and rugs by the German design pioneer Richard Herre.[8]

At the same time, Stuttgart offered an attractive setting in which to recuperate. A quiet and orderly provincial capital, the city was not particularly large. Yet it was a hotbed of modernism, filled with the advanced galleries and contemporary design that Alfred had encountered on earlier visits to Germany. In 1913, a local art gallery had put on one of the first shows of Picasso's Cubist work in Europe, arranged by Kahnweiler. By the late twenties, the city had two civic museums devoted to modern painting and one to modern sculpture. It also boasted one of the most advanced hospitals in Europe as well as the renowned Weissenhof Estate, a pioneering housing development featuring the work of Le Corbusier, Mies van der Rohe, Walter Gropius, J.J.P. Oud, and many others. "In the history of post-war modern architecture," Alfred argued, it was "the most important group of buildings in the world."[9]

But there was one thing they hadn't anticipated: the collapse of the fragile social democratic order that had held in Germany since the end of the war. By the start of 1933, after years of economic chaos, the Weimar Republic was in crisis. Along with the Communist left, the right-wing NSDAP, the National Socialist German Workers' Party, had grown rapidly. After weeks of uncertainty, at the end of January, the

German president and former war hero, Paul von Hindenburg, had appointed the National Socialist leader, Adolf Hitler, to head a conservative coalition government in Berlin.

At first it seemed unclear what this meant. While Alfred and Marga were vaguely aware of the NSDAP's extremist rhetoric and reputation for violence, it still commanded only a minority of cabinet seats, and its focus seemed to be on rallying the public. Moreover, they encountered little enthusiasm for the Nazis in Stuttgart. Dr. Garthe and his friends were progressives; Frau Hedwig Haag, who ran their hostel, was a cultivated woman who was interested in modern art. None of their fellow guests seemed to support the party either. The leading local newspaper was staunchly centrist conservative, and the political slogans they encountered most often called for a "strong center."

Gradually, though, the mood of the city began to shift. At the hostel, Frau Haag had just acquired a radio, and many of the guests spent evenings crowded around it, listening to Hitler's speeches. This held no appeal for Alfred and Marga, but they quickly learned to recognize his characteristic, high-pitched staccato and dramatic pauses; they also noticed the effect his speeches had on the other guests. "They cannot get enough of him," Marga observed a few weeks after they arrived.[10] At the end of February, when the Reichstag was burned down, most of the guests, following the Nazi line, assumed it was a Communist plot.

Then the unthinkable happened. Exploiting the atmosphere of terror surrounding the Reichstag fire, the Nazi-led government ruthlessly cracked down on the opposition and, in tightly controlled parliamentary elections six days later, acquired enough of a mandate—44 percent of the vote—to pave the way for a broader seizure of power. Though Hitler still lacked a majority, he was now firmly in control. On March 23, with the opposition largely silenced, he forced through the Enabling Act, allowing him to rule without parliament.

At first, much of the Nazi program remained vague. While the party was known for its virulent anti-Semitism, the Nuremberg Laws were still more than two years away and many German Jews, like other opponents of the regime, assumed that it would not stay in power. Nor had Hitler yet articulated the fully fledged militarism that came into the

open in 1935. Yet the determination to destroy the Weimar Republic was unmistakable from the start. All over the country, communists and socialists were arrested and jailed; even before the Reichstag fire, *The New York Times* had reported on its front page, HITLER PROCLAIMS WAR ON DEMOCRACY.[11]

In Stuttgart, Alfred and Marga were astonished by how quickly the war was won. Immediately, they began to see brownshirts marching in the streets and swastikas hanging from balconies. As they walked back to their pension in the evening, they heard the Horst Wessel Song and the hoarse voices of Hitler and Goebbels blaring from many homes. Suddenly, every shopwindow seemed to have a postcard of the grim-faced Führer giving the Fascist salute. With chilling discipline and efficiency, the new political order was established. "Stuttgart took its revolution very calmly," Alfred wrote.[12]

At least, they thought, they would be able to take refuge in the city's flourishing modern art scene. Just after the Reichstag fire, the Barrs had gone to an important show of paintings by Oskar Schlemmer, Stuttgart's most famous living artist, which had just opened at the Württemberg Art Society, one of the city's main public galleries. Alfred had met Schlemmer at the Bauhaus in 1927 and was excited to see his new work. At the exhibition, he particularly admired a large painting called *Bauhaus Stairway,* an elegant, mysterious tribute to the school, showing balletic, almost ghostlike figures moving away from the viewer as they ascend the glass-fronted concrete staircase of Gropius's Bauhaus building in Dessau. He and Marga liked the show very much, and since it was going to be up for several more weeks, they decided they would soon return.

When they returned to the Württemberg Art Society a few days later, however, they found the gallery transformed. Despite the show's scheduled run, the paintings had all been taken down and the rooms were empty. Finding the director, Alfred asked, "Where are the Schlemmers?" Silently, he led them to the end of the gallery, where he unlocked a door and led them into a pair of back rooms. There were the paintings, carefully stacked up; they could see *Bauhaus Stairway* leaning against a far wall. The director said he had had no choice. The show had

been condemned by the *National-Sozialistiches Kurier,* a leading Nazi paper, in an article that made a barely veiled threat against the gallery. "There is a discussion—so we hear—as to whether the Schlemmer exhibition ought to be hung at all in these times of returning sanity," the critic had written. "This exhibition is doubtless the last chance the public will have to see painted *Kunstbolschewismus*"—Bolshevik art—"at large."[13]

Alfred was shaken. Here was one of Germany's most prominent artists, a painter whose careful geometric works seemed utterly detached from events in Berlin. "It is very difficult to find anything of the slightest political significance in the subject matter of Schlemmer's pictures," Alfred wrote.[14] And yet Schlemmer was being smeared with the same charges used by American opponents of modern art, going back to the time of John Quinn's post-Impressionist show at the Met in 1921. Moreover, unlike in the United States, the attack seemed to be backed by the state—and in a country that had up to now been a bastion of advanced modernism. Seemingly overnight, the National Socialists had taken over the regional government, and the museum director feared he would lose his job if he did not shut down the show.

As Alfred quickly discovered, the censoring of the Schlemmer show was no accident. Soon after Alfred learned about the cancellation of the Schlemmer show, he began hearing about similar actions all over Germany. In early April, the State Gallery of Art, Stuttgart's main museum, was ordered to take down its modern art. "Paintings by five of the best known modernists in Germany have been removed from the walls," he noted.[15] In Leipzig and Dresden, officials took down even larger groups of modern paintings; in Frankfurt, they simply locked the rooms devoted to modern art. Even more disturbing were the actions taken against artists themselves. Paul Klee and Otto Dix were kicked out of the academies where they taught; Schlemmer was put on indefinite leave. A similar fate awaited the museum directors who supported their work. The heads of museums in Frankfurt, Karlsruhe, Düsseldorf, Cologne, Hamburg, Chemnitz, and Ulm were either sacked or put on leave for supporting modern art.

Nor were these efforts confined to art. At his house one evening, a

few weeks after the Nazis came to power, Dr. Garthe introduced Alfred and Marga to Richard Döcker, a young architect who had worked with Mies van der Rohe at the Weissenhof Estate. Döcker told them that the city building inspector had summoned him to his office about a private house he had designed. Though the project was already half finished, the inspector informed him that the *Flachdach,* or flat roof, would have to be replaced with a sloping Teutonic gable. The flat roof was one of the most characteristic elements of the new architecture—part of a style that had been pioneered in Germany as well as Holland and France—yet now it was effectively banned.[16]

Initially, Alfred was puzzled by these attacks. He had witnessed hostility to avant-garde painting from conservatives in the United States and Communists in Russia, but as he did with Schlemmer's paintings, he regarded the modern movement as largely free of specific ideological content. In Fascist Italy, where he and Marga had spent the fall, the Mussolini regime didn't just tolerate modern art and architecture; it embraced it. While she was attending the Georges Petit exhibition in Paris, Marga had run into one Fascist official who was trying to persuade Picasso to lend works to that summer's Venice Biennale. And a group of Italian architects, supported by the Fascist government, were developing their own version of International Style modernism. Yet already, within days of coming to power, the Nazis had begun attacking modern art and architecture.

About a month after the closing of the Schlemmer show, Alfred and Marga attended a presentation on Nazi cultural policies in one of Stuttgart's main public theaters. As they entered, they were given a pamphlet titled "Cultural Policy in the New Reich." One of the speakers was the new regional *Kultminister,* the minister of education. "It is a mistake to think that the national revolution is only political and economic," the official declared. "It is above all cultural." Driven by "insidious foreign influences" and socialist ideas, he alleged, modernism was destroying the country. Indeed, as Alfred discovered, Schlemmer had been tainted above all by his association with the Bauhaus, which the Nazis considered a dangerous hotbed of utopian socialism and international modernism. Though it was apolitical, Schlemmer had created *Bauhaus Stairway*

as a valediction to the school, which the local Nazi Party in Dessau had shut down the previous summer.[17] According to the *Kultminister,* even artistic freedom had to be rejected if it resulted in modern art. "There is no freedom for those who would weaken and destroy German art," he shouted. The new regime, he added, would do everything in its power to "make art in Germany German again."[18]

In fact, the Barrs were witnessing the beginnings of an all-out attack on modern art and architecture that would culminate in the infamous "Degenerate Art Exhibition" in Munich four years later. Going far beyond artworks themselves, the policies were aimed at the entire civic culture that had supported them. In tandem with its systematic efforts to "purify" the German race by persecuting, dehumanizing, and ultimately murdering Jews and other unwanted groups, the Hitler regime was seeking to purify German culture by attacking and eliminating all traces of modernism and modernist ideas. Even during its first weeks in power—long before the true horrors of Nazism were known—Alfred observed that "paintings were treated much as have been the persons who, politically or racially anathema to the new regime, are put in jail." It was a startling indication of how directly modern art and modern artists had become associated with the liberal democratic forces Hitler had set out to defeat.[19]

As the spring wore on, Alfred and Marga began to witness the Nazis' racial policies take hold. More and more of their acquaintances seemed to know someone who had been pressured by the new regime, and businesses with Jewish owners were now being targeted. "We saw the first Jewish persecutions. We saw the first yellow buttons. We saw the first department stores closed," Marga recalled. "And we became very ferociously anti-Fascist." Having come to Stuttgart for a quiet convalescence in modernist surroundings, they instead found themselves living through a wholesale Nazi takeover.[20]

By the end of April, the Barrs had had enough. Although Alfred was making progress, he still tired very easily, and at Dr. Garthe's urging, they left Stuttgart for Ascona, Switzerland, a favored retreat for artists and writers on the shores of Lake Maggiore. At last, they would get a taste of the restorative sanatorium culture that had until now eluded them.[21] Yet even here, they were unable to escape National Socialism.

Shortly after they arrived, Philip Johnson, who had been traveling around Germany, came to visit. Johnson idolized Barr, who had turned him into a first-rate architecture curator, and the two had long been close friends. A few weeks earlier, when Barr had been enraged by the closure of the Schlemmer show, he had cabled Johnson and persuaded him to purchase *Bauhaus Stairway,* sight unseen, in an effort to rescue it from Nazi oblivion. But Johnson was also impetuous and utterly lacked Barr's strong moral compass, preferring to be guided by his acute design sense and his attraction to power. Wealthy, good-looking, and image-obsessed, he seemed unaware, or uninterested in, the darker implications of Nazi ideology, and for the past few months, he had become increasingly enthralled by Hitler. In Ascona, Johnson was filled with excited talk about the new regime and the so-called *Nationale Erhebung,* or national rising. "He thought it would be the salvation of Germany," Marga wrote.[22]

Alfred was repelled by Johnson's infatuation, and they spent much of his visit arguing violently about Nazi politics. Barr must have recounted what he and Marga had witnessed: the attack on the Schlemmer show, the ban on the architect's flat-roof house design, the condemnation of international modernism—let alone the alarming political and racial persecutions. After all, Johnson knew and loved the Bauhaus as much as he did, and the Weissenhof Estate featured prominently in Johnson's "Modern Architecture" exhibition. Clearly, the Nazi cultural program posed an existential threat to modern artists and modernist values. But Johnson remained unmoved.

They even seemed to disagree about *Bauhaus Stairway.* Barr considered Johnson's purchase of the painting as a way to, as he put it, "spite the sons of bitches," but that was not how Johnson saw it.[23] While he admired Schlemmer as much as Barr did, he refused to believe that the Hitler regime posed a danger to European civilization, or even that it was against modern art. In a letter to Marga from Berlin a few weeks later, he insisted, "There is no Verbot of flat roofs here & the Schlemmers still hang in the Kronprinzenpalais"—the modern wing of Berlin's Nationalgalerie.[24]

Amid the Nazi takeover, Barr and Johnson were beginning to artic-ulate two very contrasting views of modernism—one imbued with un-

derlying principles of freedom and truth, the other purely aesthetic. As Johnson observed decades later, with unusual self-awareness, where Barr was driven by a kind of "moral socialism . . . with me it was pure style." For the time being, they did not let their diverging views destroy their friendship. Soon, however, Johnson's Nazi obsession would cause him to leave the museum altogether.[25]

After Johnson left, Alfred was in no mood for rest. "Instead of sunbathing, A. writes for many hours a day," Marga wrote. "He is fuming." Determined to record what they had seen in Stuttgart, Alfred began drafting a series of articles about the Nazi cultural program. He envisioned an article on each branch of the programs, including art, architecture, film, music, and literature. He planned to publish them as soon as he could. Americans needed to be warned.[26]

As Alfred chronicled the destruction of modern culture in Germany, though, he also worried about its future in the United States. If modern art were disappearing from German museums, which had long been the most active in the world in collecting new art, it would be even harder in the future to rely on Europe for his own shows. Along with his articles on the Nazi art campaigns, he began writing an urgent internal memorandum for the trustees. After some introductory comments about the museum's mission, he came to his point: "The Museum Has Not Fulfilled One of Its Fundamental Purposes." The museum had never formed a "representative collection of modern pictures."

But it was in the way the collection should be organized that Alfred presented his most radical idea. With his usual fondness for military strategy, he came up with a dramatic analogy. "The permanent collection," he wrote, "may be thought of as a torpedo moving through time, its nose the ever-advancing present, its tail the ever receding past." To illustrate what he meant, he included several diagrams of his idealized missile, in which the crucial ancestors of advanced modernism were at the back, in the engine compartment, and the newest, most radical work—the art of Picasso and Matisse and their followers in Paris—in the warhead at the front.

It was a disconcerting, even violent, way to think about modern art, but the speeding missile captured many of the qualities that Barr viewed as essential. To stay relevant, not only did the museum need to tell the

story of modern art from its origins up to the present. It had to tell it in a propulsive way that could absorb—and project—potent new developments as it went. As the torpedo rushed forward in time, its narrowing stern could leave all but the most important classic modern artworks in its wake, while its warhead could absorb ever newer innovations. Soon nicknamed the "torpedo report," Barr's memorandum, when it was finished that fall, would become legendary at the museum. It would also come to be viewed as one of his most memorable contributions to the conception of twentieth-century modern art.[27]

Far less noted, however, were the circumstances in which Barr had written the report. In devising his art torpedo, he could not have avoided thinking about the new threat to modern art he had witnessed in Nazi Germany. Barr did not specify *where* the torpedo was heading, but it was clear that its intended target was the American public. By showing that even the most radical new art was propelled by forces that had been unleashed in both European and non-European art going back centuries, the museum's art torpedo would, as Barr put it, "destroy or weaken the prejudice of the uneducated visitor against non-naturalistic kinds of art." By the summer of 1933, modern art had become a war for Barr.

Even while he was still in Switzerland, Barr began sending his articles on the Nazi cultural program to *The New Republic, The Atlantic, The New York Times, The Nation,* and other publications. In the four years since he had begun leading the museum, he had frequently written articles in newspapers and magazines about modern art and never had difficulty getting published, and he assumed there would be great interest in the extraordinary events he had witnessed in Germany. But one after another, newspapers and magazines turned him down. During his and Marga's year away, the United States had gone through a revolution of its own. Coming into office amid economic chaos that spring, Franklin D. Roosevelt had briefly shut down the banking system. Then he had announced a special three-month session of Congress to pass as much relief legislation as he could, the beginnings of the First Hundred Days and the New Deal.

Amid such upheaval, America wasn't particularly interested in the fate of modern art in Hitler's Germany. Not yet. The torpedo still needed to be built.

27
CONNECTICUT CHIC

By the time the Barrs left Europe, the worldwide economic crisis had reached France, too. Among the leading Paris galleries, the heady scene of the late 1920s was a distant memory. Daniel Kahnweiler sometimes went months without selling a painting; Paul Rosenberg's brother, Léonce, having held on through the twenties, had gone bankrupt. Even Bignou's Georges Petit Corporation, which seemed so powerful only a year earlier, had folded. For all its high profile and international connections, the consortium had failed to generate any profit with its huge Picasso and Matisse shows. "Berlin is broken, London is down, Paris is nearly desperate," Bignou had reported to an American contact.[1] Like everyone else, collectors were skittish.

While its international repercussions had yet to be felt, the Nazi regime was also beginning to raise concerns in the Paris art world. For men like Kahnweiler, who had close ties to the country, Hitler's crackdown on modern art hit particularly close. Already, dealer friends of his in Berlin had been forced to close, and exiled German artists were turning up at his gallery. "I don't believe these events will be restricted to Germany," he told the painter Vlaminck.[2] But even for those who did, it was hard not to be unsettled by what was happening across the Rhine. By one estimate, four-fifths of the Paris art trade was Jewish.[3]

For Rosenberg, the international situation added to the profound personal and business turmoil he had weathered in 1932. The Paris-centered activity that had brought him such success in the late twenties had come to an end, and business in Europe was evaporating. Despite overwhelming publicity, very few of the Picassos he had lent to the Georges Petit exhibition had found buyers. By early 1933, the Picasso market had become so difficult that he had traded the artist's large 1928 masterpiece *Painter and Model,* an intricate, playfully abstracted late Cubist work, for a small, fairly conventional Matisse interior, despite its decidedly lesser importance. "The Matisse I can sell immediately, the Picasso I wouldn't be able to sell for thirty years," he explained.[4]

But while the market was bad everywhere, there was one country that continued to intrigue him: the United States. In the early thirties, he had done a brisk business with Chester Dale, and despite the Depression, new art museums were continuing to open in several American cities. Rosenberg was convinced that there still might be chances to place paintings. Despite his previous failures, he also had never given up on the idea that he could build a broad American audience for Picasso with the right kind of museum backing.

Then an opportunity came his way. The Louvre was planning a large Daumier exhibition in the spring of 1934, and the curators asked Rosenberg, as a specialist in nineteenth-century French art with a wide international network, to assist in arranging loans from American collections. For the dealer, it would be a chance to rebuild ties in the United States, with backing from France's most prestigious institution. In late November, exactly a decade after his ill-fated 1923 trip, he set out for New York.

Rosenberg found the U.S. market almost moribund. Many collectors had stopped buying and a new austerity was setting in at many institutions. A few weeks earlier, Barr had submitted to his trustees the final draft of his "torpedo report," with its extraordinary argument for a heat-seeking, world-beating collection of modern art. But at that very moment, the Museum of Modern Art was on the verge of giving up on a permanent collection at all. In early November, Stephen Clark, the steely art collector and Singer sewing machine heir who was one of the muse-

um's most influential trustees, proposed that they forgo the paintings in the Bliss bequest, because the museum was still, after close to three years, hundreds of thousands of dollars short of the required endowment. Other trustees seemed to support him. Barr was so alarmed he wrote Mrs. Rockefeller a confidential, ten-point letter. "I know I am not supposed to concern myself with money raising," he told her. "But this is an emergency."[5]

While Rosenberg found little opportunity in New York, other parts of the country surprised him. "I was in Kansas City," he wrote Picasso, after flying out with a group of dealers for the opening of the $15 million Nelson-Atkins Museum, an improbably monumental Midwestern acropolis built from Indiana limestone and Pyrenean marble. "The situation here is no better than anywhere else, but . . . the country remains very rich."[6] His most interesting discovery, however, came from a smaller city much closer to New York. He knew that the Wadsworth Atheneum in Hartford, Connecticut, had a Daumier he hoped to borrow for the Louvre show, but when he got in touch with the museum, he discovered that the director urgently wanted to see him for another reason—one that directly pertained to Picasso. Rosenberg was immediately intrigued, and a few days before Christmas, he took the train up from New York.

By history and scale, Hartford was an unlikely center for modern art. Few Europeans had been there; Picasso had never heard of it. With a population of less than 170,000—a fifth of Boston's and a tiny fraction of New York's—the blandly prosperous city was primarily known as the insurance capital of the United States. The city's social scene was characterized by traditional New England tastes and a certain starchy insularity; the modern-art-hating J. P. Morgan came from an old Hartford family. Though it was one of the country's oldest public art galleries, the Wadsworth Atheneum, the city's main museum, had until the late 1920s been known mainly for its colonial furniture, American landscapes, and rare gun collection, donated by the wife of local firearm pioneer Samuel Colt. In many respects, Hartford was a bastion of the East Coast provincialism that John Quinn had fought against a generation earlier.

But that was before the arrival of Chick Austin, the dazzling young museum man who had taken over the Wadsworth in 1927. Arthur Everett "Chick" Austin, Jr., was a tall, dark-haired Bostonian with silent-film-star looks, infectious energy, and a wide-ranging exposure to historic and modern art. He also was a natural entertainer, and seemingly within months of his arrival, he had managed to turn the sleepy museum into one of the liveliest centers for new art in the country. By 1929, when the Museum of Modern Art was cautiously introducing itself with a group of long-dead post-Impressionists, the Wadsworth was screening Fritz Lang's *Metropolis* and holding musical performances of Stravinsky and Schoenberg. And while Austin often looked to Barr for ideas, the Wadsworth was far better equipped than the Museum of Modern Art to implement them. The same year Austin was hired, the Wadsworth had received a rare $1 million bequest for acquisitions, allowing him to spend $60,000 or more per year on paintings ranging from Tintoretto's *Hercules and Antaeus* to Pierre Roy's Surrealist masterpiece *The Electrification of the Countryside*.

Almost exact contemporaries, Barr and Austin had followed remarkably similar trajectories. Like Barr, Austin had been a protégé of Paul Sachs at Harvard and, with Sachs's help, had been given the reins of a museum at an astonishingly early age: He had been offered the Wadsworth job at twenty-six. Like Barr, he had an unusual interest in modern art—an interest that extended beyond painting to include film, music, theater, and design—and he viewed his job as a chance to reinvent the way art was brought to the public. Austin also shared Barr's ambiguous sexuality, with many members of their shared Harvard circle finding him spellbindingly attractive. "You'd fall in love with him the minute you'd meet him," Johnson said.[7]

In almost every other way, though, Barr and Austin were opposites. Where the one was restrained and considered, the other was high-spirited and headlong. Where Barr had a quiet magnetism, awing friends and acquaintances with his clarity and insight, Austin was an electrifying figure, managing always to be at the center of the most exciting new thing. Their differences were also informed by their backgrounds: A product of exceptional privilege, Austin had an innate sense of possibility; for Barr, everything had to be earned. Where Barr com-

plemented his studies with a single threadbare year of travel abroad, Austin was easily bored by scholarship but had grown up in several European countries. With family money and connections, he had supplemented his studies with stints digging up Kushite temples in the Sudan and apprenticing with a master forger in Siena.

These contrasts showed plainly in the way the two men ran their museums. Where Barr was determined to maintain the highest standards of aesthetic merit and lucid presentation, Austin skated headlong from one subject to the next, more concerned about keeping his audience entertained and getting there before anyone else. Usually he succeeded. At the Wadsworth, Austin also benefited from a generally compliant board. A savvy opportunist, he saw that his aggressive acquisitions of stellar Old Masters could assuage more conservative members, even as he continually pushed the museum in far more daring directions. It helped that he had married a cousin of J. P. Morgan who was also a niece of the Wadsworth's president. (Like Barr, Austin had had a Paris wedding shortly after he began his job, except in his case the festivities included a glittering champagne banquet at the Plaza Athénée and a several-month honeymoon in Belgium and the Veneto, where they studied Renaissance villas on which to base their future house.)

Unlike Barr, Austin had no qualms about involving dealers directly in his museum's activities. In 1931, Austin presented a pioneering show of Surrealist art that was assembled in significant part by the dealer Julien Levy, who had been planning the show for his own New York gallery. At another point, facing a sudden gap in his exhibition schedule, Austin called up Joseph Duveen, the legendary Old Master dealer, and arranged to borrow some 120 Italian Renaissance works from his inventory. The dealers had a strong incentive to help: The Wadsworth was an important client. "With Chick," observed Levy, who sold numerous works to the museum, "business and friendship were outrageously, happily, and rewardingly mixed."[8]

At the time of Rosenberg's visit to the United States, Austin had gotten himself into another last-minute jam, and more than usual was riding

on the outcome. He was about to inaugurate a $700,000 museum annex called the Avery Memorial. It was by far the biggest undertaking of his career and was going to feature the country's first high-modernist exhibition spaces. Behind a severe stone façade, the new building was white, hard-edged, and sleek, with a Bauhaus-like central court surrounded by cantilevered upper-floor galleries and a small theater in the basement. For seating, there were Marcel Breuer stools and beige pigskin benches with chrome legs. Austin's own office featured Mies-inspired door handles, a white rubber floor, and a Le Corbusier chaise longue. He had even consulted with Philip Johnson on the bathroom fittings. Whereas Barr and his friends introduced International Style architecture through photographs and small tabletop models, Austin could now present his own museum as a working prototype.

So consumed was he with the Avery, however, that he had failed to secure art for the opening show. For the main inaugural event, he had planned the world premiere of Gertrude Stein and Virgil Thomson's avant-garde opera, *Four Saints in Three Acts*. Created more than five years earlier to an almost impenetrable Stein libretto, the work had initially seemed unlikely to reach the stage. But in 1933, Stein had suddenly become a national celebrity with the publication of her breakout bestseller, *The Autobiography of Alice B. Toklas*, and Austin, with his usual exquisite sense of timing, saw that a staging of this witty and ostentatiously strange work would draw outsized attention. To make the production as sensational as possible, he brought Thomson over from Paris and the British choreographer Frederick Ashton from London; Thomson asked Manhattan modernist Florine Stettheimer to design the costumes and sets. From Philadelphia, Leopold Stokowski's deputy was asked to lead the orchestra; from Harlem, an all-Black chorus was assembled to perform the vocal parts.

Still, Austin needed a suitably provocative exhibition to fill the new galleries, and a few weeks earlier, he had belatedly decided on Picasso. After all, Gertrude Stein had a special connection to the artist, and his controversial paintings would provide a particularly apt way to showcase the ultramodern Avery galleries. Austin also was keenly aware that no American museum had staged a Picasso retrospective: It would give

him another chance to be first. But he had not laid any groundwork for such a show, and soon found himself in well over his head.

At first he planned to center the show around Stein's own collection. Surely, with the extraordinary talent they were lavishing on *Four Saints,* she would agree to send over her paintings. But Austin had failed to take account of Stein's fierce rivalry with Picasso. For years, as the artist's reputation soared, she had struggled to get her modernist writing published; now that she was finally getting recognition, she was not about to let a Picasso show upstage her. "I cannot find it in my heart to part with all my pictures," she wrote Austin. "But you will understand."[9]

Soon after, Austin approached the Wildensteins. He had done business with their New York branch and thought they would be able to help him. But he was blithely unaware that the Wildenstein-Rosenberg partnership had ruptured, and that Wildenstein no longer had any sway with Picasso. In Paris, Georges Wildenstein promised to do what he could, but it was largely meaningless. Casting around for possibilities, Austin asked the State Department to help him borrow works from the Shchukin collection in Moscow. Though the paintings had never left the Soviet Union and hardly any Westerner had seen them since Barr and Abbott in the winter of 1927–28, Austin thought that FDR's diplomatic recognition of the Soviet Union might pry them loose. He was mistaken.

But then, with his usual luck, Austin learned that Rosenberg—the man with apparently the greatest Picasso inventory in the world—happened to be in the United States. Rosenberg was thrilled to learn of the show, and Austin immediately invited him up to Connecticut to discuss it. By now, the opening of the new Wadsworth building was just seven weeks away; even by the last-minute standards of the day, it was an absurdly short time frame to select and arrange a complicated show of paintings from overseas. Moreover, Rosenberg would need to wrap up his Daumier work for the Louvre and get back to Paris before he could gather his Picassos.

In Hartford, Austin gave Rosenberg a royal welcome. The dealer's visit was covered in the local papers, and Austin gave him a preview of the new building and its International Style galleries. He also explained about the *Four Saints* opening. Rosenberg was seduced. Not only did the

Wadsworth have a rapidly growing collection of Old Master and modern paintings. It also was unusually innovative in the ways it attracted the public. It was remarkable, he wrote Austin afterward, "to see a curator of a museum capable of infusing so much life into his institute."[10]

As they discussed Picasso, Austin also made clear that the show would be centered around Rosenberg's paintings. Here, then, was the American opportunity the dealer had been seeking for more than a decade: a landmark Picasso exhibition at a top U.S. museum, over which he would have significant control. Throwing caution to the wind, he decided to go much further than lending his most important Picassos. He told Austin he would not only personally deliver his best pictures to Hartford; he would also arrange important loans from private collectors in Europe and the United States, as well as from Picasso's own collection. Even before he had visited Hartford, he had written Picasso urging him to take part. "Interest in the arts is enormous, and there's a great market for you to conquer," he wrote.[11]

By the time Rosenberg returned to Paris a few weeks later, however, the situation in France had changed dramatically. During his travels, the French government had been swept up in a corruption scandal, and opposition groups were taking to the streets; there was talk of a coup. Meanwhile, Picasso had no interest in Hartford and categorically refused to send any works from his own collection. Two weeks before the new museum was scheduled to open, Rosenberg cabled Austin: "SORRY PICASSO RETRACTS PAINTINGS." Then, that same afternoon, widespread violence broke out in Paris, with followers of the right-wing Action Française skirmishing with police in front of the Chamber of Deputies and thousands of Communists rioting at the Bastille. By the end of the night, some 750 people had been arrested.

In Hartford, Austin and his assistants began to panic. If Picasso wouldn't lend and political unrest prevented Rosenberg from getting his own paintings out of Paris, the show would collapse. But they had underestimated the dealer. "SOYEZ TRANQUILLE JOURNAUX EXAGÉRÉS," he cabled the next day—"Don't worry newspapers exaggerating." He had already crated up the paintings that hung in his dining room, and the Action Française was not rioting on rue La Boétie. As for Picasso, Rosenberg quickly exercised his dealer's prerogative and bought three

additional paintings from the artist to compensate for his refusal to lend. One of them was the 1932 masterpiece that Alfred and Marga had so admired, *Girl before a Mirror*.[12]

Two days after the riots, Rosenberg departed for New York on the *Île de France,* bringing with him nearly thirty Picassos, including nineteen of his own, seven from collectors he knew in Paris, and the three new ones from Picasso. He got off just in time. In early February, Paris descended into full-blown chaos, with far-right groups rioting in Place de la Concorde. In the end, fifteen people were killed and two thousand injured before order could be restored.

In Hartford, Chick Austin was too preoccupied with the Stein opera and the new building to give much attention to the Picasso show. Instead, he left much of the work to his brilliant deputy, James Thrall Soby, a genial and restlessly curious young man who had quickly become a secret weapon in Austin's modern art ambitions at the Wadsworth. The son of a pay-phone and cigar magnate, Soby came from an affluent Hartford family and was a few years younger than Austin and Barr. Had he not stumbled upon Matisse and Derain at a New York gallery in the late 1920s, he might have settled into a quiet suburban life of country clubs and state fairs. But he was quickly bitten by the new art, and to the horror of his neighbors, began buying avant-garde paintings with abandon. In 1932, at the height of the Depression, he spent the enormous sum of $16,000 on Picasso's *Seated Woman,* an almost frighteningly potent, curvilinear study of a figure and its shadow. "It scared me to death and I loved it," Soby wrote. A banker friend of his father's ordered him to return it, no matter how much he lost on the purchase price. He paid no attention.[13] He also became an avid student of modern art, and soon began assisting Austin at the museum. For the Picasso show, he did what he could to secure other important works and make it into a full-scale retrospective.

By the time Rosenberg and his paintings arrived in Connecticut, though, there was barely enough time for Soby and Austin to mount the show. Calling up as many museum friends from neighboring towns as they could—among them Jere Abbott from Smith College and Henry-Russell Hitchcock—they spent the day before the opening hanging

more than seventy paintings and parrying Austin's continual banter. They finished around midnight.

As the inauguration began, the Stein opera commanded overwhelming attention. To ensure maximum publicity, Austin had filled the opening night audience with people he knew from the art world, mostly from New York. In January, he had written to all his Harvard friends to support the production, which had run over budget, and to buy expensive tickets to the opening. Among them was Alfred Barr, who agreed to bring Marga, but who could scarcely hide his dismay that Austin was plowing ahead with Picasso—on top of a Stein opera. "Either one would be enough for any ordinary mortal museum director," Barr wrote Austin, incredulously.[14] Austin also invited a large contingent of national critics and society columnists. Though many were baffled by the opera's nonlinear structure and nonsense lyrics, nearly all of them were were enthralled by the soulful Harlem chorus, Stein's percussive language, and Stettheimer's extravagant sets, with their giant orange-and-yellow cloth lions under trees made of cellophane and ostrich plumes. "Since the Whiskey Rebellion and the Harvard butter riots there has never been anything like it," one columnist wrote; Joseph Alsop, the future Washington insider, found it "at once complicated, amusing and lovely."[15] For the "picked auditors," as Alsop called them, who filled the 299-seat theater, the premiere took on a legendary quality, a kind of rapturous American *Rite of Spring*.

Nearly forgotten in the excited response to the Stein pageant were the Picassos hanging in the galleries upstairs. Immediately following the premiere, Austin invited the out-of-town guests to a champagne party at his house; there was little time to linger in front of paintings. For many who came, the paintings were no more than a curious side show. In the end, the exhibition went unmentioned in any of the national magazines and was confined to a single paragraph in the *Times*'s account of the new building. Gertrude Stein had gotten her way.[16]

For Barr, it must have been hard not to greet the exhibition with a mixture of envy and schadenfreude. Given the constraints at the time, it was impressive that Austin had pulled off the show at all. But the result was a pale imitation of the sweeping, comprehensive project Barr had

envisioned. Missing was not only a sense of the different stages of Cubism and such threshold works as the *Demoiselles,* but also paintings from Picasso's personal collection, the sequential high points of his art that Barr had identified. Among the local public, the show did not stir much interest either. After the out-of-town guests went home, the exhibition depended entirely on ordinary people, the bankers and lawyers and insurance executives, the housewives and doctors and schoolteachers, who made up the Hartford middle classes, and enthusiasm was decidedly muted. Many avoided the show entirely. "There were days and days when only a handful of people came to see it," Soby wrote.[17]

If *Four Saints* had shown Chick Austin at the height of his magic, his Picasso foray had demonstrated that he was mortal after all. For all his success at impressing his Harvard friends, Austin was not particularly sensitive to mainstream taste in Depression-era America. Even in his own city. Many of Hartford's insurance executives and society ladies, while they didn't object to the pathos of Picasso's early circus pictures, were deeply alarmed by much of his recent work, which struck them as distorted or vulgar or both.[18] And for ordinary people reading about the Wadsworth's over-the-top opening party, it was difficult not to find confirmation for the view that European modernism was the province of an out-of-touch East Coast elite. That same spring, Thomas Craven, the popular American art critic, published *Modern Art,* his bestselling takedown of the European avant garde, which would be highly praised in *The Hartford Courant.* There was "not a single connecting bond," Craven argued, between Picasso and what he called "the realities of American life."[19]

Though Rosenberg did his best to put a good face on the venture, it was hardly more successful than his earlier American efforts. Notably, the Wadsworth itself passed up the opportunity to buy a single painting, though it could have had its pick, including *Girl before a Mirror.* Following the show, Rosenberg briefly presented many of his Picassos, together with an impressive series of works by Braque and Matisse from his stock, at the Durand-Ruel Gallery in New York. Writing in the *Sun,* Henry McBride called it "the finest collection of modern art yet to be seen in America."[20] But hardly anyone else seemed to notice, and Rosen-

berg soon found himself once again packing up his paintings and taking them back to Paris. For Soby, who had worked even harder on the Hartford show than Austin had, it was one of the more memorable failures of his career. "It seems almost incredible to think that a large, retrospective Picasso show could have been such a flop in 1934," he wrote. "Those were bitter days for contemporary art."[21]

28

"RISKING MY
LIFE FOR MY
WORK"

*I*f the Hartford exhibition showed how little Picasso's art seemed to speak to ordinary Americans, for Barr it also underscored something else. To build a national audience for modern art at a time of extraordinary crisis, the museum could no longer rely on the tastes and enthusiasms of its trustees and of the worldly Harvard crowd who worked for them. The new art had to relate to the struggles of ordinary people and their hunger for escape. The Roosevelt administration had already grasped the social value of art in a time of rampant joblessness and widespread hardship. In 1933, the government had launched the Public Works of Art Project, a forerunner of the WPA that paid thousands of unemployed artists to decorate libraries, schools, post offices, and other public buildings. The art was dominated by American scene painting—realist depictions of ordinary workers, regional industries, and episodes of U.S. history—and had been immediately embraced by the public. For a privately funded museum that was housed in a former Rockefeller mansion and devoted to European high modernism, however, the task was far more difficult.

Then, in the spring of 1935, Barr stumbled upon an unlikely answer: Vincent van Gogh. Today, it is hard to imagine a time when the Dutchman's irises and sunflowers did not adorn iPhone cases and umbrellas,

when his night skies were not used in "immersive" theme-park projection experiences set to mood music. Indeed, for decades, it has been difficult to identify a cultural figure from the modern era—or any era—with broader worldwide currency. Yet in the United States at the start of the Depression, the artist remained comparatively little known, and even among supporters of modern art, he was not universally admired.

At least since the Armory Show, when John Quinn's Van Gogh *Self-Portrait* was displayed alongside a handful of Van Gogh landscapes and still lifes borrowed from European dealers, the late-nineteenth-century artist had been a favorite target of opponents of modern art. Confronted with his whorled conifers, salmon-tinted roomscapes, and green-and-orange-flecked faces, many viewers could see only a shocking abandonment of rational perception. In 1920, when the Montross Gallery in New York organized a rare U.S. show devoted to Van Gogh, not a single painting found a buyer. Even in the late twenties, as international prices for his paintings soared and a few discerning Americans—including several Museum of Modern Art trustees—began collecting them, his art could scarcely be found in American museums.[1]

At least in part, the resistance related to the artist's own story. Here, after all, was a painter who had sliced his own ear, spent an anguished year in the asylum of Saint-Rémy-de-Provence, and apparently killed himself. Indeed, there had long been a small cottage industry in trying to identify Van Gogh's apparently severe abnormalities. As one correspondent of Barr's noted, the artist had been variously diagnosed with "acute mania with general delirium," "epilectic hallucinations," "solar intoxication," "meningo encephalitis," "paralysis after syphilis," "Oedipus complex—libido—homosexuality—narcissism," and "alcoholic epilepsy" among other conditions.[2] For critics of modern art, Van Gogh's mental illness provided a convenient demonstration of the concept of cultural degeneracy popularized by Max Nordau and others, seemingly providing irrefutable proof that modern art was closely related to mental derangement and psychopathology. In the 1921 controversy over the post-Impressionist exhibition at the Met, Quinn's adversaries alleged that Van Gogh had produced many of his paintings as "an inmate of a madhouse"; as the British critic C. J. Holmes observed, "The insanity of

Van Gogh's last years has furnished the enemies of the post-Impressionists with a cheap cudgel." For arbiters of traditional American values, Van Gogh was dangerous.[3]

By the time the Museum of Modern Art opened, these controversies had mostly died down. Still, it was not until the midthirties that an unusual book sparked broader interest in the artist. In the late 1920s, an aspiring American writer named Irving Stone had moved to Paris, where he stumbled upon a Van Gogh show at Paul Rosenberg's gallery. Stone knew nothing about Van Gogh, but he was powerfully seized. "It was the single most compelling emotional experience of my life," he later said.[4] He set out to write a novelization of the artist's story, and after years of rejections, *Lust for Life* was finally published in the autumn of 1934. In Stone's rhapsodic account, the Dutchman became a tragic, saintlike hero who had sacrificed everything for his art. Having toiled in obscurity under enormous mental stress, he sold hardly a single work in his lifetime, only to die an early, self-inflicted death. Crucially, Stone's Van Gogh was also a man of the people, who had suffered the same privations as the potato eaters he painted—laborers, farmers, and simple country folk. "He now lived in the same kind of house as the miners, ate the identical food, slept in the identical bed," Stone wrote. "He was one of them."[5] Even without access to the paintings, American readers found the story irresistible. An almost overnight sensation, the novel hit the bestseller list within four days of publication and went on to become one of the most successful books of the twentieth century. (Later it would inspire an enormously popular movie starring Kirk Douglas.)[6]

It was amid this groundswell of interest that Barr decided to pursue a long-held ambition. In the fall of 1927, during his study year in Europe, he had toured the collection of Helene Kröller-Müller, a formidable German-Dutch woman who had amassed the world's greatest collection of Van Goghs—including some ninety paintings and nearly two hundred drawings—at her house in The Hague.[7] He also knew that Van Gogh's nephew owned a great number of paintings of his own in Amsterdam. If Barr could borrow the most important works from these two collections, together with works from other sources, he would

be able to stage an utterly groundbreaking exhibition. In March 1935, he proposed the project to the Museum of Modern Art trustees, and they readily endorsed the idea.

As soon as the plan was approved, however, the museum's Advisory Committee issued a formal protest. Made up of a younger group that included many of Barr's old Harvard circle, the committee had long served as a counterweight to the conservative board; generally, they had urged on Barr's own, more radical ideas. This time, however, they were vehemently against him. Ever since the founding, they pointed out, Barr had struggled to counter the view that the museum was not sufficiently up to date; a Van Gogh show would reinforce the museum's backward reputation. "Van Gogh died 45 years ago and his influence on contemporary painting has waned," they wrote. They also worried about the monotony of a large show of his work. "There is such a similarity of impulse behind van Gogh's painting," the Advisory Committee continued, "that a one man show would prove less interesting than can now be imagined." Finally, they worried that the show would be ruinously costly. In a blistering resolution, the committee requested to the board "that the van Gogh exhibition be abandoned."[8]

Barr was sensitive to the criticism. After five years, he had made notable progress in pushing the museum into architecture, industrial design, and even film, yet in the core area of painting and sculpture, he had still barely touched upon the defining movements of the twentieth century. In a devastating assessment the previous summer, the *New Yorker* critic Lewis Mumford wrote that the museum had largely failed to give the country a "clear lead" in modern art. Noting that the Picasso show had gone to Hartford instead of New York, Mumford argued that "the Modern Museum has been drifting into the same sort of discreetly ambiguous attitude toward contemporary work that has been taken by the Metropolitan Museum."[9] For an enterprise that had been conjured into being precisely to do what the Metropolitan could not, it was hard to think of a more stinging rebuke.

The Advisory Committee had no formal powers and could make recommendations only. But in the face of such doubts, Barr had reason to be wary of pursuing Van Gogh rather than a more contemporary sub-

ject. At the time, no other American museum had attempted a Van Gogh show, and his most important canvases remained in Europe. If the committee had gotten its way, the history of modern art in America might have looked very different.

Yet Barr strongly disagreed with the committee about the artist's importance. And as he considered the larger struggle the museum faced with the country, he also saw a rare opening. In Van Gogh's fiery paintings and his moving struggle with mental illness, there was untapped potential to change the way ordinary Americans thought about modern art. Already in the museum's inaugural show in 1929, when they had paired Van Gogh with the three other "founders," Cézanne, Seurat, and Gauguin, Barr had intuited the unusual way his canvases could speak to ordinary viewers. "The muscles of the tree trunks bulge as they dig their roots into the earth," he wrote of one painting. "He diagrams the crackling energy radiating from a bunch of grapes. He sees with such intolerable intensity that painting alone can give him release from his torment."[10] Presented in the right setting, Van Gogh could make you feel, as few other modern artists could, the raw power that new approaches to color and form had unleashed.

And though it was little noted in the United States at the time, Barr also saw a chance to push back on the antimodern forces that he had witnessed take hold in Nazi Germany. As a close student of German art, he knew that Van Gogh had served for decades as a guiding light for Germany's modernists. He had also seen numerous important Van Goghs in German museums, such as the *Portrait of Dr. Gachet* in Frankfurt and *Daubigny's Garden* at the Nationalgalerie in Berlin. In the early years of the century, when much of the English-speaking world remained baffled by Van Gogh, an entire generation of German artists, writers, and critics were inspired by his fiery paintings. Georg Heym, who evoked Van Gogh in his poems, said that "he sees all colors as I see them." Well before the Great War, German museums began amassing his works; by the Weimar years, there was something like Van Gogh mania, with proliferating exhibitions, books, and even a stage play based on his life. (Notably, it was a German-born director, Wilhelm Valentiner, who pushed the Detroit Institute of Arts to acquire a Van Gogh in the early 1920s, well before any other American museum.)[11]

Significantly, at the center of the German Van Gogh cult was the art-ist's tragic biography. In direct contrast to their American and British counterparts, Germans tended to view Van Gogh's psychological strug-gle as one of the sources of his genius. Already before the war, Expres-sionist painters like Ernst Ludwig Kirchner and Erich Heckel had become fascinated by the artist's madness; many of them sought to emu-late his unfiltered emotions in their own work. Commenting on the great 1912 Sonderbund exhibition in Cologne, which featured an aston-ishing 108 Van Gogh paintings, alongside numerous works by his Ger-man followers, the philosopher Karl Jaspers noted that Van Gogh was the "only unwilling madman" in the group, while the Expressionists "wished to be insane but were, in fact, all too healthy."[12]

By the 1920s, the study of art and psychosis was flourishing at Ger-man universities. At almost the same moment that Americans were being warned that the post-Impressionists were "degenerates" plagued by "visual derangement," the Heidelberg psychiatrist Hans Prinzhorn was informing the German public, to the contrary, that mental illness could open up new pathways for art itself. In his highly influential 1922 book, *Artistry of the Mentally Ill,* Prinzhorn drew on his pioneering col-lection of some five thousand artworks created by psychotic patients to show that artworks of the insane were worthy of aesthetic appraisal; he also argued that they provided new insight into human perception and creativity. "Nobody disputes that van Gogh's productive potency in-creased during his illness and raised his work to previously unattainable standards," Prinzhorn wrote.[13]

For Barr, who had read and admired Prinzhorn's work, the study of madness yielded important insights about the creative process. Not only the German Expressionists but also the Paris Surrealists were deeply in-terested in the ways that people suffering from mental disorders were able to break the bounds of conventional perception. As Van Gogh's let-ters suggested, the artist's battle with his own psyche was a potent source for his art. But it also made him an immensely inspiring figure to which ordinary people could relate, the figure that Stone had exploited in *Lust for Life*. If Barr could persuade Americans to embrace Van Gogh's paint-ings the way they had embraced his story, it might change the standing of modern art in American culture. As with so many other shows,

though, everything would depend on the loans he was able to obtain from Europe.

At first, Barr was confident of his chances. He knew Kröller-Müller was generally well disposed to lending, and he and Goodyear had also arranged for the show to go on tour, allowing the Museum of Modern Art to split the cost with other U.S. museums. But he failed to anticipate a more complicated problem: Kröller-Müller no longer owned her Van Goghs. For years, she and her husband had been trying to build a museum in a large nature preserve in an inland part of the country. By the mid-1930s, however, they had been pushed to the brink of bankruptcy, and just weeks after Barr began planning the show, they had formally ceded ownership of the entire collection to the Dutch state in exchange for the government paying for their museum. "I now find that only three weeks ago the Kröller collection was bought by the Dutch government," Barr wrote Goodyear from Amsterdam in mid-June.[14]

Luckily, the museum was not yet built and the Van Goghs were still in the Kröller-Müller house, giving Barr a narrow window of opportunity. He and Goodyear asked the U.S. State Department for help— Goodyear made a direct appeal to Secretary of State Cordell Hull—and in the end, diplomatic intervention, along with a highly unusual payment of $7,500 to the foundation that now controlled the Kröller collection, closed the deal. (Barr insisted on the fee being kept secret so that it would not set a precedent of lenders forcing museums to pay to borrow art.) But the real drama came with the selection of paintings.[15]

The Barrs arrived in The Hague a few days after Alfred's letter to Goodyear. Taking a taxi to the Kröller-Müller house, they were greeted by a dignified middle-aged woman. She began to give them a slow tour of her very large drawing room, which was filled with Van Goghs, but Alfred found it too dark to examine them properly. He asked her if he could see some of them in natural light. Immediately, she summoned Bernard, her butler, who began taking them down, one by one, and carrying them out to the garden. Soon they were all propped against the clipped hedges in an enormous line: perhaps the only time several dozen Van Goghs have been shown together *en plein air*. In the strong morning

sun, the colors were dazzling; even the less dramatic pictures came star-
tlingly to life. After that, Alfred realized how big a project it would be
to narrow down his choices. He and Marga ended up staying for several
days.

In Amsterdam, they met V. W. van Gogh, known in the family as the
Engineer, the son of Theo and the artist's nephew, who had inherited the
other great collection of his work. Arriving at the Engineer's home, they
found a forty-five-year-old man who resembled one of Van Gogh's self-
portraits; luckily for Alfred, he also spoke beautiful English. Together,
they went over the oils and drawings in his collection, and Alfred, by
now immersed in Van Gogh scholarship, drew him out about his uncle.
The Engineer was full of information, sharing his mother's vivid memo-
ries of the artist, his development, and what Marga called "the drama of
his faltering mind and suicide."[16]

As he studied the paintings of Mrs. Kröller-Müller and the Engineer,
Alfred was also thinking about the catalog he needed to write. To pre-
pare himself, he read and reread Van Gogh's letters to Theo. Watching
Alfred immerse himself in the paintings and the letters, Marga was
struck by the Dutchman's hold on him. "It is stirring to penetrate the
artist's mind at work," she wrote. "To feel the intensity of his emotions
translated into a deliberate violation of correct draftsmanship and con-
ventional colors." Having weathered his own crisis, Alfred was rapt by
this son of a Dutch pastor who experienced such inner turmoil. As he
later put it, Van Gogh was an artist whose work was "a battleground
between fact and feeling."[17]

In the end, he made a radical decision: He would forgo the usual
introduction and let the letters to Theo speak for themselves. The cata-
log would simply quote the artist's own words on his art, life, illness, and
poverty, but also on his own sense of his genius: "I feel, Theo, that there
is a power within me, and I do what I can to bring it out and free it." Van
Gogh would tell his own story. It was a highly unorthodox approach,
but it allowed the artist to speak directly to viewers. Alfred was suffi-
ciently moved by the relationship of the two brothers that he dedicated
the catalog to the memory of Theo: a curiously personal gesture from a
curator known for his cool rigor.[18]

After days of careful scrutiny, Barr finally selected thirty of the best

Kröller-Müller paintings, as well as dozens of drawings and watercolors. Then he chose thirteen more paintings and a number of drawings from the Engineer. Together with paintings from a number of private U.S. collections, Barr would be able to bring together many of the greatest Van Goghs in existence. Meanwhile, museums in Boston, Cleveland, San Francisco, and Philadelphia signed on to take the show after New York. For the first time, the Museum of Modern Art would be producing an exhibition with national impact. All that was missing were the many Van Goghs in German collections, which were now off limits. Owing to new restrictions by the Nazi government, the director of the Staedel Museum in Frankfurt told Barr, he was unable to send *Dr. Gachet* to New York.[19]

In mid-October, *The New York Times* covered the paintings' arrival in Hoboken, New Jersey, on the *Statendam,* a Dutch ocean liner. Underscoring the prestige of the art, the report noted that the paintings were estimated to be worth $1 million, an astonishing sum for a painter whose works had been virtually worthless at the time of his death. But the *Times* also leaned heavily on the artist's popular image, noting that "all periods" of his career would be represented, including "six paintings done in insane asylum." The article ended by quoting the final note that Vincent had written to Theo before he shot himself in July 1890: "I am risking my life for my work and for it my sanity has half-foundered." By the time the show opened a few weeks later, New Yorkers were clamoring to see the paintings of the "mad Dutch artist."[20]

In view of the overwhelming interest, Goodyear and the trustees decided for the first time to charge admission. Even so, on West Fifty-third Street, the museum had to summon police to control the throng; it was also a different crowd than Barr had seen at previous shows. "Thousands of people are coming to the museum who I think have never been to an exhibition of paintings before," he wrote to V. W. van Gogh.[21] A month into the run, the *Times* reported that First Lady Eleanor Roosevelt had already visited the show on five different occasions. For all of the show's popular appeal, though, there was no dumbing down of the art. Viewers were asked to follow the multiple stages of Van Gogh's complicated development—the almost monochromatic early studies of

Dutch miners and laborers, to his encounters with Impressionists in Paris and exposure to Japanese prints, to his final years where he was "intoxicated by Provençal color and sunlight." Listing the astonishing range of books that Van Gogh consumed, and carefully documented, year by year, Alfred made a case for his literary imagination. (The names might have impressed John Quinn: Zola, Balzac, Dickens, Poe, the Brontës, Harriet Beecher Stowe, Carlyle, Flaubert, Turgenev, and Heine, among many others.) Swallowing his earlier scolding of the museum for being stuck in the nineteenth century, Mumford, in *The New Yorker,* called it "the most thorough, the most exemplary, and the most stimulating exhibition of modern painting [the museum] has yet put on."[22]

As the show made its way across the country, its legend grew. By the time it reached the West Coast, the mere delivery of the paintings, under heavily armed guard, was an event in itself. "[The shipment] was met at the pier by six motorcycle officers and two prowler cars from which protruded sawed-off shotguns," the *San Francisco Chronicle* reported. "They were there to kill anybody who tried to steal what the emaciated Dutch painter was never able to dispose of for gain." In all, nearly 900,000 people saw the Van Goghs during the fourteen-month tour, including 227,000 in San Francisco alone; faced with overwhelming demand, the Museum of Modern Art negotiated an additional six months for the loans and extended the itinerary to Kansas City, Minneapolis, Chicago, Detroit, and Toronto, before ending with a repeat showing in New York. Even so, it was forced to turn down requests from fifteen additional cities. Along with a popular edition of Vincent's letters to Theo, the exhibition spurred two further reprintings of *Lust for Life* and even a *Reader's Digest* abridgment of the novel. "It is unlikely—indeed, inconceivable—that any other art exhibition has ever had such an immediate impact on the public taste as the van Gogh show," the midcentury critic Russell Lynes observed. At the time, there was not yet a name for such a phenomenon, but in later years—using the term that the British Royal Air Force's bomber squadrons coined for the high-capacity bombs they dropped on Nazi cities—the show would go down as the first "blockbuster" of the twentieth century.[23]

Clearly, as Barr had intuited, there was something about Van Gogh that had tapped the national mood. Amid the worst economic crisis in U.S. history, these paintings, with their spiritual ardor and sun-drenched squalor, in the sensate force with which they seemed to express the artist's torments, had gotten through to America. For a country that had turned inward—and which had increasingly posed a virile, American regionalist style against the "arbitrary distortions and screaming colors" of European modernism—it was an extraordinary shift. As recently as December 1934, *Time* magazine had done a cover story on the triumph of "earthy Midwestern" painters like the Kansan John Curry, the Iowan Grant Wood, and the Missourian Thomas Hart Benton, who had rejected European influences in favor of "what could be seen in their own land."[24] Yet ordinary people from across the country were responding to the radical canvases of a leading post-Impressionist, imported from Holland. At last, modern art had entered the larger stream of American culture. It had also happened in the nick of time: After the opening of the Kröller-Müller Museum, the Netherlands would be highly unlikely to allow such an extraordinary group of paintings to leave the country ever again.

In fact the show also marked a far darker turning point in Europe. Just a month before the Van Goghs arrived in New York, Hitler, the failed artist, had used the 1935 Nuremberg rallies to launch an all-out war on modern art and its supporters. "Every personal dispute with them must therefore have ended in bringing them either into prison or the mad-house," he declared, "as they really believed that these creations of a diseased imagination represented their own inner experiences."[25] In the coming years, along with some twenty thousand other modern artworks that had hung in German museums, *Daubigny's Garden* and *Dr. Gachet* would be confiscated and sold abroad. As one German art historian, who had been chased into exile by the hardening Nazi regime, put it, "The Nordic painter only paints with uncut ears."[26]

The volte-face since the twenties had been dramatic. Now it was Germany that was declaring modern art "degenerate" for its pathological influences, while Van Gogh triumphed in the United States. As Americans were discovering the artist who had inspired several genera-

tions of German modernists, the modern movement in Germany was all but dead. But would Americans also warm to the far more disorienting art of Van Gogh's successors? The cypresses of Saint-Rémy were still a long way from the damsels of Avignon.[27] And many European artists, as Barr knew well, were already in danger. Just days before he and Marga had arrived in Holland the previous summer, they had spent a week in Nazi Germany, where they met the artist Kurt Schwitters and several museum directors who were desperate to get out of the country. As they would later learn, they had been tailed by the Gestapo throughout their stay.[28]

29

THE YEAR
WITHOUT
PAINTING

Alfred Barr did not accompany the Van Goghs on their giddy, yearlong procession around the country. When the exhibition finished its debut in New York in January 1936, he was already holed up in his and Marga's apartment, trying to finish a far more difficult project. The Barrs had moved into the new Art Deco building at 2 Beekman Place following his leave. Beekman Place had not yet acquired the exclusive cachet of later years, but it was only a few blocks from the museum and offered beautiful light and views of the East River.

In keeping with Alfred's rigorous design principles, they had arranged the apartment in an austere Bauhaus style. Furniture was limited to a few chairs and tables with tubular steel legs—the American designer Donald Deskey's knockoffs of Marcel Breuer's prototypes, which they could not afford. There was also a small, almost bench-like couch with no arms, and some narrow built-in shelves that Philip Johnson designed for them. Alfred generally needed a large, uncluttered space to lay out his ideas, and the well-lit living room floor became his preferred laboratory.

Now he was crouched over hundreds of photographs of artworks that were scattered across the floor: empty de Chirico streetscapes; luminous Kandinsky watercolors; amoeba-like reliefs by Hans Arp; spindly

Calder mobiles; "rubbish" constructions by Kurt Schwitters; Duchamp's insect-like machines; Natalia Goncharova's iridescent stage sets; Frederick Kiesler's aluminum lamp; Schlemmer's geometric ballet costumes. While Marga tried to keep their cat from walking on them, Alfred arranged and rearranged the images, determined to wrestle them into a coherent narrative.

It was a tremendous undertaking. In six weeks, the museum was going to open a show called *Cubism and Abstract Art*. With nearly four hundred objects in every medium, the exhibition would be the largest of Barr's career; it was also his most intellectually challenging. Since the museum's founding, he had engaged with single artists, particular countries or regions, or specific kinds of work, like mural painting or architecture or industrial design. But he had never tried to present the main plot lines of twentieth-century modern art itself, the successive schools and movements and the underlying forces that shaped them. No museum had ever attempted such a feat of cartography, and certainly not in the scope of a single exhibition.

For Barr, it was also a project that had acquired special urgency. One result of the failure to do a Picasso show in 1931 and 1932 was that the museum had never engaged with the birth and development of Cubist art, despite what he regarded as its central importance to the course of twentieth-century painting. (Paraphrasing Picasso, he would later describe Cubism as a new language, one that was "dealing primarily with forms."[1]) The museum had also neglected Russian Constructivists, Italian Futurists, and French Surrealists, among other movements. For most Americans, Juan Gris's newsprint collages and Kazimir Malevich's floating white squares were no more approachable in 1935 than they had been in 1929. Despite the influence of Cubist ideas on many American painters, even knowledgeable critics regarded Cubism as a "discarded aberration" that had little bearing on the art of recent years.[2] To the broader public, it was almost as if one of the most essential achievements of modern art had never happened. Drawing on his own thinking going back to his lectures at Wellesley, Barr wanted to reclaim Cubism's importance in a story that began well before it and continued out of it.[3]

But something else, too, was driving him as he bent over the images on his living room floor: the threat of politics. In Germany and Russia, he had witnessed two of the world's most advanced art and design cultures be crushed by authoritarian regimes. In both countries, the movements and artists that the show was tracing had been silenced before his eyes. Now the far right was beginning to menace Western Europe as well. In Paris, Kahnweiler was warning his artist friends that "Fascism . . . will stop us all from working, or showing our work."[4] And even in the United States, notwithstanding the breakout success of Van Gogh, modern art was still viewed with suspicion and even seen as anti-American. Increasingly, it was hard to find a place where avant-garde painters were not under pressure. Despite his formalist approach, viewing modern art as a development of style apart from the world, Barr increasingly recognized that the movements he was tracing had their own part in the gathering battle between democracy and totalitarianism. As Lewis Mumford—one of the few American writers alert to the Nazi art purges—observed, "in certain circumstances, a bowl of fruit by Braque might feel like the Statue of Liberty."[5]

In an effort to awaken the public to the larger story of modern art in the twentieth century, Barr had conceived of a pair of huge, wildly ambitious shows. The first, *Cubism and Abstract Art,* would present the Cubist movement not as an aberration but as an evolving force at the center of one of the two main currents in modern art. The second, to follow in the fall of 1936, would be devoted to the other, opposing current, Surrealism, Dada, and what Barr liked to call Fantastic Art. Taken together, the shows would offer a clear, sequential narrative—a demystifying cause and effect relationship—to explain the course of advanced art and why it mattered.

From the outset, Barr knew that the shows would be controversial, since much of the material was difficult and since they would be writing a history where none had existed. He also knew that both shows would depend on the work of one artist in particular: Picasso. What he hadn't anticipated was that he would face an entirely new obstacle to getting access to Picasso's work, one that had nothing to do with the art market at all.

. . .

Alfred's new troubles with Picasso began in the summer of 1935, when he and Marga arrived in Paris after their Van Gogh work in Amsterdam and The Hague. Their plans were to spend an intensive six weeks gathering loans for the Cubism show, and at first, everything seemed to go smoothly. "By now the existence of the museum is no longer unknown, and artists are mostly expectant," Marga observed when they got there. After six years, Alfred's innovative shows had begun to acquire growing notoriety in Paris, and both the pioneering generation of artists and their younger followers—artists like Joan Miró and Alberto Giacometti and André Masson—were keen to participate in the show. For the first time, Alfred and Marga began to enjoy the kind of access to artists that John Quinn had had a generation earlier.[6]

In Montparnasse, they met the well-tailored Dutch abstractionist Piet Mondrian, who had turned his spare geometric painting into a way of life. Like one of his artworks, his studio was carefully whitewashed, devoid of all extraneous objects, and accented only by a few primary colors; he also followed the Hay diet, which compartmentalized all food into several basic categories. ("One eats meat with vegetables, or starch with vegetables, but never the three at once," Marga noted.) For Barr, Mondrian's rigorous art traced a crucial shift from ideas taken from observable reality to what he called "pure" abstraction. "The cows and seascapes and dancers which lurk behind the earlier abstract compositions . . . have no significance save as points of departure from the world of nature to the world of geometry," he wrote.[7]

Their visit with Alberto Giacometti, the Swiss sculptor, was equally potent, but in a different way. Rumpled, with an unruly shock of thick dark hair, Giacometti showed them his cramped, messy studio, lit by a single light bulb dangling from the ceiling and filled with splattered plaster and clay. Affiliated with the Surrealists, Giacometti took impulses both from his imagination and from life and had begun to make crucial breakthroughs in what Barr called "biomorphic abstractions." For the show, he offered them his aptly titled plaster *Head-Landscape*.

Occasionally, the darkening political situation in Europe crept into

view. The long-exiled Russian artists Mikhail Larionov and Natalia Goncharova, aware of Barr's direct knowledge of Soviet Russia, were deeply moved by his efforts to trace the fate of the Russian avant-garde. They were doubtful they would be able to return to their country.

For the most part, however, artists were simply content to show their art. At his studio, Miró let them watch him work on a new canvas. ("He paints as if he were embroidering in black silk on a pale blue ground, putting one ornament after another into the outline of his half-length figure," Marga noted.) When they ran into Jacques Lipchitz, the French Lithuanian abstract sculptor, on a Paris street, he offered to drive them to his studio himself.

The older generation was no less welcoming. They found Braque at his townhouse and studio near the Parc Montsouris—the elegant modern retreat he had financed with Rosenberg's robust sales in the late 1920s. He maintained his usual Norman reserve, but he agreed to lend *Guitar,* an early masterpiece showing his journey from the lessons of Cézanne into Cubism. By contrast, Fernand Léger was jovial and exuberant. After showing them his work, he invited them to a noted bistro near his studio. "He loves to eat and drink," Marga observed. "He speaks loud and clear, unhindered by the language barrier."

Then they went to see Picasso and Rosenberg. At the time, Alfred had every reason to assume the artist and his dealer would support his plans. After all, such a show had never been attempted, and by presenting the first step-by-step account of Cubism and its influence on subsequent art, Alfred would be positioning Picasso's work—and that of Rosenberg's other artist Braque—at the headwaters of one of the primary streams of twentieth-century modernism. He sought, among other things, some of Picasso's little-known collages and sculptures, together with Cubist paintings from his personal collection.

In reconnecting with the artist, he also hoped to resurrect the long-postponed Picasso show, which the museum had put on its list of prospective exhibitions for the coming year. In many ways, *Cubism and Abstract Art*—as well as its twin, *Fantastic Art, Dada, Surrealism*—would provide ideal preludes to such a show, giving viewers the background that had been missing in earlier attempts to present Picasso's art in the

United States. Here, then, was an excellent moment to take stock of his most recent work, with a view to a larger collaboration to come.

At his gallery, Rosenberg greeted them cordially. By now, despite Barr's qualms about dealers and Rosenberg's skepticism about the museum, the two had a growing respect for each other. And Rosenberg had become an increasingly indispensable source of loans. For *Cubism and Abstract Art,* he agreed to share his great Léger masterpiece, *Le Grand Déjeuner,* as well as an important prewar Braque still life. Yet the dealer was unusually keyed up. Finally, Barr asked about Picasso. Rosenberg looked up at the ceiling and sighed. "Imagine," he said. "He has stopped painting!"

Then, while they were talking, Picasso walked in. It was true, Marga thought, something was not right. He seemed nervous; he was a pale imitation of the genial, flirtatious Iberian who had led her through the Galeries Georges Petit a few years earlier. Afterward, she wrote that he appeared to be in a "disturbed state of mind."[8] Nonetheless, he was eager for them to see his studio next door, and they followed him out.

First he took them to his apartment. From previous visits to Paris, they knew that Picasso and Olga had long led an elegant existence on rue La Boétie, with a housekeeper and nanny for their son; having visited Picasso's studio in his first summer as director, Alfred had some sense of the *haut-bourgeois* setting. But nothing had prepared them for what they found when Picasso unlocked the door. The apartment was completely deserted and the furniture was in disarray, as if someone had searched it. Then they noticed the string. In every room, closets, cupboards, and drawers were tied shut; nothing could be opened or moved. The strings were stamped with official seals, in large clots of red wax. It almost looked like a crime scene. "Look what they've done to me!" Picasso exclaimed, as he led them from room to room.[9]

Unwittingly, the Barrs had arrived in Paris at the peak of Picasso's divorce crisis. Pressure had been building since the spring. Six months earlier, Marie-Thérèse had told him she was pregnant. Unable to bear the prospect that the child would be illegitimate, Picasso promised her he would divorce Olga and marry her. In the spring, he had obtained a lawyer and begun formal proceedings. But he had failed to account for

Olga's wrath. For years, she had learned to look past his philandering, his absences, his abusive silences, the chaos that had always engulfed him. She was prone to violent outbursts, strange illnesses, chronic depression. But she had endured. Now, overcome with anger, she obtained her own lawyers, determined to make any settlement as difficult for Picasso as possible.

Days before the Barrs' arrival, the case had finally gone to court. In the preliminary hearing, Olga's lawyers asked the court to inventory their joint assets, but Olga was not prepared for what she had unleashed. When the bailiff appeared at their front door to inspect their apartment, she fainted, and Picasso had to send him away. Shortly afterward, she took Paulo to the Hôtel Californie, a few blocks away. She never returned. Meanwhile, the court moved to restrict all of the contents of the apartment until a settlement was reached.

But that wasn't all. There was the house in Boisgeloup and other personal assets. But for Picasso, the greatest threat hanging over him was the fate of all the paintings that remained in his possession. According to French law, half of them could be turned over to Olga when the divorce—initiated by Picasso—went through. Picasso was distraught. Going back to the days when Roché had come over to examine the "piles of paintings" in a corner of his studio, he had always held on to many of his favorite pictures. In laying claim to them, the court was depriving him of a crucial part of his identity: "Look what they've done to me!" was also his way of telling the Barrs that he was being robbed of his art.

No one understood what was at stake better than Rosenberg. After all, the dealer had preferred to remain in an unhappy marriage rather than contemplate the destruction of his own vast stock of paintings. Nor could he help getting drawn into Picasso's mess. "As a dealer, he is involved in the personal affairs of his artists," Marga noted. With his unparalleled knowledge of Picasso's work, Rosenberg had agreed to make the inventory of Picasso's paintings required by the court. Despite his own displeasure, he felt he had to go through with it. "You understand very well that I had no more desire than you did to accomplish this work," he told Picasso, as he came to the end of the report.[10]

Soon the case would become bogged down in court. But even with-

out a final settlement, in many ways Olga had already won. After Picasso showed Alfred and Marga the apartment, he took them to his studio upstairs. The windows were unwashed and there were clouds of dust everywhere; the big, unfurnished rooms were filled with old canvases, lined up with their faces to the wall. Clearly, the place hadn't been used in months. Rosenberg was right: He had stopped painting.

For an artist who, for more than thirty-five years, had never stopped, it was a startling break. But he had no idea what he was getting himself into. Seeking escape, he had instead found himself in a trap of his own making: separated but not yet divorced, his son taken from him, his home under court supervision. And he still lacked the freedom to wed Marie-Thérèse—or even to formally recognize her—before she gave birth. His own lawyer had warned him that as long as the case was in court, he shouldn't live with Marie-Thérèse. How could anyone paint under those circumstances? It must have been a peculiar sort of vindication for Olga, whose face and body had often been cruelly disfigured in Picasso's work. Picasso later described it as "the worst time of my life."

As news of Picasso's marriage crisis spread in Paris, there was growing speculation about why he had stopped painting. Picasso claimed that he had decided to become a poet. But it was also clear that he couldn't tolerate the idea that anything he painted might be claimed by the court. "He is in a state of absolute depression, in between fits of euphoria more painful to witness than the depression," Kahnweiler wrote to Gertrude Stein, a few weeks after Alfred and Marga's visit to rue La Boétie.[11] In fact, Picasso hadn't quite given up making art. He continued to work on his great, roiling psychodrama of an etching, the *Minotauromachie*. It was, in its tortured way, an expression of everything that he was going through. Later, he would give a rare signed proof of the etching to Barr as a token of his appreciation. For the moment, though, he was not working, and his existing paintings and sculptures—at least those in his personal possession—were off limits to the Museum of Modern Art or anyone else. In the end, Alfred and Marga were forced to depart Paris without Picasso's help for the Cubism show.

. . .

Back in New York that winter, Barr spent long evenings on the living room floor. In an astonishing six-week effort, he assembled the entire show and the 249-page catalog, a work that would present a sweeping new vision of the past half century of modern art, a through line that went from the sources of Picasso's earliest Cubist experiments up to the Merzbau construction of Schwitters, the spontaneous forms of Miró, and the mingling shapes of Calder. For all the chaotic diversity of the show's content, he offered an almost positivist vision of formal development that could somehow account for it all. He also came up with a theory to explain it. The entire course of modern art, he posited, or at least this crucial central strand, could be traced to a fundamental problem that artists had confronted at the beginning of the century. "The pictorial conquest of the external visual world had been completed," he wrote. "The more adventurous and original artists had grown bored with painting facts."[12] The result was Cubism and a broader movement toward abstract art. Not content merely to describe his theory in words, he decided to diagram it in an enormous flow chart, which he put on the cover of the catalog. Beginning with the four foundational artists, Van Gogh, Gauguin, Cézanne, and Seurat, the chart split into two pathways as it moved forward in time, both ending in abstraction: On the right-hand side was "Geometrical Abstract Art," which started with Cézanne and Seurat and evolved through Cubism, Constructivism, the Bauhaus, and many other movements; on the left, "Non-Geometrical Abstract Art," which started with Gauguin and Van Gogh and developed through Fauvism, Expressionism, Dada, and Surrealism.

Barr's vision was seductive. It also was highly controversial. In later decades, the effort to impose such order out of the inherent chaos of modernism would appear an act of extraordinary hubris. Even at the time, critics took issue with his deterministic formalism, and Barr seemed to be aware of the impossibility of what he set out to do. As he acknowledged in the catalog, "often, of course, these two currents intermingle, and they may both appear in one man."[13] He might have been referring to Picasso, whose works he sorely needed, not only for the Cubism show but for the Surrealism show that would follow it.

Despite the scientific framing of the show, Barr could not help ac-

knowledging the international situation in which it was playing out. As he wrote in the catalog, there was a concerted campaign under way against modern art and modernist culture in both Russia and Germany, the two countries where modern art forms had most widely flourished; in assembling the show, he was also making an urgent defense of abstract art as a form of political liberty. Not least was the fact that nine artists in the show had been forced to leave Germany since Hitler rose to power—a number that he raised to twelve by the time of the catalog's second edition. "This essay and exhibition might well be dedicated to those painters of squares and circles . . . who have suffered at the hands of philistines with political power," he wrote.

Cubism and Abstract Art had an extraordinary impact on both popular and critical understanding of modern art. It also gave new weight to abstract art at a time when it had been marginalized in the United States. What it did *not* do, though, was bring much new attention to Picasso. In the end, Barr managed to compensate for the artist's nonparticipation with twenty-one Picassos from various private collections. Yet the show was unable to include the *Demoiselles,* whose Paris owner refused to lend it, and the only Picasso collage in the exhibition was shown in a photograph, because the original was unobtainable.

The Cubism show was not the only one that suffered from Picasso's absence. For Barr, there remained the nagging problem of the larger Picasso show, which would have to be postponed yet again. Even as the Cubism show was opening, Barr had warned the trustees that doing a Picasso show was highly unlikely for the foreseeable future. As Goodyear summarized the situation to Rockefeller, "It is probably quite doubtful, that we could count on getting the Picasso pictures, which are tied up by his divorce proceedings, in time for an exhibition next season."[14]

At a time of growing political and ideological conflict across Europe—a time when artists were fleeing into exile and their paintings were being removed from museums—what was keeping Picasso's work from getting to the United States was not politics or censorship but affairs of the heart. "It was the divorce that kept him from painting," Barr later wrote. "Not rheumatism, not melancholia, not the Spanish War,

not fallowness—but the drive to keep his wife from laying hands on more of his creations."[15]

Thanks to his pending divorce, Picasso could not take up the central part in the story of modern art that Barr had been laying out on his living room floor. What was not yet clear, though, was that the larger forces confronting Europe were about to dramatically redirect that story—and Picasso's place in it.

30

SPANISH
FURY

O ne afternoon in late September 1936, Marga and a young friend walked into the Café de Flore and found Picasso at a table alone. The encounter was not altogether unexpected: In the year since his marriage crisis, Picasso had reembraced the Left Bank scene, and the Flore—long a hangout of the Surrealists—had become a regular part of his routine. Often, he would sit on one of the red leather banquettes smoking Gauloises, an untouched glass of mineral water in front of him, while members of his circle came and went. "Do you prefer your solitude?" Marga greeted him ironically. He gestured the two women to join him.[1]

For Marga the meeting was a crucial opportunity. In December, Alfred was opening his huge Surrealism show—the equally ambitious sequel to *Cubism and Abstract Art*—and he had left her in Paris to settle the final loans. In particular, he wanted her to get an important group of disquieting bronze figurines, as well as several paintings, out of Picasso. But Marga had another motive as well. The war in Spain had begun two months earlier; already, Hitler and Mussolini were backing General Franco's rebels with planes and artillery. Artists and writers were clamoring to join the International Brigades to defend the Republican government, and Spanish officials, in an effort to call world attention to the

war, had just taken the unusual step of naming Picasso as director of the Prado, Spain's national museum. The Prado announcement was an important turn in the alliance between modern artists and the anti-Fascist front, and Marga wondered if Picasso would be going to Madrid to take up the cause.

As they began talking, however, Picasso seemed strangely indifferent. "I guess we're in the same business now," he replied, archly, when she asked about the Prado. Just like everyone else, he'd heard about the appointment through the newspapers. He also had no intention of going to Madrid. Marga was incredulous. After all, there had been blood in the streets of Barcelona, where Picasso's mother and sister lived in a flat near the city center. And a few weeks earlier, Franco's forces had begun a vicious bombing campaign over Madrid. Even now, the Prado's treasures—the Velázquezes, El Grecos, Zurbaráns, Murillos, Goyas, and hundreds of other masterworks—were at serious risk. "Can't you use your authority just for an hour and see that the pictures get safely stored?" she asked. "Start writing, start wiring but get something done?" Picasso shrugged. The paintings were safe, he said, and if they got wrecked, "I can always paint new ones."

Picasso's blasé attitude was disconcerting given his friends' constant talk of the war. At the Flore, they were soon joined by Miró's dealer, Pierre Loeb, who told them that Miró was in Spain trying to get his family out. Then came Christian Zervos, the *Cahiers d'Art* publisher, and his wife, Yvonne, who were planning a trip to Barcelona and Madrid to document art and monuments threatened by the conflict and to investigate the situation of the Prado. Still Picasso showed little interest. Instead, after Marga and her friend left, he began telling the Zervoses about his nocturnal prowls that summer in the Midi. "The Zervos[es] were disgusted," Marga reported to Alfred. "In Spain they're killing each other & he wallows in brothels."

By the summer of 1936, Picasso's life had become increasingly unmoored. The previous fall, Marie-Thérèse had given birth to their daughter, Maya; with his paternity still officially unacknowledged, he had appeared at the baptism as her godfather. But around the time of Maya's birth, he had been struck, at the *Deux Magots,* by a grave, dark-

haired young woman with pale eyes and a fixed gaze. Dora Maar was a
fiercely intelligent Croat French photographer and Surrealist, exactly
half his age; when they were finally introduced that winter, she quickly
became his latest amour fou.[2] Now he was dividing his time between
Dora and Marie-Thérèse and his infant daughter. All the while, his
costly legal battle with Olga continued, and his return to art making had
been languid at best.

That spring, Rosenberg had astutely papered over Picasso's fallow
period by staging a high-profile show. There were huge crowds, and the
event played to all of the dealer's strengths. "Rosenberg, exuberant,
danced about from group to group shaking hands, listening to ques-
tions, taking care of everybody and giving constant orders to his assis-
tants," Jaime Sabartés, Picasso's faithful Spanish secretary, wrote. Even
Kahnweiler seemed to acknowledge Rosenberg's magic, calling Picasso's
new work "Michelangesque." In reality, though, the twenty-nine works
in the show had all been created before the marriage crisis. Picasso didn't
even attend, and before it was over, he had fled to Juan-les-Pins. Even as
Rosenberg was trumpeting Picasso's "new" canvases, the artist wrote
Sabartés half jokingly, "I am giving up painting, sculpture, engraving,
and poetry, to devote myself exclusively to singing."[3]

When the fighting in Spain began that summer, Picasso had again
gone away, this time to Mougins, in the south of France. He was with
Dora Maar and a group of his Surrealist friends, and the war was con-
stantly on their minds. Maar and Paul Éluard were committed anti-
Fascists who fervently supported the popular front; Roland Penrose was
planning his own trip to Barcelona to build British support for the strug-
gle against Franco. In Mougins, they were also joined by the Zervoses,
who were if anything even more militant. "No one can remain indiffer-
ent," Dora's mother wrote her during the holiday. "Poor poor poor peo-
ple!"[4] Picasso's main impulse, however, was to seek escape in beach swims,
constant flirtation, and clownish humor. One day at lunch, while the
group was discussing the latest events, he picked up a black toothbrush,
held it to his upper lip, and raised his right arm, in a spoof of Hitler.[5]

But Picasso had never been politically engaged. Kahnweiler, who
knew him as a young man, often said that he was the least political artist

he had ever met; in the early 1930s, while some of his Surrealist friends were getting into trouble with the French government for their radical politics, Picasso was written off by the Soviet embassy in Paris as a bourgeois. In Spain, he had been courted by the right-wing Falangists before the war; as late as the spring of 1937, he felt it necessary to set the record straight that he was not, as sometimes rumored, pro-Franco. Indeed, there was little in his art that betrayed a political consciousness of any kind.

For Alfred and Marga, Picasso's disengagement presented an awkward reality. In his own museum work, Barr instinctively shared Picasso's apolitical outlook. Just as Picasso's art seemed to exist outside the realm of current events, Barr had long viewed the story of modern painting as a continually evolving interplay of styles and forms that unfolded largely on its own terms. Yet Barr was acutely aware of the extent to which modern art had been drawn into the defining ideological battles of his time. Not only had he witnessed, firsthand, the ways that democratic freedoms and advanced modernism had been squelched in Stalin's Russia and Hitler's Germany. He was also immersed in the fraught debates of Depression-era America, including on such matters as social housing and even race relations. In 1935, Barr joined a group of prominent New Yorkers who sponsored an important anti-lynching exhibition organized by the NAACP; two years later, while traveling with Marga in the Jim Crow South, he insisted on sitting in the nonwhite section of the bus.[6]

Despite his formalist training, Barr's thinking about art and politics was shifting. Though his initial approach to museum work had been shaped by the establishment inclinations of Harvard insider and former banker Paul Sachs, by the mid-1930s, he was having regular arguments with the brilliant young art historian Meyer Schapiro, who was deeply involved in radical politics. In a study group that sometimes met at Schapiro's Greenwich Village apartment, Barr encountered many of the leading figures of New York's anti-Stalinist, anti-Fascist left, who viewed art and culture as another weapon in the defense of progressive democracy. In an influential essay, Schapiro took issue with Barr's notion of abstract art as a "purely aesthetic activity" driven by an internal

evolution of style, arguing instead that modern art, no less than other art forms, was crucially shaped by the social and political forces around it. In response to Barr's Cubism show, he wrote, "There is no 'pure art,' unconditioned by experience."[7]

While Barr did not abandon his approach, he increasingly recognized that Hitler's campaign to wipe out modern art provided a crucial opening to change American attitudes. Instead of subversive foreign influence, avant-garde art could be promoted as an embattled symbol of advanced democracy. "Why do totalitarian dictators hate modern art?" Barr later wrote. "Because the artist, perhaps more than any other member of society, stands for individual freedom." But this argument could only go so far as long as Europe's preeminent modern artist remained detached from the growing conflict with Fascism.[8]

Given what Marga had witnessed, Picasso seemed less an emblem of Spanish Republicanism than of Parisian decadence; at fifty-four, living on his earlier renown and sitting in Left Bank cafés while his own country was torn apart, he was at risk of becoming the self-indulgent bohemian of conservative American caricature. Hearing him joke about making new paintings for the Prado, Marga felt nauseated.

As so often in the past, it remained uncertain how much of Picasso's work the Museum of Modern Art would be able to get. Having made no progress at the Flore, Marga was running out of time. Finally, on the eve of her departure for New York, she phoned Zervos's wife, Yvonne, who told her they were expecting Picasso at the *Cahiers d'Art* offices that afternoon and urged her to join them. She rushed over, and soon after, Picasso turned up, wearing a bright tie and yellow socks. "Aren't you handsome," Marga said. "En effet," he answered—"Indeed." The room broke out in laughter. He sat down next to Marga on the Zervoses' couch, and they began to talk. Eventually, she brought up the works Alfred was hoping to borrow. "Will you lend?" This time, with Zervos and others watching, Picasso couldn't refuse, and suggested several important paintings he would be glad to offer her. But when she went to meet him the next morning to finalize the arrangements, he stood her up. She would have to return to New York empty-handed.[9]

Paradoxically, Picasso's evasion meant that, for star power, Alfred

would have to rely on the works of Salvador Dalí, whose Francoist sympathies were at odds with almost the entire modern art world. "Picasso's breakdown . . . means that Dalí will have to lend & lend importantly," Marga wrote Alfred.[10] Perhaps it was Picasso's increasingly byzantine personal affairs and his unresolved divorce; perhaps it was his resistance to a huge group show. Whatever it was, Picasso seemed no more interested in taking part in Barr's Surrealism show than in engaging with the war in Spain. The world would have to wait.

Fantastic Art, Dada, Surrealism, Barr's most radical exhibition to date, would prove to be hugely controversial. Among the hundreds of works were Duchamp's *Why Not Sneeze Rose Sélavy?,* a birdcage filled with marble "sugar" cubes, which was lent by John Quinn's old friend Henri-Pierre Roché; Magritte's *The False Mirror,* a painting of a giant eye whose pupil is a cloud-filled blue sky; Man Ray's huge painting of the disembodied lips of his former lover Lee Miller, floating over a landscape; and, most sensationally, a fur-clad teacup and tea set by the young Swiss artist Meret Oppenheim.[11] Equally provocative was Barr's inclusion of "comparative material"—nonartistic sources that ranged from Walt Disney's *Wolf Pacifier* from *The Three Little Wolves* to children's drawings and Rorschach inkblots. There even was a section of "art of the insane"—drawings by psychiatric patients that he felt were an important source for the Surrealists.

Fueled by sensational press coverage, the show drew more than fifty thousand visitors, but it was hardly the reverential interest that had greeted Van Gogh. While Dalí, with his by now famous "wet watches," was an inevitable crowd pleaser, much of the attention was sniggering. Journalists gleefully reported couples in hysterics over sculptures made of household utensils and animal detritus; one columnist wrote that the Museum of Modern Art had been turned into a "penny arcade." In the *New York Herald Tribune,* a group calling themselves Defenders of Democracy and claiming to have sixty thousand members denounced the show as a Communist plot. Even some of Barr's fellow modernists took issue with his inclusion of psychopathic drawings and children's art, at a

time when the Nazis were condemning all modern art as "degenerate."
"Personally, I considered it very dangerous for our American public,"
the avant-garde patron Katherine Dreier told him.[12]

Most worrying was the reaction of the trustees. Goodyear, known for
his adventurous tastes, found the show so embarrassing that he feared it
had done serious damage to the museum. "It includes a number of things
that are ridiculous and could hardly be included in any definition of art,"
he wrote to Abby Rockefeller. She was even more troubled than Good-
year, and for the first time expressed serious misgivings about Barr's
leadership. "I feel that he is neither physically nor temperamentally fit-
ted to cope with the intricate problems of the management of the mu-
seum," she told Goodyear. It was time, she said, for some higher
authority to start vetting his shows. She added, "We should from now
on have a director who directs."[13]

For Barr, it was an ominous turn. Almost since the day she had hired
him, Rockefeller had been one of his most loyal supporters. She had
often been awed by the breadth of his knowledge and the impact of his
shows; she stood by him during his breakdown, provided him with doc-
tors, granted him a year's leave at the height of the economic crisis. She
approved his bold expansion of the museum into architecture, film, and
photography and solicited his advice in her own collection. But he was a
hopeless manager, and in his zeal to embrace the most experimental new
work, he was starting to lose her. Even as he pushed the museum to the
forefront of the art world, he had opened a new rift with its principal
founder.

By the winter of 1936–37, Europe's first military confrontation with
Fascism had grown increasingly dark. Even before the opening of Barr's
Surrealism show, Franco's forces had begun the siege of Madrid, with
vicious street fighting and German bombers pounding the city. As
Marga had predicted, not only civilians but also prized artworks were
threatened. In early November, Spanish officials began evacuating the
Prado's most important paintings to Valencia; shortly afterward, the
museum was hit by multiple incendiary bombs. "See the builders of

ruins at work," Picasso's friend Éluard wrote in a major protest poem, breaking the Surrealist taboo on poetry about current events. Then, in early February, Franco's forces overtook Málaga, Picasso's city of birth. From his Spanish friends, like the poet José Bergamín, he was also receiving alarming reports from the front lines.[14]

Despite these events, Picasso's attitude had changed little since the summer. Contrary to what has often been written about the artist, and despite the intense involvement of many of his friends, there is very little evidence of his political engagement during the first nine months of the war.[15] He now spent weeks mostly in Paris with Dora Maar, followed by long weekends with Marie-Thérèse and Maya, who was now a year and a half old, at Vollard's farmhouse in Le Tremblay, an hour's drive west of the city. Meanwhile, he continued to frequent his usual spots and spend long hours at the café. In Spain that fall, Zervos and his wife had visited Picasso's mother in Barcelona and sent him vivid accounts of watching young soldiers leaving for the front lines. "There is no public display, no tears, no sign of sadness, only a great dignity that grabs you deep in the gut," Zervos reported in one letter. Yet when they returned to Paris, they found Picasso as emotionally detached from the war as ever. "For a long time he fought his own feelings," Zervos wrote.[16]

Despite his official position at the Prado, Picasso hadn't been involved in the evacuation, and apart from the satirical comic strip he had started but not finished, called *The Dream and Lie of Franco,* and an unusual portrait of Dora waving a Spanish flag, there was hardly a trace of the war in his work. Four days after the fall of Málaga, he painted an absurdist scene of two robot-like nudes playing with a toy boat on the beach. "Picasso was joking, trying to shock, playing at contradictions," the critic John Berger wrote. "But this was because he didn't know what else to do."[17]

Then, one afternoon in late April, while Picasso was sitting at his usual table at the Flore, the Spanish poet Juan Larrea jumped out of a taxi and accosted him. Larrea worked as an information officer for the Spanish Republic and had been part of a committee that had persuaded Picasso, a few months earlier, to create a very large mural for the Spanish Pavilion at the Paris World's Fair that summer. Picasso had been

reluctant to accept the commission, and for months he had done very little work on it. But now Larrea brought some shocking news. The Basque president had just announced on the radio that something unimaginable had happened in northern Spain. "German airmen in the service of the Spanish rebels have bombarded Gernika, burning the historic town that is held in such veneration by all Basques," he had said. There were still few details about the attack, but it appeared that the entire town had been reduced to smoldering ruins. Larrea urged Picasso to take up the bombing as the subject of his mural.[18]

Picasso was noncommittal. It was not the kind of theme he dealt with; he wasn't even sure what a bombed city looked like. It also wasn't clear what had happened. But the atrocity wouldn't go away. That evening, *Ce soir,* a newspaper edited by Picasso's friend Louis Aragon, described it as "the most horrible bombardment of the war." The next morning, the Communist daily *L'Humanité,* also one of Picasso's regular papers, ran the startling headline: A THOUSAND INCENDIARY BOMBS DROPPED BY THE PLANES OF HITLER AND MUSSOLINI REDUCE THE CITY OF GUERNICA TO ASHES. And on the next day: ONLY FIVE HOUSES LEFT STANDING IN GUERNICA! Then, finally, the first shocking photographs began to appear in *Le Figaro* and *Ce soir*.[19]

As more details emerged, it became clear that the bombing was meticulously planned and unspeakably awful. In fact, Mussolini's planes were not involved, but the initial news contributed to an overwhelming sense of Fascist terror. Timed for the afternoon of a market day, when the streets would be full of people, the attack had involved waves of Heinkel warplanes, alternating with larger and slower Junkers, blanketing the town with incendiary bombs, and strafing fleeing civilians with machine-gun fire, until the entire area was reduced to rubble. The remains of the town had burned for three days. Hundreds of people were killed and thousands more were uprooted. Here was all the horror of the Spanish war compressed into a single, terrible event.

That weekend, Picasso didn't join Marie-Thérèse and Maya in the countryside. He stayed in his studio and began to sketch. On May 1, he completed six drawings; soon there were a dozen: a woman holding a lantern; a majestic, terrified, writhing horse; a woman, twisted and up-

turned in agony, grasping the limp body of a young child; a fallen war-rior; an appalling pile of twisted limbs; a menacing bull; a petrified bird. For nearly two weeks, as he furiously drew, *L'Humanité* published new photographs of the grim aftermath: burned buildings; dead animals; refugees fleeing Guernica on foot, some of them carrying infants.

As he worked, Picasso was in a rage. Dora was struck by what she called his "indignation." Man Ray had never seen him react so violently to world events; Bergamín, his poet friend, described it as "Spanish fury."[20] This was an almost unrecognizable Picasso from the man of pre-vious weeks and months. Everyone around him noticed it: Something about this particular tragedy, this attack on an entire people, had shaken him out of his passivity. The emotional dam that had protected him from the war had suddenly broken.

In almost every way, the project was a departure for him. He had never made a political painting; he had never made a public mural. In-deed, for all his decades as an artist, for all his restless experimentation, there was hardly anything about the format that related to any previous work. In scale alone, the challenge was formidable: The canvas was twenty-five feet long and eleven feet high; somehow, he would have to project his repertoire of intimate human and animal images onto a sur-face that was far larger than any person or beast. And it would have to have a unifying vision. "I know I am going to have terrible problems with this painting," he told Dora. "But I am determined to do it." He added, "We have to arm for the war to come."[21]

After ten days of nonstop sketching, he drew his first full design on the canvas; already, much of the final conception of the painting had taken shape. Then, in subsequent phases, the central motifs of an im-mense, dark, claustrophobic tableau began to emerge, restricted to the same unremitting gray-black-and-white colors of the newspaper photo-graphs that had inspired him. In the end, it didn't matter what a bombed city looked like. The human violence ran deeper. "The military caste," as Picasso would soon put it in a rare public statement, had "sunk Spain in an ocean of pain and death."[22] To convey the horror he needed the full range of his art: Goya, Athenian tragedy, medieval Catalan art, bull-fighting, Crucifixion iconography, Cubist collage, Surrealist biomor-phism, the endlessly transposed Minotaur series.

As he worked and reworked the canvas, Dora watched and photographed. Providing a riveting, start-to-finish record of the painting's creation, her images captured not only Picasso's developing vision, but the extraordinary pace at which he executed it. Each day, the canvas, with its contorted limbs and faces and animals in agony, evolved; in thirty-five days, it was finished. For any painter, it would have been a breakneck project. For a middle-aged artist who two years earlier had almost ceased painting altogether, it was an astonishing, athletic feat of self-reinvention. Having insulated himself from the events in Spain for so long, Zervos noted, Picasso now let his paintbrush explode with "distress, anguish, terror, insurmountable pain, massacres, and finally peace found in death."[23]

As he was immersed in making the huge painting, Picasso also thrust himself into the Republican cause. He donated the payment he received for the mural commission to Spanish war relief. He decried the destruction by Franco's forces and began to take an intense interest in the Prado. And likely with significant help from Éluard and his Spanish friends, he also made the first political statement of his life. "The Spanish struggle is the fight of reaction against the people, against freedom," he declared, in a text he provided the American Artists' Congress, the anti-Fascist artists' front in New York. Suddenly, Picasso was identifying himself with the democratic values that Barr championed. But his most important statement would be the painting itself.[24]

The Spanish Pavilion of the Paris Expo should have provided an ideal setting for the giant work that would soon be titled *Guernica*. Designed by the young Catalan architect Josep Lluís Sert, the building was a simple, steel-framed glass box, and its exhibit provided a bold combination of high modernism and pro-Republican propaganda. Along with *Guernica* and several Picasso sculptures, it featured another mural, by Miró, and a fountain by Alexander Calder, as well as photographs and documents about the war and a film program organized by the avant-garde filmmaker Luis Buñuel. Overall, the presentation seemed designed to show that art could be both aesthetically advanced and politically urgent. And it would have an unparalleled world audience.

Almost from the moment the pavilion opened, however, *Guernica* was distinctly unloved. Though millions of international visitors at-

tended the Expo, few seem to have paused very long in front of the huge, dark, unsettling mural; fewer still appear to have appreciated it. "They looked at this thing and they didn't understand it," Sert, the architect, said. "I watched them pass by."[25] Many were put off by the painting's limited palette. Others disdained its abstract imagery and its lack of direct reference to the town itself or the Fascist aggressors. The journalist Emily Genauer, one of the few Americans who commented on it that summer, noted that it was "incomprehensible to most people who see it." According to Le Corbusier, the mural "saw only the backs of visitors, for they were repelled by it."[26]

Spanish officials were hardly more enthusiastic. The Basque delegation in Paris pointedly snubbed Picasso's offer to give the work to the Basque people, while the Basque artist José María de Ucelay was more blunt: "As a work of art it's one of the poorest things ever produced in the world."[27] Picasso's friend Juan Larrea listened to Spanish officials in Paris describe it as "antisocial."[28] So reviled was *Guernica* among the pavilion's own staff that several officials suggested taking it down and replacing it with a different work. Buñuel, who had helped install the mural and was an avowed modernist himself, said that he and several others at the pavilion hated everything about it. "Indeed all three of us would be delighted to blow up the painting," he said.[29]

With few exceptions, the French press ignored *Guernica* altogether. Amid almost daily coverage of the Expo, *Excelsior, L'Intransigeant, Le Temps, Le Figaro,* and *Le Matin* made no mention of the work; nor did *Le Populaire,* the socialist newspaper that had often appeared in Picasso's Cubist paintings. Even the Communist *L'Humanité,* which had done more reporting on the bombing of Guernica than any other French paper, made only glancing reference to the mural. Not wanting to criticize Picasso directly, his friend Aragon, who was director of *Ce soir,* avoided any comment about Picasso or the painting. Intended as an overpowering statement about the war, *Guernica* had instead met with silence.

It did not help that one of the most careful observers of Picasso's work was not in Paris at all that summer. For Alfred Barr, Picasso's political turn should have carried dramatic importance. But in 1937, in a

rare exception to their usual summer routine, he and Marga had stayed in the United States: Marga was pregnant. For years, they had been ambivalent about children, but Marga was now in her midthirties and had been determined to try; in October, their daughter, Victoria, was born. During the final weeks of Marga's pregnancy, a Paris friend of theirs sent them a postcard from the Spanish Pavilion with a picture of *Guernica* on it. But amid pressing matters at home, there is little evidence that Alfred gave it much thought.[30]

Still, there were Zervos and his friends at *Cahiers d'Art,* who had closely followed the genesis of *Guernica* and fervently wanted the painting to reach the world. Picasso scholars have long maintained that the influential magazine, bucking the French press, gave the giant anti-war mural instantaneous international acclaim in a now celebrated double issue. "A powerful defense of *Guernica* . . . was almost immediately marshalled by the artists, writers, and poets of the *Cahiers d'Art* circle . . . heralding a painting virtually unknown except to Picasso's friends," the late-twentieth-century scholar Herschel B. Chipp, one of the work's leading chroniclers, wrote.[31]

But this is mistaken. Although the special *"Guernica"* issue of *Cahiers d'Art* is undated, the magazine's account books make clear that it was not published until October, a full three months after the painting's unveiling and nearly at the end of the Expo itself; many readers did not see it until weeks after that. All indications are that the magazine had almost no effect on the painting's abysmal reception in Paris.[32] Paradoxically, one of the only mass-circulation publications to take up the painting at the time of the opening was the official Nazi guidebook to the Expo, which predictably called it "the dream of a madman, a hodgepodge of parts of bodies that a four-year-old child could have painted."[33]

As a personal political awakening, *Guernica* marked an astonishing turn. For a group of Picasso's friends, it was also the most powerful work of his life. As a rousing call to defend the Spanish Republic, however, the painting had gone nowhere. Among those who noted the lack of response was Jean-Paul Sartre, who was teaching at the Lycée Pasteur in Paris at the time and had just written an acclaimed short story about the war. "Does anyone think it won over a single heart to the Spanish cause?"

he later asked.[34] For much of the summer, all that Picasso's giant mural seemed to have achieved, on a popular level, was to rile the enemies of modern art. When the Expo closed that fall, though the painting officially belonged to the Republican government in Spain, it was returned to Picasso's studio. Based on its disastrous debut in Paris, it seemed possible that *Guernica* might soon be forgotten.

31

"SUCH A PAINTING COULD NEVER AGAIN BE HAD"

FOR HEAVENS SAKE, do not mention to anyone," the dealer wrote to his counterparts in the United States. "Do not show photographs to anyone, and do not mention pictures to anyone." Written by a prominent Paris art trader, the September 24, 1937, letter concerned a very large Picasso that was about to travel across the Atlantic on the S.S. *Normandie*. It was not *Guernica*.[1]

While Picasso's great anti-war mural was perplexing visitors to the Spanish Pavilion in the Trocadéro Gardens, a different monumental painting—created decades earlier, yet virtually unknown to the public—had quietly been extracted from the private collection on the outskirts of Paris where it had long been kept. With France now in full-blown economic crisis, the dealer thought his best chances for a high price would be in the United States. Such was the legend surrounding the work, moreover, that he wanted to keep it completely under wraps until its unveiling in New York.

But Alfred Barr soon found out anyway. The mysterious painting was *Les Demoiselles d'Avignon,* the nearly eight-foot-tall, discomfiting brothel scene with which Picasso, at twenty-five, had thrown away the rules that had governed painting for nearly five centuries. In avant-garde circles in Paris, it had a cultlike status; Barr regarded it as the first Cubist picture, a painting that was to earlier art what Einstein was to

Newton. "In few modern works," he would argue, "is the arrogance of genius so powerfully asserted." Yet as far as he knew, in its thirty-year existence, the *Demoiselles* had never been exhibited. Only a year earlier, he had desperately wanted to borrow it for his landmark exhibition *Cubism and Abstract Art*. The widow of its longtime owner, the Paris fashion designer Jacques Doucet, had refused. Now, however, the painting was being unpacked at Seligmann & Co., a prominent gallery less than five minutes' walk from the museum. And it was for sale.[2]

Barr was excited, and apprehensive. If there was a single work that embodied the insurgent spirit he was trying to capture at the museum, the *Demoiselles* was it. Here was a painting that could define the collection, a painting that Barr could, in essence, bring into the greater world. It was an almost unfathomable opportunity. But Seligmann had priced it at an ambitious $30,000. While that price hardly seems extravagant to a twenty-first-century reader—adjusted for inflation, it would amount today to about a half million dollars, a moderate sum for a premier work by a leading contemporary artist—the amount was considerably more than was being asked for almost any contemporary painting at the time. It was also more than all the money the museum had spent in the art market combined.

Not least was the question of its content. Fueled by the Federal Art Project, the New Deal's public art program, the dominant style of large-scale painting in America continued to be a socially engaged realism. In the fall of 1937, artists were decorating post offices, libraries, and government buildings across the country with murals of farmers and factory workers, scenes from American history, and ordinary people experiencing the vicissitudes of American life. Here, by contrast, was a stomach-turning semiabstracted scene from a European whorehouse. As it was, the unbridled rule breaking of Picasso's execution quite literally masked several of the five prostitutes and their lurid precoital poses: scandal eclipsed by revolt. Still smarting from the fallout of his Surrealism show, Barr had reason to doubt that the trustees would go for either quality.

. . .

In fact, the unexpected arrival of the *Demoiselles* on Fifth Avenue couldn't have come at a more critical juncture for the museum. In his shows, Barr was finally starting to bring the avant-garde movements of Europe to a broad public. He had expanded the scope of modern art to include everything from low-income housing to buzz saws. And after years in makeshift quarters, he and his staff were finally on the cusp of getting a very modern permanent home. Thanks to a curious marital transaction, the trustees had acquired a series of Rockefeller-owned properties on West Fifty-third Street. John Rockefeller, Jr., refused to donate the land to the museum, but he was willing to sell it for $250,000; Abby Rockefeller, using her own funds, gave the museum the money to buy it from her husband.[3] (When it came to modern art, the question of *biens conjugaux* seems to have been as crucial for the Rockefellers as it had been for Picasso and Rosenberg.) The board had even agreed to build the museum in the International Style—though they swatted away Barr's strenuous efforts to hire Mies van der Rohe, opting instead for a tamer design by their trustee Philip Goodwin, and his young American partner, Edward Durell Stone.

Yet amid this remarkable success, Barr had made embarrassingly little headway on his most central aim: the assembly of the first great museum collection of twentieth-century painting and sculpture. Well before the museum's first show, he and the founders had announced that their "ultimate purpose" was to build a "collection of the best modern works of art."[4] This was the utopian ambition that, working from his own instincts, John Quinn had set out to accomplish with Henri-Pierre Roché a generation earlier; it was also the project that Barr had turned into a programmatic vision when he began drawing torpedoes in Stuttgart. As he had long argued, only with a sequence of exceptional creations by the greatest artists—works that continually looked forward to the "ever advancing present"—would the museum be able to tell the unfolding story of twentieth-century art in a durable way.

But while the trustees supported Barr's collection-building concept, they showed very little interest in paying for it. As early as 1930, he had tried to get Seurat's masterpiece *Parade* as a foundational work. "Buildings may be had for money," he told one board member, "but such a

painting as this . . . could never again be had." The trustees were un-moved. Over the following years, an extraordinary series of avant-garde paintings became available for Depression-era prices—not just impor-tant works but defining, essential contributions to the development of modern art. Again and again, Alfred found his hands tied. One of Cha-gall's greatest paintings for $1,500? He couldn't raise more than $1,000. Giacomo Balla's *Dog on a Leash,* a high point of the entire Futurist movement, for $600? Impossible. Six thousand for the incomparable Cubist masterpiece of Roger de La Fresnaye, whose work Quinn had introduced to New York more than two decades earlier? "Needless to say the museum cannot afford it," Marga noted dryly.[5]

Alfred did no better when he staged successful shows of the artists in question. After his landmark Matisse retrospective, the trustees failed to acquire a single painting for the museum. The pattern held for Diego Rivera and many other exhibitions. "The Museum has been borrowing works of art but never buying," Marga observed as late as 1935. Even after the breakout success of Van Gogh, Alfred was unable to persuade the trustees to purchase *Starry Night,* one of the preeminent modern paintings. Though the exhibition itself had generated a rare profit for the museum, the money, he was told, was needed for other purposes.[6]

The trustees seemed to assume that gifts and donations would take up the slack. It was true that, after strenuous lobbying on Barr's part and a stark reduction in the endowment requirements, they had belatedly taken possession of the Bliss Collection in 1934. But most of her paintings—Cézannes, Degases, Gauguins—were from the late nine-teenth century; her single Cubist still life by Picasso and rather mild Matisse interior were hardly the beginnings of an avant-garde corpus. Meanwhile, the smattering of contemporary gifts that had come in also showed how much was lacking. Around its fifth anniversary, the mu-seum was given two significant works from the late twenties: Brancusi's ethereal bronze *Bird in Space* and Picasso's *The Studio,* a distinguished, if not quite epochal, abstract painting inspired by his experiments with wire sculpture. At almost the same moment, Abby Rockefeller also do-nated thirty-six paintings and dozens of watercolors, mostly by Ameri-can artists. It might have seemed that the ground was at last being laid

for the great collection that Alfred sought. But John Quinn had once owned dozens of Brancusis and Picassos, along with his incomparable Seurats and Rousseaus and hundreds of paintings by American modernists.

Picasso was a special sore point. In 1934, Barr learned that Reber, the Swiss-German collector who had backed his initial Picasso plans, had suffered catastrophic losses on the Paris Bourse. "I've now got all the dope on Dr. R," one of Barr's European sources told him. "He is said to be in a very bad financial state . . . I believe that everything he has is for sale."[7] The news alone was tantalizing: Reber had perhaps the premier collection of Picassos at the time, along with huge numbers of Grises, Légers, and Braques. He also owned one of the two versions of *Three Musicians,* the twin Fontainebleau paintings that were the majestic culmination of Picasso's long road through Cubism during the war. When Barr learned that Reber might be prepared to sell *Three Musicians* for as little as $7,000 or even lower, he launched an all-out offensive to get it.

First he tried Stephen Clark, one of the few trustees who was actively buying art during the crisis. In a series of letters and calls, Barr plied him with blandishments, praising his taste and his earlier efforts on behalf of the museum. Reporting what he had learned about Reber, he told him that "one of the greatest twentieth century paintings" could be bagged for "an astonishing bargain." So innovative was *Three Musicians,* he added, that its purchase alone would silence critics who faulted the museum for "not being sufficiently modern." At the same time, he wrote to Abby Rockefeller to see if she might contribute funds to the effort. The hard-nosed Clark—who had already almost derailed the Bliss bequest—was not impressed. He was not averse to the painting, but it was a buyer's market and there were two versions available. He was in no hurry. For her part, Rockefeller, distracted at the time by the wedding of her son Laurance, apparently didn't respond.[8]

Unwilling to give up, Barr opened a second front with the man who owned the other version of *Three Musicians* and was, as usual, at the center of all things Picasso: Paul Rosenberg. Despite a collapsed market, the dealer had clung to his high prices, initially asking up to four times

Reber's figure for his painting, which was slightly larger. Rosenberg clearly wasn't selling much, though, and through intermediaries, Barr learned that he was open to negotiation. The following winter, Barr persuaded Rosenberg to lend the painting for the museum's fifth anniversary exhibition; trying to get the trustees' attention, he also described it in the show as Picasso's "greatest Cubist composition." But Rosenberg was unwilling to go below $20,000, and the efforts went nowhere.

Finally, as the summer of 1936 approached, Alfred made a new campaign for Reber's painting, which was miraculously still on the market. He decided he would persuade Rockefeller to jointly buy the painting with Walter Chrysler, Jr., the adventurous young automotive heir who had just given Picasso's *The Studio* to the museum. The talks extended from New York to Paris, including a meeting with a lukewarm Rockefeller at the very ancien régime Hôtel de Crillon. ("She is neither encouraging nor discouraging," Marga noted.) But in the end Alfred was only able to raise $4,800 and soon after, a rival collector scooped up the painting. Alfred called the whole affair "the worst disappointment I have had in seven years as director."[9]

It was now a full year since the *Three Musicians* fiasco, however, and the trustees were facing a looming test. Having committed to opening a costly new building in the spring of 1939—a building that would nearly triple the museum's current gallery space—they were now at risk of appearing house poor. Where were the star pieces? The quarter million Abby Rockefeller had given her husband for the land alone was the same amount that a decade earlier could have netted hundreds of the most important paintings in the Quinn collection. But though they were spending lavishly on the new museum, they still had only a handful of exceptional twentieth-century artworks to put in it. A collection dominated by Lillie Bliss's post-Impressionists and Rockefeller's Americans was hardly going to put the museum at the forefront of modern art. Amid their many missed chances, Barr's warning that buildings, but not artworks, could always be had for money was starting to seem prescient.

Still, the *Demoiselles* presented a formidable challenge. Seligmann's asking price was the same amount the museum had refused to pay for *Starry Night* only a year earlier. If the trustees were unwilling to spend $30,000 on a classic work by the crowd-pleasing Van Gogh, it seemed unlikely they would spring for the radical painting that Picasso himself liked to call *mon bordel*. So profane was the subject matter that Jacques Doucet, the painting's only previous owner, had expressed reservations at the time he bought it: Madame Doucet, he had told Picasso, wouldn't abide a group of giant naked whores in the living room. (In the end, after briefly considering his Art Deco bathroom, the collector had mounted the painting in the stairwell of his top-floor studio.) Nor was the critical reaction promising: Soon after the painting was unveiled, not only the conservative *New York Herald* but also the *Times* had dismissed it, with the *Times*'s art critic suggesting it should be "tucked away in the reference files."[10]

To have any chance of getting the painting, Barr needed a plan of battle. First, he would go to the Advisory Committee. Notwithstanding their opposition to the Van Gogh show, this group of mostly younger enthusiasts generally had his back and were far more likely to rally around such an unusual painting. Though they had no voting power, they could make formal recommendations to the board. About a week after the *Demoiselles* went on view, he made an impassioned case to the committee. He stressed the work's unique importance as the roiling birthplace of Cubism, its radical use of non-European source material, its startling new answers to the age-old problems of representing space and volume and multiple points of view on a flat surface. As Barr would later argue, the painting even showed—in the dramatic shift from the figures on the left to the almost savagely abstracted figures on the right—Picasso's ideas emerging "right before our eyes."[11]

After Barr made his case, there was a great deal of debate. It would be a very big purchase. But then someone pointed out that the museum was "so frequently criticized" for not acquiring important paintings. Someone else noted the public expectations that would come in 1939 with the new building and that a number of museums were "visited by thousands of people annually" because of one or two standout artworks.

A few members were so persuaded by Barr's arguments that they suggested the *Demoiselles* might be "the most important painting of the 20th century." In the end, they passed a resolution recommending purchase.

The trustees were another matter. They had an exceedingly poor track record when it came to making bold purchases; they also had a history of ignoring whatever the Advisory Committee suggested. Rockefeller and Clark had already failed to rally around the far more modestly priced *Three Musicians*. Still, Barr had another card to play. In the fall of 1929, just a few weeks before Doucet's death, Conger Goodyear had been in Paris and had received an invitation to the designer's townhouse; he was among the very few Americans who had seen and admired the painting before its arrival in the United States. Goodyear had also weathered his own Picasso hurricane when he had bought John Quinn's *La Toilette* for the Albright Art Gallery and was not particularly concerned about scandal. Barr knew that in this instance he could count on Goodyear's strong support, and it was Goodyear who would be leading the meeting.

Two days after the committee's recommendation, Goodyear convened the trustees. Armed with Barr's arguments and the committee's overwhelming endorsement, he had a forceful case. And in the end, Barr's fierce conviction carried the day. Here was a work, the trustees concurred, that would be essential to the museum's very purpose. Along the way, hardly anyone seemed to have noticed what the *Demoiselles* was really about. (In fact, it would take thirty-five years before the art historian Leo Steinberg, in a barn-burning essay in *Art News,* decisively shifted public attention to what he called Picasso's "naked problem," the dramatic scene of carnal encounter at the heart of the painting.) "If possible," the board resolved, "the *Demoiselles d'Avignon* should be acquired for the permanent collection as an epoch-making work, a turning point in 20th century art."[12]

There was *still* a catch. Having convinced the trustees of the painting's exceptional importance, Barr still needed to find a way to pay for it. Even with pledges of support from the gung-ho Advisory Committee, adequate funds were no more available than before. Would the *Demoiselles* slip through their fingers anyway? It was at this point that he and

Goodyear hit upon an ingenious plan. Though it had never been exercised, Lillie Bliss had added a farsighted clause to her bequest: Paintings from her collection could be traded for more important works as the museum saw fit. There were numerous nineteenth-century Bliss paintings the museum didn't need, and it didn't take long for Alfred to find a Degas horse racing scene from 1884 that no one would miss.

Having had no success finding a private buyer for the *Demoiselles*, meanwhile, Germain Seligmann was open to a cashless arrangement with the museum. He accepted the Degas as $18,000 toward the purchase price, which he now reduced to $28,000; then, in an unusual gesture, he and his associate agreed to "donate" the remaining $10,000 of the painting's purported market value to the museum. (In reality, this "gift" was entirely hypothetical, given that Seligmann had paid just 150,000 francs, or about $6,000, when he bought the painting two months earlier. He and his associate were still making a threefold profit on the Degas trade alone.) The gallery still needed to sell the Degas before the museum could take ownership of the *Demoiselles*, but in principle they had a deal.[13]

It was a remarkable coup. At last, they were acquiring a work that could live up to Barr's bold vision for the museum. For the moment, nothing could be said publicly about the *Demoiselles*, pending the Degas sale. But the arrangement for the first time suggested the potential of Barr's torpedo, hurtling forward to absorb crucial new works while discarding old ones in its wake. Here was the "metabolic" museum that he had long imagined—both permanent and evolving at the same time. Amid the improbable victory, however, was another truth: The trustees' attitude toward the collection had not fundamentally shifted. They were glad to see it grow but remained unwilling to spend large sums on it. He would need to find other ways to get more such works.

A few weeks after the *Demoiselles* deal, Alfred was sitting in his office when a spritely older woman with pince-nez glasses walked in. Though they had never met, she told him she came often to his shows. She also said she was hoping he might choose a painting that she could buy and give to the museum. It could be anything he wanted, she said, provided it was a "masterpiece." Alfred was taken aback; as far as he

knew, the woman had no personal ties to the museum. The unknown benefactor turned out to be Mrs. Simon Guggenheim, sister-in-law of museum founder Solomon Guggenheim and aunt of flamboyant art patron Peggy Guggenheim. It was the beginning of one of the most important patron relationships in museum history—Mrs. Guggenheim providing the cash and Alfred Barr choosing the art.

For almost anyone else in Barr's place, having just secured the *Demoiselles,* it might have been an ideal opportunity to acquire an exceptional Matisse. Or the great Seurat or Van Gogh they still lacked. Or perhaps Max Beckmann's astonishing triptych *Departure,* which captured, in unsettling allegory, the Nazi rise to power and which had just arrived at a gallery in New York. With such a landmark Picasso in hand, the museum could now concentrate on one of the other great pioneers whose work it sorely needed. Not Barr. Even now, he felt, Picasso was more important. Like Quinn before him, Barr had a driving sense that the collection needed to be anchored around the greatest works of Picasso, because of his central importance to the new art of the twentieth century. There also was a fresh opportunity.

Paul Rosenberg had recently sent *Girl before a Mirror* to Valentine Dudensing, the New York dealer with whom he sometimes worked. This was the painting that Alfred and Marga had admired above all others at the 1932 shows in Paris and Zurich. For Alfred, it was one of the artist's four or five essential works. Just as *Three Musicians* was in relation to Picasso's Cubism, *Girl before a Mirror,* he felt, was the highly complex end point of the curvilinear style the artist had developed in the early months of 1932. It was precisely the kind of eclipsing work he sought in his quest to map out the successive high points of modern art.

Not everyone agreed. To many viewers, the girl embracing her own reflection was a disturbing puzzle. Exquisitely designed in almost phosphorescent yellows and greens and orange-reds, the painting had a rich, almost Matissean patterning. Yet it was also rendered with a disorienting multiple vision in which geometric abstraction combined with unsettling psychological tension and sexual puns. As Barr observed, the woman was clothed, unclothed, and x-rayed at the same time. It was not exactly what Mrs. Guggenheim had in mind when she said "master-

piece." Still, Rosenberg was willing to sell it for $10,000, and Mrs. Guggenheim dutifully obliged. The sale was quickly concluded.

Within the space of a few weeks, Alfred had managed to anchor his fledgling collection with two of Picasso's most important paintings. After years of setbacks, he could finally signal to the European art world that the museum was more than just a staging ground for loan shows. But it was not time to celebrate yet. When he got home and told Marga about the purchase of *Girl before a Mirror*—a painting laden with personal meaning for both of them—she exclaimed, "Aren't you happy? Isn't it wonderful?" He was silent. Already there was another great, controversial painting that troubled him. And like the *Demoiselles,* it had long been hidden in a private collection in Europe.[14]

Alfred and Marga arrived in Zurich five months after the purchase of *Girl before a Mirror*. At the train station, they were met by a Swiss museum friend of Alfred's, who drove them to the small village of Küssnacht about forty kilometers away. An affluent enclave on the north shore of Lake Lucerne, Küssnacht was primarily known as the place where William Tell killed the Austrian tyrant Albrecht Gessler with a crossbow, paving the way for Swiss independence in the fourteenth century. But as Alfred had recently learned, it was also home to a mysterious painting that he had been thinking about since his early twenties.

Among the most disconcerting outcomes of the breakup of the John Quinn estate was the fate of Rousseau's *The Sleeping Gypsy*. Picked out for Quinn by Picasso, Roché, Brancusi, and his other friends in the final months of Quinn's life, the nocturnal encounter of the huge lion and the dreaming woman had seemed to form the magical key to all of his paintings. Barr himself fell hard for the painting at the John Quinn memorial exhibition in 1926, and then, when it arrived back in Paris to be auctioned at the Hôtel Drouot, it had captivated the Parisian public. In his encomium to Quinn, Jean Cocteau called the painting "the heart of the wheel, the center of the center, the place where speed sleeps in place, the eye of the storm, the sleep of sleeps, the silence of silences."[15]

But then the painting had abruptly fallen into disrepute. At the time

of the sale, there was apparently a quarrel between the winning bidder, an art dealer named Henri Bing, and a rival dealer; then, in the months after the sale, there were murmurings in Paris that the picture was a fake. There were even rumors that Picasso or perhaps Derain had painted it as a joke. Since *The Sleeping Gypsy* had been entirely unknown at the time Quinn bought it—and even Kahnweiler, who sold it to him, seemed to know very little about its provenance—it was easy to give credence to these claims. Soon the painting was discredited, and it all but vanished. Almost as quickly as it had been discovered by Quinn's friends, it seemed to recede back into the obscurity from which it had emerged.

Along with a handful of people who had seen it in New York, Alfred refused to believe the stories. He was certain that the painting was authentic. Like Quinn, he considered it one of the most important works of the modern era. After he had become director of the museum, and was traveling often to Europe, he began to ask about the painting; occasionally, he would encounter a fellow enthusiast who remembered it, from New York or Paris. Eventually, he learned that *The Sleeping Gypsy* had ended up in a private collection in Switzerland, though, as he noted, a cloud continued to hang over the picture on the one or two occasions it had been shown in a Swiss museum. Finally, during that spring of 1938, he had decided to track down the painting's owner, a Madame Ruckstuhl-Siegwert, who apparently lived in Küssnacht. Shortly after he and Marga arrived in Europe that spring, he wrote to the woman, asking if he could come look at her painting. Then Alfred and Marga had set out for Switzerland.

When they arrived at the address in Küssnacht, they encountered a curious, absentminded woman who lived alone in a dark chalet and seemed to have emerged from an Edgar Allan Poe story. According to Marga, Madame Ruckstuhl-Siegwert was a "rather confused middle-aged widow." Eventually she led them into the room where the painting was kept. Filling the center of the room was an elaborate crystal chandelier, something clearly designed for a ballroom or grand dining room with high ceilings. Here, it hung down to within a few feet of the floor, largely blocking the view of the wall behind it where the painting was hung. "The picture was very hard to see," Alfred wrote.[16]

But there they were: the woman and the lion, the barren desert, the night sky. For Alfred, seeing the painting again, after twelve years, was a flash of thunder. The widow was reluctant to part with the painting, but she was also flattered by Alfred's interest, and after some persuasion, she agreed to lend it to the museum for the opening of its new building the next spring. If all went well, Alfred hoped to persuade Mrs. Guggenheim to buy it from Madame Ruckstuhl. He knew that the trustees would have heard the stories and would likely regard it with suspicion. But while it was on loan, they would also have a chance to see it. Not long after the painting arrived at the museum, the trustees met to discuss its possible acquisition. Alfred himself was surprised by their reaction. "They were so impressed by it," he wrote, "that . . . they were willing to approve its acquisition, even if in the end it should turn out not to be by Rousseau." Thanks to Alfred's yearslong fixation, this repudiated painting was going to get a second chance in the art world; at last, he was beginning to reassemble the collection that New York had forsaken at the death of John Quinn.[17]

32

THE LAST
OF PARIS

he revelations roiled Washington for weeks. In late January 1939, *The New York Times* reported that the French government was buying more than six hundred American warplanes. Another five hundred were going to Britain. Curtiss Hawk single-engine fighters, Glenn Martin light bombers, Douglas DB-7 attack aircraft, Chance Vought dive-bombers. Isolationists in the Senate were furious; the Glenn Martins and Douglases were so new that the U.S. military hadn't used them yet. With these huge arms deals, Roosevelt was all but taking sides in the growing standoff in Europe. Pressed to justify his actions, the president cited his own diplomats' sobering assessment of Hitler's airpower and the likelihood of war. The Luftwaffe had only grown stronger in the two years since an ancient Basque town was reduced to rubble, and Europe's remaining democracies desperately needed an answer for it. Behind closed doors, FDR told a group of senators that America's first line of defense was now in France.[1]

If the prospect of more Guernicas was increasingly real to military planners in Paris and Washington, however, it remained far from the minds of most Americans. With New Deal policies at last having some effect, a new optimism was sweeping the country. Hollywood was entering one of its most successful years in history, with films like *The Wizard*

of Oz, Stagecoach, and *Gone with the Wind,* and despite high unemployment, productivity was up and industrial breakthroughs were making consumer products more affordable than ever. (In 1938, the Museum of Modern Art assembled a show called *Useful Objects Under Five Dollars,* aimed at showing that excellent modern design could be found in cheap household goods such as a sleek Pliofilm shower curtain and a dish rack cased in red rubber.) To signal America's resurgence, investors were pouring well over $100 million into dueling world's fairs, to take place that summer in New York and San Francisco. Ignoring Germany and Italy's aggressive military buildup, Japan's brutal war in China, and Franco's blood-soaked takeover of Spain, the New York organizers were centering their huge pageant on a peaceful, technology-driven "World of Tomorrow."

At the Museum of Modern Art, there was an unusual bullishness as well. Construction work was already far advanced on the museum's long-awaited permanent home on West Fifty-third Street. Already the building was attracting attention for its smooth, factorylike façade and its million-dollar budget, which was being financed by an $800,000 loan and an aggressive fundraising effort by Abby Rockefeller's son Nelson.[2] Apparently, when one group of trustees began to worry about the expense, they were reassured that the building could be used for other purposes if the museum failed.[3] (In stark contrast to avant-garde paintings, spending big on real estate was clearly uncontroversial for the Rockefellers, especially on a building whose sixth-floor members' lounge would soon command prized views of Rockefeller Center, of which Nelson was now the president.[4]) With the opening set for early May, the trustees could also look forward to unveiling their white-marble-and-thermolux-glass art temple during the beginning of the fair, when the world would be watching. Though it was ultimately shelved as too extravagant, there had even been talk of a Modern Art Ball at the Waldorf, with prizes of actual works of art for the best costumes.[5]

Unlike many of his distracted colleagues, though, Barr was acutely aware of the threat of war. Having visited France and Germany constantly since the late 1920s, he had watched—and experienced—the Hitler revolution unfold since the days of the Reichstag fire. Through

his many European contacts, he'd also taken an intense interest in the war in Spain. And despite his cool, formalist approach to modern art, he had begun to allow his anti-Fascist sympathies to color his shows. In the spring of 1938, at the urging of Ernest Hemingway, he had exhibited the Spanish war drawings of the ardent loyalist Luis Quintanilla. In Hemingway's lyrical introduction to the show, Quintanilla was a man who had "fought in the pines and the grey rocks of the Guadarrama; on the yellow plain of the Tagus; in the streets of Toledo, and back to the suburbs of Madrid where men with rifles, hand grenades, and bundled sticks of dynamite faced tanks, artillery, and planes, and died so that their country might be free."[6] It was a powerful reminder that artists were quite literally on the front lines of the battle between democracies and dictatorships.

Perversely, the Nazi crackdown on "degenerate, bolshevik" art helped Barr's efforts to promote modernism. Not only did Hitler's policies reinforce the connection between liberal government and advanced modern art, they were forcing growing numbers of modern artists, architects, and museum leaders—some of them with Alfred and Marga's help—to seek refuge in the United States. Two months after Chamberlain's capitulation at Munich, Alfred organized the first international show devoted to the Bauhaus, drawing on a group of exiled German artists and designers. "With the help of the fatherland," he observed acidly, "Bauhaus designs, Bauhaus men, Bauhaus ideas . . . have been spread throughout the world."[7]

Even with Barr's recent acquisitions, however, the museum continued to depend on borrowed art. Under normal circumstances, obtaining important loans had taken months of campaigning in European capitals. Now the repression of modern art and the possibility of a wider conflict threatened to make it much harder. Already the Bauhaus show had had to be truncated because of material that couldn't be gotten out of Germany. Meanwhile, in France, collectors, and even some dealers, were becoming skittish about sending artworks across borders. The loans issue would be especially critical in 1939, with the opening of the new museum. While Roosevelt jousted with the U.S. Senate about sending experimental warplanes to France, Barr was embarking on a furious

new round of diplomacy to bring avant-garde paintings to the United States.

Above all was the question of Picasso. After nearly a decade of false starts and dashed hopes, Barr had committed, that autumn, to filling all three floors of the museum's pristine new galleries with hundreds of the artist's most important works. Though the show would be hugely reliant on European loans, Barr had entered the year confident that it was finally in his grasp. For the first time, the museum had a pair of preeminent Picassos of its own, *Demoiselles* and *Girl before a Mirror*. Barr had enlisted a formidable co-sponsor, the Art Institute of Chicago (whose ambitious new director, Daniel Catton Rich, was a fellow protégé of Paul Sachs). And he had, or thought he had, the full support of Picasso and Rosenberg, whom he and Goodyear had met with in Paris the previous summer. He even hoped to include *Guernica*.

In contrast to previous years, ordinary Americans were also starting to seem less resistant to avant-garde art. Museums around the country were cautiously beginning to embrace post-Impressionist painting; in January, a dozen years after its board had been scandalized by Picasso, the Albright Art Gallery opened a special gallery for contemporary art. Amid the new atmosphere, Barr had taken the unusual step of announcing the Picasso show, still ten months away, to *The New York Times,* which reported that it was going to be "the most comprehensive ever held."[8] A few weeks later, Henry Luce's *Time* magazine, hardly a hotbed of radical taste, put Picasso on its cover, suggesting that the artist who had "confounded" ordinary people for decades was finally ready "to emerge from the smoke of controversy into the lucidity of history."[9]

Even without the possibility of war, Barr knew that nothing was ever certain with Picasso. Somehow, he needed to engage with the artist directly. In late January, he had lunch with Mary Callery, an American sculptor and modern art collector who was on her way back to Paris, where she lived. A vivacious, twice-divorced socialite, Callery knew Picasso and Rosenberg; she also owned a number of Picassos herself. Alfred asked her if she might be willing to test the waters with both to ensure their continued support for the show. A few weeks later, Callery called on Rosenberg. At the time of her visit, he had just opened his own

Picasso show, a selection of thirty-three brightly colored still lifes—candles, pitchers, birdcages, ox skulls, simple utensils—many of them completed since *Guernica*. Callery didn't like the new style, which she found too easy on the eye, but the show had attracted extraordinary interest. At the gallery, Rosenberg was in his element, dancing around the room, greeting visitors and talking about the artist's latest self-reinvention. Accosting his American friend, he excitedly told her he was getting more than six hundred people a day.

When Callery asked him about the Museum of Modern Art plans, however, he darkened. In theory, Rosenberg should have been delighted that museums in America's two largest cities were finally prepared to showcase the work of his premier artist. After all, he had been trying to bring Picasso to New York and Chicago for nearly two decades. But he also knew from long experience how difficult the United States was, and the advance report in *The New York Times* alarmed him. Confronted with such an enormous show, people might come away liking Picasso less than when they started. As he put it to Callery, no one wanted to see "100,000 oil paintings"—no matter who painted them. And if the ultimate prize was the vast U.S. market, a misfire on this scale might be fatal.[10]

Underlying Rosenberg's opposition was another anxiety as well: control. By now, he was Picasso's undisputed kingmaker. He had been personally involved in nearly all of the artist's major shows since the twenties, and that included museums. He'd largely dictated the shape of the 1934 show in Hartford, and in recent years, he had organized museum shows in Amsterdam, Brussels, Stockholm, Helsinki, Norway, and Belgrade. Even now, he was being courted by a museum in Basel. No other modern art dealer enjoyed such cultural power. Notably, it was Rosenberg's Paris show, not Barr's museum plans, that had landed Picasso on the cover of *Time*. (Though the artist's complicated private life clearly intrigued the magazine as well: "Last week Dora Maar had her second exhibition of photographs," the article noted, adding that she also "had her nose punched outside the Café de Flore by the ex-Mme Picasso."[11]) By letting Barr write Picasso's American story, Rosenberg seemed to fear he might be losing his own hold on the artist.

Whatever the dealer's motivations, his support for the show was critical. If he was out, they would almost certainly lose Picasso as well. "Somehow it will be very difficult for you if Rosenberg is against you," Callery wrote Barr after her visit to rue La Boétie. "He has a way of knowing how to poison Picasso's mind. I have seen him at it many times." Callery's warning came too late. A few days later, Rosenberg sent him an ultimatum. The dealer said he had talked to Picasso, and they both had "great objections" to the show. "We are afraid to tired [sic] the public," he wrote. If the museum would agree instead to a smaller, more selective presentation, following his and Picasso's suggestions, he would lend his best paintings. "Otherwise," he said, "I will . . . not be able to contribute."[12] The poisoning had already happened.

As he absorbed Rosenberg's letter, Barr was incensed. By now, there was a great deal more than a single exhibition in play. Over the dozen years since he had seen the John Quinn memorial show in New York, Picasso had become a sort of talisman for him. In building the museum, not only had he set out to tell the story that Quinn had first embraced—the story that began with the Paris avant-garde. For all his wide view of modern art, taking in design, film, and photography, he had also sought to build the core of the story around many of the same artists that Quinn had pursued. Picasso, whose paintings had once filled the lawyer's apartment, had been the elusive center of these efforts. Repeatedly, he had watched Picasso get swept up in the games of his dealers. He had also been stymied, in his Picasso plans, by everything from marital strife to artist's block to his own health.

Barr hoped this time was different: He would be bringing together an unparalleled constellation of masterpieces, including the *Demoiselles* and *Guernica,* and he had not one but two prominent American museums. He even had an extraordinary new building in New York, perhaps the most up-to-date museum in the world, in which to show the paintings. And with the growing threat of war, there might not be another chance at such a show for the foreseeable future. Yet despite all this, Rosenberg was threatening to walk away. Unable to maintain his usual composure, Barr drafted a blistering reply. Rebuking the dealer for going back on his word, he wrote that he would be letting down "many

thousands of people" in America's "two greatest cities." He also accused the dealer of turning Picasso against the show. "It would be a really serious affair," he wrote, "if you and Monsieur Picasso were to withdraw your cooperation at this late hour."[13]

Luckily, the letter was never sent. Alarmed by Barr's anger, Goodyear and Rich persuaded him to revise it, and four drafts later, he arrived at a far more subtle reply.[14] It had all been a misunderstanding, he now suggested to Rosenberg: They had never intended to show 300 paintings, but a far more limited 150, which Barr planned to choose "with the greatest care." Yet they also were concerned "not to restrict too much" a show that was meant to represent "the magnificently fecund genius of Picasso," including works in other media. Finally, he suggested that they would depend on Rosenberg's "expert knowledge" of Picasso's work. "You more than anyone else, during the past 20 years, have been the most influential friend and supporter of Picasso," he wrote. He carefully omitted any mention of the dealer pressuring Picasso.[15]

If the letter was painful to write, it was tactically brilliant. Appealing to Rosenberg's vanity, Barr appeared to be conceding the dealer's unparalleled connoisseurship, even as he preserved his own, extremely ambitious vision for the show. At the end of March—six tense weeks after the crisis began—Rosenberg offered his full assent to an exhibition of 150 paintings. "This of course changes the situation," he wrote. Underscoring his influence over Picasso, he added, "I am already quite sure that he will support you."[16] He let the matter of curatorial control quietly drop, and he made no restrictions on works in other media, which would in fact bring the show to more than 300 artworks in total. As Alfred and Marga's departure for Europe loomed, it looked like the Picasso show was on after all.

While Alfred was resolving the standoff with Rosenberg, however, the political situation in Europe continued to deteriorate. In mid-March, German troops marched into Czechoslovakia, proving the failure of the

Allies' appeasement policy. "Hitler in Prague," Marga wrote.[17] In Washington, the invasion gave new fuel to Roosevelt's controversial efforts to arm France and Britain and prepare the country for war. For Alfred and Marga, it also hit uncomfortably close to home: Just the previous summer, in preparation for the Picasso show, they had gone to the Czech capital in pursuit of a rare group of the artist's prewar canvases. In the years before 1914, the Czech connoisseur Vincenc Kramář had acquired several dozen of Picasso's and Braque's most important analytical Cubist paintings, which he kept in his modest house on a bluff overlooking Prague.[18] Unfortunately, Kramář had been away at the time, and now, with the Nazi occupation, it would be impossible to get any of his paintings out. Like its teetering democracies, Europe's modern art collections were increasingly encircled.

Meanwhile, a different reminder of the Fascist advance came with the arrival of *Guernica* in New York harbor. Following the painting's dismal showing in Paris two years earlier, it had undergone a remarkable reassessment. First, in the early months of 1938, Rosenberg had arranged to borrow it for a large traveling show of work by Picasso, Braque, Matisse, and the sculptor Henri Laurens, which he took to museums in Oslo, Copenhagen, Stockholm, and Gothenburg. As one of the first major presentations of these artists in Scandinavia, the show attracted great interest, with *Guernica* generally embraced as a powerful, if difficult, addition to an already astounding assembly. Then, in the months after the Munich crisis, Picasso's friends had arranged to take the painting on a tour in Great Britain to raise funds for Spanish aid. Though the tour was not a financial success, the publicity it drew had begun to turn the controversial painting into a potent symbol of Spanish resistance.

For Barr *Guernica* was a vital new step for modern art, and he desperately wanted it for his exhibition. As he later wrote, it was a work that spoke "of world catastrophe in a language not immediately intelligible to the ordinary man." At the same time, however, the Spanish Refugee Relief Campaign, a group that had been formed in 1936 to provide humanitarian aid to the Spanish Republic, wanted the painting for its own fundraising tour of several U.S. cities, a proposal favored by Pi-

casso, who had become increasingly militant about the Spanish tragedy. In the end, Barr reached a compromise by which the museum would cover the cost of bringing the painting to the United States, provided that the Relief Campaign finish its propaganda tour in time for Barr's Picasso show.

By the time *Guernica* crossed the Atlantic at the end of April, however, the Spanish war had already been lost. During the first two months of the year, the Nationalists waged a vicious assault on Catalonia, capturing Picasso's beloved Barcelona; by the end of March, they had also taken Valencia and Madrid, the last Republican holdouts, leading to a final surrender soon after. Even as *Guernica* reached New York, the notorious Condor Legion, which was responsible for the atrocity and many that followed, was already preparing its triumphant return to Germany.[19] It was one of the bitter ironies surrounding the painting that it would not gain true international celebrity until Franco had completed his conquest.

Even the celebrations for the new Museum of Modern Art were overhung by world events. On the surface, the building's grand opening, which unfolded during the second week of May, was all glamour and froth: The culminating event was a black-tie soiree for seven thousand guests, an eclectically prominent crowd that spanned Mrs. Cornelius Vanderbilt and Mrs. Charles Lindbergh, Lillian Gish and Salvador Dalí, the Norwegian and Swedish ambassadors, and Juan Negrín, the recently exiled prime minister of Republican Spain. For the occasion, Barr had filled the galleries with a kind of greatest hits show that aimed to provide as popular an introduction to modern art as possible. Equally divided between American and European art, it included a number of late-nineteenth-century masterpieces as well as a select group of more contemporary works and ranged widely across different media. Though it was hardly groundbreaking, its significance was not lost on the aging critic Henry McBride, who considered it a sonorous tribute to John Quinn and the organizers of the Armory Show a quarter century earlier. "It was especially startling to remeet *The Sleeping Gypsy*," he wrote in his New York *Sun* column. "It remains one of the most amazing pictures of modern times."[20]

Rather than the art, however, the high point of the evening was a fifteen-minute radio speech by President Roosevelt, which was piped in from the White House. The symbolism was hard to miss. Though FDR was not known to have a particular interest in modernism, Eleanor Roosevelt had been a patron of the museum and may have convinced him of its importance.[21] He also was closely engaged with U.S. culture at the time, having just inaugurated the New York World's Fair. Whatever his motivations, for the first time, the federal government was giving a full-throated endorsement of a tendency in art that had long been regarded with suspicion by wide swaths of the American public.

Equally important, though, were the geopolitical overtones. Less than two weeks earlier, Hitler had all but dismissed Roosevelt's plea for peace in a speech to the German Reichstag. It now seemed clear that a wider war was inevitable. Dedicating the new museum to "the cause of peace," FDR took up the theme that Barr had been pushing ever since his initial encounters with Nazism: the essential connection between modern art and liberal government. "The arts cannot thrive except where men are free to be themselves and to be in charge of the discipline of their own energies and ardors," Roosevelt said. "The conditions for democracy and for art are one and the same."[22]

The speech sent an unmistakable message: America was prepared to provide a new refuge for the threatened arts of the twentieth century. It was hard to think of a better mise-en-scène for the Picasso show that fall. All that remained was for Alfred to meet with Rosenberg, Picasso, and other lenders, make his final choices, and get the paintings to New York in time for the opening. In her diary, Marga wrote, "How many years A. has hoped and worked and schemed for this!"

Arriving in Paris in June 1939, Alfred and Marga found an art world subdued. Everyone seemed to be talking about war; many collectors and dealers had already stored their paintings in bank vaults for safety. Since there was very little art that was easily accessible, they found themselves spending most days holed up at Rosenberg's gallery, poring over his own paintings and his extensive photographic files of Picassos elsewhere in

France. Soon they had spread out all the photographs in a large room in Rosenberg's house: If it wasn't quite like lining up paintings in Mrs. Kröller-Müller's garden in The Hague, it was a decent approximation of Alfred's living room floor. Rosenberg was clearly flattered to have become the command center of the exhibition and left them largely to themselves.

Within the Rosenberg household, however, the Barrs' intense labors—and their plans to bring his premier Picassos to New York—exposed new tensions. By now, Rosenberg was anxious to get as many paintings as he could out of Paris. One day, he presented Barr with a far more radical proposal: What if he sent his *entire* collection to the Museum of Modern Art at his own expense? It would be a drastic step, given that the United States was thousands of miles away and his business and family were deeply rooted in France. But Rosenberg could see how vulnerable he would be if the Germans invaded; somehow, he needed to secure his inventory. For the museum, of course, receiving hundreds of additional Rosenberg paintings would present a significant logistical challenge, but would offer access to dozens of other modern masterworks. Immediately, Barr sent a flurry of cables to New York to try to make arrangements.

Margot Rosenberg, on the other hand, took a different view. Parisian to the core, she refused to believe that their comfortable existence on rue La Boétie might be in jeopardy. And while, in their cool truce, she had tolerated her husband's continual show making abroad, many of the paintings in their own collection she regarded as off limits. There were the Massons and Légers that lined the walls of the quadrangular stairway that led up to their private apartment; there were the inlaid mosaic benches that Braque had designed and personally installed in their dining room. And there were the Picassos. When Rosenberg agreed to lend Barr the five great Picasso still lifes that hung in their formal dining room—an extraordinary large-scale series from the midtwenties executed in a restrained, decorative late Cubist style—Margot exploded. She adored these canvases and couldn't imagine getting through the winter without them.

There was a heated fight, and in the end, Rosenberg mostly gave in.

After all of Barr's arrangements, he withdrew his plans to send his entire collection to New York, deciding instead to send many of his paintings to a series of storerooms in the provinces. And he placed new restrictions on the dining room pictures. Pulling Barr aside, he said he thought his wife would calm down, but he also insisted that he retain the right to have the museum return the still lifes to Paris immediately after the New York show rather than sending them with the other loans on to the Art Institute. Barr, mindful of the dealer's inclinations and the ominous international situation, was doubtful that Rosenberg would risk recalling any of his paintings. "I did my best for Chicago," he reported to Rich. "Hitler may provide the solution."[23]

Even as the Barrs were trying to get Picassos out of France, the Nazi campaign against modern art was creating a new dilemma in neighboring Switzerland. In late June, agents for the Third Reich consigned 126 of the most important "degenerate" paintings confiscated from German museums to a controversial auction in Lucerne. Among them were important works by Matisse, Picasso, Braque, Derain, and Gauguin, as well as dozens of works by leading German Expressionists like Otto Dix, Paul Klee, August Macke, Emil Nolde, and others; many of them had belonged to museums whose progressive policies Barr himself had emulated in the early 1930s. In Paris, Rosenberg thought it was immoral to bid in the auction, warning his colleagues that the Nazi government would "certainly convert this money into bombs and machine guns."[24] But Barr and many other museum professionals took the opposite view. As they saw it, here were works that had been ruthlessly orphaned from German public collections, and rather than have them destroyed or disappeared, here was a rare opportunity to get them out.

By now, the Museum of Modern Art had at last set up a decent purchase fund for art, and in a decision for which he would be heavily criticized in later decades, Barr instructed a gallery he worked with in New York to bid on several of the Lucerne paintings. One of them was Matisse's incomparable 1913 masterpiece *Blue Window,* from the Essen Museum. For Barr, there was little question he was doing the right thing: Better to have this crucial Matisse safely in the public trust in New York than in the private clutches of some Nazi potentate. As he later put

it, *Blue Window* was "ransomed privately, that is virtually bootlegged, out of the cellar of Goering's *Luftministerium* to the Museum of Modern Art in New York."[25] Even as the museum was defending modern art as a bulwark of democracy, Barr was doing what he could to get it out of the hands of the dictatorship that now threatened much of Western Europe.

Perhaps in defiance of what was soon to come, Bastille Day in Paris in 1939 was unusually exuberant. There were extravagant balls and parties; there was dancing in the streets. On the Champs-Élysées, close to Rosenberg's gallery, the Foreign Legion paraded by, playing Moroccan marching songs on their fifes. Having already gotten far in their negotiations with Rosenberg and Picasso, Alfred and Marga decided to join Brancusi for dinner at his studio in the Impasse Ronsin, much as John Quinn and Jeanne Foster had done eighteen years earlier. Now in his early sixties, the Romanian sculptor had changed little, still spending most of his days working on blocks of marble and polishing brass forms, still spending evenings cooking meals on his woodstove.

That evening, he invited the Barrs over, together with Henri Matisse's son Pierre and his wife. Then, after feasting on roast gigot, the group walked over to the Île Saint-Louis in red and pink party hats. A swing band was playing, and Brancusi, carried away by the music, danced with Marga to the hit tune "Bei Mir Bist Du Schön." Though no one seemed to notice, it was a particularly fitting song for these waning hours of European cosmopolitanism: Written by a Yiddish composer and popularized by African American singers in Harlem, it had become a pan-European hit in the late thirties, including, in a Germanized version, in the Third Reich, where its Jewish origins remained unknown. (In the English lyrics, one of the refrains is "I could say 'bella, bella,' even 'sehr wunderbar'/Each language only helps me tell you how grand you are.")[26] It was the last they would see of Brancusi for a very long time.

Soon after the holiday, Paris emptied out, and there was little more that Alfred and Marga could do. Most of the Picasso loans were now lined up; what remained was getting them to the United States that fall.

Already, though, everyone seemed to be expecting war. Having moved Marie-Thérèse and Maya to Royan, on the Atlantic Coast, for safety, Picasso had escaped with Dora to Antibes, where he would spend much of August making ominous studies of night fishermen. To be out of harm's way, Rosenberg was moving his own family to Tours, in the Loire Valley, where he had also begun to transfer some of his inventory. Near the end of July, Alfred returned to the United States on the *Normandie* to write the Picasso catalog and begin the frantic preparations for the show; Marga stayed on to tie up loose ends in Paris and to visit her mother in Rome.[27] While many questions about the show remained, Alfred's labors had been fruitful: Together, artist and dealer had agreed to send more than seventy works of art to New York, of which some two dozen, by his count, were among the most important of Picasso's career.

Almost as soon as he got back, however, events began to overtake them. In late August, the Nazi-Soviet Nonaggression Pact was announced, signaling an open field for Hitler in Central Europe; Marga, who had returned to Paris, noted how the news ricocheted from table to table at the Flore. Finally, at the end of the month, with a general mobilization under way in France, she made her own tense crossing back to the United States. Despite constant radio alerts, the ship's captain asserted, "*Il n'y aura pas de guerre*" ("There won't be any war"). Marga wasn't sure. "At Southampton the anti-submarine nets are clearly visible," she wrote.

On September 1, the fearsome German "air armada" that FDR had been warning Congress about began bombing Poland. Two days later, Europe was at war. From Greensboro, where Marga had joined Alfred for the final days of summer, Alfred was strangely silent. On the afternoon of the third day after the French declaration of war, Dan Rich could wait no longer. "IS PICASSO STILL ON?" he frantically cabled. "WILL YOU PROCEED WITH EXHIBIT IF WAR PREVENTS EUROPEAN LOANS?"[28] That same day, Jere Abbott, who had followed the plans from afar, wrote Alfred a note of commiseration. "I presume that the Picasso show is out," he wrote. "What a pity! You must be relieved that Marga got home safely."[29]

33

"MORE IMPORTANT THAN WAR"

As Europe went to war, Barr was consumed by a new battle of his own on West Fifty-third Street. At the time the new building opened in May, Abby Rockefeller's son Nelson had replaced Goodyear as museum president. He had ambitious ideas about making the museum more corporate and efficient, and while Alfred and Marga were away in Paris arranging the Picasso show, he had ruthlessly reorganized the administration. Several staff members were purged, among them the museum's chief finance man, who had worked closely with Alfred and who was replaced by someone loyal to Nelson Rockefeller. When Alfred returned, he found staff morale at a new low and was forced to come to terms with a significant waning of his own authority. Amid this crisis, and the rapidly unfolding events across the Atlantic, Alfred was uncharacteristically slow to process Dan Rich's anxious telegram about the fate of the exhibition.

On September 11, 1939—ten days after the Nazis invaded Poland, eight days after France and Britain had entered the war, four days after French divisions began their land offensive in the Saarland, three days after Hitler annexed a large part of Polish territory into the Third Reich, two days after the British War Cabinet announced that it expected the war to last "three years or more"—Barr finally cabled Rich his reply:

"SEVENTY EUROPEAN LOANS HERE INCLUDING PICASSO'S, ROSENBERG'S, CAL-
LERY'S. THIRTY MORE POSSIBLY UNOBTAINABLE . . ." He added: "CARRYING
NO WAR INSURANCE."[1]

Rich was stunned. It was clearly not everything they wanted, but,
improbably and despite the outbreak of war, the core components of a
show—the main shipment of works from Picasso and Rosenberg—
were in place and in New York. It was all the more impressive that Barr
had persuaded them to forgo war insurance, which would have been
prohibitively costly for the two museums. "You are more of a general
than even *I* suspected," Rich wrote back the next morning.[2]

In fact, Barr had even more than he let on. He had secured many of
Rosenberg's best paintings from the 1920s and 1930s. From Picasso's
own collection, he had nearly a dozen works that had never been seen
before anywhere, as well as *Three Dancers* (1925), a painting of almost
volcanic psychological energy and violence that was unlike anything
that had come before it. Barr called it "a turning point in Picasso's art
almost as radical as was the *Demoiselles d'Avignon*." Meanwhile, he'd
persuaded Justin Thannhauser, the dealer who'd fled Germany for
Paris two years earlier, to lend *Moulin de la Galette* (1900), the culmina-
tion of Picasso's early Toulouse-Lautrec phase. And from Marcel
Fleischmann—a Zurich connoisseur who had sought the museum's
help in bringing his small but important collection to New York for
safekeeping—he also had *Ma Jolie* (1911–12), the analytical Cubist
masterpiece that Picasso created as a coded tribute to Eva Gouel at the
height of their love affair.

And yet the "thirty more" in Barr's message to Rich hinted at a battle
still being fought. Having gotten this far—and after so many years of
trying—he couldn't bear the idea of doing a Picasso show that lacked a
quarter or more of the European loans he was aiming at. And many of
the remaining paintings and other works filled in crucial gaps in the se-
quence of works he had already secured. Now, with barely two months
to go until the November 14 opening, and with a war breaking out
across the Continent, he would have to find new ways to continue his
all-out campaign for the most important Picassos in Europe.

On his list were further pieces from Picasso and Rosenberg them-

selves, including a large group of sculptures from Picasso and Rosenberg's version of *Three Musicians,* the 1921 Cubist masterpiece that Barr had spent much of the thirties fruitlessly chasing. To his chagrin, earlier in the summer Rosenberg had lent *Three Musicians* to a show in Buenos Aires—another part of the dealer's effort to get as many paintings as he could out of Europe—but Barr still hoped they could somehow have it sent to New York in time for the show. Gertrude Stein had not yet decided whether she would lend the artist's breakthrough 1906 portrait of her. Alphonse Kann, the legendary French connoisseur who had once discussed the ideal modern art collection with John Quinn, owned a 1915 *Harlequin* that Barr regarded as one of Picasso's greatest wartime paintings. Still other paintings he hoped to get from, among others, the widow of the poet Guillaume Apollinaire, the fashion designer Elsa Schiaparelli, and the Chilean socialite Eugenia Errázuriz, in whose villa Picasso had spent his honeymoon.

As Alfred set out in mid-September to capture these remaining works from afar, he faced daunting new challenges. Already within hours of the British and French declarations of war, a German U-boat had torpedoed the British ocean liner S.S. *Athenia* off the coast of Ireland. Like the ship Marga had taken only a few days earlier, it was a civilian vessel bound for North America. Of its 1,418 passengers and crew, 117 were killed, including 28 Americans. Over the next few weeks, numerous other British and French ships would be sunk by mines and torpedoes. These were the same shipping lanes that any additional artworks coming to New York would have to traverse, and it made it even harder to persuade lenders to take the risk.

In Paris itself, it was an extremely inopportune moment to be tracking down paintings. Shops were closed. Men were being mobilized. Families were busy storing their possessions in cellars and underground vaults. Many who could had moved to the countryside, and those who remained were adjusting to the unsettling reality that Paris might, for the second time in the twentieth century, be in the sights of the German military. Gertrude Stein and Alice Toklas lingered in Bilignin, the country house they had long been going to in the southeast of France. Mary Callery courageously stayed put in the capital and signed up to be an ambulance driver if and when the actual fighting started.

For many European collectors, concerns about art had already been supplanted by more existential problems. Already on September 6, just three days after France entered the war, Christian Zervos wrote a plaintive letter to Barr. His wife was staying in Vézelay, in Burgundy, he reported, while he waited in Paris to be called up for military service. *Cahiers d'Art,* he said, was virtually bankrupt. He asked Barr to try and sell "as fast as you can" the small Picasso they had lent to the show, and to send the money directly to his wife, who had none. "Keep working for the cause of modern art," Zervos added. "It is more necessary than ever, for here it is going to be stopped for a long time."[3]

The conflict in Europe meant that even more was riding on the Picasso show and the exceptional opportunity it offered to reshape American opinion about modern art. While modernism was being squelched on the Continent, Barr couldn't afford to have anything less than an utterly convincing defense of it in the United States. And Picasso would likely present the last chance the museum would have to assemble a large-scale show of a European artist for years to come. It made him all the more determined to make it as complete as possible. "The war has come making picture exhibitions seem unimportant," he wrote Rosenberg on September 12, "yet in a way we must believe that painting is more important than war."[4]

As he reapproached other European collectors, he was sensitive to the threat of a Nazi invasion. "Although there may be some risk in shipping pictures," he wrote to Gertrude Stein, "you may feel that your portrait would be safer in America for the duration of the war."[5] Already, Picasso, Rosenberg, and Callery had agreed to keep their loans at the museum until hostilities had ended, and Barr offered similar arrangements to Stein and other lenders. In addition to safeguarding the paintings themselves, he also began to see that having so many extraordinary Picassos marooned in the United States would be a rare opportunity. "If the war should continue and you wish to have your pictures held here," he wrote Thannhauser, "will you give us permission to exhibit them in other museums, with of course full insurance coverage?"[6]

Some of Barr's appeals went nowhere. At the end of September, the French dealer Pierre Loeb, who owned several important Cubist collages Barr had been hoping to get, cabled: "IMPOSSIBLE TO SEND PICASSO

PAINTINGS GALLERY CLOSED I CAN'T DO ANYTHING."[7] A week later, Jacqueline Apollinaire informed him that, much as she wanted her husband's memory associated with the show, the prospect of losing one of Picasso's precious portraits of the poet to a German submarine was too much to contemplate.[8] Kann in the end declined to send his exquisite *Harlequin*— a decision he would come to regret when the Nazis reached Paris the following summer.

Meanwhile, Gertrude Stein apparently lost her nerve about the portrait, despite Alfred's monthslong charm offensive. At the time, Scribner's had just published Stein's small book on Picasso and asked the museum if it would publicize it in connection with the show. "Reviewers have said this is much more understandable than most of Gertrude Stein's books," a Scribner executive assured the museum.[9] Alfred had agreed to mention the book, and Stein's importance as an early patron of Picasso, in connection with the show, but she remained disdainful of the Museum of Modern Art. (According to Marga, it was during their visit with her that summer in Paris that she made her now famous quip that "you can be a museum or you can be modern but you can't be both."[10]) To the end, the American writer who had more than any other patron been at the center of the Paris avant-garde remained stubbornly apart from efforts to bring the art she supported to the United States.

Still, Alfred's unrelenting tenacity yielded other gains. In mid-October, the S.S. *Washington,* an American liner, brought six important Picassos from Roland Penrose, the British Surrealist. Having spent much of August vacationing with Picasso and Dora at Antibes, Penrose had returned to London just as the war was starting. Greeted by air raid sirens, he immediately arranged to put his art collection in safe storage near Norfolk, but since Barr had already requested his Picassos, he decided to take his chances and send them to New York instead.[11] One of them was *Head* of 1914, an abstract, pasted-paper collage that was as radical as anything that Miró or the Surrealists were doing twenty years later. ("As a head," Barr observed, "it is so fantastically far-fetched that it easily meets the surrealist esthetic of the marvelous."[12])

By this point, there was less than a month to go before the opening, and Barr was running out of time. He knew there was at least one final

crate of paintings that the museum's shipper in Paris was still trying to send to New York. There also remained open questions about other works, such as Rosenberg's *Three Musicians* from South America and Picasso's sculptures. Despite the uncertainty, he needed to go ahead with the catalog for the show, one of the largest the museum had ever done. He also needed to begin working on the installation, which was going to fill up much of the new museum galleries and would require a comprehensive vision of the artist's entire career.

To his great relief, *Guernica* reached the museum more or less on schedule in mid-October, by express train from the Midwest. With the immense painting were seven accompanying study paintings, some fifty drawings, and *The Dream and Lie of Franco,* the two comic-strip-like etching sequences that Picasso had completed in the winter and late spring of 1937. As Barr had arranged with the Spanish Refugee Relief Campaign, the *Guernica* group had been shown briefly at several venues across the country to raise money for the victims of Franco. Along with the Valentine Gallery in New York, the stops had included a gallery on Wiltshire Boulevard in Los Angeles, at the San Francisco Museum of Art, and at the Arts Club of Chicago, before finally returning to New York to join the other Picassos in the show.

For Barr, it was an enormous coup to have *Guernica,* but the fundraising tour offered scant reassurance about American readiness for Picasso. By 1939, *Guernica* had finally begun to acquire international notoriety, and the Spanish Relief effort was backed by a prominent group of intellectuals and cultural figures. (In Los Angeles, the sponsors included Bette Davis and George Cukor.) But while these showings of the painting generated considerable attention, they were anything but a popular success. In L.A., a total of 735 people came to see the painting; the total fundraising proceeds of all four cities amounted to $700.

Press coverage was even more disheartening. The *Los Angeles Examiner* called the painting "revolting"; another West Coast paper described it as "cuckoo art." The critic for the *San Francisco Chronicle,* while making an effort to understand Picasso's iconography, concluded that "some of these heads resemble the drawings of the insane." In Chicago, the *Herald and Examiner* announced *Guernica*'s arrival with the headline,

BOLSHEVIST ART CONTROLLED BY THE HAND OF MOSCOW.[13] Here were all the old charges of the antimodernist camp resurfacing yet again. Given that *Guernica* had been created as a response to a bombing by the Fascist regime that was itself trying to silence modern art, Barr realized he would have to work even harder to shape a new American understanding of the artist.

Even as *Guernica* arrived at the museum, other troubles emerged. First was the apparent disappearance of an entire crate of Picassos. For weeks, Barr had been awaiting news from the museum's trusted Parisian shipper, R. Lérondelle, about the final group of paintings and drawings from Paris. For security, the museum insisted that only an American boat be used, but by October, there were very few U.S. liners making the crossing. Finally, at the end of the month, Lérondelle found a boat. He reported that eleven more Picassos would be leaving France on the S.S. *President Roosevelt,* among them additional early Picassos from Thannhauser; three additional charcoals from Callery; and Schiaparelli's important 1937 still life *Birdcage and Playing Cards,* which the designer had agreed to lend after all. It would just allow enough time for the museum to receive them and include them in the installation.

When the *Roosevelt* reached New York on November 4, it was absolutely packed with passengers. With many people trying to get out of Europe and few neutral boats running the Le Havre–New York line, demand for passage was extremely high. When the ship was finally unloaded, however, the Picassos were nowhere to be found. Barr was frantic. "SHIPMENT NOT ON ROOSEVELT CABLE IMMEDIATELY . . . URGENT," the museum cabled Lérondelle.[14] The paintings had definitely been delivered to Le Havre and consigned to the boat; somehow they had not been loaded. After a search in Le Havre, the missing crate finally turned up: Amid the chaotic boarding, the Picassos had been inadvertently left on the dock. Barr was relieved not to have lost the paintings, but now they would have to wait for another American ship, and as a result of new neutrality legislation in Congress, U.S. shipping lines were curtailing their services even further. The next boat, a freighter, was not scheduled to depart France until early December, several weeks after the show's start.[15] Luckily, none of these paintings were among the show's essential works.

Unsurprisingly, one of the greatest problems in the run-up to the show was dealing with Picasso himself. Going back to his initial vision of the show, Barr had wanted to include a large and important group of sculptures, which he regarded as central to Picasso's art. Among other things, though Picasso had made sculptures his entire career, they had rarely been exhibited, and remained widely unknown to the public. During their initial talks in Paris, Picasso seemed enthusiastic about sending a group of sculptures, but he also said that he wanted to have a new series of casts made before making his choice. Then he and Dora had gone to Antibes.

Feeling none too reassured, Barr wrote Dora in August, asking her to "use whatever influence you can" to get Picasso to select the sculptures by the end of September, so that there would be time to get them to New York.[16] After the outbreak of war, Barr also wrote to Rosenberg and Zervos for help. "Since Picasso almost never writes letters, we hope that you will send us some word of him too," he wrote to Rosenberg. "We still hope there may be some chance of receiving sculpture from him."[17] But the dealer was no more in contact with Picasso than anyone else, and since the start of the war hardly anyone in the artist's own circle had heard from him. "Picasso has disappeared, two weeks of mail await him at rue La Boétie," Callery reported in the third week of September.[18]

Meanwhile, the museum had been trying to reach Picasso for another reason: The trustees wanted to invite him to New York for the opening. Barr knew this was extremely unlikely. Already during the summer, he had asked Picasso if he might consider coming to New York, and Picasso had simply shaken his head, smiled, and shrugged.[19] And that was before the war had started. Still, the trustees felt it was important to try, and in late September, a long formal invitation was cabled to "Mr. Pablo Picasso" signed by Nelson Rockefeller. Unsurprisingly, it had been met with silence.

Picasso was up to his usual vanishing act, but this time it was driven as much by international events as by caprice. In the final days of August, after Hitler and Stalin's nonaggression pact was reached and France ordered a general mobilization, the town square of Antibes had filled with troops. Picasso hated war and was spooked by the prospect of a German air campaign. He also had bitter memories of the seizure of

his paintings from Kahnweiler's gallery back in 1914. Racing back to Paris, he tried to secure his scattered possessions. "He was a worried man, seeming helpless, not knowing what to do," recalled the photographer Brassaï, who had known him since the early thirties and ran into him in Saint-Germain-des-Prés.[20]

In the end, he gave up trying to pack up his things and abruptly left the city with Dora, Sabartés, and his dog, Kasbek, by car. This time, they did not head back to the Mediterranean. Instead, they drove all night to Royan, the small town north of Bordeaux, on the Atlantic coast, where he had already sent Marie-Thérèse and Maya in July. In choosing the town, flight had clearly been on Picasso's mind: Bordeaux was a major seaport for Atlantic crossings that could offer some possibility of escape. Sabartés later talked about Picasso's "tragic mood" about the "events that drove him from Paris."[21] For the time being, however, he was not contemplating escape so much as a kind of internal exile, and, with his two mistresses and young daughter, he quickly settled in to a new, reclusive wartime existence.

As a result, during the entire, frantic ten-week stretch in which the most important show of his four-decade career was being assembled, Picasso was completely unreachable. "Picasso has disappeared," Mary Callery reported in late September.[22] A month later, Zervos wrote to Barr that he had been to the foundry and seen the casts of Picasso's new sculptures but had lost touch with the artist himself.[23] "I truly regret that Picasso left these sculptures at the foundry instead of sending them to you," Zervos wrote. "They are magnificent pieces." By now the exhibition in New York was less than three weeks away, and all hopes of contacting Picasso before the opening had to be abandoned. Neither the sculptures nor Picasso himself would make it across the Atlantic. In fact, not even Rosenberg, who ordinarily would have come immediately for such an event, was able to attend, fearing that his son might be drafted in his absence. "If I had no son, which [sic] might be called if war lasted too long, I certainly would sail to the States," he wrote Barr shortly before the opening.[24]

. . .

Picasso: Forty Years of His Art opened at the Museum of Modern Art on a cool Tuesday evening in mid-November. The previous day, one French and four British ships were sunk by German mines and torpedoes; that same week, *The New York Times* reported that "the bulk of the German Army . . . is in the West ready to take the initiative."[25] In Manhattan, though, events in Europe seemed far away in a season filled with other distractions. "When we tune off the war broadcasts," a contributor to *Harper's Bazaar* wrote,

> we tune in on Alex Templeton, the blind pianist, with his malicious musical take-offs . . . Féfé's Monte Carlo is open again. There's the new Martinique, with two crack Latin bands, voodoo gyrations, and drum pounders. . . . Carmen Miranda is ay-ay-aying at the Waldorf. Downstairs in the St. Regis, all is Hawaiian now. . . . The Met promises the most glamorous opera singer that New York has seen in years—the Czech soprano, Jarmila Novotna. And the balletomanes are discussing furiously Dalí's "Bacchanale," the new Massine symphonic ballet, "Rouge et Noir," to the Shostakovich First, and Dick Rodgers's "Ghost Town."[26]

And yet, for the some seven thousand guests who attended the show's opening night, the shadow of world conflict hung over much of what they experienced, starting with the museum itself. Designed by American architects, the new building boldly proclaimed the arrival of the International Style in Midtown Manhattan. Yet the horizontal factorylike structure—a vivid departure from the city's upthrusting Art Deco towers—had been directly inspired by the Bauhaus, long since proscribed by the Nazi regime. Indeed, the two most prominent Bauhaus architects, Gropius and Mies, had recently arrived in the United States after fleeing the Third Reich. (If Barr had gotten his way, one of them would have designed the museum.) As much as the the building suggested an emerging new style, it also reflected a Europe that was rapidly disappearing.

But it was the museum's contents that captured this tension most

strongly. After passing through the building's signature revolving doors, the guests were greeted by three floors of some of the most astonishing paintings created since the century began, a great many of them brought over from France just weeks earlier: giant standing nudes reinterpreted through the burly, squat volumes of West African sculpture; violins and guitars that seemed to disappear entirely into a profusion of intersecting lines and planes; comic stock characters from Baroque opera rendered with the exquisite realism of Velázquez—or the mind-bending geometries of a three-dimensional jigsaw puzzle; corpulent bathers transposed into a fugue of curves, eyes, and breasts; shrieking, contorted shapes of animals, women, and children filling a huge wall with primal expressions of terror. Here was modern art at its most concentrated and clamorous, rescued in the nick of time from impending doom.

Barr had made a point of stressing the show's comprehensiveness, and faced with more than 360 works of stupefying variety, many viewers found the presentation overpowering. (So much for the smaller show Rosenberg thought he was getting.) Yet the exhibition was not merely a novelty show or a grab bag of avant-garde tricks. With his usual taxonomic zeal, Barr had arranged the art in an improbably lucid progression of styles and idioms, initiating viewers in stepwise fashion into the new and difficult. Beginning with Picasso's earliest paintings, the show continued chronologically, culminating, at regular intervals, in a series of defining moments: the early *Moulin de la Galette;* the Blue period *Old Guitarist* and Rose period *La Toilette; Two Nudes,* and, bringing to culmination the first floor, *Les Demoiselles d'Avignon*. Later floors took viewers through the "hermetic," "analytical," and "synthetic" stages of Cubism, through the monumental women of the early 1920s, *Three Dancers,* and the rapturously colored Marie-Thérèse paintings; and finally, through the tortured Minotaur period to the apocalyptic horror of *Guernica*. On every wall was a continuing struggle between form and the way to express it, but also an exhilarating search for beauty.

The show was not without gaps. Apparently not yet over his old falling-out with the museum, Chester Dale had refused to loan *The Saltimbanques,* perhaps the very greatest of Picasso's early circus paintings. Gertrude Stein's portrait, though Barr had optimistically put it in

the catalog, was no more present here than it had been in Chick Austin's show in 1934. There were all the sculptures that Picasso had failed to send, thus omitting a crucial dimension of his art. And then there was Rosenberg's *Three Musicians,* still missing on a boat somewhere en route from Buenos Aires. Even now, the painting continued to elude Barr. (It finally turned up in New York a month into the show's run, and would be hailed as the last picture to be hung.)

But few viewers noticed. In Barr's clarifying sequences, even a work as difficult as *Guernica* could gain powerful new coherence as the end point of many works before it. Because of its immense size, the painting was given a long gray room of its own, where it could be taken in from a proper distance, lit by hidden ceiling fixtures; adjacent galleries contained dozens of sketches, drawings, and study paintings as well as Dora Maar's thrilling photographs of the work itself in eight successive stages, offering rare insight into how Picasso created it. If nothing else, few viewers in this setting could walk away indifferent, or in reflexive disgust.

Here was *Guernica*'s true debut. Though the war that provoked it had already been lost, it was all too prescient of the one that had just begun. It would be Barr's 1939 show—rather than the Paris Expo in 1937 or any of the Spanish relief shows that had come after it—that would finally sear *Guernica* into the public consciousness and definitively establish it as one of the century's most enduring statements.

Having worried to the last if the show would come off okay, Barr himself was surprised by how feverishly it was embraced. Going into the exhibition, he had reason to fear a mixed reception: There was the long-standing fickleness of the American public with avant-garde art, and the checkered experience of previous Picasso shows, from Stieglitz in 1911 on up to Hartford in 1934. There was the hostile reaction that had greeted *Guernica* as recently as that same summer. And yet amid the backdrop of war, and the publicity about all the paintings the museum had gotten out of Europe, the show had electrified the city. People were lining up to get in to the museum in numbers that surpassed all previous records. Suddenly Picasso seemed to be everywhere—in newspaper headlines, on the cover of magazine supplements, even in shopwindows.

Almost overnight, it seemed, the artist had been transformed from controversial Paris provocateur into New York fashion icon.

Indeed, some of the most immediate echoes of the show came in the realm of couture. In *Vogue,* Frank Crowninshield, the longtime Condé Nast editor and founding Modern trustee, argued that Picasso's art captured the "strange and wholly new order" of feminine beauty in contemporary society. In Fifth Avenue window displays, the advent of Picasso-themed clothing was already taking place. To show off its winter 1939 collection, Bonwit Teller matched Cubist-faced mannequins with replicas of paintings from different phases of Picasso's career: The Blue period *Absinthe Drinker* was paired with a Persian blue coat and furs; in another window, the multihued *Girl before a Mirror* inspired a "stained glass" patterned evening dress. Bergdorf Goodman went further, borrowing seven *actual* Picassos from Walter Chrysler, Jr.—lesser paintings from the artist's Blue, Rose, and neoclassical periods—to hang next to ermine and sable coats. Whether Picasso's work was understood or not, the onetime enfant terrible of the *bateau-lavoir* had, apparently overnight, become a mainstay of department store chic.

As the show continued its run, however, there were also signs that the paintings were tapping into deeper currents in American life. "It is his vital will to change . . . which reflects the most profoundly characteristic urge of our time," the young critic Andrew C. Ritchie wrote in *Burlington Magazine.* Titling his take in the *Partisan Review* "Picasso: 4000 Years of His Art," George L. K. Morris argued that the show "demonstrates how the accelerated tempo of today has compressed a whole cultural cycle into a single life-time." In an unsigned editorial, even *The New York Times* weighed in, with clumsy discomfort, on what Picasso meant to twentieth-century culture. "Modern art, with all its baffling affirmations, its sloughs into chaos and unintelligibility . . . is the logical, again the inevitable, product of our time," the *Times*'s editors wrote. "And so Picasso—although we are certainly not called upon to approve everything he does, and may well turn in dismay or frank disgust from some of his art's grotesque phases—Picasso should be given his due."[27]

For viewers prepared to take on the full measure of Picasso's work, the show seemed to hold out the prospect of a new turn in American

culture. In a letter published in the *New York Herald Tribune,* one reader called it "the most important art event in America since the armory show," chiding the paper's own critic for not grasping its significance. "This stage of art is merely a step toward abstract art," the reader added with uncanny prescience.[28] In fact, several of the future leaders of the Abstract Expressionist movement found the exhibition overpowering. Willem de Kooning called the presentation "staggering"; Roy Lichtenstein, who was still in high school when the show opened, would keep going back to Barr's exhibition catalog for years after. Louise Bourgeois, at the time a recent arrival from Europe herself, found the show so entrancing that she was unable to paint for a month: "Complete shut down," she wrote.[29]

For many of these artists, the show seemed to throw down a challenge. For years, a handful of American painters, including Stuart Davis, Arshile Gorky, and John Graham, had been arguing that Picasso needed to be contended with. "All painting after Picasso is *after* and can not be before," Graham had said in the early thirties.[30] But they were in a minority, and for much of the thirties, as the American art world went elsewhere, few had paid much attention. Now it was clear for all to see: Artists in the United States would have to take account of what Picasso had done and find a new direction. "Another artist cannot begin at the point at which Picasso ends," concluded the art historian Robert Goldwater, who was also Bourgeois's husband, in a widely read review of the show.[31] Goldwater's insight would, in various ways, come to haunt the painters who came to maturity at midcentury. Years later, Jackson Pollock's partner, Lee Krasner, recalled how Pollock once picked up his dog-eared copy of *Picasso: Forty Years of His Art* and threw it across the floor of his studio in frustration. "God damn it! That guy missed nothing!" he shouted.[32]

But it was not in New York that most ordinary Americans would feel the show's impact. That happened when the Picassos left West Fifty-third Street and, as Barr had foreseen, were unable to return to Europe.

34

ESCAPE

icasso returned to Paris on the evening of November 12, 1939, two days before the opening party in New York.[1] Having spent the fall holed up in Royan, he had missed—or ignored—all of Barr's efforts to get in touch with him during the run-up to the show. Shortly after the war began, he had made a single, hurried overnight visit to Paris with Dora and Sabartés to update his residency papers, but the few hours they had spent there had been interrupted by an air raid siren, which had sent them briefly into a bomb shelter. "At ten in the morning we arrived at rue La Boétie, just in time to hear the sirens," Sabartés wrote. Still, Picasso had had time for Brassaï to take pictures of him having lunch at the Brasserie Lipp.

Now, however, the situation was calm and he was spending a longer stretch at rue La Boétie. And he was there when the first cables from New York arrived later that week, all saying essentially the same thing: "PICASSO EXHIBITION IMMENSE SUCCESS. NEW YORK AND ALL OF AMERICA IS PAYING HOMAGE TO YOU."[2]

Soon news about the show began to spread in France. After the initial weeks, the museum released attendance figures, and even Matisse was envious. "I know that art in New York is flourishing," he wrote his son Pierre. "More people attended the Picasso exhibition than the Van

Gogh one."[3] Picasso, though, made no response to the museum. To gauge his reaction, Barr had to rely on Callery, who was seeing him often. "He is in good form and very happy about the exhibition," she wrote, five days after the opening.[4]

But Picasso had not come to Paris to get news of the show. He had come to continue the unwelcome work he had abandoned when the war started. He and Sabartés needed to secure all the art he had left behind. It was difficult and time-consuming, since there were huge numbers of paintings, drawings, and other pieces of art scattered among his different studios and living spaces—the apartment and studio on rue La Boétie, his rue des Grands-Augustins studio, the big house at Boisgeloup, and the farmhouse in Le Tremblay. Rising early each day, he and Sabartés were racing around the city, stashing everything they could gather in a series of safe rooms he had rented in the Banque de France under the Boulevard des Italiens.[5]

One day, Callery came with him to the bank vaults to watch him work. "He had a great corridor to himself, with rooms leading off of it," she later wrote. "And in those rooms the paintings and drawings were stacked in their familiar order."[6] Sometimes, he pulled out something to show her, a work that, for one reason or another, he had never exhibited. Now, it would be even further out of sight. It was hard not to taste the irony: While in New York his paintings were being celebrated by tens of thousands of people, in Paris, Picasso was hiding them deep underground.

As France awaited the Nazi invasion, uncertainty hung over Paris. No one was ready to give up on the city, yet few thought that it was safe, either. Kahnweiler kept his gallery open and tried to do whatever business he could. But he was also determined to avoid a repeat of 1914, and he sent 154 paintings from his stock to his brother-in-law near Limoges.[7] Later that fall, Fernand Léger came back after three months on his farm in Normandy, intent on working in Paris again. But as he told Rosenberg, the atmosphere was so subdued it seemed like a "provincial town." Amid his art gathering, Picasso found time for a regular afternoon pause at the Flore. "The days passed as always," Sabartés wrote. But the tension was pervasive.[8]

Few felt it more than Rosenberg. He had watched the progressive stages of Nazism in Germany, the growing persecutions, the dramatic purging of modern art. He had also seen what happened to Kahnweiler in the previous war, and as a man of Jewish background who dealt in modern art, he was acutely aware of the dangers he faced. Already during the summer, amid his negotiations with Alfred and Marga, he had begun preparing for a German attack, hiding paintings in vaults and in the country, and sending as many of them as he could abroad. Not only did he have nearly all of his best Picassos now in the United States; he had also sent other works, like *Three Musicians,* to exhibitions in South America and even Australia. Having spent the early fall near Tours, he now moved his family again, to a big house in Floirac, a small town across the river from Bordeaux that was well positioned for a possible escape.

And yet the dealer was as committed as anyone to staying in France and continuing his business. After all, none of his artists were going anywhere, and they needed him. In October, he arranged new one-year "war" contracts with Matisse and Braque, confirming his right of first refusal on their work and the prices he would pay.[9] Then there was Margot, who couldn't imagine living anywhere else but France, and Alexandre, who was eighteen and would likely soon be drafted. Under the circumstances, leaving seemed impossible.

It was during this uneasy calm, a few weeks after the Picasso opening in New York, that Rosenberg received an important request from Barr. In the face of the overwhelming response to the show, requests had been pouring in from other museums hoping to take it after Chicago. Already he was in talks with museums in St. Louis, Pittsburgh, and San Francisco. According to Barr's astute "war loan" arrangements, Rosenberg and Picasso—as well as Thannhauser, Callery, Penrose, and the other major European lenders—had agreed to allow their Picassos to stay in New York for the duration of the war. Now Barr was asking Rosenberg and the other lenders if they would agree to let the Modern circulate their paintings to these other cities.

For Barr, it was an extraordinary opportunity. The Van Gogh show had already demonstrated the potential of a touring exhibition, and for

once, it seemed, the country might be ready. With the start of the war, museums were cut off from the usual sources of loans in Europe and particularly eager for material. And with all the Picassos from Paris already in New York, Barr could count on sending, along with its own masterpieces, *Les Demoiselles* and *Girl before a Mirror,* nearly all of the primary works in the original show, including *Guernica* and its accompanying studies. In a rare alignment of institutional demand and geopolitical circumstance, the Picasso show could turn into a truly national event.

Reading Barr's letter, Rosenberg was enthusiastic. An extended tour would bring his paintings to a potentially huge American audience; and since many of his loans were also for sale, it also could lead to new collector interest. As long as he was in France and the paintings were in the United States, it made sense for them to be exhibited. In mid-December, he wrote to Barr that he was glad that "during war time my pictures are lent to various museums in the United States."[10] What Rosenberg couldn't know at the time was that his participation in the Picasso tour would soon become a matter of existential importance to his own future.

For the time being, however, Rosenberg had other distractions. Throughout the fall, he had been dealing with another divorce crisis— this time Matisse's. Once again there were messy questions about the division of artworks and assets, and the dealer was centrally involved. At the same time, with the prospect of an invasion less imminent, Rosenberg began to develop new plans in France. In January 1940, he visited Picasso in Royan and came back with five new paintings. Margot hated them, but his son, Alexandre, found them entrancing. "He's hung it in his bedroom," he wrote Picasso, of one portrait of a woman's head with a spiral-shaped nose. "Howls from his mother and the housekeeper."[11] Then, a few weeks later, Rosenberg visited Matisse in Nice and acquired a group of new works from him too.

Meanwhile, by early spring, as the Picasso show in the United States left Chicago and moved on to St. Louis, life in Paris was picking up again. There were ambitious productions at the Comédie Française and the Opéra; Left Bank bistros were full. "For the first time since October," the art connoisseur and French army medic Douglas Cooper wrote,

"children were playing in the Tuileries and the Luxembourg Gardens."[12] Amid the thaw, Picasso came back to the city for a longer sojourn, and Rosenberg began to plan a return to rue La Boétie. "I'm going to reopen the gallery with a show of 5 new Matisses, 5 Braques, 5 Picassos," the dealer wrote Matisse, in early April.[13]

But the show never happened. On April 9, Hitler began his assault on Scandinavia, and Rosenberg stayed in Floirac. At first it seemed unclear how quickly the war in the West would progress. Beginning in mid-May, though, the Nazis' rapid conquest of the Netherlands and Belgium made clear that Paris was now under threat. Over the previous two years, Rosenberg had organized exhibitions in several of these countries. He had sent nearly a hundred of his Braques, Picassos, and Matisses, along with *Guernica,* to museums in Oslo and Copenhagen in 1938; and in the spring of 1939, he had organized Picasso shows in Amsterdam and Belgium. Now, while many of those same Picassos were touring the American Midwest, Northern Europe had fallen to a regime that hated modern art.

Still, Rosenberg's artists were not going anywhere, and he did not see any immediate need to act. In late May, Braque and his wife had visited Rosenberg, and the dealer helped him store some of his paintings in a bank vault next to his own in Libourne, a nearby town. Braque told Rosenberg he intended to stay put in Normandy. Then Matisse also visited the dealer, together with his secretary and longtime model, Lydia Delectorskaya, the woman who had pushed his wife to divorce. Rosenberg bought a few more paintings from him. But Matisse too, despite having his son Pierre in New York and various invitations to come to the United States, was determined to remain in Nice. "Whatever happens, I'm not leaving," he wrote Pierre a few months later. "If everything of any worth runs away, what will remain in France?"[14] Meanwhile, Picasso and Dora had left Paris and returned to Royan. Even if his paintings had to be locked up or sent overseas, Picasso was no more prepared to go into exile than Braque or Matisse.

By the second week of June, however, the Nazis were rapidly closing in on Paris. Faced with the imminent arrival of the German Wehrmacht, the city and surrounding areas experienced one of the largest human

upheavals in France's thousand-year history. The government made clear that it was no longer prepared or able to defend the capital, and on June 14, it fled to Bordeaux, just as it had at the beginning of the previous war. It was soon followed by some two million Parisians—by some estimates as much as two-thirds of the city's population. For hundreds of miles on the roads leading south and west out of the city, an endless stream of cars inched along, many with furniture and mattresses strapped to the roof; crowding among them were people on bicycles, or pushing heavily laden baby carriages and makeshift carts, or simply trudging along on foot. With gasoline supplies requisitioned by the army, the roads were littered with abandoned cars. During the flight, an estimated ninety thousand children became separated from their parents.

Watching a desperate situation unfold across the river from Floirac, Rosenberg was unsure what to do. Over the first two weeks of June, the population of Bordeaux swelled from less than three hundred thousand to more than a million. Thousands of people were camped out in parks and public squares while others slept in their cars. Not only Frenchmen but refugees from all over Europe were trying to reach this haven on the Atlantic coast. And with the arrival of the French government in exile, which quickly commandeered the major hotel and offices, it was even more difficult for Bordeaux to cope with the influx. Still, Rosenberg knew that flight, at this point, would be very difficult. He also had still not come around to the idea of abandoning his country and his artists. It was Rosenberg's brother-in-law Jacques Helft who finally persuaded him otherwise.

In Floirac, the Rosenbergs had spent much of the year with the two Helft brothers, Yvon and Jacques, who were also involved in the Paris art trade and were also Jewish. In early June, Jacques was staying near Paris, arranging his affairs, and when the Germans approached the capital, he somehow managed to get back to Bordeaux. As soon as he returned, the family gathered at the house in Floirac. Rosenberg and Yvon wanted to stay put, but Jacques, who had witnessed the exodus from Paris himself, was adamant that they flee immediately. "My father was a very quiet person. It was the first time I saw him in a fit," Jacques's son,

Jorge, who was then six years old, recalled in a 2016 interview. "He started shouting that he had read *Mein Kampf* twice, and that he could vouch that all Jews would be exterminated."[15]

By the summer of 1940, options for getting out of Europe were extremely limited. The United States had severely restricted the number of Jewish refugees it was bringing in. Cuba and South America were possibilities, but that required paperwork as well, and the economic prospects in these places seemed far more doubtful. Even if one could get visas, moreover, there were by now very few boats crossing the Atlantic. Still, staying in Nazi-occupied France seemed untenable, and Rosenberg and Yvon gave in: They would all leave together, bringing whatever financial assets they could get out with them.

From Bordeaux, the most plausible escape route was overland to Portugal, where there were still boats plying the Atlantic. Together, the three families were a large clan—fifteen people—and they would need Portuguese visas. They would also have to move quickly. The same day they decided to leave, the French war cabinet resigned and Marshall Petain was appointed prime minister, virtually assuring an imminent capitulation to Nazi Germany. Meanwhile, they had heard that the Portuguese consulate in Bordeaux was besieged with refugees. Jacques's wife, however, had a friend who worked high up in the French government, now in Bordeaux, and, armed with a special referral, went to the consulate with the stack of passports. "My mother was getting ready to line up at the Portuguese consulate for maybe a couple of days," Rosenberg's nephew recalled.[16]

The rumors turned out to be true. Since the first week of June, there had been thousands of people camped out in front of the Portuguese mission, which was on the Quai Louis XVIII in central Bordeaux. Faced with an onslaught of refugees, António Salazar, the Portuguese dictator, had passed harsh new border controls, and the foreign ministry in Lisbon had ordered its foreign consuls not to grant visas to Jews, or anyone else, under any circumstances, unless the applicant had a personal sponsor in Portugal. Unknown to Rosenberg or his Helft in-laws, however, the consulate was in the midst of a full-scale revolt.

The Portuguese consul general was a man named Aristides de Sousa

Mendes, a portly, white-haired man in his midfifties from an old Catholic landowning family. An able if undistinguished diplomat, he was chronically in debt, a result, in part, of maintaining a household that had come to include eight sons, four daughters, and several servants. In the twenties, while he was serving in San Francisco, the family had lived in a big, rambling house in Berkeley. By the time he was sent to Antwerp, in 1929, there were so many children that he commissioned a local Ford factory to build a minibus designed by one of his teenage sons. Then, in 1938, he was accused of financial irregularities by Salazar's Foreign Ministry and transferred to Bordeaux, at the time a backwater.[17]

With the German invasion, however, Bordeaux had become one of the chief gateways out of Europe. Sousa Mendes knew that many of the refugees streaming into the city faced dire consequences if they remained, but with his government's orders, his hands were tied. As the crowd outside the consulate became increasingly unruly, he became violently ill. "Here the situation is terrible, and I am in bed with severe mental exhaustion," he wrote to his brother-in-law on the day Paris fell to the Germans.[18]

Three days later, Sousa Mendes finally emerged from his room. His nephew, who was staying with him at the time, remembered the consul marching into the offices and going out to address the crowd. He would be issuing everyone visas, he said, regardless of religion or political belief. Over the next few days, just blocks away from where the French government was preparing to surrender to the Third Reich, Sousa Mendes signed visas from morning till night. He began abbreviating his signature to save time.

When Mrs. Helft arrived at the consulate with her large stack of passports, there was a huge throng outside the building. But she showed her letter from the government and was quickly whisked inside. Within ten minutes, the consul had stamped and signed the visas. For decades, neither Rosenberg nor his in-laws would know that the man who had approved their entry to Portugal had been acting on his own, against the orders of his government, in a heroic effort to save as many people as he could. In the end, Sousa Mendes would issue thousands of visas in the space of a few days. When the Portuguese government discovered what

he was doing, they sent agents after him and finally shut him down. Recalled to Lisbon, he was expelled from the diplomatic service and consigned to financial ruin. He would die in obscurity in the early fifties, a broken man. Today he is regarded in Israel as a hero of the Holocaust era, a Portuguese Wallenberg.

After receiving their visas on June 18, the Rosenbergs and Helfts packed into their family cars as quickly as they could and drove south to the border town of Hendaye. There was already a huge column of refugees waiting to cross; after spending two nights in their cars, inching along, they finally reached the Spanish frontier on the afternoon of June 20. At the time, the Franco regime permitted Portuguese visa holders to cross through the country, provided they didn't stop along the way. Rosenberg and his brothers-in-law, already exhausted from their journey to the border, negotiated permission for two overnight stopovers along the way. At the border, however, French police called out Rosenberg's son, Alexandre, and two of his Helft cousins, who had all reached military age: They would not be permitted to leave and would have to stay behind and enlist. It was a wrenching separation, and Margot was distraught.[19]

The day they received their visas in Bordeaux, however, Charles de Gaulle, who had secretly escaped to London, had given a fiery speech calling on French soldiers to form a resistance army in Britain. Alexandre and his cousins were determined to fight, and soon after, they managed to sneak onto a Polish troop ship headed for England, where they joined de Gaulle's forces. Alexandre would go on to train French resistance forces in Africa and fight in the Allied offensives in Europe later in the war. It was the last time Rosenberg and Margot would see him until Germany was defeated more than five years later.[20]

Crossing Franco's Spain proved to be a hair-raising experience. After nearly three years of brutal civil war, the country was deeply scarred. In some places, Rosenberg's nephew said, the roads had been so severely bombed that they had to drive in the fields alongside. The first night passed without incident, but on the second night, when they checked in to their hotel, they discovered, to their horror, that it was filled with Gestapo agents. Miraculously, the owner, a Republican who hated Franco,

immediately recognized them as Jewish refugees and warned them to stay in their rooms. They left early the following morning without eating breakfast.[21]

Rosenberg and his relatives finally reached the Portuguese border on June 22, the day France formally surrendered to Nazi Germany. Senior Portuguese officials had alerted Salazar to Sousa Mendes's rogue operation, and had sent agents to France to shut it down.[22] Had word reached the Spanish-Portuguese border, Rosenberg and his relatives might have been turned away. But the visas were accepted, though they were told they couldn't stay in Lisbon, which was already overflowing with refugees. They were required to go to Sintra, about fifteen miles west of the city, where they found lodgings in a hotel.

Rosenberg made it out just in time. On July 4, 1940, less than two weeks after his arrival in Portugal, the Vichy government turned over the names and addresses of the city's fifteen leading Jewish art dealers to the German embassy in Paris, including, along with Rosenberg, the galleries of Seligmann, Bernheim-Jeune, Wildenstein, and others. German officials immediately issued instructions to remove any art found on their premises; the French police provided vans to transport it. At gallery after gallery, the Nazis seized any artworks that had not been secured and "aryanized" businesses that had had Jewish owners.[23]

A couple of galleries, however, managed to escape largely unscathed. One was the gallery of Rosenberg's old neighbor and nemesis on rue La Boétie, Georges Wildenstein, who managed to make favorable arrangements with German officials by which he was able to immigrate to the United States, leaving his gallery in charge of a non-Jewish associate. The gallery continued to do a flourishing business during the war— with the French and with the Nazis. It would add one more element to Rosenberg's lifelong loathing of Wildenstein.[24]

Another Jewish-owned gallery managed to escape in a different way. Kahnweiler, opting to stay in France, had fled with his wife to the unoccupied zone, but since his French business partner was also Jewish, he, too, was vulnerable to seizure. Unlike in 1914, however, this time Kahnweiler was ready. In the spring of 1941, he managed to arrange for his daughter-in-law, who was French and Catholic, to take over ownership

of the gallery. It was left untouched. As momentous as was Rosenberg's decision to leave, Kahnweiler's decision to stay was equally so. If he could survive the war, he would now have new opportunities with the artist he had lost to Rosenberg more than two decades earlier. Overall, though, the great era of modern art that had flourished in Paris since the end of the last war had inexorably come to an end.

Stuck in Sintra, Rosenberg tried to figure out what to do. By the summer of 1940, Lisbon was an unsettling, chaotic city, filled with Allied and Nazi spies and increasingly overrun with exiled Europeans, from royalty and prominent businessmen to anti-Nazi resistance fighters and ordinary civilians. Everyone in the city, it seemed, was trying to escape from Europe, and even for those who could get visas to a foreign destination, boats were extremely scarce. Cut off from his paintings and his artists, there was little Rosenberg could do, and, like other refugees, he was fearful of his status. Still, he imagined that he would be able to travel on to the United States. After all, he had done business there for many years and had visited there multiple times without difficulty. With so many of his paintings already in the country, and numerous contacts with American dealers and collectors, he assumed it would be a formality to gain visas for his family. Entry would be easy, provided they could find a ship.

At the U.S. consulate in Lisbon, Rosenberg discovered how wrong he was. "I am trying hard to come to the States, but the consulates are invaded [*sic*] by demands," he wrote to his American friend, the art dealer Edward Fowles. No demonstration of his long record as a prominent international businessman seemed to make much difference. "I have shown affidavits of support by very rich friends of mine in America, shown that I possess still a large amount of cash," he wrote. "It is not enough and they have asked for an order of Washington!"[25] By now, Rosenberg was increasingly desperate. In Portugal, he had no paintings and knew no one; they would have to go somewhere else. He explored going to Argentina.

The dealer also couldn't help but see the absurdity of the situation. While he waited in endless visa lines in Lisbon, halfway around the world, a huge mass of people were lining up to see his Picassos—along

with *Guernica* and the other paintings from Europe—at the opening of the Picasso show in San Francisco. His paintings were now touring around the United States, having already attracted hundreds of thousands of visitors in New York, Chicago, St. Louis, and Boston. For the first time in his career, after years of trying, the works of the artist whom he had backed for more than twenty years were reaching a huge American public. Yet he himself was in Portuguese limbo, reduced at times to taking handouts from a British refugee relief agency.[26] He would need a new strategy.

At the Museum of Modern Art, the effects of the fall of France were felt almost immediately. After a decade of nearly constant transatlantic activity, Alfred Barr was known in Europe as one of the main conduits of modern art in the United States. In the summer of 1940, he began receiving requests from dozens of art world refugees asking him to assist them in getting U.S. visas. It was a difficult and costly task, involving not only extensive documentation but also some kind of personal sponsorship to show that the applicant could be gainfully employed. Alfred, consumed by the museum as always, had no time to deal with these requests, and he turned over the work to Marga. Eventually, Marga was able to help a number of artists get to the United States, including Yves Tanguy, André Masson, Piet Mondrian, Jacques Lipchitz, Max Ernst, and Marc Chagall. At the same time, though, Alfred had decided from the outset that they would have to strictly limit whom they would try to rescue. As Marga noted, "Only artists, not critics, scholars, or dealers."[27]

While Marga was launching the museum's refugee effort in New York, Rosenberg was shifting strategy in Lisbon. Alarmed by his cold reception at the consulate, he realized that he would need to show that his expertise in modern art transcended the realm of the international art trade. In effect, he needed to demonstrate that he was a person of exceptional value to American culture—that he could make unique contributions to the American art world and that it was therefore in the national interest of the United States to allow him to immigrate. It was a difficult argument to make, since his own activity in the United States

had been largely commercial. As a result of the Picasso tour, however, which had already gone to five different museums and counting, he now had a distinguished roster of museum directors who were, during this same season, benefiting enormously from his loans.

Quickly, Rosenberg cabled as many museum directors as he could about his predicament. He asked if they would be willing to write to the consul general in Lisbon on his behalf. In Lisbon, the telegrams began arriving almost immediately. Walter Heil of the De Young Museum in San Francisco referred to the dealer's "unmatched reputation" in the field and invited him to give a series of lectures on French art in the fall, which he said would draw "immense interest." The president of the St. Louis Museum, which had hosted the Picasso show that spring, invited Rosenberg to come to St. Louis. Henry McIlhenny of the Philadelphia Museum of Art, who had just bought a big Picasso still life from Rosenberg that he had seen in the show in New York, wrote that the dealer's presence in America would be "of inestimable value for American museums." In his cable, McIlhenny asked the consul how he might assist in getting "visas for him and his family immediately." From Chicago, Daniel Catton Rich, Alfred's co-sponsor of the Picasso show, had already invited Rosenberg to come lecture at the Art Institute the following winter. He wrote that the dealer's admission to the United States would be "excellent for the art of this country."[28]

To these voices was added, from Cambridge, Massachusetts, Barr's old mentor Paul Sachs, who had known Rosenberg for many years. Sachs telegraphed that he was hoping to bring Rosenberg to Harvard to speak to his museum class. Finally came Barr's own cable from New York, in many ways the most impressive. Addressing the consul general himself, he wrote, "DELIGHTED PAUL ROSENBERG, THE EMINENT FRENCH CONNOISSEUR AND DEALER OF MODERN ART COME TO THIS COUNTRY IN ORDER TO BE ADVISOR TO OUR MUSEUM.—ALFRED BARR DIRECTOR MUSEUM OF MODERN ART NEW YORK."

Barr was effectively calling him an affiliate of the Museum of Modern Art. Despite his vow to limit his European rescue efforts to artists; despite his decade-long struggle with the big Paris dealers and his concerns about involving them in the museum's affairs; despite years of ten-

sions with Rosenberg himself, tensions that had, as recently as the spring of 1939, nearly derailed the Picasso show—despite all of this, Barr was intervening decisively to get Rosenberg out of Europe.

The cables had a dramatic effect. When Rosenberg returned to the consulate a few days later, he was no longer a mere art dealer who had done business in the United States. He was now an "eminent French connoisseur" whose expertise was in demand from museums across the country as well as from Harvard University. His application still needed to pass some final vetting, but the consul general indicated that an answer would be forthcoming. Two days later, he awarded visas to the dealer and his extended family. Rosenberg was stunned—by the generous and immediate help he had received from his American colleagues, and by the consul's response to it. After nearly twenty years of trying to bring Americans around to Picasso's work, he had finally done it—without being there himself. In a final, jubilant letter to Fowles, he looked forward to his arrival in New York and to the task of creating, as he called it, "a great art center in the States."[29]

The Rosenbergs arrived in New York harbor on September 20, 1940. The crossing had not been particularly calm. They had left Portugal during the height of the Blitz, on one of the few American liners that was still plying the Lisbon–New York route, and the war at sea put even neutral shipping at some risk. The dealer was also leaving a great deal behind: His gallery and house in Paris. His artists Picasso, Braque, and Matisse. And the hundreds of paintings he had stored in vaults, in Paris, Tours, and Libourne.

In the end, his precautions would prove far too little. His Paris inventory would be ransacked; later, German agents working for Hermann Goering would seize the 162 paintings he had stored in Libourne, as well as the ones that Braque had stored adjacent to his. (In their dark exactitude, while Nazi bureaucrats designated the art belonging to "the Jew Paul Rosenberg" for sale or trade, they ultimately released Braque's paintings because he was "an Aryan."[30]) And in the spring of 1941, Nazi officials went further, transforming Rosenberg's gallery into the Institute

for the Study of the Jewish Question, a Gestapo-financed organization whose sole purpose was the dissemination of anti-Semitic propaganda. Around the same time, the Paris police began their first roundups of Jews. Rosenberg's own French citizenship would be revoked.

Yet as important for Rosenberg were the paintings that he had already gotten out. Awaiting him in the United States were not only the dozens of prime Picassos that he and Alfred Barr had astutely sent to New York the previous summer, but also a series of prominent museums that were clamoring to show them and a large new American audience that was eagerly absorbing them. Not least was the fact that the Picasso show had turned Rosenberg himself into one of the more sought-after figures in the American art world.

While Rosenberg was still in Portugal, Henry McIlhenny, the young Philadelphia curator, was one of the first to pick up on the dealer's feat. After months of waiting, while the Picasso tour continued, McIlhenny was impatient to get the big, challenging 1931 still life, *Pitcher and Bowl of Fruit,* that he had bought from Rosenberg after seeing it in the Museum of Modern Art show. "I am terribly keen to have it," he wrote one of Alfred's assistants. Then he added: "Rosenberg has been in Portugal, but is, I hear, coming to this country. The Picasso show certainly has helped him out."[31]

Somehow the war had saved the exhibition, and the exhibition had saved Rosenberg. Transformed into a national tour by the disintegration of Europe, the show not only fulfilled, in spectacular fashion, Barr's longstanding ambition to bring the full force of Picasso's art to the United States. It also finally brought to America the man who had built and shaped his international reputation since World War I. With Paris's most emblematic painter captivating audiences from Boston to the upper Midwest, and its most influential dealer now in New York, it was hard not to sense that a tectonic shift was under way. Rosenberg would soon be joined by many other members of the European art world. Two months after his arrival, Fernand Léger made it to the United States; and in early January, Justin Thannhauser, the dealer who had intro-

duced Picasso to Germany and lent important works to the Museum of Modern Art, also gained entry.

By the following summer, with the help of the Barrs and others, Marc Chagall, Max Ernst, and a number of other artists would also have escaped. Meanwhile, the Picasso show itself would continue its tour, now going, in a new season, to Cincinnati, Cleveland, New Orleans, Minneapolis, and Pittsburgh. In many ways, the unending Picasso show seemed to provide a backdrop to the new émigré avant-garde scene that was taking root alongside it.

Among those who never did cross the ocean was Picasso himself. While his paintings traveled from city to city around the United States, the fate of the man who made them remained a mystery. For much of the war, the artist's existence in Vichy France remained largely unknown, even to Alfred Barr. (He had ultimately gone back to Nazi-occupied Paris, where he defiantly continued his wartime existence.) Yet Picasso's absence was curiously beside the point. Already his work, helped now by Rosenberg in New York, was gaining a new market in the United States, and from now on, Americans would be his most enthusiastic audience—and his most avid buyers.

It was a quarter century late, and it took two World Wars to make it happen, but the prediction that Quinn confidently made in 1913 had finally come true. From now on, the story of modern art— the collectors who acquired it, the scholars who studied it, the museums that showed it, and the ordinary people who waited in long lines to see it—would be written in America.

Epilogue

*I*n February 1945, Frank Kleinholz, the host of the weekly radio program *Art in New York,* decided to interview the veteran art critic Elizabeth McCausland. In her columns for the Springfield *Republican,* McCausland had long been one of the most astute observers of contemporary art in the United States. She also had a deep interest in artists' engagement in politics, and in the great ideological battles of the time. On his show, Kleinholz wanted to ask her about one artist in particular. Over the past few years, the United States had been fixated on an aging painter in Nazi-occupied Paris. The artist did not speak English and had never set foot in this country. His art was often challenging and difficult. And until American forces reached the Champs-Élysées in the summer of 1944, almost nothing was known about his fate during the previous four years—or even whether he was still painting. And yet, since the war began, the artist had acquired a peculiarly central place in American culture.

Despite his remoteness and mystery, Kleinholz noted, Pablo Picasso had become a household name, and even more unexpectedly, a potent symbol of American values. Defiantly staying in Paris during the darkest days of Vichy, he was regarded as a hero of the anti-Fascist resistance, a man whom American soldiers were dying to meet. At the same time,

having aroused suspicion for years, his exuberantly modern work was suddenly being embraced by hundreds of thousands of people across the country, from the traditional art centers of the Northeast to cities in the upper Midwest, from college towns in the Deep South to farm communities in the Central Valley.

When Kleinholz asked McCausland to account for this curious phenomenon, she began to talk about the influence of a single institution in New York. "The past fifteen years have seen a tremendous change in aesthetic values," she said, "just because of the education, propaganda, call it what you will, carried on by the Museum of Modern Art."

"But what does this have to do with Picasso?" Kleinholz asked.

"Everything," she said.[1]

By the end of the war, *Picasso: Forty Years of His Art* had become one of the longest-running, and most talked-about, modern art shows in history. Interest in the show had grown steadily throughout the first winter of its run. In New York, the show drew fifteen thousand visitors a week during its first month, a record that surpassed even that of the Van Gogh exhibit four years earlier. At the Art Institute of Chicago, people came from all over the Midwest to see it. "The Picasso exhibit in Chicago is great fun," a writer for *The Nebraska State Journal* wrote after making the trek. "It's amazing. It's overwhelming even when taken in two jumps."[2] In conservative Boston, the show alternately fascinated and flummoxed viewers, with the *Boston Globe* critic conceding that everything else in the Museum of Fine Arts looked "rather tame and drab" afterward; during three and a half weeks in St. Louis, nearly fifty thousand people squeezed into the City Art Museum to see *Les Demoiselles, Girl before a Mirror,* and *Guernica.*[3] Then it reached the San Francisco Museum of Art, where interest was so intense that some people had to be turned away. In early August, on the final day of the show's run there, more than a thousand people sat down on the floor of the galleries and refused to leave, in what may have been the country's first protest *for* modern art. The museum was forced to stay open long after its ten o'clock closing time.[4]

. . .

By the fall of 1940, museums across the country were aggressively competing for the show, and a second, more crowded season began. New Orleans was so intent on getting *Picasso: Forty Years of His Art* that it formed a Picasso Exhibition Committee backed by all the main arts groups—museum, art school, art club, and college—to raise the necessary funds to sponsor it.[5] After reserving the show for four weeks in early 1941, the Minneapolis Institute of Arts spent months preparing viewers for the artist it called "the storm-center of discussion on two continents," noting that "over 307,000 people in eight American cities" had already seen these formidable paintings.[6]

In the summer of 1941, the show returned to the Museum of Modern Art, according to the *Times,* "in response to hundreds of requests from teachers and students . . . as well as from New Yorkers who were unable to visit the exhibition during its first run." Then it was back on the road again. By the time of the Pearl Harbor attack, the show had traveled to eleven cities; when the Allies began their invasion of Italy in 1943, the number had doubled. Among the stops in these later iterations of the show were not only such major urban centers as Kansas City and Portland but also smaller cities like Grand Rapids, Michigan, and Durham, North Carolina.[7]

Not to leave out more far-flung regions of the country, Barr and his staff at the museum sent Picasso's *La Coiffure,* a decidedly demure portrait of two women and a young child from 1906, on a solo tour of its own to more than a dozen smaller venues, including a women's college in upstate New York and a historical society in Stockton, California, a town that was primarily known as the birthplace of the modern tractor. "I believe more persons brought notebooks and carefully studied the [Picasso] than any other exhibition we have ever held," the director of the San Joaquin Pioneer Historical Museum in Stockton reported to one of Barr's colleagues in New York.[8]

Finally, in early 1944—more than four years after the New York debut of *Picasso: Forty Years of His Art*—the Museum of Modern Art arranged

to send several dozen Picassos to Mexico City in an armored Pullman car, for the launch of a new modern art society backed by a group of leading Mexican art patrons. Though the paintings were held up in Laredo, Texas, for several weeks while they awaited border clearance, the show was a wild success, and the organizers begged New York to extend the loans. "It's difficult to describe the strong reaction the show has produced in Mexico," one of the organizers wrote. "The work of Pablo Picasso has served as a kind of healthy bomb in a place that was dull and complacent."[9]

But it was the fate of the paintings themselves that perhaps best captured the show's most durable legacy. Of all the Picassos that crossed the ocean back in 1939, many of them never returned to Europe. Some of the Paris loans, like *Pitcher and Bowl of Fruit,* acquired by McIlhenny, and *Girl with Dark Hair,* bought by Museum of Modern Art trustee Edgar Kaufmann, were purchased right off the walls of the show. ("Will you kindly send us the prices of the works . . . which are for sale," a curator at the Chicago Art Institute had written Barr, in response to demand there.) Others found permanent homes in museums and private collections across the United States in the years after the tour finally ended. Picasso himself, though he remained in Paris, did not reclaim the paintings he had lent the museum until the 1950s. And as Franco's dictatorship became increasingly entrenched in Spain, *Guernica* became one of the longest "war loans" ever—becoming a cornerstone of the museum's permanent galleries until it finally went back to Spain in the early 1980s.

After the show, the Modern's own collection of premier Picassos, from its dramatic start in the late thirties, now began to grow at an ever accelerating pace. In 1945 came *Ma Jolie;* four years later, with Mrs. Guggenheim's checkbook, the museum finally managed to snare Rosenberg's *Three Musicians.* Later still came several more Quinn pictures, by now hardly controversial. Having for years struggled to get by without a permanent collection at all, the museum amassed so many Picassos that in the early 1950s one trustee estimated that 20 percent of its wall space was devoted to the artist.[10] In 1968, despite everything else that was happening that year, *Life* magazine devoted a special double issue to Picasso and the huge shadow he cast over American culture. To its seven

million readers, the magazine wrote, "The revolution he generated, sweeping far beyond artist studios, has helped shape the geometries of cities, concepts and techniques of movies and TV, the graphic idioms of advertisements, the homes we live in and the clothes we wear."[11] Once the Picasso juggernaut had finally started, it could not be stopped.

Yet it might easily have been otherwise. Again and again, for more than a quarter century, efforts to show Picasso's art in the United States failed to captivate the public. Had it not been for John Quinn's determined pursuit of Picasso and his fellow Paris rebels back in the teens and early twenties, the seeds of the Museum of Modern Art—and its specific orientation to the Paris School modernists—might never have been planted. Had it not then been for Alfred Barr's own fascination with Quinn, and his decade-long tauromachy with Picasso and his dealer to bring his work to New York, it is unlikely that Picasso's art would have reached a broad American audience until the war was over. Had Rosenberg, for all his false starts in the United States, not been willing to risk his best works on Barr's show, the project might once again have been stopped in its tracks. And even then, it was an accident of war—and personal necessity—that finally made the show possible and that gave it such lasting power.

In the end, it was a curiously tiny number of people who fought Picasso's War for the United States.

JOHN QUINN: By the time the Picasso show opened in 1939, the Irish American attorney had been almost completely forgotten. Not only had his collection been widely dispersed, but his extraordinary correspondence, including many thousands of letters to leading artists, writers, critics, and statesmen, was placed under seal for a decade and then under a publication ban for another fifty years, leaving his enormous imprint on modernist culture largely unknown.[12] It is strange to imagine what Quinn might have made of a museum in New York avidly chasing down the paintings he had once owned and the artists he had

once befriended. Knowing Quinn, he would have been bemused. "It is sad to think that the paintings that I buy now, Picasso, Matisse, Derain, Dufy, Rouault . . . may seem 'old hat' in ten or twenty years," he wrote to W. B. Yeats in 1915. "But what is one to do?"[13] New York in 1939 did not find Picasso and Matisse old hat. Nor did New York in 2003—ninety years after the Armory Show—when the Museum of Modern Art devoted a revelatory exhibition to the relationship between Picasso and Matisse.

PAUL ROSENBERG: Following his harrowing escape from Bordeaux in the summer of 1940, the dealer arrived in New York just in time to capitalize on an exploding American market. Quickly reestablishing himself in Manhattan, a few blocks from the Museum of Modern Art, he was soon selling Picassos—a number of them right out of the show—to a new crop of American collectors. He was also sought after by museums around the country. In 1941, seven years after it had passed on the opportunity, he persuaded the Modern to acquire Van Gogh's *Starry Night*—the first Van Gogh to enter any New York museum. It would soon become, alongside *The Sleeping Gypsy* and the *Demoiselles,* one of the most celebrated paintings in its collection.

If Rosenberg's Picassos had gotten him out of Europe, however, they also separated him definitively from his artist. After the war, he began corresponding with Picasso again and even, for the first time, began addressing him with the informal French *tu;* by now they had two wars and nearly thirty years of history between them. But despite his efforts, Rosenberg never resumed his old relationship with the artist. In Europe, he spent years trying to track down paintings stolen by the Nazis, and from time to time he called on Picasso. But they were separated by an ocean now, and Rosenberg himself—despite his wife's constant desire to return to Paris—refused to move back to the country that had betrayed him. In the final months of the dealer's life, an important curator in Europe asked to borrow the artist's *Harlequin with Violin (Si tu veux),* the great Cubist work that had once belonged to John Quinn. Uncharacteristically, Rosenberg refused. No matter how important the show, his son,

Alexandre, wrote, Rosenberg could not let out of his sight a painting for which he had, for decades, felt an almost "tyrannical attraction."[14]

DANIEL-HENRY KAHNWEILER: In a stunning reversal of what had happened in the previous war, this time it was Rosenberg who fled into exile and had some of his paintings seized, while Kahnweiler stayed in France and benefited from his absence. Patient as always, Kahnweiler rode out the war in the free zone of occupied France, first in Limoges, and then, after narrowly averting arrest by the Gestapo, in a nearby hamlet, where he and his wife lived under false names. As soon as Paris was liberated, he made contact with Picasso; by October 1944, he had moved into a new apartment on quai des Grands-Augustins, around the corner from Picasso's rue des Grands-Augustins studio. And with Rosenberg gone, he was perfectly poised to take up the role he had lost more than thirty years earlier, as Picasso's dealer. He and Picasso had always remained friends, and the two immediately reached an understanding. He was helped by Rosenberg in another way too. As Rosenberg built up a lucrative new market for Picasso in the United States, it was Kahnweiler, in Paris, who could now sell Picasso's newest paintings to American buyers at extraordinary prices. At last the tenacious Mannheimer could enjoy the fruits of his youthful wager. Having been cruelly denied his inventory—and his premier artist—for more than two decades, he was getting the last word.

ALEXANDRE ROSENBERG: After parting with his parents on the Spanish border back in June 1940, the dealer's son and erstwhile philosophy student escaped to England and joined de Gaulle's resistance army. Soon he was dispatched to the French Congo, where he trained African troops; then he made his way north to fight the Germans in North Africa, and finally took part in the liberation of France itself. In the late summer of 1944, his unit was sent to intercept the final German train leaving Paris filled with French war loot. On the train they found crates of paintings belonging to his father, taken from the rue La Boétie gallery. After the

war, he joined his father's New York business—reluctantly—and, marrying an American woman, became a prominent art dealer in his own right. Fifteen years after his father's death, he would finally allow the Cleveland Museum of Art to acquire *Harlequin with Violin* (*Si tu veux*), bringing to end the odyssey of a painting that Quinn had first brought to the United States in 1920.

ALFRED BARR: In October 1943, even as his Picasso triumph continued to play out, Barr was summarily fired as director of the Museum of Modern Art. After fourteen years of Herculean labors for the museum, he was informed by Stephen Clark, the museum's steely chairman, that he was not writing enough. Allegedly, for all his extraordinary shows and deeply researched catalogs, Barr had not been producing enough scholarship; in reality, the trustees, or some of them, felt that Barr was a poor "executive" and his tastes too radical and risqué for an increasingly corporate institution. Barr was unbowed. Relegated to a small cubicle in the museum's library and demoted to an advisory position at half salary, he began working on a huge new book on Picasso.

As the war reached its climactic battles in the fall of 1944 and the spring of 1945, Barr used a network of museum curators turned GIs in Europe to help him research his book. When it was published in 1946, *Picasso: Fifty Years of His Art* quickly became the definitive midcentury work on the artist. Barr submitted it to Harvard, where it was accepted for the Ph.D. he had never completed when he left to run the museum seventeen years earlier. In his dedication, Barr wrote: "For my wife Margaret Scolari-Fitzmaurice, advisor and invaluable assistant in the Picasso campaigns of 1931, 1932, 1936, 1939."

MARGA BARR: With the outbreak of war, Marga found herself for the first time cut off from the Europe she loved. "There were no more 'campaigns' and we were stuck in America," she said. But she quickly found another way to engage with the Continent, assisting Varian Fry's Emergency Rescue Committee in its efforts to help modern artists flee the

Nazis. Along with all the Picasso paintings that were now stuck in the United States, the remarkable influx of refugee artists like Ernst, Lipchitz, Tanguy, and Léger would fundamentally transform the American art world. Still, there were a few artists they never heard from. "We kept always thinking, would Picasso want to come?" she recalled. She and Alfred did not learn until late in the war that the Germans hadn't dared touch him. After the war, when Alfred's European campaigns resumed, Marga returned to her indispensable work as interpreter, adviser, and all-purpose charmer. But it didn't get any easier with Picasso. When they finally managed to meet him again, in Vallauris in 1952, Picasso kissed Marga and asked her, "Why didn't you send me a postcard?" Then he turned to Alfred, who had recently published a major study on Matisse, and said, "You did a great book on Matisse!" He had not a word to say about *Picasso: Fifty Years of His Art.*[15]

PABLO PICASSO: Confounding to the last, the artist continued to live at odds with his own reputation. Just months after he was greeted by American GIs in Paris as a Resistance hero, he was recruited to join the French Communist Party, despite Stalin's stance against modern art. In fact, by the 1950s, the FBI kept an active file on Picasso's activities as a possible Communist agent, and he never did visit the United States. Leaving Dora Maar during the war, he took up with Françoise Gilot, his next conquest, with whom he settled in Vallauris, in the south of France, where he became fascinated by ceramics and had two more children. When Barr, who was now director of collections at the Museum of Modern Art, prepared Picasso's seventy-fifth anniversary exhibition in 1957—a show even bigger than the one in 1939—Picasso designed him a necktie, which Alfred wore to the opening. Picasso stayed in France.

HENRI-PIERRE ROCHÉ: In the years after Quinn's death, Roché continued his very active social life in Paris, and eventually found himself advising the young Maharajah of Indore, an Oxford-educated prince, whom he introduced to Brancusi. During the Nazi occupation, he took refuge in

a small town in the free zone in southeastern France, where he taught English and gymnastics in a school for refugee children. In 1953, just six years before his death, Roché would at last enjoy the literary success that had eluded him for decades, with *Jules et Jim,* the bestselling novel he based on his experiences with Franz and Helen back at the time he knew Quinn.

After the war, Roché kept up his friendship with Picasso, just as he did with everybody in Paris. But, like everyone else's, his letters mostly went unanswered. One day in 1946, however, he was determined to get through. On a large sheet of paper, he wrote Picasso a series of questions, each one followed by a blank for Picasso to fill in. "Since you are a very lazy writer," Roché wrote, "I've enclosed an envelope with my address." At the end of the letter, he asked, "I would like to see you again, just once by yourself, amid your paintings, as back in the days of Leo Stein, Erik Satie, John Quinn, Doucet—but will it ever happen? _____." This time the ploy worked. Picasso wrote on the blank line: "<u>Me too. When I return.</u>" Then he sent the letter back to Roché.[16]

Acknowledgments

In 2014, I had the rare luck to meet the late Elaine Rosenberg, who was not only the ninety-three-year-old daughter-in-law of the art dealer Paul Rosenberg, but also a charming woman with an almost photographic memory of events that had taken place three-quarters of a century earlier. That encounter would later start me on an odyssey that took me to more than a dozen research institutions, libraries, and archives in the United States and Europe, and that drew on the help of many people, including more than I am able to name here.

I would not have been able to take on this project without the outstanding work of others. On John Quinn I was guided by B. L. Reid, Aline B. Saarinen, Judith Zilczer, and Richard and Janis Londraville, among others; on Alfred H. Barr, Jr., I profited from the insights of Dwight Macdonald, Russell Lynes, Irving Sandler, Rona Roob, and Sybil Gordon Kantor; on Paul Rosenberg, Michael C. FitzGerald and Anne Sinclair pointed the way to a crucial overlooked story. I was particularly fortunate to have interviewed Pierre Daix, Françoise Gilot, and Bill Rubin years before I began this book and to have met, at the end of his life, John Richardson.

The research for this book would not have been possible without yearlong fellowships from the Cullman Center for Scholars and Writers at the New York Public Library and from the National Endowment for the Humanities, as well as generous grants from the Getty Research Institute, the Harry Ransom Center, the Robert B. Silvers Foundation, and the Dora Maar House. I am also grateful to *The New York Review of Books* for granting me the leave that

allowed me to begin my research and to my current employer, *Foreign Affairs,* for generously accommodating my final book deadlines.

At the Cullman Center, Salvatore Scibona, Lauren Goldenberg, and Paul Delaverdac enabled me to spend an unforgettable year with an impossibly accomplished group of writers. At the New York Public Library I was expertly assisted by Deirdre Donohue, Richard Foster, Declan Kiely, Matt Knutzen, Thomas Lannon, Melanie Locay, Tal Nadan, Kyle Triplett, Lori Salmon, Emily Walz, and many others.

At the Museum of Modern Art Archives, Michelle Elligott, Christina Eliopoulos, Michelle Harvey, Ana Marie, Elisabeth Thomas, and their colleagues efficiently steered me through vast holdings on Alfred Barr and the early years of the museum. In the Conservation Department, Michael Duffy provided valuable help with *The Sleeping Gypsy* and in the Department of Painting and Sculpture, Janet Yoon generously shared information about several crucial artworks. At the MoMA Library, Jennifer Tobias and others helped me locate rare early-twentieth-century publications. Victoria Barr not only enthusiastically supported the project but shared her own fascinating memories and assisted with seemingly intractable research questions.

Elaine Rosenberg (1921–2020) and her daughters Marianne Rosenberg and Elisabeth R. Clark provided extraordinary access to the Paul Rosenberg Archives, without which this story could not have been told. I owe a special debt to Ilda François, who facilitated innumerable visits to the Rosenberg library, often on very short notice.

At the Harry Ransom Center, Elizabeth L. Garver helped me navigate the Carlton Lake Collection and its exceptionally rich holdings on Henri-Pierre Roché. At the Getty Research Institute, Sally McKay and her colleagues allowed me to work in one of the world's great art libraries and to consult their sprawling archives of twentieth-century art dealers, critics, and artists. At the Harvard Art Museums Archives, Megan Schwenke provided indispensable assistance with the Paul J. Sachs Papers and allowed me to complete a yearslong quest for documents related to *The Sleeping Gypsy.*

At the Musée national Picasso in Paris, Emilia Philippot, Violette Andres, and Audrey Mazeyrie provided generous access to the Picasso Archives and helped with research questions. At the Picasso Administration, Christine Pinault permitted me to draw on important Picasso letters and materials. In Brussels, Bernard Ruiz-Picasso and Pauline Vidal at the Fundacíon Almine y Bernard Ruiz-Picasso para el Arte allowed me to use rare material related to Olga Picasso and to the Paul Rosenberg family, and Thomas Chaineux came through with crucial information about Olga Picasso's family in Russia and

career in the Ballets Russes. Georges Matisse welcomed me at the Archives Matisse in Issy-les-Moulineaux. At the Bibliothèque Kandinsky in Paris, Thomas Bertail helped with essential research in the *Cahiers d'Art* archives. At Editions Cahiers d'Art in Paris, Staffan Ahrenberg, Paul Ferloni, and Gaëtane Girard answered innumerable queries. Pierre Sicre de Fontbrune and Christian Derouet shared valuable insights, as did Caroline Fournillon-Courant at the Musée Zervos in Vézelay. In Amsterdam, Michiel Nijhoff allowed me to study Paul Rosenberg's correspondence with the Stedelijk Museum. And despite multiple COVID postponements, Gwen Strauss at the Dora Maar House in Ménerbes gave unflagging support to the project.

In the United States, many other institutions and archives helped at critical junctures. At the Morgan Library and Museum in New York, Maria Molestina-Kurlat allowed me to spend many days studying their Paul Rosenberg and Pierre Matisse papers. At the Albright-Knox Art Gallery, Gabrielle Carlo shared documents related to A. Conger Goodyear. At Yale, I was able to consult the Gertrude Stein and Alice B. Toklas Papers at the Beinecke Rare Book and Manuscript Library and the Dwight Macdonald Papers at the Yale University Library. At Columbia University's Oral History Archives, David A. Olson helped with a transcript of Paul J. Sachs's unpublished memoirs. And at the Archives of American Art, Marisa Bourgoin and her staff allowed me to make frequent use of their phenomenal artists' records, as well as their copies of the Alfred H. Barr, Jr. Papers.

A great many people in Europe and the United States assisted with unpublished material, images, and information, including Janet Hicks and Dan Trujillo at Artists Rights Society (ARS), New York; Jennifer Belt and Ken Johnston at Art Resource, New York; Amanda McKnight at the Barnes Foundation in Philadelphia; Diana Widmaier-Ruiz-Picasso, Maya Widmaier-Ruiz-Picasso, Claire Rougée, and Olivia Speer at DWP Editions in Paris; Paul Matisse at the Pierre Matisse Estate; Marilyn Palmeri at the Morgan Library and Museum in New York; and Jonathan Hoppe and Anastasia Hughes-Peng at the Philadelphia Museum of Art.

Phyllis Stigliano not only provided superb photo research but also shared her unparalleled expertise in the Picasso world. I am also grateful to her team, Mikael Colboc and Maud Fernandez, who diligently helped with final research on two continents. Macy Bayern and Sophie Strauss-Jenkins assisted with difficult archival quests. Suzanne Pekow Carlson and Quinton Singer contributed invaluable fact-checking. Any remaining errors are my own.

Many other people shared advice, knowledge, and support, among them Christopher Benfey, Andrew Butterfield, Faya Causey, Harry Cooper, Eliza-

beth Cowling, Andrea Crawford, Jim Cuno, Yasmine El Rashidi, John Elder-field, Cathy Fagan, Martin Filler, Ross Finocchio, Barbara Fleischman, Jamey Gambrell, Alma Guillermoprieto, Delphine Huisinga, Janis Londraville, Ed Mendelson, Philippe de Montebello, Francine Prose, Jill Shaw, Charles Stuckey, Mark Tribe, Gijs van Hensbergen, and Robert Walsh.

To many editors I owe the opportunity to explore themes related to this book. A decade and a half ago at *The New York Times,* Nancy Kenney and Jodi Kantor gave me the chance to investigate the hidden secrets of the Museum of Modern Art. Daniel Zalewski at *The New Yorker* encouraged me to examine the deep human forces at play in the international museum world. At *The Wall Street Journal,* Robert Messenger pushed me to think critically about the geo-politics of the art market. At *Vanity Fair,* David Friend supported a delightful foray into Alfred Barr's adventures in art and politics during the Cuban Revo-lution. And at *Book Post,* Ann Kjellberg allowed me to reconsider a number of crucial figures in the early-twentieth-century avant-garde.

I am incomparably fortunate to have had as a mentor the late Bob Silvers, who taught me how to write about politics and ideas in the pages of *The New York Review of Books* and who introduced me to many of the writers I admire most. I am grateful to Rea Hederman and Daniel Mendelsohn of the Robert B. Silvers Foundation for allowing me the honor of being among the inaugural recipients of the writer's grant established in his will.

Special acknowledgment goes to Emily Eakin, who connected me with my fantastic agents, David Kuhn and Nate Muscato; their enthusiasm and expert attention has been unwavering. I am also grateful to Becky Sweren, Erin Files, and other members of the remarkable Aevitas team for seeing the project through. To Andrew Blackwell I owe thanks for diagramming the story for me at a sushi restaurant—and making it look easy. Blake Gopnik provided invalu-able criticism and advice at a crucial stage.

The editorial team at Crown have energetically supported the project from the outset. In Libby Burton, I am lucky to have an exceptionally talented editor who not only embraced my manuscript but greatly improved it. Tim Duggan first recognized the importance of this story and gave me the chance to write it. Aubrey Martinson offered incisive input and kept the project rigorously on track. Loren Noveck provided expert production help. And the design team, Debbie Glasserman and Anna Kochman, came up with a particularly inspired layout and cover.

Finally, I owe more than I can say to friends and family. Antoine and Maya Schouman provided accommodations in Paris and Jessica Nash and Elmar Caspers offered me their house in the Netherlands. In New York, Susan and

Jesse Roth always managed to have an extraordinary feast ready. On the North Shore of Lake Superior, John Shepard and Suzanne Brust provided a pristine retreat in which to complete a difficult chapter. And in Georgian Bay, Mike Eakin and Janet Schumacher allowed me to finish the book on one of the most beautiful islands in the world. John and Sybil Eakin provided invaluable comments on numerous drafts; Marion Eakin listened to me tell and retell the story. As for EJ, LP, and AR, they know who they are. Without them, the radium would be gone.

Selected Bibliography

Assouline, Pierre. *An Artful Life: A Biography of D. H. Kahnweiler 1884–1979.* Translated by Charles Ruas. New York: Grove Weidenfeld, 1990.

Baldassari, Anne. *Picasso: Life with Dora Maar: Love and War, 1935–1945.* Paris: Flammarion, 2006.

Barr, Alfred H., Jr. *Picasso: Forty Years of His Art.* New York: The Museum of Modern Art, 1939.

———. *Picasso: Fifty Years of His Art.* New York: The Museum of Modern Art, 1946.

———. *Matisse: His Art and His Public.* New York: The Museum of Modern Art, 1951.

———. *What Is Modern Painting?* 9th ed. New York: The Museum of Modern Art, 1966.

———. *Paintings and Sculptures in the Museum of Modern Art, 1929–1967.* New York: The Museum of Modern Art, 1977.

———. *Defining Modern Art: Selected Writings of Alfred H. Barr, Jr.* Edited by Irving Sandler. New York: Harry N. Abrams, 1986.

Barr, Margaret Scolari. "'Our Campaigns': Alfred H. Barr, Jr., and the Museum of Modern Art: A Biographical Chronicle of the Years 1930–1944," *The New Criterion,* special issue (Summer 1987), 23–74.

Berger, John. *The Success and Failure of Picasso.* New York: Pantheon Books, 1989.

Bezzola, Tobias, ed. *Picasso by Picasso: His First Museum Exhibition 1932.* Munich, Berlin, London, and New York: Prestel, 2010.

Brassaï. *Picasso and Company*. Translated by Francis Price. New York: Doubleday, 1966.

Brown, Milton W. *The Story of the Armory Show*. New York: Abbeville Press, 1988.

Bullen, J. B., ed. *Post-Impressionists in England: The Critical Reception*. London and New York: Routledge, 1988.

Caizergues, Pierre, and Hélène Seckel, eds. *Picasso/Apollinaire: Correspondence*. Paris: Gallimard, 1992.

Chipp, Herschel B. *Picasso's "Guernica": History, Transformation, Meanings*. Berkeley: University of California Press, 1988.

Cowling, Elizabeth. *Visiting Picasso: The Notebooks and Letters of Roland Penrose*. New York: Thames and Hudson, 2006.

Cowling, Elizabeth, Anne Baldassari, et al. *Matisse Picasso*. New York: The Museum of Modern Art, 2002.

Craven, Thomas. *Modern Art: The Men, the Movements, the Meaning*. New York: Simon and Schuster, 1934.

Daix, Pierre. *Picasso: Life and Art*. Translated by Olivia Emmet. New York: HarperCollins, 1993.

Danchev, Alex. *Georges Braque: A Life*. New York: Arcade Publishing, 2012.

de Zayas, Marius. *How, When, and Why Modern Art Came to New York*. Edited by Francis M. Naumann. Cambridge, Mass.: MIT Press, 1996.

Duncan, Sally Ann, and Andrew McClellan. *The Art of Curating: Paul J. Sachs and the Museum Course at Harvard*. Los Angeles: Getty Research Institute, 2018.

Eksteins, Modris. *Solar Dance: Van Gogh, Forgery, and the Eclipse of Certainty*. Cambridge, Mass.: Harvard University Press, 2012.

Elderfield, John. *Modern Painting and Sculpture: 1880 to the Present at the Museum of Modern Art*. New York: The Museum of Modern Art, 2004.

———. "Alfred H. Barr, Jr.'s 'Matisse and His Public,' 1951." *Burlington Magazine*, vol. 152, no. 1282 (January 2010), 36–39.

Feliciano, Hector. *The Lost Museum: The Nazi Conspiracy to Steal the World's Greatest Works of Art*. Translated by Tim Bent. New York: Basic Books, 1997.

FitzGerald, Michael C. *Making Modernism: Picasso and the Creation of the Market for Twentieth-Century Art*. Berkeley: University of California Press, 1996.

———. *Picasso and American Art*. New Haven: Whitney Museum of American Art in association with Yale University Press, 2006.

Flam, Jack. *Matisse and Picasso: The Story of Their Rivalry and Friendship*. New York: Westview Press, 2003.

Force, Christel H., ed. *Pioneers of the Global Art Market: Paris-Based Dealers Networks, 1850–1950*. London: Bloomsbury, 2020.

Fralon, José-Alain. *A Good Man in Evil Times: The Story of Aristides de Sousa Mendes—The Man Who Saved Countless Refugees in World War II*. Translated by Peter Graham. New York: Carroll and Graf, 2001.

Gaddis, Eugene R. *Magician of the Modern: Chick Austin and the Transformation of the Arts in America*. New York: Alfred A. Knopf, 2000.

Gervereau, Laurent. *Autopsie d'un chef d'oeuvre: "Guernica."* Paris: Editions Paris-Méditerranée, 1996.

Green, Christopher, ed. *Picasso's "Les Demoiselles d'Avignon."* Cambridge, U.K.: Cambridge University Press, 2001.

Greenough, Sarah, ed. *Modern Art in America: Alfred Stieglitz and His New York Galleries*. Washington, D.C., and Boston: National Gallery of Art in association with Bulfinch Press, 2000.

Holroyd, Michael. *Augustus John: The New Biography*. New York: Farrar, Straus and Giroux, 1996.

Hook, Philip. *Rogues' Gallery: The Rise (and Occasional Fall) of Art Dealers, the Hidden Players in the History of Art*. New York: The Experiment, LLC, 2017.

John, Augustus. *Chiaroscuro: Fragments of Autobiography*. New York: Pellegrini and Cudahy, 1952.

Jones, Kimberly A., and Maygene Daniels. *The Chester Dale Collection*. Washington, D.C.: The National Gallery of Art, 2009.

Kahnweiler, Daniel-Henry, with Francis Crémieux. *My Galleries and Painters*. Translated by Helen Weaver. Boston: MFA Publications, 2003.

Kantor, Sybil Gordon. *Alfred H. Barr, Jr., and the Intellectual Origins of the Museum of Modern Art*. Cambridge, Mass.: MIT Press, 2002.

Kean, Beverly Whitney. *French Painters, Russian Collectors: The Merchant Patrons of Modern Art in Pre-Revolutionary Russia,* rev. ed. London: Hodder and Stoughton, 1994.

Kert, Bernice. *Abby Aldrich Rockefeller: The Woman in the Family*. New York: Random House, 1993.

Kushner, Marilyn Satin, and Kimberly Orcutt, eds. *The Armory Show at 100: Modernism and Revolution*. New York: New-York Historical Society, 2013.

Lake, Carlton, and Linda Ashton. *Henri-Pierre Roché: An Introduction*. Austin, Texas: Harry Ransom Humanities Research Center, 1991.

Londraville, Janis, ed. *On Poetry, Painting, and Politics: The Letters of May Morris and John Quinn*. Selinsgrove, Pa.: Susquehanna University Press, 1997.

Londraville, Richard, and Janis Londraville. *Dear Yeats, Dear Pound, Dear Ford: Jeanne Robert Foster and Her Circle of Friends*. Syracuse, N.Y.: Syracuse University Press, 2001.

———, eds. *Too Long a Sacrifice: The Letters of Maud Gonne and John Quinn*. Selinsgrove, Pa.: Susquehanna University Press, 1999.

Lynes, Russell. *Good Old Modern: An Intimate Portrait of the Museum of Modern Art*. New York: Atheneum, 1973.

Macdonald, Dwight. "Action on West Fifty-third Street." *The New Yorker,* December 12 and 19, 1953.

Madeline, Laurence, ed. *Correspondence: Pablo Picasso and Gertrude Stein*. Translated by Lorna Scott Fox. London: Seagull Books, 2008.

Marquis, Alice Goldfarb. *Alfred H. Barr, Jr.: Missionary for the Modern*. Chicago: Contemporary Books, 1989.

Mather, Frank Jewett, Jr. *Modern Painting*. New York: Henry Holt, 1927.

McBride, Henry. *An Eye on the Modern Century: Selected Letters of Henry McBride*. Edited by Steven Watson and Catherine J. Morris. New Haven: Yale University Press, 2000.

Monod-Fontaine, Isabelle, ed. *Daniel-Henry Kahnweiler: Marchand, éditeur, écrivain*. Paris: Centre Georges Pompidou, 1984.

Mumford, Lewis. *Mumford on Modern Art in the 1930s*. Edited by Robert Wojtowicz. Berkeley: University of California Press, 2007.

Nordau, Max. *Degeneration*. Translated from the second edition of the German work. New York: D. Appleton and Company, 1895.

O'Brian, Patrick. *Picasso: A Biography*. New York: W. W. Norton, 1994.

Olivier, Fernande. *Picasso and His Friends*. Translated by Jane Miller. New York: Appleton-Century, 1965.

Oppler, Ellen, ed. *Picasso's "Guernica."* New York: W. W. Norton, 1988.

Paul Rosenberg and Company: From France to America; Exhibition of Documents Selected from the Paul Rosenberg Archives. New York: Paul Rosenberg and Company, 2012.

Pemberton, Sally. *Portrait of Murdock Pemberton: The New Yorker's First Art Critic*. Enfield, N.H.: Enfield Publishing and Distribution Company, 2011.

Penrose, Roland. *Picasso: His Life and Work*. 3rd ed. Berkeley and Los Angeles: University of California Press, 1981.

Perlman, Bennard B. *The Lives, Loves, and Art of Arthur B. Davies*. Albany: State University of New York Press, 1998.

Philippot, Émilia, Joachim Pissarro, and Bernard Ruiz-Picasso. *Olga Picasso*. Paris: Gallimard, 2019.

Platt, Susan Noyes. *Art and Politics in the 1930s: Modernism, Marxism, Americanism*. New York: Midmarch Arts Press, 1999.

Pound, Ezra. *A Memoir of Gaudier-Brzeska*. New York: New Directions, 1970.

Reid, B. L. *The Man from New York: John Quinn and His Friends*. New York: Oxford University Press, 1968.

Reliquet, Scarlett, and Phillippe Reliquet. *Henri-Pierre Roché: L'Enchanteur collectionneur*. Paris: Éditions Ramsay, 1999.

Richardson, John. *A Life of Picasso*. Vol. 1, *The Early Years, 1881–1906*. New York: Random House, 1991.

———. *A Life of Picasso*. Vol. 2, *The Painter of Modern Life, 1906–1917*. New York: Random House, 1996.

———. *A Life of Picasso*. Vol. 3, *The Triumphant Years, 1917–1932*. New York: Alfred A. Knopf, 2007.

———. *A Life of Picasso*. Vol. 4, *The Minotaur Years, 1933–1943*. New York: Alfred A. Knopf, 2021.

Roché, Henri-Pierre. *Carnets: Les années Jules et Jim: première partie 1920–1921*. Marseille: André Dimanche Éditeur, 1990.

———. "Hommage à John Quinn, Collectionneur." *La Parisienne,* August–September 1954.

Roob, Rona. "Alfred H. Barr, Jr.: A Chronicle of the Years 1902–1929." *The New Criterion,* special issue (Summer 1987), 1–19.

Rubin, William, Hélène Seckel, and Judith Cousins. *"Les Demoiselles d'Avignon."* Studies in Modern Art 3. New York: The Museum of Modern Art, 1993.

Russell, John. *Matisse: Father and Son*. New York: Harry N. Abrams, 1999.

Saarinen, Aline B. *The Proud Possessors: The Lives, Times and Tastes of Some Adventurous American Art Collectors*. New York: Random House, 1958.

Sabartés, Jaime. *Picasso: An Intimate Portrait*. Translated by Angel Flores. New York: Prentice-Hall, 1948.

Saltzman, Cynthia. *Old Masters, New World: America's Raid on Europe's Great Pictures*. New York: Viking Penguin, 2008.

Semenova, Natalya, with André Delocque. *The Collector: The Story of Sergei Shchukin and His Lost Masterpieces*. Translated by Anthony Roberts. New Haven: Yale University Press, 2018.

Sinclair, Anne. *My Grandfather's Gallery: A Family Memoir of Art and War*. Translated by Shaun Whiteside. New York: Farrar, Straus and Giroux, 2014.

Spurling, Hilary. *Matisse the Master: A Life of Henri Matisse: The Conquest of Color*. New York: Alfred A. Knopf, 2005.

Stein, Gertrude. *The Autobiography of Alice B. Toklas*. New York: Harcourt, Brace and Company, 1933.

Tinterow, Gary, and Susan Alyson Stein, eds. *Picasso in the Metropolitan Museum of Art*. New York: The Metropolitan Museum of Art, 2010.

Tomkins, Calvin. *Merchants and Masterpieces: The Story of the Metropolitan Museum of Art*. New York: E. P. Dutton and Company, 1970.

Utley, Gertje R. *Picasso: The Communist Years*. New Haven: Yale University Press, 2000.

van Hensbergen, Gijs. *"Guernica": The Biography of a Twentieth-Century Icon*. New York and London: Bloomsbury, 2004.

Weber, Nicholas Fox. *Patron Saints: Five Rebels Who Opened America to New Art, 1928–1943*. New Haven: Yale University Press, 1992.

Whelan, Richard. *Alfred Stieglitz: A Biography*. New York: Little, Brown, 1995.

Wood, Beatrice. *I Shock Myself: The Autobiography of Beatrice Wood*. Edited by Lindsay Smith. San Francisco: Chronicle Books, 2006.

Zilczer, Judith. *"The Noble Buyer": John Quinn, Patron of the Avant-Garde*. Washington, D.C.: Smithsonian Institution Press, 1978.

Notes

Unless otherwise indicated in the notes:

Letters by John Quinn, and letters from Henri-Pierre Roché to John Quinn, are in the John Quinn Papers, Manuscripts, and Archives Division, The New York Public Library.

The diaries of Jeanne Robert Foster and the letters of Foster to Quinn are in the Foster-Murphy Collection, Manuscripts and Archives Division, The New York Public Library.

Letters from Paul Rosenberg to Picasso are in the Picasso Archives, Musée national Picasso, Paris.

The diaries of Henri-Pierre Roché are in the Carlton Lake Collection of French Manuscripts, Harry Ransom Center, The University of Texas at Austin.

Translations of Paul Rosenberg's letters to Picasso, Henri-Pierre Roché's diary entries, and other French texts are by the author.

ABBREVIATIONS OF ARCHIVES WHERE
ORIGINAL DOCUMENTS ARE LOCATED:

Archives Matisse: Archives Matisse, Issy-les-Moulineaux, France.

Getty Research Institute: Getty Research Institute, Los Angeles, California.

Harvard Art Museums Archives: Harvard Art Museums Archives, Harvard University, Cambridge, Massachusetts.

Harry Ransom Center: Harry Ransom Center, The University of Texas at Austin, Texas.

MoMA Archives: Museum of Modern Art Archives, Museum of Modern Art, New York.

Morgan Library: Department of Literary and Historical Manuscripts, The Morgan Library and Museum, New York.

PROLOGUE

1. Quinn to Roché, March 14, 1924.
2. Joseph Brummer knew Rousseau in Paris and had his portrait painted by him shortly before Rousseau's death.
3. Quinn to Gwen John, March 13, 1924.
4. Walter Pach reported Havemeyer's comments in Pach to Quinn, December 26, 1923, in Reid, *Man from New York*, 608.
5. Jeanne Robert Foster, interview by Richard Londraville, in Londraville, *Too Long a Sacrifice*, 213.
6. Quinn to John, March 13, 1924.

1. NOT IN AMERICA

1. Quinn to James Huneker, May 30, 1911.
2. Arthur Hoeber, "Art and Artists," *Globe and Commercial Advertiser*, April 21, 1911, in Marilyn McCully, ed., *A Picasso Anthology: Documents, Criticism, Reminiscences* (Princeton, N.J.: Princeton University Press, 1997), 79–80.
3. Edward Steichen to Alfred Stieglitz, undated, 1911, in Charles Brock, "Pablo Picasso, 1911: An Intellectual Cocktail," in Greenough, *Modern Art in America*, 118.
4. Quinn to Gwen John, January 5, 1911.
5. Bullen, *Post-Impressionists in England*, 100.
6. George Russell to Quinn, December 7, 1910, in Reid, *Man from New York*, 95.
7. Quinn to George Russell, February 7, 1911.
8. Quinn to Augustus John, February 3, 1911.
9. Quinn to Augustus John, February 3, 1911.
10. One of Quinn's few known encounters with French modern art before 1911 was a pair of Manets he saw in Dublin in 1902. Reid, *Man from New York*, 29. In spring 1911, Quinn also writes that he has seen works by Cézanne and "one or two" Van Goghs. Quinn to George Russell, March 5, 1911.
11. May Morris to Quinn, April 5, 1911, in Londraville, *On Poetry, Painting, and Politics*, 82.

12. Quinn to Townsend Walsh, December 9, 1910.

13. Quinn's early biography is recounted in Reid, *Man from New York,* 4–6.

14. Francis Hackett to Quinn, August 16, 1907, in Reid, *Man from New York,* 49.

15. Brock, "Pablo Picasso," 121.

16. Quinn to Huneker, May 30, 1911.

17. Lisa Mintz Messinger, ed., *Stieglitz and His Artists: Matisse to O'Keeffe* (New York: Metropolitan Museum of Art, 2011), 50.

18. Alfred Stieglitz to Edward Alden Jewell, December 19, 1939, in Greenough, *Modern Art in America,* 499n50.

2. THE HALF-LIFE OF A PAINTING

1. John Sloan to Quinn, August 16, 1910, in Reid, *Man from New York,* 88.

2. John Butler Yeats to Quinn, October 23, 1902, in Reid, *Man from New York,* 11.

3. Quinn to T. W. Rolleston, March 8, 1912, in Reid, *Man from New York,* 118.

4. Mike Wallace, *Greater Gotham: A History of New York City from 1898 to 1919* (New York: Oxford University Press, 2017), 344.

5. Ezra Pound to Quinn, March 9, 1915, in Timothy Materer, ed., *The Selected Letters of Ezra Pound to John Quinn, 1915–1924* (Durham and London: Duke University Press, 1991), 20. American collectors had been buying Impressionist paintings since the late nineteenth century, but as late as 1907, Roger Fry's purchase of a Renoir caused controversy at the Metropolitan Museum and for the most part the post-Impressionists were shunned.

6. Henry James, *The American Scene* (New York and London: Harper and Brothers Publishers, 1907), 186.

7. Quinn to Augustus John, February 10, 1913; Quinn to Judge Learned Hand, July 29, 1913.

8. Quinn to Townsend Walsh, September 3, 1909, in Reid, *Man from New York,* 74.

9. Quinn to Judge Learned Hand, July 29, 1913.

10. Quinn to John Butler Yeats, March 22, 1911.

3. PARIS, EAST

1. By 1914, both painters had begun signing the front of their canvases again. William Rubin, *Picasso and Braque: Pioneering Cubism* (New York: Museum of Modern Art, 1989), 19.

2. Marius de Zayas to Alfred Stieglitz, July 10, 1911, in de Zayas, *How, When, and Why Modern Art Came to New York,* 164–65.

3. Penrose, *Picasso: His Life and Work,* 146; Richardson, *Life of Picasso: Painter of Modern Life,* 228.

4. Richardson, *Life of Picasso: Early Years,* 400.

5. O'Brian, *Picasso,* 66. Alfred H. Barr, Jr., described Leo Stein's limited influence with devastating precision: "For the two brief years between 1905 and 1907 he was possibly the most discerning connoisseur and collector of 20th-century painting in the world." Barr, *Matisse: His Art and His Public,* 57.

6. Richardson, *Life of Picasso: Painter of Modern Life,* 35.

7. Kahnweiler, *My Galleries and Painters,* 24.

8. Kahnweiler, *My Galleries and Painters,* 27.

9. Daniel-Henry Kahnweiler, 1969 interview by Pierre Cabanne, in Georges Bernier and Pierre Cabanne, *D.-H. Kahnweiler: Marchand et critique* (Paris: Nouvelles Éditions Séguier, 1996), 34.

10. Kahnweiler learned of the painting from the German connoisseur Wilhelm Uhde in May 1907. His visit to rue Ravignan took place some weeks after July 1. Monod-Fontaine, *Daniel-Henry Kahnweiler,* 97.

11. Kahnweiler, *My Galleries and Painters,* 38.

12. Richardson, *Life of Picasso: Painter of Modern Life,* 34.

13. Kahnweiler, *My Galleries and Painters,* 38.

14. Richardson, *Life of Picasso: Painter of Modern Life,* 34.

15. Kahnweiler, "Der Kubismus," 1916, in Rubin et al., *"Les Demoiselles d'Avignon,"* 234.

16. Richardson, *Life of Picasso: Early Years,* 352–54.

17. Olivier, *Picasso and His Friends,* 96.

18. Kahnweiler, *My Galleries and Painters,* 36.

19. Kahnweiler, *My Galleries and Painters,* 29.

20. Semenova, *The Collector,* 202.

21. Kean, *French Painters, Russian Collectors,* 205.

22. Richardson, *Life of Picasso: Painter of Modern Life,* 317.

23. Richardson, *Life of Picasso: Painter of Modern Life,* 299; FitzGerald, *Making Modernism,* 41.

24. Richardson, *Life of Picasso: Painter of Modern Life,* 324.

25. Olivier, *Picasso and His Friends,* 151. A rare exception was Hamilton Easter Field, a wealthy expatriate Brooklynite who commissioned Picasso to make a series of large-scale Cubist paintings for his library in Brooklyn Heights. But Field quickly cooled on the whole idea, and Picasso, who

worked on the project on and off for more than two years, never received any payment for his efforts and eventually destroyed one of the giant canvases he had made for it. Rubin, "Appendix: The Library of Hamilton Easter Field," in *Picasso and Braque,* 63–69.

4. FRENCH LESSONS

1. Holroyd, *Augustus John,* 344.
2. Holroyd, *Augustus John,* 378.
3. Reid, *Man from New York,* 105.
4. Holroyd, *Augustus John,* 378.
5. Reid, *Man from New York,* 106–08.
6. Holroyd, *Augustus John,* 379–80.
7. Quinn to John Sloan, undated [November 1912]; Quinn to Augustus John, December 7, 1912.
8. Quinn to Augustus John, December 7, 1912.
9. Though it has been largely forgotten today, the original aim of the Armory Show was to exhibit new American, not European, avant-garde art. Meyer Schapiro, "Rebellion in Art," in Daniel Aaron, ed., *America in Crisis: Fourteen Crucial Episodes in American History* (New York: Alfred A. Knopf, 1952), 203–04.
10. Martin Birnbaum to Quinn, July 1912, in Zilczer, *"Noble Buyer,"* 26. Davies obtained the catalog from Birnbaum after Birnbaum's return to New York. Perlman, *Lives, Loves, and Art of Arthur B. Davies,* 212. Kuhn recalled Davies's comment in Walt Kuhn, *The Story of the Armory Show* (New York: W. Kuhn, 1938), 8.
11. Reid, *Man from New York,* 133.
12. Quinn to Jack Yeats, December 21, 1912.
13. Walt Kuhn to Walter Pach, December 12, 1912, in Brown, *Armory Show,* 78; Quinn to John, December 7, 1912.
14. Quinn to William Marchant, December 9, 1912; John Quinn, "Modern Art from a Layman's Point of View," *Arts and Decoration,* vol. 3, no. 5 (March 1913), 155–58.
15. Quinn to John, December 7, 1912.

5. A GLIMPSE OF THE LADY

1. Brown, *Armory Show,* 157.
2. Quinn, introductory speech, February 17, 1913, in Brown, *Armory Show,* 43–44. For the warning about Quinn's reputation with women, see Londraville, *Dear Yeats, Dear Pound,* 136.

3. Foster's review of the Armory Show is Jeanne Robert Foster, "Art Revolutionists on Exhibition in America," *American Review of Reviews,* April 1913; the "hard-boiled egg" quote is in Brown, *Armory Show,* 139.

4. Jeanne Robert Foster, interview by B. L. Reid, in Reid, *Man from New York,* 148.

5. The details of Foster's biography are in Londraville, *Dear Yeats, Dear Pound,* 18, 23–25.

6. Foster, "Character Sketch of Charles Copeland," unpublished typescript [1906]; Charles Copeland to Foster, February 9, 1906, in Londraville, *Dear Yeats, Dear Pound,* 32–33.

7. John Butler Yeats to Foster, February 26, 1921, and John Butler Yeats to W. B. Yeats, May 10, 1914, in Londraville, *Dear Yeats, Dear Pound,* 66–67, 73.

8. Brown, *Armory Show,* 145.

9. Brown, *Armory Show,* 235. The heroic account of the show was first written by the participants themselves, including Walt Kuhn in his 1938 memoir, *The Story of the Armory Show.*

10. Quinn to Joseph Conrad, March 30, 1913. Quinn's burlesque toast at the Armory is recorded in Walter Pach, *Queer Thing, Painting* (New York: Harper and Brothers, 1938), 203.

11. Avis Berman, "'Creating a New Epoch': American Collectors and Dealers and the Armory Show," in Kushner and Orcutt, *The Armory Show at 100,* 417, 422.

12. "Cubists of All Sorts," *New York Times,* March 16, 1913.

13. Quinn to Walter Pach, April 2, 1913.

14. Flam, *Matisse and Picasso,* 37.

15. Quinn to Jacob Epstein, April 28, 1913.

16. Meyer Schapiro, "Rebellion in Art," in Daniel Aaron, ed., *America in Crisis: Fourteen Crucial Episodes in American History* (New York: Alfred A. Knopf, 1952), 204.

17. Frederick James Gregg, "The World's New Art Centre," *Vanity Fair,* January 1915.

18. One outsider who did buy significantly from the show was Arthur Jerome Eddy, a Chicago lawyer and collector, who was the second-largest private buyer (after Quinn) and acquired works by Picabia, Duchamp, and Derain. Brown, *Armory Show,* 122–24.

19. Quinn to George Russell, March 2, 1913.

20. Brown, *Armory Show,* 183.

21. Foster, "Art Revolutionists on Exhibition in America."

6. CUBISM IN CONGRESS

1. Quinn to Maud Gonne, April 12, 1914.
2. Quinn to James Huneker, February 4, 1913.
3. Quinn to Augustus John, January 19, 1913; "Mr. Morgan's Art Objects," *New York Times,* March 14, 1903; Robert May, "Culture Wars: The U.S. Art Lobby and Congressional Tariff Legislation During the Gilded Age and Progressive Era," *Journal of the Gilded Age and Progressive Era,* vol. 9, no. 1 (January 2010), 77.
4. Quinn to Arthur Brisbane, June 30, 1913.
5. Whelan, *Alfred Stieglitz,* 289.
6. Quinn to John Kewstub, February 1911.
7. Quinn to John, January 19, 1913.
8. Chairman Oscar Underwood, tariff hearings, January 29, 1913, in John Quinn, "Memorandum in Regard to the Art Provisions of the Pending Tariff Bill," submitted to the Senate Finance Committee, June 1913.
9. May, "Culture Wars," 84; Quinn to Brisbane, June 30, 1913; Quinn, "Memorandum," 13.
10. Quinn to Senator James O'Gorman, June 27, 1913.
11. Quinn to President Woodrow Wilson, September 13, 1913.
12. Quinn to May Morris, December 16, 1913, in Londraville, *On Poetry, Painting, and Politics,* 140; Quinn to John Johnson, October 2, 1913.
13. Quinn, "Memorandum," 19.
14. Quinn to Judge Learned Hand, July 1913.
15. Quinn to John Cotton Dana, January 26, 1914.
16. Alice Thursby to Quinn, quoted in Quinn to Walter Pach, February 17, 1914.
17. Quinn to Mary Harriman Rumsey, December 22, 1913.
18. Joseph Conrad to Quinn, August 17, 1913, in Reid, *Man from New York,* 167.
19. Quinn to Alice Thursby, February 17, 1914.

7. THE CHESS PLAYER AND THE SHOWMAN

1. Seymour de Ricci, "La 'Peau de l'Ours,'" *Gil Blas,* March 3, 1914.
2. Joachim Gasquet, "La bataille autour de la 'Peau de l'Ours,'" *Paris-Midi,* March 3, 1914.
3. Daniel-Henry Kahnweiler, 1955 interview by Georges Bernier, in Bernier and Cabanne, *D.-H. Kahnweiler,* 23; Kahnweiler, *My Galleries and Painters,* 45.

4. Kahnweiler sold Picasso's *Young Acrobat on a Ball* (1905) to Ivan Morosov in October 1913. To the Armory, Kahnweiler sent *Woman with a Mustard Pot* (1910) for $675; *Head of a Man* (1912) for $486; and the early Blue period masterpiece *Madame Soler* (1903) for $1,350. Brown, *Armory Show,* 301–02.

5. Louis Vauxcelles, "Les Arts: Exposition Toulouse-Lautrec," *Gil Blas,* January 25, 1914.

6. André Gybal, "Toulouse-Lautrec," *Les Hommes du jour,* February 21, 1914.

7. Rosenberg, "Autobiographical Notes," in *Paul Rosenberg and Company,* 131.

8. Ephrussi's friendship with Proust is discussed in Edmund de Waal, *The Hare with Amber Eyes: A Family's Century of Art and Loss* (New York: Farrar, Straus and Giroux, 2010), 75–76.

9. In his memoir, Rosenberg recalls that his father bought *Bedroom* (1889) when they attended Émile Bernard's 1892 Van Gogh exhibition, but since that work was not shown there, it seems more likely that he acquired it from Ambroise Vollard's 1895 exhibition, where it did appear. The work is now in the collection of the Art Institute of Chicago. Rosenberg, "Autobiographical Notes," 128–30.

10. Julie Manet recorded Renoir's comments during her visit to his studio two days after the January 13, 1898, publication of "J'accuse! . . . ," which had created a national uproar. Renoir was still complaining about Zola when she saw him again the following week. Julie Manet, diary, January 15 and January 20, 1898, in Jane Roberts, ed. and trans., *Growing Up with the Impressionists: The Diary of Julie Manet* (London: Sotheby's Publications, 1987), 124–26.

11. Rosenberg made a brief written account of his final meeting with Renoir, two weeks before the artist's death, and of Renoir's funeral. Rosenberg, "My Two Visits to Renoir's Home," in *Paul Rosenberg and Company,* 137–40.

12. Rosenberg, "Autobiographical Notes," 134.

13. Kahnweiler, *My Galleries and Painters,* 32.

14. A typescript draft of Rosenberg's manifesto has survived. Rosenberg, "Letter Draft," undated [early 1914], in *Paul Rosenberg and Company,* 22–23. For Kahnweiler's comment about Rosenberg, see Hook, *Rogues' Gallery,* 159.

8. END OF AN IDYLL

1. Foster, diary, August 5–6, 1914, in Londraville, *Dear Yeats, Dear Pound,* 55.

2. Foster, diary, August 15, 1914, in Londraville, *Dear Yeats, Dear Pound,* 55–56.

3. Richardson, *Life of Picasso: Painter of Modern Life,* 341.

4. Danchev, *Braque,* 116.

5. Kahnweiler, *My Galleries and Painters,* 41.

6. Picasso to Kahnweiler, June 12, 1912, in William Rubin, *Picasso and Braque: Pioneering Cubism* (New York: Museum of Modern Art, 1989), 394–95.

7. Stein, *Autobiography of Alice B. Toklas,* 136.

8. Stein to Mabel Dodge Luhan, December 1912, in Richardson, *Life of Picasso: Painter of Modern Life,* 271.

9. Eva Gouel to Stein, November 10, 1914, in Madeline, *Correspondence: Picasso and Stein,* 169.

10. Eva Gouel to Stein, June 23, 1914, and Gouel and Picasso to Stein, June 25, 1914, in Madeline, *Correspondence: Picasso and Stein,* 145–47.

11. Braque to Kahnweiler, July 15, 1914, in Rubin, *Picasso and Braque,* 429.

12. Picasso to Kahnweiler, July 21, 1914, in Daix, *Picasso: Life and Art,* 138.

13. Braque to Kahnweiler, August 1, 1914, in Rubin, *Picasso and Braque,* 430.

14. "We went up to Paris before the call up . . . just for a few hours to put my affairs in order," Picasso wrote to Stein on August 8, 1914. According to John Richardson, Picasso and Eva made the trip on July 30 or 31, in which case he would have learned of the imminent mobilization before Braque. Richardson, *Life of Picasso: Painter of Modern Life,* 344.

15. O'Brian, *Picasso,* 207.

16. Picasso and Eva Gouel to Stein, October 6, 1914, in Madeline, *Correspondence: Picasso and Stein,* 162.

17. Picasso to Stein, September 11, 1914, in Madeline, *Correspondence: Picasso and Stein,* 159.

18. Assouline, *Artful Life,* 114–15.

19. Richardson, *Life of Picasso: Painter of Modern Life,* 346.

20. Assouline, *Artful Life,* 114.

21. Daniel-Henry Kahnweiler, 1961–62 interview by Paule Chavasse, "Le cubisme et son temps—la guerre," one of six broadcasts for France III, INA (Institut national de l'audiovisuel) archives, www.ina.fr.

22. Kahnweiler, *My Galleries and Painters,* 35.

23. Richardson, *Life of Picasso: Painter of Modern Life,* 344.

24. Along with Arthur Davies, who bought the Picasso watercolor, John Quinn was one of the very few buyers of a Kahnweiler work at the Armory Show, acquiring Derain's 1912 *Window at Vers* for $486. Notably, none of the six Picasso and Braque oil paintings Kahnweiler sent found buyers. Brown, *Armory Show,* 250, 262, 301–02.

25. Assouline, *Artful Life,* 117.

26. Richardson, *Life of Picasso: Painter of Modern Life,* 346.

27. Kahnweiler, *My Galleries and Painters,* 50.

9. THE GRAND ILLUSION

1. Henry McBride, "Cubistic Water Colors and Drawings Attract Many Visitors to Carroll Galleries," New York *Sun,* December 14, 1914.

2. Frederick James Gregg, "The World's New Art Centre," *Vanity Fair,* January 1915.

3. Henry McBride, "Arthur B. Davies and Cubism," New York *Sun,* November 2, 1913.

4. Quinn to Walter Pach, August 30, 1915.

5. Vérane Tasseau, "Daniel-Henry Kahnweiler's International Partnerships," in Force, *Pioneers of the Global Art Market,* 81.

6. Judith K. Zilczer, "Robert J. Coady, Forgotten Spokesman for Avant-Garde Culture in America," *American Art Review,* vol. 2, no. 6 (November–December 1975), 81.

7. Reid, *Man from New York,* 207.

8. De Zayas, *How, When, and Why Modern Art Came to New York,* 93–94.

9. Stieglitz also claimed that declines in the stock market were hurting sales. Pepe Karmel, "Pablo Picasso and Georges Braque, 1914–1915," in Greenough, *Modern Art in America,* 193.

10. *Third Exhibition of Contemporary French Art* (New York: Carroll Galleries, 1915), 10.

11. Henry McBride, "What Is Happening in the World of Art," New York *Sun,* March 14, 1915.

12. Frederick James Gregg, "A Note on Pablo Picasso," in *Third Exhibition of Contemporary French Art,* 14.

13. McBride, "Cubistic Water Colors."

14. Quinn to James Huneker, April 3, 1915.

15. Reid, *Man from New York,* 207.

16. Quinn to C. K. Butler, September 3, 1914.

17. Quinn to Harriet Bryant, October 6, 1914.

18. Quinn to Walt Kuhn, November 17, 1914.

19. *First Exhibition of Works by Contemporary French Artists* (New York: Carroll Galleries, 1914), 2.

20. See Quinn to Harriet Bryant, February 19, 1915; Quinn to John Butler Yeats, February 20, 1915; and Quinn to Walt Kuhn, August 30, 1915.

21. Quinn to Walter Pach, August 24, 1915, in Reid, *Man from New York,* 208.

22. Quinn bought Picasso's *Nudes in a Forest (Study for "Three Women")* (1908) from Stieglitz in July 1908. Judith Zilczer, "Alfred Stieglitz and John Quinn: Allies in the American Avant-Garde," *American Art Journal,* vol. 17, no. 3 (Summer 1985), 21.

23. Quinn to Ambroise Vollard, August 11, 1915.

24. Quinn to Roché, March 24, 1923.

25. Quinn to Mrs. James Byrne, March 26, 1915.

26. Quinn to Jacob Epstein, July 31, 1915, in Reid, *Man from New York,* 209.

27. Quinn to Vollard, August 11, 1915.

28. Quinn to Gordon Craig, August 10, 1915.

29. Quinn to Lady Gregory, April 27, 1915.

30. Reid, *Man from New York,* 214.

31. Unsigned introduction to *Third Exhibition of Contemporary French Art,* 13. Quinn was closely involved with the catalog and likely supervised this text.

10. CUBISTS AT WAR

1. Juan Gris to Kahnweiler, August 1, 1914, in Richardson, *Life of Picasso: Painter of Modern Life,* 344.

2. Richardson, *Life of Picasso: Painter of Modern Life,* 235–46.

3. Richardson, *Life of Picasso: Painter of Modern Life,* 277.

4. Eva Gouel to Stein, October 6, 1914, and Picasso to Stein, October 19, 1914, in Madeline, *Correspondence: Picasso and Stein,* 162–64.

5. Claire Maingon, *Le Musée invisible: Le Louvre et la grande guerre (1914–1921)* (Paris: Musée du Louvre Éditions, 2016), 48, 62–63.

6. Assouline, *Artful Life,* 117.

7. Daniela L. Caglioti, "Property Rights in Time of War: Sequestration and Liquidation of Enemy Aliens' Assets in Western Europe During the First World War," *Journal of Modern European History,* vol. 12, no. 4 (2014), 525.

8. Quinn had advised the U.S. Senate on the Trading with the Enemy Act, which was signed into law in October 1917. Reid, *Man from New York,* 322. By the end of the war, the United States had seized more than $470 million in property belonging to Germany and its allies. "The Disposal of Alien Property," in *Editorial Research Reports,* vol. 3 (Washington, D.C.: CQ Press, 1925), 540.

9. Kahnweiler, *My Galleries and Painters,* 50.

10. Vérane Tasseau, "Les Ventes de séquestre du marchand Daniel-Henry Kahnweiler (1921–1923)," *Archives juives,* vol. 50, no. 1 (2017), 27.

11. Olivier, *Picasso and His Friends,* 119.

12. Picasso to Guillaume Apollinaire, December 22 and 31, 1914, in Caizergues and Seckel, *Picasso/Apollinaire*, 122–25.

13. Picasso to Apollinaire, April 24, 1915, in Caizergues and Seckel, *Picasso/ Apollinaire*, 133. On Doucet, see Madeline, *Correspondence: Picasso and Stein*, 169n3.

14. Danchev, *Braque*, 125.

15. Picasso to Roché, May 24[?], 1915, in Danchev, *Braque*, 127.

16. Quinn to Alice Thursby, November 11, 1914.

17. Maud Gonne to Quinn, January 7 and April 22, 1915, in Londraville, *Too Long a Sacrifice*, 146–49; Gonne to Quinn, May 4, 1915, in Reid, *Man from New York*, 217.

18. Quinn to Gonne, June 8, 1915, in Londraville, *Too Long a Sacrifice*, 149.

19. Henri Gaudier-Brzeska to Ezra Pound, June 3, 1915, in Pound, *Memoir of Gaudier-Brzeska*, 63–64.

20. According to Gertrude Stein, Picasso said, "C'est nous qui a fait ça." Stein, *Autobiography of Alice B. Toklas*, 110.

21. Jean Paulhan, *Braque le patron* (Paris: Gallimard, 1986), 134, quoted in Caizergues and Seckel, *Picasso/Apollinaire*, 128n4.

22. Picasso to Apollinaire, February 7, 1915, in Caizergues and Seckel, *Picasso/Apollinaire*, 128–29.

23. André Dunoyer de Segonzac to Quinn, March 21, 1918.

24. Quinn to Segonzac, January 17, 1916.

25. Franz Marc to Maria Marc, February 6, 1916, in *Briefe aus dem Feld 1914– 1916* (Berlin: Rembrandt-Verlag, 1959), 141–42.

26. Klee's efforts later inspired an absurdist short story by Donald Barthelme in which one of his camouflaged warplanes mysteriously vanishes from a transport train. Klee resolves the problem by "repainting" the shipping manifest. Donald Barthelme, "Engineer-Private Paul Klee Misplaces an Aircraft Between Milbertshofen and Cambrai, March 1916," *New Yorker*, April 3, 1971.

27. Picasso to Apollinaire, February 7, 1915, in Caizergues and Seckel, *Picasso/Apollinaire*, 128–29.

28. Richardson has likened the drawing to Mantegna's *Dead Christ*. Richardson, *Life of Picasso: Painter of Modern Life*, 375.

29. Picasso to Stein, January 8, 1916, in Madeline, *Correspondence: Picasso and Stein*, 180.

30. O'Brian, *Picasso*, 215.

31. Jacques Doucet to Roché, undated [1916], in Richardson, *Life of Picasso: Painter of Modern Life*, 399.

32. Quinn to James Huneker, April 6, 1916.

11. A NEW BEGINNING

1. Foster to William M. Murphy, March 27, 1968, in Londraville, *Dear Yeats, Dear Pound,* 136.

2. Quinn to John Butler Yeats, November 23, 1918.

3. Londraville, *Dear Yeats, Dear Pound,* 137.

4. The book had been prepared for the Irish Convention, an assembly convened in Dublin in 1917–18 in an ultimately unsuccessful attempt to reach a constitutional settlement for Ireland. Reid, *Man from New York,* 330, 358–59.

5. Ezra Pound to Quinn, February 19, 1918.

6. Alfred Knopf to Quinn, August 17, 1917, in Reid, *Man from New York,* 279.

7. Standish O'Grady to Quinn, October 10, 1917, in Reid, *Man from New York,* 271.

8. Quinn to T. W. Rolleston, September 15, 1918.

9. Quinn to Joseph Conrad, February 18, 1918, in Reid, *Man from New York,* 335.

10. Quinn to John Butler Yeats, March 5, 1917.

11. Londraville, *Dear Yeats, Dear Pound,* 74.

12. Foster to Quinn, February 16, 1920.

13. Foster to Quinn, August 16, 1921.

14. Foster to Quinn, October 4, 1920.

15. Quinn to Foster, undated, and Foster to Quinn, undated [summer 1921?], in Londraville, *Dear Yeats, Dear Pound,* 140–42.

16. Quinn to James Huneker, April 6, 1916.

17. Quinn to André Dunoyer de Segonzac, April 29, 1919.

18. Quinn to Oscar Underwood, August 6, 1914.

19. In a retrospective account, written thirty-five years later, Roché suggests that the lunch took place the day after his first meeting with Quinn in the spring of 1917. Roché, "Hommage à John Quinn," 965–66. But Roché's diaries and Quinn's letters make clear that it occurred in September 1919. Roché, diary, September 7, 1919.

20. With Roché as an intermediary, Picasso sold Doucet a small still life and a Cubist Harlequin for 4,000 francs. Roché, diary, August 4, 1916.

21. Stein, *Autobiography of Alice B. Toklas,* 54.

22. Roché, diary, September 13, 1919.

23. Stein, "Roché by Gertrude Stein," March 1911, in Lake and Ashton, *Henri-Pierre Roché,* 28.

24. Henri-Pierre Roché, *Deux Semaines a la Conciergerie pendant la bataille de la Marne* (Paris: Attinger Frères, 1916), 64.

25. Roché, "Hommage à John Quinn," 966.

26. Quinn to Roché, September 17, 1919.

27. Roché to Quinn, September 18, 1919.

28. Jeanne Robert Foster, interview by Richard Londraville, in Londraville, *Too Long a Sacrifice,* 296n1.

29. Quinn to Roché, September 17, 1919.

12. DO I KNOW THIS MAN?

1. Céleste Albaret, *Monsieur Proust*, trans. Barbara Bray (New York: New York Review Books Classics, 2003), 77.

2. Richardson, *Life of Picasso: Triumphant Years,* 297.

3. "Lettres & Arts," *Le Cri de Paris,* July 23, 1916, in Rubin et al., *"Les Demoiselles d'Avignon,"* 168.

4. Georges Martin, "Dans l'Air de Paris," *L'Intransigeant,* October 29, 1919.

5. Richardson, *Life of Picasso: Painter of Modern Life,* 379.

6. Gertrude Stein records Braque saying, with dry irony, "Je dois connaître ce monsieur" [I ought to know this gentleman]. Stein, *Autobiography of Alice B. Toklas,* 238.

7. See, for example, Daix, *Picasso: Life and Art,* 161.

8. Rosenberg to Picasso, undated [summer 1918].

9. Irène Lagut, unpublished 1973 interview, in Richardson, *Life of Picasso: Painter of Modern Life,* 402.

10. O'Brian, *Picasso,* 215.

11. Richardson, *Life of Picasso: Triumphant Years,* 173.

12. Picasso to Apollinaire, August 16, 1918, in Caizergues and Seckel, *Picasso/ Apollinaire,* 176.

13. Rosenberg to Picasso, September 27, 1918.

14. The story was recalled years later by Matisse's daughter, Marguerite Duthuit. Matisse and Shchukin had had an awkward meeting in Nice in 1919, but Shchukin told him he was no longer in a position to buy and soon after broke off contact. Semenova, *The Collector,* 234–35.

15. Elaine Rosenberg, interview with the author, September 2016.

16. Rosenberg to Picasso, April 7, 1919.

17. Picasso's comment to Léonce Rosenberg is recorded in Léonce Rosenberg to Picasso, December 2, 1918, in FitzGerald, *Making Modernism,* 3.

18. Thomas Chaineux, "Olga Picasso: Between France and Russia," in Philippot et al., *Olga Picasso,* 105–09.

19. By 1920, the number of art museums in the United States had more than

doubled in fifteen years, to ninety-two. Tomkins, *Merchants and Master-pieces,* 192.

20. Rosenberg to Picasso, July 13, August 12, and August 27, 1920.

21. Richardson, *Life of Picasso: Triumphant Years,* 166–67.

22. Roché to Rosenberg, September 28, 1920, Morgan Library.

13. IN PICASSO'S GARDEN

1. Roché to Quinn, June 6, 1921.

2. Roché, diary, July 5, 1921, in Roché, *Carnets,* 275.

3. Roché to Quinn, December 2, 1920.

4. Roché, diary, November 13, 1920, in Roché, *Carnets,* 104.

5. Roché, diary, July 5, 1921, in Roché, *Carnets,* 275.

6. Foster to Quinn, October 4, 1920.

7. Foster, diary, July 10, 1921.

8. Roché, diary, July 7, 1921, in Roché, *Carnets,* 276.

9. Quinn to Lady Gregory, May 11, 1922.

10. Foster, diary, July 29, 1921; Roché, diary, July 29, 1921, in Roché, *Carnets,* 295.

11. Foster, diary, July 9, 1921.

12. Foster, diary, July 9, 1921. Olga Picasso took part in the first American tour of the Ballets Russes, which stopped in seventeen U.S. cities between January and April 1916. Thomas Chaineux, email to author, February 10, 2022.

13. *Two Nudes,* in particular, provided an uncanny complement to a much earlier *Two Nudes* that Quinn had bought from Vollard during the war. In the earlier picture, the figures are sculpted, yet seem to be merging with the picture plane; in the later one, the figures are compressed into a visual space that seems unable to contain them. Together, the paintings bookend Picasso's crucial journey into, and then out of and beyond, Cubism.

14. Roché to Quinn, February 11, 1922.

15. Roché to Quinn, January 8, 1922; Quinn to Roché, January 27, 1922.

16. Matisse, *The Artist and His Model* (1919) currently in a private collection.

17. Roché to Quinn, October 20, 1920.

18. Quinn recalled the conversation in Quinn to Rosenberg, May 25, 1922.

19. Kahnweiler to Picasso, February 10, 1920, in Richardson, *Life of Picasso: Painter of Modern Life,* 358.

20. Vérane Tasseau, "Les Ventes de séquestre du marchand Daniel-Henry Kahnweiler (1921–1923)," *Archives juives,* vol. 50, no. 1 (2017), 32.

21. Assouline, *Artful Life,* 174.

22. Assouline, *Artful Life,* 168–69.

23. Roché to Quinn, December 25, 1920.

24. Roché, diary, July 22, 1921, in Roché, *Carnets,* 290.

25. Quinn to Kahnweiler, November 29, 1921.

26. Roché, diary, July 7, 1921, in Roché, *Carnets,* 276–77.

27. Roché, diary, August 12, 1921, in Roché, *Carnets,* 305.

28. Foster, diary, July 10, 1921.

29. Roché, diary, August 15, 1921, in Roché, *Carnets,* 307.

30. Quinn to Maud Gonne, August 29, 1921.

31. Roché, diary, August 15, 1921, in Roché, *Carnets,* 307.

32. Quinn to Gwen John, August 29, 1921.

14. KU KLUX CRITICISM

1. The case was Stoehr v. Wallace 255 U.S. 239 (1921), in which Quinn defended the constitutionality of the government sale of seized enemy assets. Quinn complained that despite his Supreme Court victory, the government reduced his fee by $19,000. Quinn to Walther Halvorsen, November 17, 1921.

2. Quinn to Margaret Anderson, October 19, 1921.

3. Quinn to Bryson Burroughs, March 24, 1921, in Gary Tinterow, "Picasso in the Metropolitan Museum of Art," in Tinterow and Stein, *Picasso in the Metropolitan Museum of Art,* 5–6.

4. Quinn to Ezra Pound, May 7, 1921.

5. "1,500 See French Pictures: Work of Impressionist Painters a Surprise to Many Visitors," *New York Times,* May 3, 1921; Augusta Owen Patterson, "Arts and Decoration," *Town and Country,* June 1921, 30–32; "The Metropolitan French Show," *The Arts,* April–May 1921, 2.

6. Forbes Watson, "Institutional Versus Individual Collectors: A Polite Plea for the Abolition of the Committee Rule," *Arts and Decoration,* February 1921, 340.

7. "A Protest Against the Present Exhibition of Degenerate 'Modernistic' Works in the Metropolitan Museum of Art," undated pamphlet [September 1921].

8. Quinn to John Butler Yeats, September 9, 1921, in Reid, *Man from New York,* 507.

9. "Pennell Enters Into Art War Here; Etcher Calls Post-Impressionist Exhibit at the Museum Dangerous," *New York Times,* September 8, 1921; "Pennell Criticizes Post Impressionist Works as Rubbish," *New York Herald,* September 8, 1921.

10. Johannes Hendrikus Burgers, "Max Nordau, Madison Grant, and Radi-calized Theories of Ideology," *Journal of the History of Ideas,* vol. 72, no. 1 (January 2011), 119–40.

11. Nordau, *Degeneration,* viii.

12. Brown, *Armory Show,* 164.

13. James Huneker, "The Case of Dr. Nordau," *The Forum,* November 1915, 571–87.

14. Burgers, "Max Nordau," 125.

15. Quinn to Yeats, September 9, 1921, in Reid, *Man from New York,* 507.

16. "Artists Rise in Aid of Post-Impressionists: John Quinn Calls Anony-mous Attack on Museum Exhibit Ku Klux Criticism," *New York Times,* September 7, 1921.

17. Roché to Quinn, November 22, 1921.

18. Quinn to Roché, December 29, 1921.

19. Quinn to Léonce Rosenberg, November 29, 1921.

20. Quinn to Roché, February 19, 1922.

21. Quinn to Roché, July 28, 1922.

22. Quinn to Léonce Rosenberg, November 29, 1921.

15. DANGEROUS LIAISONS

1. Roché, diary, November 10, 1921, in *Carnets,* 426.

2. Roché, diary, November 26, 1921, in *Carnets,* 448.

3. Roché to Quinn, January 27, 1922.

4. Roché, diary, November 30, 1921, in *Carnets,* 451.

5. Roché to Quinn, January 8, 1922.

6. Rosenberg to Picasso, January 21, 1921.

7. Rosenberg to Picasso, July 9, 1921.

8. Roché to Quinn, February 11, 1922.

9. Quinn to Roché, December 8, 1920.

10. Rosenberg to Picasso, July 9, 1921.

11. Quinn to Rosenberg, May 25, 1922.

12. Michael C. FitzGerald points out "how unusual Quinn's purchases were at this time when the pool of buyers was still very shallow." FitzGerald, *Making Modernism,* 114.

13. Roché to Quinn, January 8, 1922.

14. Picasso described Quinn's purist approach to collecting at the time of Quinn's death. Saarinen, *Proud Possessors,* 234.

15. Roché to Quinn, January 28, 1922 (addendum February 1).

16. Roché to Quinn, January 8, 1922.

17. Quinn to Roché, January 27, 1922.

18. Roché to Quinn, February 10, 1922.

19. Roché to Quinn, February 10, 1922.

20. Man Ray, *Self Portrait* (Boston: Bulfinch Press, 1998), 177.

21. Roché, diary, February 16, 1922.

22. Roché to Quinn, February 17, 1922.

23. Roché to Quinn (cable), March 7, 1922.

24. Quinn to Roché, February 19, 1922.

25. Quinn to Roché (cable), March 7, 1922.

26. Quinn to Roché, March 5, 1922.

27. Roché to Quinn, March 29, 1922.

28. Roché, diary, May 20, 1922.

29. Roché to Quinn, May 18 and June 19, 1922.

30. Reid, *Man from New York,* 541.

31. Quinn to George Russell, July 30, 1922.

32. Quinn to Lady Gregory, July 17, 1922, in Reid, *Man from New York,* 542.

33. James Joyce to Quinn (cable), February 3, 1922, in Reid, *Man from New York,* 529.

34. Roché to Quinn, June 19, 1922.

35. Roché to Quinn, July 10, 1922.

36. Roché to Quinn, July 2, 1922.

37. Sheldon Cheney, "An Adventurer Among Art Collectors," *New York Times,* January 3, 1926.

38. Roché to Quinn, June 11, 1922.

39. Quinn to Roché, July 11, 1922.

16. DINNER AT QUINN'S

1. Rosenberg to Picasso, November 16, 1923.

2. Ford Madox Ford, *It Was the Nightingale* (Philadelphia and London: J. B. Lippincott, 1933), 311. Conrad had come to the United States as the guest of the publisher F. N. Doubleday, who apparently prevented him from seeing Quinn. Reid, *Man from New York,* 566–70.

3. Roché, "Hommage à John Quinn," 967; Roché to Quinn, November 8, 1923.

4. Rosenberg to Quinn, November 20, 1923.

5. Quinn to Rosenberg, January 26 and March 2, 1922.

6. Rosenberg to Picasso, November 21 and 26, 1923.

7. Quinn to Roché, December 6, 1923, Harry Ransom Center.

8. Rosenberg to Picasso, November 26, 1923.

9. Quinn to Roché, December 6, 1923, Harry Ransom Center.

10. Quinn to Roché, June 1, 1922; Quinn to Ezra Pound, October 21, 1920, in Reid, *Man from New York*, 437.

11. Clive Bell to Mary Hutchinson, December 4, 1922, Mary Hutchinson Papers, Harry Ransom Center.

12. Rosenberg to Picasso, December 20, 1923.

13. Rosenberg to Picasso, December 11, 1923.

17. THE LAST BATTLE

1. Roché to Jos Hessel and Alphonse Bellier, October 11, 1926, Harry Ransom Center.

2. Kahnweiler to Quinn (receipt), October 31, 1923; Quinn to Kahnweiler, November 12, 1923.

3. Picasso told Marius de Zayas that he was very much disappointed with Rosenberg's American venture and would have sold his "clowns" for 40,000 to 50,000 francs instead of the 75,000 or 80,000 francs the dealer insisted on. Quinn to Roché, March 14, 1924.

4. Roché to Quinn, March 28, 1924.

5. Roché, "Hommage à John Quinn," 969.

6. Roché to Hessel and Bellier, October 11, 1926.

7. Roché to Quinn, February 1, 1924.

8. Roché to Quinn (cable), February 5, 1924.

9. Roché to Quinn (cable), February 6, 1924; Roché, diary, February 7, 1924.

10. Roché, diary, February 6, 1924; Roché to Quinn, February 11, 1924; Roché to Quinn (cable), February 7, 1924.

11. Reid, *Man from New York*, 624.

12. Quinn to Roché (cable and separate "confidential" cable), February 8, 1924.

13. Roché, diary, February 7, 1924.

14. Roché to Quinn, February 11, 1924.

15. Roché to Quinn, April 6, 1923.

16. Roché to Quinn (cable), February 15, 1924.

17. Foster to Aline Saarinen, January 1, 1958, quoted in Londraville, *Dear Yeats, Dear Pound*, 144–45.

18. Roché to Quinn, March 31, 1924 (addendum April 4).

19. Kahnweiler to Quinn, February 21, 1924.

20. Quinn to Walter Pach, April 21, 1924.

21. Quinn to Roché, March 14, 1924.

22. Quinn to Roché, June 25, 1924.

23. Foster to Quinn, August 16, 1921.

18. THE MAN VANISHES

1. Paul J. Sachs to Charles Rufus Morey, June 12, 1925, in Kantor, *Intellectual Origins of the Museum of Modern Art,* 83.

2. Kantor, *Intellectual Origins of the Museum of Modern Art,* 89.

3. The few exceptions were well outside of New York and Boston. The Detroit Institute of Arts acquired a Van Gogh and other modern works in the twenties, and the Worcester Art Museum in Massachusetts presented shows of twentieth-century modern art in 1921 and 1924.

4. Barr to Paul J. Sachs, July 5, 1955, Harvard Art Museums Archives.

5. Barr to Ben L. Reid, July 24, 1968, Alfred H. Barr Papers (I.A.580), MoMA Archives.

6. Murdock Pemberton, "Critique Art," *New Yorker,* January 16, 1926; Sheldon Cheney, "An Adventurer Among Art Collectors: Modern Painting and Sculptures Gathered by John Quinn to Be Shown to the Public," *New York Times,* January 3, 1926; Forbes Watson, editorial, and "The John Quinn Collection," *The Arts,* vol. 9, no. 1 (January 1926), 3–5.

7. "52 Picasso Paintings Sold," *New York Times,* January 10, 1926.

8. Reid, *Man from New York,* 645.

9. Judith Zilczer, "The Dispersal of the John Quinn Collection," *Archives of American Art Journal,* vol. 19, no. 13 (1979), 15–21.

10. Roché to Quinn, June 29, 1922; Quinn to Roché, June 11 and 17, 1922.

11. To Clara, his other surviving sister, who had joined a convent in Ohio years earlier, he left a small bequest of $2,500 as well as a trust fund of $10,000, on the assumption that she would be looked after by Julia. Reid, *Man from New York,* 639.

12. Saarinen, *Proud Possessors,* 237.

13. Walter Pach, February 1956 interview by Aline B. Saarinen, in Zilczer, "Dispersal of the John Quinn Collection," 16.

14. Londraville, *Dear Yeats, Dear Pound,* 147; "Girl Can't Collect from Quinn Estate: Surrogate Finds No Proof That Lawyer Made $50,000 Investment for Miss Coates," *New York Times,* June 16, 1926.

15. Foster to Thomas Curtin, October 18, 1924, in Zilczer, *"Noble Buyer,"* 58–61.

16. Reliquet, *L'Enchanteur collectionneur,* 150.

17. Roché, "Hommage à John Quinn," 969.

18. Rosenberg to Picasso, September 5, 1924.

19. Roché to Rosenberg, January 10, 1925.

20. Henry McBride argued that Quinn had become an American Cousin

Pons, Balzac's misunderstood aesthete, in the novel of that name, whose extraordinary art collection falls prey to swirling intrigues. *The Dial,* March 1926.

21. Frederick James Gregg, "Europe Raids the John Quinn Collection," *The Independent,* February 27, 1926.

22. Jean Cocteau, introduction to *Catalogue des tableaux modernes provenant de la collection John Quinn* (Paris: Hôtel Drouot, October 1926); Janet Flanner, *Paris Was Yesterday: 1925–1939* (New York: Viking Press, 1972), 10.

23. Confusion about exchange rates has distorted historical understanding of the Quinn estate sales. Judith Zilczer has written that the Hôtel Drouot sale of thirty-six paintings and thirty-six watercolors yielded "approximately $308,000 for the Quinn Estate," with *The Sleeping Gypsy* selling for "520,000 francs or about $102,900." In fact, according to U.S. Federal Reserve exchange rates for October 1926, *The Sleeping Gypsy* sold for about $15,300 and the total auction yielded $48,510. Combined with the $91,570 achieved for the 819 works sold in New York and private sales of perhaps as much as $200,000 for the Picassos, Seurats, and other works, total proceeds would have amounted to about $350,000 for more than twenty-five hundred artworks—well below Zilczer's estimate of $600,000 and a significant loss on Quinn's original investment. Even in Paris, the Quinn estate probably lost money overall on his original investment. Zilczer, "Dispersal of the John Quinn Collection," 17.

24. Zilczer, "Dispersal of the John Quinn Collection," 20.

19. THE VERY MODERN MR. BARR

1. Barr to Annie Elizabeth Wilson Barr, March 18, 1924, in Roob, "Alfred H. Barr, Jr.," 5; "Lectures on Modern Art," *Poughkeepsie Star,* November 3, 1923, in Kantor, *Intellectual Origins of the Museum of Modern Art,* 32.

2. Kantor, *Intellectual Origins of the Museum of Modern Art,* 8.

3. Macdonald, "Action on West Fifty-third Street—II," *New Yorker,* December 19, 1953.

4. Interview with Philip Johnson, December 18, 1990, Oral History Program, MoMA Archives, 2.

5. Roob, "Alfred H. Barr, Jr.," 2.

6. Erwin Panofsky compared Morey to Kepler after the publication of his book *Sources in Medieval Style.* Lee Sorensen, "Charles Rufus Morey," in *The Dictionary of Art Historians,* arthistorians.info/moreyc.

7. Application for a fellowship at Harvard, undated, in Kantor, *Intellectual Origins of the Museum of Modern Art,* 33.

8. Roob, "Alfred H. Barr, Jr.," 5; Barr to Paul J. Sachs, August 3, 1925, in Kantor, *Intellectual Origins of the Museum of Modern Art,* 89.

9. "Boston Is Modern Art Pauper," *Harvard Crimson,* October 30, 1926, in Barr, *Defining Modern Art,* 52–53.

10. Macdonald, "Action on West Fifty-third Street," 81.

11. Roob, "Alfred H. Barr, Jr.," 11.

12. Barr to Sachs, May 1, 1927, Paul J. Sachs Papers (HC 3), folder 109, Harvard Art Museums Archives.

13. Barr, "An American Museum of Modern Art," *Vanity Fair,* November 1929.

14. Kantor, *Intellectual Origins of the Museum of Modern Art,* 172.

15. In 1928, the museum in Shchukin's former palace was closed and his paintings were combined with the former Morosov collection in the former Morosov townhouse, but many were put in storage for insufficient space. The combined collection was entirely closed at the start of World War II. Semenova, *The Collector,* 242–45.

16. Alfred H. Barr, Jr., "Is Modern Art Communistic?," *New York Times Magazine,* December 14, 1952.

17. Sachs to Barr, January 19, 1929, Paul J. Sachs Papers (HC 3), folder 110, Harvard Art Museums Archives.

20. "HAD HE LIVED ANOTHER DECADE . . ."

1. Marquis, *Missionary for the Modern,* 62; Saarinen, *Proud Possessors,* 364.

2. Kert, *Woman in the Family,* 273.

3. Valentine Dudensing to Pierre Matisse, November 6, 1928, in Pemberton, *Portrait of Murdock Pemberton,* 99.

4. Abby Rockefeller to Eustache de Lorey, August 26, 1929, in Kert, *Woman in the Family,* 262.

5. Perlman, *Lives, Loves, and Art of Arthur B. Davies,* 360.

6. Perlman, *Lives, Loves, and Art of Arthur B. Davies,* 372.

7. Lynes, *Good Old Modern,* 10.

8. Barr, *Picasso: Fifty Years of His Art,* 45.

9. After meeting with Goodyear, Hekking traveled to New York City to locate *La Toilette,* which was now at the Wildenstein Gallery following Paul Rosenberg's purchase. On January 26, Hekking arranged to buy the Picasso for $6,500 through the Fellows for Life Fund, which Goodyear and Hekking had created. Minutes, Special Meeting of the Art Committee, January 23, 1926, and Rosenberg cables to Hekking, January 23 and

26, 1926, William M. Hekking Papers, Albright-Knox Art Gallery Digital Assets and Archives, Buffalo, New York.

10. George F. Goodyear, *Goodyear Family History* (Buffalo: Goodyear, 1976), 182; interview with Elizabeth Bliss Parkinson Cobb, July 6, 1988, Oral History Program, MoMA Archives, 17.

11. Forbes Watson, editorial, *The Arts,* vol. 9, no. 1 (January 1926), 3.

12. Kert, *Woman in the Family,* 277.

13. Kert, *Woman in the Family,* 277.

14. Lynes, *Good Old Modern,* 47.

15. The statement is unsigned, but its language and references are unmistakably Barr's. "Publicity for Organization of Museum" (second release), August 1929, 3–4, Press Release Archives, MoMA Archives.

16. Barr, "An American Museum of Modern Art," *Vanity Fair,* November 1929, 136.

17. Barr to Mrs. Thomas F. Conroy, August 8, 1966, Alfred H. Barr Papers (I.A.580), MoMA Archives.

18. Lynes, *Good Old Modern,* 49.

19. "Publicity for Organization of Museum," 6.

21. A MUSEUM OF HIS OWN

1. Roob, "Alfred H. Barr, Jr.," 19.

2. "The New Museum of Modern Art Opens," *New York Times,* November 10, 1929.

3. All quotations by Margaret Scolari in this chapter come from Paul Cummings, "Oral History Interview with Margaret Scolari Barr Concerning Alfred H. Barr," New York, February 22, April 8, and May 14, 1974, Archives of American Art, Washington, D.C.

4. "Modern Art Museum Opens in New York," *Art News,* November 9, 1929; Edward Alden Jewell, "The New Museum of Modern Art Opens," *New York Times,* November 10, 1929; Lloyd Goodrich, "A Museum of Modern Art," *The Nation,* December 4, 1929.

5. "I have no painting by Picasso," Conger Goodyear wrote to Jere Abbott, April 9, 1931, Alfred H. Barr Papers (XI.J.2), MoMA Archives.

6. Kantor, *Intellectual Origins of the Museum of Modern Art,* 208. Kirstein would later attribute his early Picasso infatuation to Barr's influence.

7. Jacques Mauny, "Painting in Paris," *The Arts,* January 1930, 317.

8. Agnes Mongan to Bernard Berenson, January 2, 1939, in Weber, *Patron Saints,* 338.

9. Philip Johnson to Margaret Scolari, April 30, 1929, Margaret Scolari Barr Papers (II.34), MoMA Archives.

22. THE PARIS PROJECT

1. On the advice of Barr's mother, who was concerned about dealing with the French bureaucracy, Scolari and Barr had decided to get a marriage license at City Hall in New York before departing for Europe. Margaret Scolari Barr, "Our Campaigns," 24.

2. Paul Cummings, "Oral History Interview with Margaret Scolari Barr Concerning Alfred H. Barr," New York, February 22, April 8, and May 14, 1974. Archives of American Art, Washington, D.C., 9.

3. P. Morton Shand, "The Work of Mr. Robert Mallet-Stevens," *Architects' Journal,* vol. 66 (October 5, 1927), 443; Margaret Scolari Barr, "Our Campaigns," 25.

4. Murdock Pemberton, "The Art Galleries," *New Yorker,* December 13, 1930.

5. Margaret Scolari Barr, "Footnotes to Picasso Lecture," note 3, Margaret Scolari Barr Papers (III.A.19), MoMA Archives.

6. Margaret Scolari Barr, "Our Campaigns," 25.

7. Barr, "Critical Catalog: Loan Exhibition of Modern Graphic Art," Fogg Museum, spring 1925, 201, Alfred H. Barr Papers (IV.B.164), MoMA Archives.

8. Henry McBride, "More Paintings by Picasso," New York *Sun,* March 11, 1933.

9. Barr viewed Picasso's art as driven by a series of "supersessions and conflicts: sculptural, three-dimensional forms versus flat pictorial forms; the monochrome versus maximum intensity and variety of color; overt prettiness versus grotesque ugliness; emotional nullity versus convulsive passion; realism versus abstraction." Barr, *Picasso: Fifty Years of His Art,* 11.

10. Margaret Scolari Barr, "Footnotes to Picasso Lecture," note 3.

11. Mather, *Modern Painting,* 373.

12. Erwin Panofsky, *Meaning in the Visual Arts* (Garden City, N.Y.: Doubleday, 1955), 328.

13. Kantor, *Intellectual Origins of the Museum of Modern Art,* 33.

14. Barr, diary, December 30, 1927, in "Russian Diary 1927–28," *October,* vol. 7 (Winter 1978), 17.

23. "WHEN A PICASSO WINS ALL THE RACES . . ."

1. Tériade, "Une Visite à Picasso," *L'Intransigeant,* November 27, 1928.

2. FitzGerald, *Making Modernism,* 155.

3. "On Expose," *L'Intransigeant,* April 29, 1929.

4. Rosenberg to Picasso, September 10, 1929.

5. Louis Vauxcelles, "Une Rétrospective Corot," *Excelsior,* May 31, 1930, 1.

6. "Carnet Mondain," *Le Journal,* June 15, 1930.

7. Richardson, *Life of Picasso: Triumphant Years,* 323, 327.

8. Rosenberg to Picasso, July 16, 1927.

9. Harry Kessler, diary, April 10, 1930, in Charles Kessler, trans. and ed., *Berlin in Lights: The Diaries of Count Harry Kessler (1918–1937)* (New York: Grove Press, 2000), 382.

10. Rosenberg to Picasso, June 30, 1930, and June 1, 1931.

11. Rosenberg to Margot Rosenberg, undated, 1942, in Sinclair, *My Grandfather's Gallery,* 150.

12. Sinclair, *My Grandfather's Gallery,* 149–50.

13. Rosenberg to Picasso, July[?] 1925 and September 14, 1929.

14. Rosenberg to Picasso, August 5, 1927.

15. "Les Courses," *Le Journal,* April 16, 21, and 28, and May 6 and 20, 1929.

16. Rosenberg to Picasso, September 10, 1929.

17. Mauny brought along the adventurous New York collector Albert Gallatin, who had met Picasso a few years earlier and to whom Mauny was an informal art adviser. Barr to Jacques Mauny, July 20, 1931, Alfred H. Barr Papers (XI.J.2), MoMA Archives.

18. Brassaï, *Picasso and Company,* 5; Barr, *Picasso: Fifty Years of His Art,* 167.

19. Margaret Scolari Barr, "Footnotes to Picasso Lecture," note 3, Margaret Scolari Barr Papers (III.A.19), MoMA Archives.

20. Barr to Jere Abbott (cable), June 17[?], 1930, and Conger Goodyear to Barr (cable), June 18, 1930, Alfred H. Barr Papers (I.A.3), MoMA Archives.

21. Léger had just completed the first of three murals for Reber on the theme of gastronomy and music. Dorothy Kosinski, "G. F. Reber: Collector of Cubism," *Burlington Magazine,* vol. 133, no. 1061 (August 1991), 520, 522.

22. Barr to Jere Abbott (cable), June 23[?], 1930.

24. THE BALANCE OF POWER

1. See Simonetta Fraquelli, "Picasso's Retrospective at the Galeries Georges Petit, Paris 1932," in Bezzola, *Picasso by Picasso,* 87, 93n33.

2. Barr to Abby Rockefeller, September 8, 1930, in Kert, *Woman in the Family,* 283; Conger Goodyear to Paul J. Sachs, October 2, 1931, Paul J. Sachs Papers (HC 3), folder 1363, Harvard Art Museums Archives.

3. Goodyear to Rockefeller, September 26, 1930, in Kert, *Woman in the Family,* 301.

4. Barr to Jacques Mauny, April 25, 1931, Alfred H. Barr Papers (XI.J.2), MoMA Archives.

5. Tériade, "Une grande exposition Henri-Matisse," *L'Intransigeant,* June 22, 1931.

6. Henry McBride to Malcolm MacAdam, June 11, 1930, in McBride, *Eye on the Modern Century,* 198.

7. Barr to Mauny, July 20, 1931, Alfred H. Barr Papers (XI.J.2), MoMA Archives.

8. Kert, *Woman in the Family,* 303–04.

9. Barr to Rockefeller, June 25, 1931, Alfred H. Barr Papers (I.A.3), MoMA Archives.

10. See, for example, Spurling, *Matisse the Master,* 330–31, and Russell, *Matisse: Father and Son,* 81. The confusion may stem from Margaret Scolari Barr's imprecise recollections in "Our Campaigns," in which she writes they had traveled to Europe "to prepare the Matisse exhibition." Margaret Scolari Barr, "Our Campaigns," 26.

11. Alfred Barr, ed., *Henri-Matisse Retrospective Exhibition* (New York: Museum of Modern Art, 1931), 19.

12. Henry McBride, "The Museum of Modern Art Gives a Matisse Exhibition with Special Success," New York *Sun,* November 7, 1931; Pierre Matisse to Henri Matisse, November 12, 1931, in Spurling, *Matisse the Master,* 330.

13. Barr to G. F. Reber, July 1, 1931, Alfred H. Barr Papers (XI.J.2), MoMA Archives; Margaret Scolari Barr, notes for "Our Campaigns," September 1930, Margaret Scolari Barr Papers (III.F.20), MoMA Archives.

14. Barr to Picasso, draft letter in French, December 16, 1939, Alfred H. Barr Papers (XI.J.2), MoMA Archives.

15. Barr to Goodyear, December 19, 1931, Alfred H. Barr Papers (XI.J.2), MoMA Archives.

16. Goodyear to Barr, December 22 and 30, 1931, Alfred H. Barr Papers (XI.J.2), MoMA Archives.

17. Barr to Picasso, January 26, 1932, Alfred H. Barr Papers (XI.J.2), MoMA Archives.

18. Mauny to Barr, February 26, 1932, Alfred H. Barr Papers (XI.J.2), MoMA Archives.

25. DEFEAT

1. Paul J. Sachs to Conger Goodyear, June 13, 1932, Paul J. Sachs Papers (HC 3), folder 1364, Harvard Art Museums Archives.

2. Barr to Abby Rockefeller, June 21, 1932, Alfred H. Barr Papers (I.A.3), MoMA Archives.

3. Rockefeller to Goodyear, December 16, 1936, Alfred H. Barr Papers (I.A.17), MoMA Archives.

4. Kert, *Woman in the Family*, 315, 319–20.

5. Barr to Sachs, February 1932, in Lynes, *Good Old Modern*, 94.

6. Jere Abbott to his father, April 7, 1927, in Leah Dickerman, "An Introduction to Jere Abbott's Russian Diary, 1927–1928," *October*, vol. 145 (Summer 2013), 116.

7. Henry-Russell Hitchcock to Virgil Thomson, September 27, 1928, in Marquis, *Missionary for the Modern*, 47–48; interview with Philip Johnson, December 18, 1990, Oral History Program, MoMA Archives, 15.

8. Barr to Margaret Scolari Barr, undated [early July 1930], Margaret Scolari Barr Papers (II.18), MoMA Archives.

9. Barr to Margaret Scolari Barr, undated [July 1933], Margaret Scolari Barr Papers (II.21), MoMA Archives.

10. Margaret Scolari Barr to Barr, July 17–23, 1932, Margaret Scolari Barr Papers (II.21), MoMA Archives.

11. Margaret Scolari Barr to Barr, July 23 and 28, 1932.

12. Margaret Scolari Barr to Barr, July 28, 1932.

13. Richardson, *Life of Picasso: Triumphant Years*, 467.

14. Margaret Scolari Barr to Barr, July 28, 1932.

15. Margaret Scolari Barr to Barr, July 28 and August 1, 1932, pt II, Margaret Scolari Barr Papers (II.21), MoMA Archives; Henri Matisse to Pierre Matisse, August 10, 1933, quoted in Cowling et al., *Matisse Picasso*, 376.

16. Margaret Scolari Barr to Barr, August 2, 1932, Margaret Scolari Barr Papers (II.21), MoMA Archives. This was despite the Carnegie Institute having awarded Picasso its international art prize, the Carnegie Prize, in 1930, for an elegant but deeply conservative 1923 portrait of Olga, which, as Jack Flam writes, "gave the impression that modern art had never really happened." Flam, *Matisse and Picasso*, 149.

17. Rosenberg to Picasso, July 22 and 25, 1932.

18. Anne Sinclair states that the letter was written in 1942 and not intended to be opened until after Rosenberg's death. It is uncertain that Margot Rosenberg ever knew about it. Sinclair, *My Grandfather's Gallery*, 149–51.

19. Elaine Rosenberg, interview with the author, March 2016.

20. Rosenberg, typed notes describing Wildenstein partnership, Paul Rosenberg Archives (B.29.13), Museum of Modern Art.

21. Margaret Scolari Barr to Barr, August 3, 1932, Margaret Scolari Barr Papers (II.21), MoMA Archives.

26. "MAKE ART . . . GERMAN AGAIN"

1. *Picasso: 11. September Bis 30. October 1932* (Zurich: Kunsthaus Zürich, 1932), with Barr's pencil annotations, Alfred H. Barr Papers (XI.B.39), MoMA Archives.
2. Barr to Conger Goodyear, November 25, 1932, Alfred H. Barr Papers (I.A.5), MoMA Archives.
3. Christian Geelhaar, "Picasso: The First Zurich Exhibition," in Bezzola, *Picasso by Picasso*, 38.
4. C. G. Jung, "Picasso," *Neue Zürcher Zeitung*, November 13, 1932, in Gerhard Adler and R.F.C. Hull, eds. and trans., *The Collected Works of C. G. Jung*, vol. 15, *Spirit in Man, Art, and Literature* (Princeton, N.J.: Princeton University Press, 1966), 136–41.
5. Geelhaar, "Picasso: The First Zurich Exhibition," 38.
6. Interview with Helen Franc, April 16, 1991, Oral History Program, MoMA Archives, 30; Paul Cummings, "Oral History Interview with Margaret Scolari Barr Concerning Alfred H. Barr," New York, February 22, April 8, and May 14, 1974. Archives of American Art, Washington, D.C., 17.
7. Writing from St. Anton am Alberg on February 4, Barr informed Abby Rockefeller that he would "probably go to a specialist in Stuttgart or Vienna." In her retrospective account in "Our Campaigns," Margaret Scolari Barr writes that they arrived in Stuttgart before Hitler was named chancellor, but Barr's contemporaneous letters make clear they were in Austria until early February. Barr to Rockefeller, February 4, 1933, Alfred H. Barr Papers (I.A.8), MoMA Archives.
8. The woman's father had lived in Marseille and known Cézanne's friend Fortuné Marion, who wrote him an important series of letters about Cézanne. Frau Haag gave these to Barr, who would publish them in 1937. John Elderfield, "Alfred Barr's Insomnia—and the Awakening of Cézanne's Interest in Geology," Princeton Art Museum, spring 2020, 9–11.
9. Barr, "Art in the Third Reich—Preview, 1933," in Barr, *Defining Modern Art*, 172.
10. Margaret Scolari Barr, notes for "Our Campaigns," 1933, Margaret Scolari Barr Papers (III.F.21), MoMA Archives.
11. "Hitler Proclaims War on Democracy at Huge Nazi Rally," *New York Times*, February 11, 1933.

12. Barr, "Art in the Third Reich," 163.

13. Barr, "Art in the Third Reich," 167.

14. Barr, "Art in the Third Reich," 168.

15. Barr, "Art in the Third Reich," 169.

16. Margaret Scolari Barr, notes for "Our Campaigns," 1933.

17. After coming under intense pressure from local Nazi officials, the Dessau Bauhaus closed in August 1932; Schlemmer finished *Bauhaus Stairway* the following month. The Bauhaus briefly moved to Berlin under Mies van der Rohe, but was shut down in August 1933. John-Paul Stonard, "Oskar Schlemmer's 'Bauhaustreppe,' 1932: Part I," *Burlington Magazine,* vol. 151, no. 1276 (July 2009), 456.

18. Christian Mengenthaler, National Socialist minister of education for the state of Württemberg, quoted in Barr, "Art in the Third Reich," 166.

19. Barr, "Art in the Third Reich," 168.

20. Cummings, "Oral History Interview with Margaret Scolari Barr," 17.

21. During their stay, the Barrs frequented the Hotel Monte Verità, a former hilltop sanatorium that had been converted into a modernist luxury hotel, with Gauguins, Matisses, and Picassos in the dining room. Barr to Rockefeller, June 3, 1933, Alfred H. Barr Papers (I.A.8), MoMA Archives.

22. Margaret Scolari Barr, "Our Campaigns," 32.

23. Barr, undated memo, "Stuttgart," Alfred H. Barr Papers (IV.B.113), MoMA Archives.

24. Philip Johnson to Margaret Scolari Barr, July 1, 1933, in John-Paul Stonard, "Oskar Schlemmer's 'Bauhaustreppe,' 1932: Part II," *Burlington Magazine,* vol. 152, no. 1290 (September 2010), 595–602.

25. Interview with Philip Johnson, December 18, 1990, Oral History Program, MoMA Archives, 32.

26. Margaret Scolari Barr, "Our Campaigns," 32.

27. Barr, "Report on the Permanent Collection," 3rd draft, summer 1933, Alfred H. Barr Papers (II.C.17), MoMA Archives.

27. CONNECTICUT CHIC

1. Étienne Bignou to Charles Henschel, January 8, 1932, in Christel Force, "Étienne Bignou: The Gallery as Antechamber of the Museum," in *Pioneers of the Global Art Market,* 208.

2. Kahnweiler to Maurice de Vlaminck, March 8, 1934, in Monod-Fontaine, *Daniel-Henry Kahnweiler,* 148.

3. Madeleine Chapsal, "Entretien avec Pierre Loeb," *L'Express,* April 9, 1964, in Assouline, *An Artful Life,* 230.

4. FitzGerald, *Making Modernism,* 188.

5. Barr to Abby Rockefeller, November 6, 1933, Alfred H. Barr Papers (I.A.8), MoMA Archives.

6. Rosenberg to Picasso, December 16, 1933.

7. Philip Johnson, interview by Eugene R. Gaddis, November 30, 1982, in Gaddis, *Magician of the Modern,* 59.

8. Julien Levy, *Memoir of an Art Gallery* (Boston: MFA Publications, 2003), 137.

9. Stein to A. Everett Austin, undated, November 1933, in Gaddis, *Magician of the Modern,* 226.

10. Rosenberg to Austin, December 23, 1923, in Gaddis, *Magician of the Modern,* 228. Rosenberg's visit was covered by *The Hartford Times,* December 22, 1933. FitzGerald, *Making Modernism,* 221.

11. Rosenberg to Picasso, December 16, 1933.

12. Rosenberg to Austin (cable), January 22, 1934, in FitzGerald, *Making Modernism,* 223; Rosenberg to Austin (cable), undated [January 23?] 1934, in James Thrall Soby to Sidney Janis, June 19, 1967, Collectors Records (37), MoMA Archives.

13. James Thrall Soby, "My Life in the Art World," unpublished ms., ch. 9, 6–7, James Thrall Soby Papers (VIII.A.1), MoMA Archives.

14. Barr to Austin, January 18, 1933, Alfred H. Barr Papers (I.A.7), MoMA Archives.

15. Gaddis, *Magician of the Modern,* 245; Lucius Beebe, "Smart Art and Miss Stein Overwhelm Hartford," *New York Herald Tribune,* February 11, 1934; Joseph W. Alsop, Jr., "Gertrude Stein Opera Amazes First Audience: Picked Auditors Laugh at First, but Last Curtain Brings Wild Applause," *New York Herald Tribune,* February 8, 1934.

16. Weber, *Patron Saints,* 234.

17. Soby, "My Life in the Art World," ch. 4, 14.

18. Gaddis, *Magician of the Modern,* 242.

19. Weber, *Patron Saints,* 237; Craven, *Modern Art,* 365.

20. Henry McBride, "Modern Masterpieces Shown," New York *Sun,* March 17, 1934.

21. Soby to Janis, June 19, 1967.

28. "RISKING MY LIFE FOR MY WORK"

1. Lynes, *Good Old Modern,* 132. Among the few exceptions were the Detroit Institute of Arts, which had acquired Van Gogh's 1887 *Self-Portrait* in 1922, and the Art Institute of Chicago, which had, via the collector Frederick Clay Bartlett, acquired *The Bedroom* from Paul Rosenberg in 1926.

2. Douglas Cooper, undated notes, 1938, Douglas Cooper Papers (I.7), Getty Research Institute.

3. "Pennell Enters Into Art War Here: Etcher Calls Post-Impressionist Exhibit at the Museum Dangerous," *New York Times,* September 8, 1921; C. J. Holmes, *Notes on the Post-Impressionist Painters: Grafton Galleries 1910–1911* (London: Philip Lee Warner, 1910), in Bullen, *Post-Impressionists in England,* 186.

4. Albin Krebs, "Irving Stone, Author of 'Lust for Life,' Dies at 86," *New York Times,* August 28, 1989.

5. Irving Stone, *Lust for Life,* 50th anniv. ed. (New York: Plume, 1984), 70.

6. Richard Pearson, "Irving Stone, Bestselling Author, Dies," *Washington Post,* August 28, 1989.

7. Barr to Helene Kröller-Müller, November 1, 1927, in Eva Rovers, *De eeuwigheid verzameld: Helene Kröller-Müller (1868–1939)* (Amsterdam: Prometheus-Bert Bakker, 2014), 373.

8. Lynes, *Good Old Modern,* 132.

9. Lewis Mumford, "Tips for Travellers—The Modern Museum," *New Yorker,* June 9, 1934, in Mumford, *Mumford on Modern Art,* 125–28.

10. Barr, foreword to *The Museum of Modern Art First Loan Exhibition: Cézanne, Gauguin, Seurat, Van Gogh* (New York: Museum of Modern Art, 1929), 16. See also Kantor, *Intellectual Origins of the Museum of Modern Art,* 216.

11. Eksteins, *Solar Dance,* 57, 109. Valentiner was working as a consultant for the Detroit Institute of Arts at the time he arranged the purchase of the Van Gogh *Self-Portrait.* He became director two years later.

12. Karl Jaspers, *Strindberg und Van Gogh: Versuch einer pathographischen Analyse* (Berlin: P. Stringer, 1926), in John M. MacGregor, *The Discovery of the Art of the Insane* (Princeton, N.J.: Princeton University Press, 1989), 222.

13. Hans Prinzhorn, *Artistry of the Mentally Ill: A Contribution to the Psychology and Psychopathology of Configuration,* trans. Eric von Brockdorff (New York: Springer Verlag, 1972), 267.

14. Barr to Conger Goodyear, June 14, 1935, MoMA Exhibition Records (44.3), MoMA Archives. According to the 1935 agreement, the Dutch government turned the Kröller-Müller lands into a new national park and set up a private foundation to run the Kröller-Müller Museum, which opened in 1938.

15. Goodyear to Hon. Cordell Hull, May 14, 1935, and Barr to Grenville T. Emmet, July 8, 1935, in MoMA Exhibition Records (44.4), MoMA Archives. The secret payment is recorded in Rovers, *De eeuwigheid verzameld: Helene Kröller-Müller (1868–1939),* 426.

16. Margaret Scolari Barr, "Our Campaigns," 40.

17. Barr, *What Is Modern Painting?*, 20; Kantor, *Intellectual Origins of the Museum of Modern Art*, 216.

18. Alfred H. Barr, Jr., ed., *Vincent Van Gogh: With an Introduction and Notes Selected from the Letters of the Artist* (New York: Museum of Modern Art, 1935), 20.

19. Staedel Museum director George Swarzenski to Barr, August 17, 1935, MoMA Exhibition Records (44.3), MoMA Archives. In 1938, Swarzenski fled Germany for the United States.

20. "$1,000,000 Paintings by Van Gogh Here: Collection Lent to Museum of Modern Art to Be Put on View Next Month," *New York Times*, October 14, 1935.

21. Barr to Ing. V. W. van Gogh, November 21, 1935, MoMA Exhibition Records (44.4), MoMA Archives.

22. "Van Gogh Attendance," *New York Times*, December 11, 1935; Lewis Mumford, "The Art Galleries," *New Yorker*, November 16, 1935.

23. "Van Gogh Art Arrives: Guarded Like Mint; Exhibit Opens Tuesday," *San Francisco Chronicle*, April 26, 1936; Steve Spence, "Van Gogh in Alabama, 1936," *Representations*, vol. 75, no. 1 (Summer 2001), 35–36; Lynes, *Good Old Modern*, 135.

24. "U.S. Scene," *Time*, December 24, 1934, 24.

25. Adolf Hitler, "Address on Art and Politics," September 11, 1935, in Norman H. Baynes, ed. and trans., *The Speeches of Adolf Hitler: April 1922–August 1939*, vol. 1 (New York: Howard Fertig, 1969), 569–92.

26. Paul Westheim, who was Jewish, fled Germany in 1933 and made his comments in 1938. Huber, "'The Nordic Painter Only Paints with Uncut Ears,'" 197.

27. In fact, Saint-Rémy is a short drive from Avignon, but Picasso's Avignon was the Carrer d'Avinyó in Barcelona—the street whose brothel was an inspiration for the *Demoiselles d'Avignon*—which was considerably farther away.

28. Margaret Scolari Barr, "Our Campaigns," 39.

29. THE YEAR WITHOUT PAINTING

1. In a 1923 interview with Marius de Zayas, Picasso said, "Cubism is not either a seed or a foetus, but an art dealing primarily with forms." Barr, *Picasso: Forty Years of His Art*, 12.

2. In 1927, in one of the first popular histories of modern art, Barr's mentor Frank Jewett Mather wrote that Cubism "is effectively dead," adding that

"Futurism, again a discarded aberration, is only interesting for its incidental philosophical and historical implications." Mather, *Modern Painting,* 367.

3. In the catalog, Barr wrote that the exhibition had evolved from "a series of lectures based on material collected in Europe in 1927–28 and given in Spring 1929." Alfred H. Barr, Jr., *Cubism and Abstract Art* (New York: Museum of Modern Art, 1936), 9.

4. Daix, *Picasso: Life and Art,* 229.

5. Mumford, "The Art Galleries," *New Yorker,* November 16, 1935, in Mumford, *Mumford on Modern Art,* 125.

6. The details of their summer in Paris come from Margaret Scolari Barr, "Our Campaigns," 42–43.

7. Barr, *Cubism and Abstract Art,* 16.

8. Margaret Scolari Barr, "Picasso: A Reminiscence," unpublished ms., 1975, 5, Margaret Scolari Barr Papers (III.A.19), MoMA Archives.

9. Margaret Scolari Barr, "Our Campaigns," 42.

10. Margaret Scolari Barr, "Our Campaigns," 42; Rosenberg to Picasso, January 1936, in FitzGerald, *Making Modernism,* 235.

11. Kahnweiler to Stein, August 7, 1935, in Madeline, *Correspondence: Picasso and Stein,* 350.

12. Barr, *Cubism and Abstract Art,* 11.

13. Barr, *Cubism and Abstract Art,* 19.

14. Conger Goodyear to Abby Rockefeller, March 12, 1936, Alfred H. Barr Papers (I.A.17), MoMA Archives.

15. Barr to Margaret Scolari Barr, undated, 1946, Margaret Scolari Barr Papers (II.16), MoMA Archives.

30. SPANISH FURY

1. Margaret Scolari Barr to Barr, September 25, 1936, Alfred H. Barr Papers (I.B.3), MoMA Archives.

2. In his 1964 memoir, Brassaï claimed that Picasso met Dora Maar at the café shortly after he had first seen her, "at almost exactly the same time" as Maya's birth. But in her 1988 interview with Juan Marín, Maar refuted that they met at that time, explaining that they were first introduced by Éluard at a film screening in January 1936. Brassaï, *Picasso and Company,* 42; Juan Marín, "Conversando con Dora Maar," *Goya,* no. 311 (March–April 2006), 117.

3. Sabartés, *Picasso: An Intimate Portrait,* 128.

4. Baldassari, *Picasso: Life with Dora Maar,* 194.

5. Penrose, *Picasso: His Life and Work*, 291.

6. Among the other sponsors of the NAACP exhibition, titled "An Art Commentary on Lynching," were Sherwood Anderson, Pearl Buck, Dorothy Parker, Carl Van Vechten, and George Gershwin. Marlene Park, "Lynching and Antilynching: Art and Politics in the 1930s," *Prospects,* vol. 18 (1993), 328. Barr's trip to the Jim Crow South is recorded in Margaret Scolari Barr, "Our Campaigns," 49.

7. Meyer Schapiro, "Nature of Abstract Art," *Marxist Quarterly* (January–March 1937), 77.

8. Barr, *What Is Modern Painting?,* 47.

9. Margaret Scolari Barr, "Picasso: A Reminiscence," lecture, 1973, 8, Margaret Scolari Barr Papers (III.A.19), MoMA Archives. The episode is recounted in less detail in Margaret Scolari Barr, "Our Campaigns," 48.

10. Margaret Scolari Barr to Barr, September 25, 1936.

11. Anne Umland and Adrian Sudhalter, eds., *Dada in the Collection of the Museum of Modern Art* (New York: Museum of Modern Art, 2008), 17.

12. Katherine Dreier to Barr, February 27, 1937, MoMA Exhibition Records (55.2), MoMA Archives.

13. Conger Goodyear to Abby Rockefeller, December 15, 1936, and Rockefeller to Goodyear, December 16, 1936, Alfred H. Barr Papers (I.A.17), MoMA Archives.

14. Paul Éluard, "November 1936," *L'Humanité,* December 17, 1936, quoted in Daix, *Picasso: Life and Art,* 246.

15. Pierre Daix, for example, writes that in 1936 Picasso "did not engage directly in political action . . . but in his work one can see he was moving toward intervention in the war." Daix, *Picasso: Life and Art,* 247. John Richardson has recently offered a more tempered view, noting that the extent of Picasso's involvement with the Prado is "unclear." Richardson, *Life of Picasso: Minotaur Years,* 115. In fact, there is little evidence that Picasso did much of anything to support the frantic evacuation of the Prado, despite repeated invitations to Spain, and the intense efforts of several of his friends, including Zervos, José Bergamín, and Roland Penrose.

16. Christian Zervos to Picasso, November 26, 1936, in Baldassari, *Picasso: Life with Dora Maar,* 195; Christian Zervos, "Histoire d'un tableau de Picasso," *Cahiers d'Art,* vol. 12, no. 4–5 (1937), 105, in Oppler, *Picasso's "Guernica,"* 207.

17. Berger, *Success and Failure of Picasso,* 147.

18. Van Hensbergen, *"Guernica,"* 32–33.

19. Chipp, Picasso's "Guernica," 39. Picasso himself told Pierre Daix that the pictures in Ce soir on April 30 impelled him to make the initial drawings the next day. Daix, Picasso: Life and Art, 250.

20. Marín, "Conversando con Dora Maar," 117; Man Ray, Self Portrait (Boston: Bulfinch Press, 1998), 179; José Bergamín, "Le Mystère tremble: Picasso furioso," Cahiers d'Art, vol. 12, no. 4–5 (1937), 135.

21. Maar recounted her conversation with Picasso to John Richardson in 1992. Richardson, "A Different Guernica," New York Review of Books, May 12, 2016.

22. Picasso's statement was made in May 1937 while he was working on Guernica. Barr, Picasso: Fifty Years of His Art, 202, 264.

23. Zervos, "Histoire d'un tableau," in Oppler, Picasso's "Guernica," 207.

24. Barr, Picasso: Fifty Years of His Art, 264.

25. Josep Lluís Sert, "The Architect Remembers," statement from "Symposium on Guernica," typescript, 1947, in Oppler, Picasso's "Guernica," 200.

26. Chipp, Picasso's "Guernica," 152.

27. Van Hensbergen, "Guernica," 72, 76.

28. Juan Larrea, Pablo Picasso (New York: Curt Valentin, 1947), 72.

29. Richardson, "A Different Guernica."

30. Janice Loeb to Barr, September 8, 1937, Alfred H. Barr Papers (XI.B.11), MoMA Archives.

31. Cahiers d'Art, vol. 12, no. 4–5 (1937); Chipp, Picasso's "Guernica," 152. Ellen C. Oppler refers to the "historic summer issue devoted to Guernica," in Oppler, Picasso's "Guernica," 206. Anne Baldassari dates the release to the opening of the Spanish Pavilion on July 12, in Baldassari, Picasso: Life with Dora Maar, 310.

32. The first sales of the "Guernica" issue appear to have taken place in mid-October 1937. "Caisse octobre 1937," in Livre de caisse (June 1937– December 1938), Fonds Cahiers d'Art (CA 71), Bibliothèque Kandinsky, Paris. The fall publication date is also supported by information provided to the author by Pierre de Fontbrune and Christian Derouet.

33. Chipp, Picasso's "Guernica," 152.

34. Jean-Paul Sartre, "What Is Writing?," in "What Is Literature" and Other Essays (Cambridge, Mass.: Harvard University Press, 1988), 28.

31. "SUCH A PAINTING COULD NEVER AGAIN BE HAD"

1. César M. de Hauke to Robert Levy, September 24, 1937, in Rubin et al., "Les Demoiselles d'Avignon," 195.

2. Writing at the end of the war, Barr stated that "the painting seems to

have been publicly exhibited for the first time in 1937." Barr, *Picasso: Fifty Years of His Art,* 258. The painting's brief exhibition at a group show in Paris during World War I was rediscovered in the late twentieth century. Rubin et al., *"Les Demoiselles d'Avignon,"* 164.

3. Kert, *Woman in the Family,* 376.

4. Kirk Varnedoe, "The Evolving Torpedo: Changing Ideas of the Collection of Painting and Sculpture of the Museum of Modern Art," in John Elderfield et al., *The Museum of Modern Art at Mid-Century: Continuity and Change,* Studies in Modern Art 5 (New York: Museum of Modern Art, 1995), 14–15.

5. Barr to Cornelius Sullivan, May 7, 1930, in Varnedoe, "Evolving Torpedo," 63n5; Marquis, *Missionary for the Modern,* 163; Margaret Scolari Barr, "Our Campaigns," 47.

6. Margaret Scolari Barr, "Our Campaigns," 42; Alfred H. Barr, Jr., "Chronicle of the Collection," in *Painting and Sculpture in the Museum of Modern Art, 1929–1967* (New York: Museum of Modern Art, 1977), 625.

7. James Ede to Barr, undated [1934], in Kosinski, "G. F. Reber: Collector of Cubism," 527.

8. Barr to Stephen Clark, July 13, 1934, and Barr to Abby Rockefeller, July 13, 1934, Alfred H. Barr Papers (I.A.11), MoMA Archives.

9. Barr, "Chronicle of the Collection," 625; Margaret Scolari Barr, "Our Campaigns," 47; Barr to Albert Gallatin, September 9, 1936, in FitzGerald, *Making Modernism,* 230–31.

10. Barr, "Chronicle of the Collection," 625; Rubin et al., *"Les Demoiselles d'Avignon,"* 178, 198; Edward Alden Jewell, "An Overwhelming Week: A Full Half Hundred Shows, from Picasso to Academism, Inundate the Galleries," *New York Times,* November 7, 1937. Doucet promised Picasso that he would bequeath the painting to the Louvre when he died, but he did not.

11. "Museum of Modern Art, New York, and Art Institute of Chicago Will Cooperate in Showing Largest Exhibition of Works by Picasso Ever Held in This Country," January 20, 1939, Press Release Archives, MoMA Archives.

12. Rubin et al., *"Les Demoiselles d'Avignon,"* 198.

13. See "Chronology," in Rubin et al., *"Les Demoiselles d'Avignon,"* 194–99.

14. Margaret Scolari Barr, "Footnotes to Picasso Lecture," note 5, Margaret Scolari Barr Papers (III.A.19), MoMA Archives.

15. Jean Cocteau, preface to *Catalogue des tableaux modernes provenant de la Collection John Quinn* (Paris: Hôtel Drouot, 1926), 3.

16. Margaret Scolari Barr, "Our Campaigns," 52; Barr to Paul J. Sachs, Sep-

tember 9, 1955, Paul J. Sachs Papers (HC 3), folder 78, Harvard Art Museums Archives.

17. Barr, letter and transcript dated May 3, 1955, to Paul J. Sachs, July 5, 1955, Paul J. Sachs Papers (HC 3), folder 78. Harvard Art Museums Archives.

32. THE LAST OF PARIS

1. "United States Planes New European Factor," *New York Times,* January 29, 1939; "Conference Secret," *New York Times,* February 1, 1939; "Fight for Details on Foreign Policy Looms in Congress," *New York Times,* February 5, 1939.
2. Lynes, *Good Old Modern,* 195.
3. Interview with Monroe Wheeler, July 21, 1987, Oral History Program, MoMA Archives, 64.
4. Lynes, *Good Old Modern,* 202.
5. Lynes, *Good Old Modern,* 197.
6. Ernest Hemingway, "A year ago today . . . ," in Ernest Hemingway and Alfred H. Barr, *Quintanilla: An Exhibition of Drawings of the War in Spain* (New York: Museum of Modern Art, March 1938). Hemingway had been trying to interest Barr in Quintanilla for several years. Hemingway to Barr, September 1, 1934, Alfred H. Barr Papers (6.B.17), MoMA Archives.
7. Barr, preface to *Bauhaus 1919–1928,* ed. Herbert Bayer, Walter Gropius, and Ise Gropius (New York: Museum of Modern Art, December 1938).
8. Edward Alden Jewell, "Plan Picasso Show," *New York Times,* January 24, 1939.
9. "Art's Acrobat," *Time,* February 13, 1939, 44–46.
10. Mary Callery to Barr, February 17, 1939, MoMA Exhibition Records (91.7), MoMA Archives.
11. "Art's Acrobat," 44.
12. Mary Callery to Barr, February 17, 1939, MoMA Exhibition Records (91.2), MoMA Archives; Rosenberg to Barr, February 23, 1939, MoMA Exhibition Records (91.3), MoMA Archives.
13. Barr to Rosenberg, draft letter, March 16, 1939, MoMA Exhibition Records (91.3), MoMA Archives.
14. Daniel Catton Rich to Barr, March 15, 1939, MoMA Exhibition Records (138.2), MoMA Archives.
15. Barr to Rosenberg, March 20, 1939, MoMA Exhibition Records (91.3), MoMA Archives.
16. Rosenberg to Barr, March 28, 1939, MoMA Exhibition Records (91.3), MoMA Archives.

17. Margaret Scolari Barr, "Our Campaigns," 54.

18. Interview with Stanton L. Catlin, July–September 1989, Oral History Program, MoMA Archives, 24.

19. "Reich Legion of 5,000 Ready to Quit Spain," *New York Times,* April 23, 1939.

20. Henry McBride, "Opening of the New Museum of Modern Art," New York *Sun,* May 13, 1939.

21. In addition to attending shows like the Van Gogh show, Eleanor Roosevelt would go on to write an introduction to the museum's 1941 exhibition of Native American art. Frederick H. Douglas and René d'Harnoncourt, *Indian Art of the United States* (New York: Museum of Modern Art, 1941), 8.

22. Franklin D. Roosevelt, "Address on Museum of Modern Art" [delivered May 10, 1939], *New York Herald Tribune,* May 11, 1939.

23. Barr to Daniel Catton Rich, July 20, 1939, MoMA Exhibition Records (138.2), MoMA Archives.

24. Rosenberg, in Benoît Remiche, ed., *21 rue La Boétie* (Ganshoren, Belgium: IPM Printing SA, 2016), 131.

25. Barr, *Matisse: His Art and His Public,* 224.

26. Margaret Scolari Barr, notes with party hats inscribed by Brancusi, Alfred H. Barr Papers (VI.B), MoMA Archives. See also Margaret Scolari Barr, "Our Campaigns," 56–57.

27. In "Our Campaigns," Margaret Scolari Barr writes that Barr accompanied her to Geneva in "late July/early August." But Barr's correspondence indicates that he sailed for New York on July 26, so the Geneva trip must have taken place before then. Barr to Rich, July 20, 1939.

28. Rich to Barr (cable), September 6, 1939, MoMA Exhibition Records (138.2), MoMA Archives.

29. Jere Abbott to Barr, September 1939, Alfred H. Barr Papers (I.A.27), MoMA Archives.

33. "MORE IMPORTANT THAN WAR"

1. Barr to Daniel Catton Rich (cable), September 11, 1939, MoMA Exhibition Records (138.2), MoMA Archives.

2. Rich to Barr, September 12, 1939, MoMA Exhibition Records (138.2), MoMA Archives.

3. Christian Zervos to Barr, September 6, 1939, MoMA Exhibition Records (91.4), MoMA Archives.

4. Barr to Rosenberg, September 12, 1939, MoMA Exhibition Records (91.7), MoMA Archives.

5. Barr to Stein, September 8, 1939, MoMA Exhibition Records (91.4), MoMA Archives.

6. Barr to Justin Thannhauser, September 8, 1939, MoMA Exhibition Records (91.4), MoMA Archives.

7. Pierre Loeb to Barr (cable), September 29, 1939, MoMA Exhibition Records (91.3), MoMA Archives.

8. Jacqueline Apollinaire to Barr, October 5, 1939, MoMA Exhibition Records (91.2), MoMA Archives.

9. Whitney Darrow to Julian Street, Jr., August 10, 1939, MoMA Exhibition Records (91.4), MoMA Archives.

10. Margaret Scolari Barr, "Our Campaigns," 56.

11. Cowling, *Visiting Picasso,* 47.

12. Barr, *Picasso: Fifty Years of His Art,* 70, 88.

13. Van Hensbergen, *"Guernica,"* 122–24; Alfred Frankenstein, "Out of the Bombing of Guernica Came a Picasso Mural," *San Francisco Chronicle,* September 3, 1939.

14. Museum of Modern Art (unidentified sender) to R. Lérondelle (cable), November 4, 1939, MoMA Exhibition Records (91.3), MoMA Archives.

15. "Final Paintings Arrive from Europe in Time for Big Picasso Exhibition at Museum of Modern Art," November 6, 1939, Press Release Archives, MoMA Archives.

16. Barr to Dora Maar, August 16, 1939, MoMA Exhibition Records (91.3), MoMA Archives.

17. Barr to Rosenberg, September 12, 1939.

18. Mary Callery to Barr, September 20, 1939, MoMA Exhibition Records (91.2), MoMA Archives.

19. Julian Street to Sara Newmayer (memorandum), August 18, 1939, MoMA Exhibition Records (91.3), MoMA Archives.

20. Brassaï, *Picasso and Company,* 40.

21. Sabartés, *Picasso: An Intimate Portrait,* 191.

22. Callery to Barr, September 20, 1939.

23. Zervos to Barr, October 26, 1939, MoMA Exhibition Records (91.4), MoMA Archives.

24. Rosenberg to Barr, October 25, 1939, MoMA Exhibition Records (91.7), MoMA Archives.

25. "Nazis Boast Entire Army Fills West Ready for Attack," *New York Times,* November 11, 1939.

26. "Almanac de Gotham," *Harper's Bazaar,* November 1939, 51.

27. Andrew C. Ritchie, "The Picasso Retrospective Exhibition in New York," *Burlington Magazine,* vol. 76, no. 444 (March 1940), 101; George

L. K. Morris, "Picasso: 4000 Years of His Art," *Partisan Review,* vol. 7, no. 1 (January–February 1940), 50–53; "The Picasso Show," *New York Times,* November 18, 1939.

28. "The Usefulness of Picasso," *New York Herald Tribune,* November 26, 1939.

29. FitzGerald, *Picasso and American Art,* 169, 182.

30. John Graham to Duncan Phillips, undated [1931], in FitzGerald, *Picasso and American Art,* 123.

31. Robert Goldwater, "Picasso: Forty Years of His Art," *Art in America,* vol. 28, no. 1 (1940), 43–44.

32. B. H. Friedman, "An Interview with Lee Krasner Pollock," in Friedman, *Jackson Pollock: Black and White* (New York: Marlborough-Gerson Gallery, 1969). Michael FitzGerald has persuasively identified the thrown book as Barr's *Picasso: Forty Years of His Art*. FitzGerald, *Picasso and American Art,* 196.

34. ESCAPE

1. Sabartés, *Picasso: An Intimate Portrait,* 196.

2. Barr to Picasso, Rosenberg, and Mary Callery (cables), November 15, 1939, MoMA Exhibition Records (91.3), MoMA Archives.

3. Henri Matisse to Pierre Matisse, December 17, 1939, in Cowling et al., *Matisse Picasso,* 381.

4. Callery to Barr, November 19, 1939, MoMA Exhibition Records (91.2), MoMA Archives.

5. Sabartés, *Picasso: An Intimate Portrait,* 196.

6. Callery, "The Last Time I Saw Picasso," *Art News,* March 1–14, 1942.

7. Monod-Fontaine, *Daniel-Henry Kahnweiler* 151–52.

8. Fernand Léger to Rosenberg, December 14, 1939, Literary and Historical Manuscripts (MA3500.270), Morgan Library; Sabartés, *Picasso: An Intimate Portrait,* 196.

9. The renewable contracts entered into effect on October 1 for Braque and October 30 for Matisse. Braque to Rosenberg, November 17, 1939, Rosenberg Collection of artist letters (MA 3500.27), Morgan Library; contract between Henri Matisse and Paul Rosenberg dated October 30, 1939, Archives Matisse.

10. Rosenberg to Barr, December 16, 1939, quoted in Barr to Rosenberg, December 26, 1940, MoMA Exhibition Records (91.7), MoMA Archives.

11. Rosenberg to Picasso, February 1, 1940.

12. C. Denis Freeman and Douglas Cooper, *The Road to Bordeaux* (New York and London: Harper and Brothers, 1941), 5.

13. Rosenberg to Henri Matisse, April 4, 1940, Archives Matisse.

14. Henri Matisse to Pierre Matisse, October 11, 1940, Pierre Matisse Gallery Archives (MA 5020), Morgan Library.

15. Jorge Helft, interview by Zachary Donnenfield, Bordeaux, France, 2016, Sousa Mendes Foundation, Greenlawn, New York, vimeo.com/189047352.

16. Helft, interview by Donnenfield.

17. Sousa Mendes's earlier career is recounted in Fralon, *A Good Man in Evil Times,* 12–39.

18. Aristides de Sousa Mendes to his brother-in-law, Silvério, June 13, 1940, Sousa Mendes Foundation, Greenlawn, New York.

19. Helft, interview by Donnenfield.

20. Margot Rosenberg would spend the rest of the war consumed by her separation from her son. Elaine Rosenberg, interview with the author, September 2016.

21. Helft, interview by Donnenfield.

22. Portuguese agents were sent to the French border on June 22, the same day the Rosenbergs crossed into Portugal. Fralon, *A Good Man in Evil Times,* 88–89.

23. Lynn H. Nicholas, *The Rape of Europa: The Fate of Europe's Treasures in the Third Reich and the Second World War* (New York: Alfred A. Knopf, 1994), 125.

24. Nicholas, *Rape of Europa,* 159–64.

25. Rosenberg to Edward Fowles, July 25, 1940, correspondence: Paul Rosenberg, 1923–1948, Duveen Brothers Records, Getty Research Institute.

26. Sinclair, *My Grandfather's Gallery,* 54.

27. Margaret Scolari Barr, "Our Campaigns," 60.

28. The original cables from museum directors to the U.S. consulate in Lisbon have not been located. The Paul Rosenberg Archives contain French translations of them, which the author has rendered in English.

29. Rosenberg to Fowles, August 3, 1940, Getty Research Institute.

30. Feliciano, *Lost Museum,* 112–13.

31. Henry McIlhenny to Henrietta Callaway, August 19, 1940, MoMA Exhibition Records (91.7), MoMA Archives.

EPILOGUE

1. Elizabeth McCausland, interview by Frank Kleinholz for the weekly radio program *Art in New York,* February 7, 1945, wnyc.org/story/elizabeth-mccausland.

2. "Picasso Exhibit in Chicago Great Fun," *Nebraska State Journal,* February 25, 1940.

3. A. J. Philpott, "Picasso Paintings at Museum Seen as Art Sensation; Spanish-French Work Puzzles Onlookers, Shows a Queer Genius," *Boston Globe,* April 28, 1940.

4. "Visitors Stage Sit-Down," *Press Democrat,* Santa Rosa, California, August 8, 1940.

5. *Museum of Modern Art Bulletin,* September 1940.

6. *Bulletin of the Minneapolis Institute of Arts,* November 23, 1940, and January 18, January 25, and February 1, 1941.

7. Thomas C. Linn, "Picasso Exhibit Returns to City: Modern Museum to Show It Again After 250,000 in 9 Cities Viewed It," *New York Times,* July 13, 1941; "Picasso: Forty Years of His Art: Itinerary," MoMA Department of Circulating Exhibitions Records (II.1.91.10.3), MoMA Archives.

8. Earl Rowland to Elodie Courter, January 29, 1941, MoMA Exhibition Records (91.4), MoMA Archives.

9. Susana Gamboa to Luis de Zulueta, Jr., November 25, 1944, MoMA Exhibition Records (258.J.3), MoMA Archives.

10. Marquis, *Missionary for the Modern,* 309.

11. "Picasso: Special Double Issue," *Life,* December 27, 1968.

12. According to the wishes of the Quinn Estate, the Quinn letters were deposited at the Manuscripts Division of the New York Public Library, where they were available for inspection only. They were finally rediscovered in 1960, when a rogue scholar, using a Quinn-like technique, memorized a large group of them and secretly published them. McCandlish Phillips, "Purloined Letters? Intrigue in the Library: Printer Defies a Ban to Publish Papers of John Quinn," *New York Times,* January 17, 1960.

13. Quinn to W. B. Yeats, February 25, 1915.

14. Alexandre Rosenberg to Douglas Cooper, February 21, 1959, in *Paul Rosenberg and Company,* 71.

15. Margaret Scolari Barr, "Picasso: A Reminiscence," lecture, 1973, 12, Margaret Scolari Barr Papers (III.A.19), MoMA Archives.

16. Roché to Picasso, March 1946, Harry Ransom Center.

Text Permissions

Grateful acknowledgement is made to the following for use of unpublished and other material:

Albright-Knox Art Gallery Digital Assets and Archives, Buffalo, New York, for documents related to A. Conger Goodyear's trusteeship at the Albright Art Gallery.

Victoria Barr for the letters of Margaret Scolari Barr to Alfred H. Barr, Jr., and other documents from the Margaret Scolari Barr Papers at the Museum of Modern Art Archives, New York; and numerous excerpts from "'Our Campaigns': Alfred H. Barr, Jr., and the Museum of Modern Art: A Biographical Chronicle of the Years 1930–1944," *New Criterion,* Special Issue (Summer 1987).

Editions Cahiers d'Art, Paris, for letters from Christian Zervos to Alfred H. Barr, Jr., Museum of Modern Art Archives, Museum of Modern Art, New York; and excerpts from Christian Zervos, "Histoire d'un tableau de Picasso," *Cahiers d'Art,* XII, 4–5 (1937). Letters and excerpts © Christian Zervos, Editions Cahiers d'Art, Paris.

The Getty Research Institute in Los Angeles, California, for letters from Paul Rosenberg to Edward Fowles in the Duveen Brothers Records.

The Harvard Art Museums Archives, Harvard University, Cambridge, Massachusetts, for letters from Alfred H. Barr, Jr., and A. Conger Goodyear to Paul J. Sachs, and the memoirs of Paul J. Sachs, in the Paul J. Sachs Papers.

Estate of Pierre Matisse for an excerpt from an autograph letter from Henri

Matisse to Pierre Matisse, October 11, 1940, Morgan Library & Museum, New York, Gift of The Pierre Matisse Foundation, 1997. Henri Matisse © 2022 Succession H. Matisse / Artists Rights Society (ARS), New York; © 2022 Estate of Pierre Matisse / Artists Rights Society (ARS), New York.

The Morgan Library and Museum, Department of Literary and Historical Manuscripts, for letters from the Pierre Matisse Gallery Archives and the Rosenberg Collection of artist letters.

Musée national Picasso, Paris, for letters from Paul Rosenberg to Picasso in the Picasso Archives.

The Museum of Modern Art Archives, The Museum of Modern Art, New York, for letters and documents from the Alfred H. Barr, Jr. Papers and other museum records.

The New York Public Library, Astor, Lenox, and Tilden Foundations, for the correspondence and papers of John Quinn and the letters and diaries of Jeanne Robert Foster.

The Picasso Administration, Paris, for letters and documents in the Picasso Archives, Musée national Picasso, Paris, Don Succession Picasso, 1992; and letters between Picasso and Henri-Pierre Roché, The Carlton Lake Collection of French Manuscripts, Harry Ransom Center, The University of Texas at Austin.

The Harry Ransom Center, The University of Texas at Austin, for the letters and diaries of Henri-Pierre Roché in the Carlton Lake Collection of French Manuscripts.

Elisabeth R. Clark, Marianne Rosenberg, and Anne Sinclair for letters and records in the Paul Rosenberg Archives, Museum of Modern Art, New York; and for Paul Rosenberg's letters to Edward Fowles, Getty Research Institute, Los Angeles; to Henri Matisse, Archives Matisse, Issy-les-Moulineaux; to Picasso, Picasso Archives, Musée national Picasso, Paris; to John Quinn, The New York Public Library, Astor, Lenox, and Tilden Foundations; and to Henri-Pierre Roché, Harry Ransom Center, The University of Texas at Austin.

Photo Credits

Page 4:

Top left: The Carlton Lake Literary File Photography Collection, Harry Ransom Center, The University of Texas at Austin.

Center right: Digital Image © The Museum of Modern Art / Licensed by SCALA / Art Resource, NY.

Bottom: © Archives Olga Ruiz-Picasso, Fundación Almine y Bernard Ruiz-Picasso para el Arte, Madrid. Photographer unknown / All rights reserved.

Page 5:

Top left: The Margaret Scolari Barr Papers, Scrapbook 1933–1934, MSB and AHB's sabbatical year 1933: incl. Easter. The Museum of Modern Art Archives, New York. Digital Image © The Museum of Modern Art / Licensed by SCALA / Art Resource, NY. Photographer unknown / All rights reserved.

Center right: The Margaret Scolari Barr Papers, V.75. The Museum of Modern Art Archives. Digital Image © The Museum of Modern Art / Licensed by SCALA / Art Resource, NY.

Bottom: The Alfred H. Barr, Jr. Papers, II.C.38, The Museum of Modern Art Archives, New York. Digital Image © The Museum of Modern Art / Licensed by SCALA / Art Resource, NY.

Page 6:

Top left: © Archives Olga Ruiz-Picasso, Fundación Almine y Bernard Ruiz-Picasso para el Arte, Madrid. Photographer unknown, All rights reserved.

Center right: © Archives Maya Widmaier-Ruiz-Picasso. Photographer unknown / All rights reserved.

Bottom left: © RMN-Grand Palais / Art Resource, NY.

Page 7:

Top right: Digital Image © The Museum of Modern Art / Licensed by SCALA / Art Resource, NY.

Bottom: A. Conger Goodyear Scrapbooks, 52. The Museum of Modern Art Archives, New York. Digital Image © The Museum of Modern Art / Licensed by SCALA / Art Resource, NY. Photographer unknown / All rights reserved.

Page 8:

Top: Digital Image © The Museum of Modern Art / Licensed by SCALA / Art Resource, NY. © Estate of Andreas Feininger. Andreas Feininger / Premium Archive via Getty Images.

Bottom: Digital Image © The Museum of Modern Art/Licensed by SCALA / Art Resource, NY.

Index

Hugh Eakin is a senior editor at *Foreign Affairs*. His writing about museums and the art world has appeared in *The New York Review of Books*, *Vanity Fair*, *The New Yorker*, and *The New York Times*.